the art of glass

Vitrana, 1970. Dominick Labino (United
States, 1910–1987). Polychrome glass,
cast, H: 245.7 cm (96 ¾ in.); W: 275.3
cm (108 ⅜ in.). Gift of Mr. and Mrs.
Dominick Labino, 1970.449.

the art of glass

TOLEDO MUSEUM OF ART

Jutta-Annette Page

Foreword by Don Bacigalupi

Essays by Stefano Carboni, Sidney M. Goldstein, Sandra E. Knudsen, Martha Drexler Lynn, Jutta-Annette Page, and Arlene Palmer, and contributions by Ellenor Alcorn

Toledo Museum of Art, in association with D Giles Limited, London

This book was published with the assistance of The Andrew W. Mellon Foundation.

FIRST EDITION
© 2006 Toledo Museum of Art
P.O. Box 1013
Toledo, Ohio USA 43697-1013
www.toledomuseum.org

First published in 2006 by GILES
An imprint of D Giles Limited
57 Abingdon Road, London, W8 6AN, UK
www.gilesltd.com

All the objects featured in this book, unless otherwise specified, are in the collection of the Toledo Museum of Art. Black-and-white photographs, color transparencies, color slides, and digitized images are available.

ISBN 1 904832 23 7

For the Toledo Museum of Art:
Coordinator of Publications: Sandra E. Knudsen
Editor: Monica S. Rumsey, Richmond, Va.
For D Giles Limited:
Design: Anikst Design Ltd, Misha Anikst and Alfonso Iacurci
David Rose, proof-reader
Produced by D Giles Limited, London
Printed and bound in China

Front jacket: Dominick Labino, *Vitrana* (detail), 1970, glass, TMA 1970.449; See p.12, fig. 5.
Back jacket: Shell-shaped flask, Italy, Venice, sixteenth century, glass, TMA 1913.420; See p.91, 35A

Contributors:

E.A. Ellenor Alcorn
S.C. Stefano Carboni
S.M.G. Sidney M. Goldstein
S.E.K. Sandra E. Knudsen
M.D.L. Martha Drexler Lynn
J.A.P. Jutta-Annette Page
A.P. Arlene Palmer

IMAGE CREDITS

Misha Anikst, London: Figs. 29.1, 31.1
Toni Marie Gonzalez, Toledo Museum of Art: Nos. 8, 14, 16, 51, 75, 80; Figs. 14.1, 17.1, 27.1, 29.1, 31.1, 38.1, 43.1, 43.2, 44.1, 46.2-.4, 51, 53.2, 63.2, 63.3, 74.1
Richard Goodbody, New York, N.Y.: Nos. 1, 2, 3, 6, 7, 11, 12, 13, 15, 17, 18, 19, 20, 22, 23, 24, 25, 26, 27, 28, 29, 30, 31, 32, 33, 34, 35, 36, 37, 38, 39, 40, 41, 42, 44, 45, 46, 47, 48, 49, 50, 52, 53, 54, 55, 56, 57, 59A, 59B, 60, 62, 63, 64, 65, 66, 70, 72, 73, 74, 76, 82, 83, 86, 87, 92, 93, 97, 99; Figs. 17.1, 20.1, 36.1, 46.1, 53.1, 54.1, 55.1, 66.1, 68.1, 70.1, 75.2, 76.1, 86.1, 97.1
Suzanne Hargrove, Toledo Museum of Art: Fig. 6.1
Image Source, Toledo, Ohio: No. 21; Fig. 26.1
Photo Inc., Toledo, Ohio: Nos. 4, 5, 9, 58, 61, 67, 68, 78, 85; Figs. 1.1, 5.1, 6.2, 40.1, 63.1, 75.1
SANAA, Tokyo, Japan: Digital images of Glass Pavilion p. 7.
Lorene Sterner, Ann Arbor, MI: Figs. 15.1, 47.1
Tim Thayer, Oak Park, MI: Nos. 10, 69, 71, 77, 79, 81, 84, 88, 89, 90, 91, 94, 95, 96, 98, 100; Figs 8.1, 72.1, 78.1, 88.1, 89.1, 90.1, 94.1

CONTENTS

In 2006, the Toledo Museum of Art is proud to open the Glass Pavilion, a unique place where artists and visitors will explore the creative process by relating the works of art in the collection and art being created in the studios. The landmark building—a work of art in itself—grows from the enduring legacies of Toledo itself—the "Glass City," Museum founder Edward D. Libbey, and the studio glass movement. At the same time the Pavilion propels the Museum and Toledo into the vanguard of twenty-first-century art and architecture.

The Toledo Museum of Art is the offspring of the foresight, energy, and financial support of our founders, Edward Drummond Libbey and Florence Scott Libbey. Mrs. Libbey's family contributed to Toledo's growth from the 1840s, and in 1888 Mr. Libbey moved his factory from Boston to Toledo, where he nurtured new technologies and business expertise into a family of flourishing glass industries. The Toledo Museum of Art was born in 1901, when the Libbeys led several hundred fellow citizens to charter a dream. A few years later they began seriously to collect Old Master paintings, Egyptian antiquities, and art in glass for the nascent Museum. Mr. Libbey spearheaded campaigns to construct and expand the building, as his appreciative and equally energetic Director George W. Stevens wrote: "he taught men by example how to create temples of beauty, divulged to them also the methods by which this beauty could be applied to their lives and the lives of their fellows. Such achievements as his will surely... flower in increasing abundance as the years press on and the generations advance."

Created expressly as the home for the Museum's glass collection, the Glass Pavilion was designed by Kazuyo Sejima and Ryue Nishizawa, lead architects of SANAA Limited, Tokyo. The Pavilion serves two complementary purposes—as museum and studio. Structural glass is the architectural key to the dual roles. Exterior and interior glass walls divide space, while at the same time their transparency encourages visitors to connect objects and activities across the boundaries. Five galleries display the glass collection and related art in other mediums. The glassmaking facility includes two hot shops plus studios for lampworking, casting, molding, fusing, and cold-working. The Pavilion is thus unique in the way it fosters a close physical relationship between the art collection and the glass-working studios.

The Glass Pavilion's design is an extension of a twentieth-century concept—that buildings and cities made of glass might symbolize cultural transparency and openness. From its beginnings in antiquity, art made with glass has broken new ground, combining the latest technical advances with the many extraordinary properties of glass. The Trustees and staff of the Toledo Museum of Art join me in the hope that visitors to Toledo and readers of this book will be inspired, as we have been for more than a century, by the astonishing ways in which artists have utilized and responded to glass.

Don Bacigalupi
President, Director, and CEO
Toledo Museum of Art

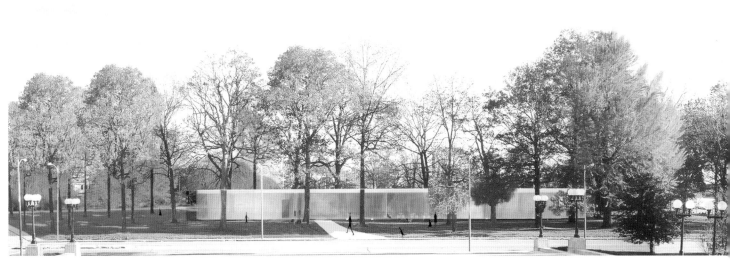

The Glass Pavilion of the Toledo Museum of Art. Digital images: Courtesy SANAA, Tokyo, 2005

"It is most proper and fortunate that we are able to show to our artisans and students the finest products of all periods from the dawn of glassmaking in Phoenicia and Egypt down to that of our time and country."[1]

These ambitious words, penned in 1918, sum up the spirit that has sustained the growth of the collection of glass objects at the Toledo Museum of Art. Today it is one of the most comprehensive and historically significant collections dedicated to the medium in the world, and its creation and growth are as unique as the Museum itself. When civic and business leaders of Toledo resolved at the turn of the twentieth century to create a new organization dedicated to the arts, their goals called for a collecting institution that would serve as a gathering place with multi-faceted activities for all citizens. They underscored this public-minded art-advocacy, embracing people of all ages and backgrounds, by assuring that Museum admission would at all times be free of charge. Trustees, directors, curators, and Museum Members have lavished support on Toledo's collecting of the art of glass for more than a century. Objects have been continuously acquired, studied, conserved, published, and exhibited. This book celebrates milestones in the history of glass by spotlighting representative masterpieces. However, in order to truly appreciate works of art in glass they need to be seen in person — the photographs and texts printed here can only serve to tempt and encourage the reader to visit the collection.

The Toledo Museum's art collection was formed first and foremost to provide aesthetic education for the people of the city and northwest Ohio. The historic glass objects, more specifically, were also to serve as models and inspiration for the designers and craftsmen employed in the flourishing local glass industry. In creating this dual role as civic treasury and artistic–technical collection, the Museum's founders combined the concepts behind fine arts museums and applied and technical arts museums instituted in European cities during the nineteenth century. The Toledo Museum's mandate was to represent the entire history of glass from antiquity to the present, an approach echoing that of London's South Kensington Museum (later the Victoria and Albert Museum), the largest European museum of applied art.

Toledo's image as the "Glass City" of the United States was firmly established by 1901 (when the Museum was founded), based on a spate of inventions across the glass industry — bottles, window glass, tableware, windshields, and construction materials. Glass industrialist Edward

Drummond Libbey (1854–1925), founder and benefactor of the Museum, recognized the importance of the Museum's role in maintaining high standards of craftsmanship and artistic design. He spearheaded the initiative to improve the education of local craftsmen and designers by assembling a model glass collection, as well as promoting training, competitions, and exhibitions of new work. Libbey was supported by the Museum's charismatic director, George W. Stevens (1866–1926);[2] and in 1913, a year after the fledgling institution took up residence in its purpose-built new home, Libbey purchased the first of several significant glass collections.[3] He was assisted and advised in this endeavor by his friend Frank Wakely Gunsaulus of Chicago, a minister, educator, philanthropist, and trustee of several art museums in that city, who had connections in the international art market.[4] The group of fifty-three European Renaissance and Baroque glasses they decided to pursue came from the estate of German publisher Julius Heinrich Wilhelm Campe (1846–1909).[5] With this purchase, the Museum acquired the most important historic European glass collection in the United States at the time, and many of the rare objects remain the only examples of their kind in the country (see Nos. 44, 45). The Campe collection, assembled under the expert guidance of Justus Brinckmann (then director of the Museum of Arts and Crafts, Hamburg), set the standard for the high quality desired by the Toledo Museum of Art for its glass collection.[6]

Libbey continued to acquire systematically formed collections of high repute. In 1917 he purchased the vast collection of (mostly) American glass amassed by Edwin AtLee Barber (1851–1916), the pioneering scholar of American glass and ceramics and first director at the Pennsylvania Museum and School of Industrial Arts (later the Philadelphia Museum of Art).[7] Libbey's desire to document the history of American glass from the seventeenth century onward, understandable on a personal level, was at the time remarkably forward-looking. Until the beginning of the twentieth century, American-made glass was generally viewed as inferior to its European counterparts in both design and execution and only recently deemed worthy of serious study and collecting.[8]

Continuing his goal to create an encyclopedic Museum collection of art in glass, Libbey seized the opportunity in 1916 to acquire the collec-

tion of Thomas E. Hulse Curtis (1852–1915), one of the largest collections of ancient and Islamic glass ever assembled. Purchased by Curtis mostly from dealers and auction houses in New York, the collection illustrates early glassmaking from the Eighteenth Dynasty in Egypt through the early Islamic period, with a strong emphasis on Roman glass from the Levant — Syria and Palestine.[9] It also included the ancient Roman glass acquired between 1866 and 1884 by expatriate American painter Charles Caryl Coleman (1840–1928) from antiquities dealers in and around Rome.[10] By the early 1920s, Toledo's glass collection ranked with the most important in the United States, that at The Metropolitan Museum of Art, and already enjoyed a world-wide reputation.[11] Stained glass was favored at both institutions as a representative form of early European pictorial art, resulting in significant acquisitions (Fig. 1).[12]

In subsequent years, the Toledo Museum added judiciously to its strong holdings of glass from the Islamic world, thanks to Director Blake-More Godwin's love of Islamic art, making it one of the largest and most outstanding collections in the world. *The Toledo Flagon*, a large enameled and gilded flask probably commissioned in Damascus to celebrate a sultan in the early fourteenth century, was acquired in 1927,[13] and a mosque lamp made in Egypt in the mid-fourteenth century, was purchased in 1933 (No. 25). Both are stellar examples of the nearly five hundred Islamic works in glass at the Museum today.

In the 1930s, Godwin began negotiations with Frederic Neuburg of Leitmeritz (today Litoměřice), Czechoslovakia, who owned the preeminent collection of European glass at the time (see Nos. 41, 44, 46, 47). The outbreak of World War II postponed conclusion of these negotiations for nearly two decades, but in the meantime two important vessels arrived in Toledo with much fanfare in 1940: a Venetian Renaissance footed bowl (No. 29) and a Mamluk mosque lamp.[14] The fragile vessels were purchased at the auction of the George Eumorfopoulos collection, London, and transported to New York in a convoy escorted across the Atlantic by British men-of-war until the ships reached Canadian waters.[15] After years of an even more precarious existence, crates with about fifty objects of European glass from the imperiled Neuburg collection finally arrived at the Museum in 1950. An important enameled *Humpen* celebrating the Peace of Westphalia that ended the Thirty Years War (1648), formerly in the ducal collection at Dessau Castle, Saxony, was part of this group (Fig. 2). In his rigorous selection of works from the Neuburg collection, Godwin sought objects appropriate for the Museum's displays. He rejected several important diamond-engraved glasses because "...they are much more impressive in private collections where they can be handled."[16] The Dutch flute with a portrait of Charles II (No. 40) acquired by Otto Wittmann in 1966, and the plate with the arms of Pope Pius IV (No. 34) acquired by Roger Mandle in 1980, prove that this view was not shared by his successors. Collecting policies are determined as

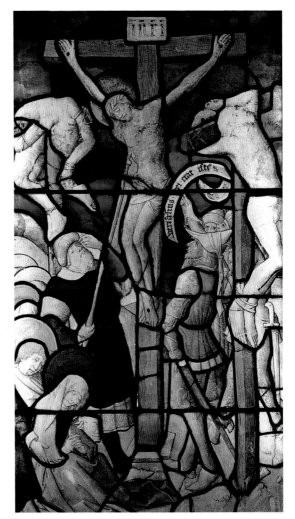

Fig. 1. *Crucifixion*, fifteenth century. Flanders or Burgundy. Stained glass, H: 114.1 cm (45 in.). Gift of George H. Ketcham, 1926.6.

much by the personal views and preferences of directors, curators, and benefactors as by the way they reflect their time, and they are consequently subject to change.

While most of the Toledo Museum of Art's acquisitions in glass until the 1950s looked far back in time, modern and contemporary glass objects were not omitted. For example, following the lead of The Metropolitan Museum of Art and other American institutions, in 1936 the Museum acquired an example of Sidney Waugh's *Gazelle Bowl,* made in

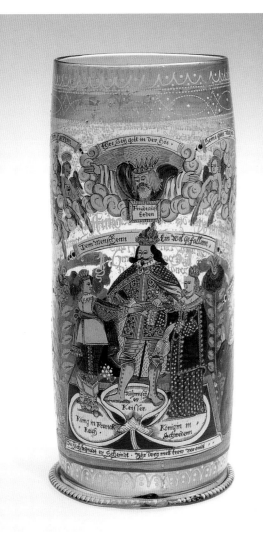

Fig. 2. *Humpen*, dated 1651. Germany. Colorless glass, enameled, H 26.7 cm (10 ¹/₂ in.). Purchased with funds from the Libbey Endowment, Gift of Edward Drummond Libbey, 1950.29.

(No. 72) and an intricate floor lamp, as well as a formal dress made entirely of glass fiber that had been spun, woven, sewn, and exhibited in the Libbey Pavilion at the 1893 Columbian Exposition and World's Fair, Chicago. Several hundred examples of tableware document the evolution of the company's cut and engraved glass production from the 1880s through the 1940s. Toledo's American glass ranks today among the principal collections in the field, including objects of exceptional quality and historical importance.[17] This status was cemented by the acquisition of two more historic collections: in 1959, some sixty examples of early American blown glass from the collection of George S. McKearin, then the leading scholar of American glass (see No. 62), and, soon thereafter, nearly a thousand objects of blown three-mold and pressed glass donated by Mr. and Mrs. Harold G. Duckworth (see Nos. 59, 63).

In response to glass as a field of collecting, the Toledo Museum of Art has also acquired works of art in other media that refer to glass; for example, the paintings reproduced in this book by Jan Davidsz. de Heem (Fig. 40.1), Pieter Claesz. (Fig. 43.1), and John Lewis Krimmel (Fig. 53.2). The Department of Works of Art on Paper also collects prints, drawings, and photographs relating to glass. These range from an etching by Nicolas de Larmassin II representing the French glazier's trade (Fig. 3), to an important photograph by William Henry Fox Talbot (1800–1877) titled *Articles in Glass* from 1844,[18] and two images from 1855 by German photographer Ludwig Belitski of glasses in the Alexander von Minutoli (1806–1887) collection (Fig. 4).[19] In recent years, drawings by contemporary glass artists, such as Dale Chihuly, have been added.[20]

The Toledo Museum expanded its role as a center for the art and history of glass in 1962, when Director Otto Wittmann agreed to host the first studio glassblowing workshops (see Nos. 84–87). The American studio glass movement was born, encouraging artists to express ideas in glass outside a factory setting. Harvey Littleton, a ceramics instructor at the University of Wisconsin (see No. 84), and Harvey Leafgreen, a retired glassblower from Libbey Glass, were the first to create glass art in these workshops. Dominick Labino, a scientist at Johns-Manville Fiber Glass Corporation, provided key technological expertise and became an emerging artist in glass himself (see No. 85).

Labino advised the Toledo Museum as Honorary Curator of Glass, and his mural *Vitrana* (frontispiece) was commissioned in 1969 for the entrance of the Museum's new *Art in Glass* gallery. This two-story gallery space was the gift of Mr. and Mrs. Harold W. Boeschenstein; Mr. Boeschenstein (1896–1972) served as Museum President as well as the first president of Owens-Corning Fiberglas Corporation. Dedicated to highlights of the glass collection, the gallery was designed "in the most modern manner to present the translucent quality of the glass."[21] The *John D. Biggers Glass Study Room* opened in 1976, the gift of Libbey-Owens-Ford Glass Company. It was named for the company's first presi-

the previous year (No. 78). Later, the Libbey Glass Company's extensive corporate archive entered the collection in two gifts, in 1951 and 1969. The first installment included additional objects from the company's famous display at the 1904 Louisiana Purchase Centennial Exposition and World's Fair in St. Louis (the famed Libbey Punch Bowl, Fig. 72.1, having been donated earlier). Among these were a spectacular cut-glass table

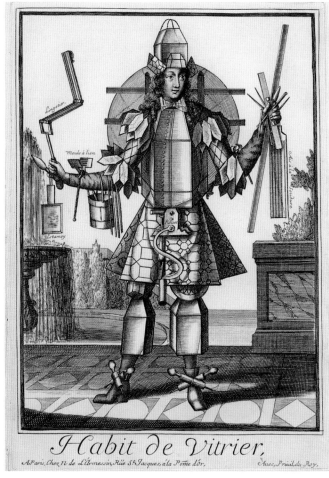

Fig. 3. *Habit de Vitrier*, from *Costumes Grotesques*, about 1690–94. Nicolas de Larmessin II (France, 1638–1694). Etching with engraved title, H. (image): 28.5 cm (11 ¼ in.). Frederick B. and Kate L. Shoemaker Fund, 2001.40C.

Fig. 4. *Glassware*, 1855. Ludwig Belitski (Germany, 1830–1902). Salt print from paper negative, W. (image) 22.1 cm (8 ¹¹⁄₁₆ in.). Purchased with funds from the Libbey Endowment, Gift of Edward Drummond Libbey, 2004.11.

dent (1888–1974), who was also a former President of the Museum. The room was built for the use of all Museum visitors as well as scholars and students to augment the *Art in Glass* gallery and to exhibit the balance of the collection, about 5,000 objects.

Since the 1970s, works of art in glass continue to be added judiciously to the collection by purchase and through the generosity of donors. The Museum's first Curator of Glass (1976–77), David F. Grose, methodically reviewed the collection and proposed that a program of research, publication, and exhibition should become a priority.[22] Davira S. Taragin, Curator of Modern and Contemporary Glass from 1990 to 2002, continued these efforts with decisive expertise and professionalism. She also seized an opportunity presented by the Apollo Society—a Museum donor group formed in 1986 to help acquire significant works of art—and by Director David W. Steadman to augment the collection of contemporary glass art. Seven works by Dale Chihuly, dating from 1976 through 1990, were purchased (see No. 92), and the Apollo Society also commissioned *Bench for Claude Monod I* by Howard Ben Tré.[23] In 1998, the Apollo Society decided to acquire a historic chandelier and selected a nineteenth-century cut-glass chandelier by the London firm Perry & Company.[24]

In recognition of the Toledo Museum of Art's role as the cradle of the Studio Glass Movement, many artists and collectors have donated works of art (see Nos. 83, 93, 98). In 1991 California-based collectors Dorothy and George Saxe gave sixty-two objects, representing leading international artists (Nos. 88, 94–96; Figs. 89.1, 90.1). This significant donation was augmented by nineteen sculptures made between 1995 and 2003, given by Maxine and William Block of Toledo and Pittsburgh (Nos. 89, 91).

The innovative Glass Pavilion project, launched in 2000 under the leadership of former Director Roger M. Berkowitz, signals the beginning of a new era for Toledo's glass collection (see also pp. 6–7). The Pavilion inspired

local benefactors Anne and Carl Hirsch to contribute the Museum's most recent object by Dale Chihuly, a large "chandelier" (Fig. 5). The work was fabricated at Waterford Crystal, Ireland, in 1995 and installed the next year in Campiello del Remer, a small square in Venice (from which it takes its name) during the *Chihuly Over Venice* project, presented in conjunction with *Venezia Aperto Vetro*, the city's first biennale of contemporary glass.[25]

With the opening of the Glass Pavilion in 2006, the Toledo Museum of Art acquires a state-of-the-art facility to house, care for, study, and display its renowned glass collection. While explorations of glass, informed by new technologies, will expand perceptions of glass as an artistic medium, Toledo's collection will be enriched accordingly and its boundaries continue to be redefined.

Lastly, a note about the organization of this book. The works from the collection of glass at the Toledo Museum of Art were selected in collaboration with the authors, who were also closely involved with their sequential arrangement, the object groupings, the choice of specific views, and suggestions for supplementary images. The objects are arranged in seven sections, which mostly follow chronological order. One exception was made for the works from the Islamic world, dating as late as the eighteenth century, in order to maintain cultural continuity. The strength of the American glass collection from the beginning of the nineteenth century suggested another exception — that it would be worthwhile to intersperse contemporary European glasses to show more effectively the increasing international exchange in trade and in technological development between the continents. The studio glass movement — of eminent historic importance to Toledo — prompted in-depth discussion of modern studio glass that includes segments dedicated to its antecedents in the middle of the twentieth century, the Toledo workshops, and a section illuminating its international impact and context.

Jutta-Annette Page
Curator of Glass

Notes

1 George W. Stevens, "XVI Century Venetian Glass," TMA *Museum News*, 30 (January 1918): unp. [3].

2 Blake-More Godwin, "George W. Stevens," TMA *Museum News* 9.1 (Spring 1966): 5–22; *Enduring Legacy* 2001; 5–14; McMaster and Taragin 2002, 11–12.

3 Libbey did not collect glass for himself. The many Museum objects credited "Gift of Edward Drummond Libbey" were purchased either by him for immediate donation or through the financial endowments established after his death in November 1925. One of the rare exceptions is the Longfellow plate, TMA 1925.50, here No. 58.

4 *Frank Wakely Gunsaulus, 1856–1921: In Memoriam* (Chicago: Donnelly, 1921).

5 Campe's extensive art collection was sold privately to benefit the Hamburg museums. The purchase of the initial group of seventy-five objects, brokered by dealers Alfred Chatain of Chicago and Julius Böhler of Munich, also included a small group of ancient glasses that may or may not have been original to the Campe collection. The objects were first displayed at the Art Institute of Chicago (*Bulletin of the Art Institute of Chicago*, 6.4 [April 1913]: 56). Initial TMA publication: "Ancient and Medieval Glass," TMA *Museum News* 21 (April 1914): unp. [10–12]. Gunsaulus and Libbey were not the only Americans to purchase glasses from the Campe collection: William Randolph Hearst acquired a *Reichsadlerhumpen* dated 1605 (Christie's, London, 19 May 1983, lot 198).

6 Brinckmann also assisted with the selection of objects from the Campe collection for TMA (letter from Gunsaulus to Libbey, dated 28 January 1913).

7 Wilson 1994, 18.

8 Wilson credits the start of this fashion to the 1909 Hudson–Fulton exhibition at The Metropolitan Museum of Art and Frederick William Hunter's 1914 book, *Stiegel Glass*, about the early American glass manufacturers Henry William Stiegel and Caspar Wistar (Wilson 1994, 18–19).

9 Grose 1989, 19–21.

10 The majority are Roman mosaic, cast, and cameo glass fragments. Many of these "samples" were polished by dealers and often wrapped in cardboard strips with gilded edges (Grose 1989, 21–23, 243, fig. 115).

11 Letter from New York antiquities dealer Gustav Eisen to Director Blake-More Godwin, dated 29 September 1922. The Metropolitan Museum of Art (founded in 1870) owned a large collection of ancient Cypriote glasses donated by its colorful Director Luigi Palma di Cesnola. And in 1881, the Metropolitan received both the Charvet collection of ancient glass presented by Henry Marquand, a Museum trustee and later its second president, and a large group of Venetian glasses collected by James Jackson Jarves. Jarves had assembled these in Italy as an agent for Cornelius Vanderbilt in the preceding year and eventually donated them in honor of his father (Metropolitan Museum 1881(?), 19).

12 TMA 1926.6, published: Putney 2002, 51.

13 TMA 1927.317, H 35.6 cm (14 in.), said to originate from Spain, published: Lamm 1929–30, vol. 1, pls. 417–418, vol. 2, pl. 183; Labino 1968, 37, fig. 24; *Art in Glass* 1969, 40.

14 TMA 1940.118, published: *Toledo Treasures* 1995, 61.

15 "Toledo Art Museum acquires rare glass at English War Sales," Boston *Globe*, 15 September 1940. Mosque lamp TMA 1940.118, published: *Toledo Treasures* 1995, 61.

16 Letter from Godwin to Neuburg, dated 15 March 1950.

17 The publication of the collection by Kenneth M. Wilson (Wilson 1994) was the first comprehensive discussion of this material from the industry's infancy in the eighteenth century to 1930.

18 TMA 1989.32, published: *Toledo Treasures* 1995, 122.

19 Minutoli assembled his photograph collection of arts and crafts in Liegnitz in Silesia from 1850 onward. Photography at this time replaced drawings and printed reproductions, which had previously formed the basis for books recording model and specimen collections.

20 For example, TMA 1991.115, *Terra Rosa Venetian*, drawing, which is related to TMA 1993.3, *Transparent Terra Rosa Venetian*, blown glass, TMA 1993.3, published: *Contemporary Crafts*, 33, pl. 9, 193, no. 16. Both drawing and object were gifts from Dorothy and George Saxe.

21 TMA News Release, 1 April 1969.

22 Grose 1989; *Contemporary Crafts* 1993; Wilson 1994; Stern 1995; *Toledo Treasures* 1995; *Alliance of Art and Industry* 2002; and *Contemporary Directions* 2002.

23 This sculpture (1992.18 a, b) and its pair, *Bench for Claude Monod II* (1992.19 a, b), were commissioned from the artist in 1990 and delivered two years later, published: *Toledo Treasures* 1995, 183; *A Decade of Collecting* 1996, 14–15.

24 TMA 1998.7, H: 213.4 cm (84 in.), published: TMA *Members Magazine and 97/98 Annual Report*, 16.

25 TMA 2006, published: *Chihuly Over Venice* (Seattle, Wash.: Portland Press, 1996), unp., no. 3; Donald B. Kuspit et al., *Chihuly* (2nd ed., New York: Abrams, 1998), 292; TMA *arTMAtters* (Winter 2006): 16. The original components were divided to create two chandeliers: *Campiello del Remer #1*, now at the Kemper Museum of Contemporary Art, Kansas City, Mo., and *Campiello del Remer #2*, installed in the Glass Pavilion in 2006.

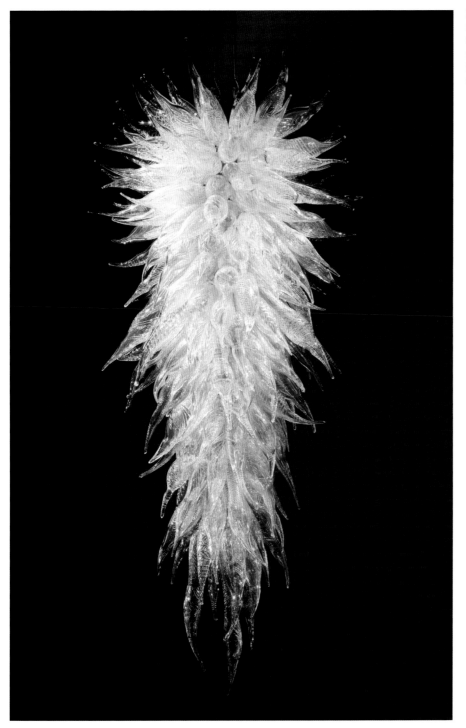

Fig. 5. *Campiello del Remer #2,* 1996.
Dale Chihuly (United States, born 1941).
Colorless lead glass; blown, tooled, cut,
polished at Waterford® factory, Ireland.
Purchased with funds given by Anne and
Carl Hirsch, 2006. Photo: Jack Crane.

ACKNOWLEDGMENTS

This book has been desired by visitors, staff, and colleagues around the world for a number of decades. *The Art of Glass* is published to celebrate the opening of the Glass Pavilion of the Toledo Museum of Art. Publication in the short period of a little more than two years would not have been possible without the help of a wide range of supporters, inside and outside the Museum. Continual support and guidance were provided by Director Don Bacigalupi, and by Roger M. Berkowitz, his precursor who supervised the project through its initial planning stages. I also hope this book will honor the persistence of their illustrious predecessors, who directed the formation, growth, and expanding uses of the glass collection — George W. Stevens, Blake-More Godwin, Otto Wittmann, Roger Mandle, and David W. Steadman.

I wish to express my sincere gratitude to authors Stefano Carboni, Arlene Palmer, and Martha Drexler Lynn for their invaluable expertise, continuous enthusiasm, and professional insight. A special heartfelt thanks goes to Sidney M. Goldstein and Sandra E. Knudsen for taking on jointly the section on ancient glass after the untimely death of David Frederick Grose (1945–2004), eminent scholar of ancient glass and a great friend of the Museum. He passed away early in the project and is sadly missed.

I am of course grateful to the entire staff of the Toledo Museum of Art, especially to Carolyn M. Putney, Director of Collections and Curator of Asian Art, for her cheerful encouragement and confidence in the project's merits and progress. I would like to thank my other curatorial colleagues — Amy Gilman, Associate Curator of Modern and Contemporary Art; Sandra E. Knudsen, Associate Curator of Ancient Art; Thomas Loeffler, Collections Manager for Works of Art on Paper; Paula Reich, Curatorial Projects Manager; and Lawrence W. Nichols, Curator of European and American Painting and Sculpture before 1900, for generously giving both encouragement and expertise. Suzanne Hargrove, Chief Conservator, and Jeffrey Boyer, Technical Assistant in Conservation, carefully prepared the objects for study and photography and attentively monitored the countless times objects were moved by the Museum's accommodating art handlers Russell Curry, Jiro Masuda, André Sepetavec, and Stephen Walbolt, under the supervision of Claude Fixler, Installation Coordinator, and Julia

G. Habrecht, Exhibitions Administrator. Kim Oberhaus, Administrative Assistant to Conservation, meticulously maintained object movement and conservation records. Patricia J. Whitesides, Registrar; Karen A. Serota, Associate Registrar, and Nicole M. Rivette, Assistant Registrar, provided precious access to files and, just as importantly, to their collective "institutional memory." Archivist Julie McMaster graciously looked into her cache of records regardless of how extensive a search or consultation appeared to be needed. Leonard Marty, Master Instructor –Glassblowing, generously offered insights on the technology of glasses in the collection. Images of objects and supporting visuals were efficiently processed and cheerfully retrieved by Julia Chytil and Carli C. Smith in the Visual Resources Center. Toni Marie Gonzales, Assistant Curator of Visual Resources and Photographer, mastered the challenging task of producing images for the frequently changing object lists, late-arriving new acquisitions, and extra object views with her customary charm and visual sensitivity. The library staff at the Toledo Museum of Art, led by Anne O. Morris but including the unflagging zeal of Marilyn Czerniejewski, Irene Keczkes, Katy Miller, Michael Ryan, Kathleen Tweney, and Julie Vozobule, responded with speed and proficiency to innumerable requests for often obscure literature and patiently checked countless historic facts. The Information Technology Department, managed by Sandra Moore and aided by Mark Spiess and John Kramer, Network Technicians, assisted capably in all aspects of electronic information processing. Curatorial interns Lauren Applebaum and Erin Valentine cheerfully aided all facets of the project despite often tedious and tiresome chores. The production schedule was vigilantly coordinated by Sandra E. Knudsen, and editing was thoughtfully performed by Monica S. Rumsey. Assistance with typing, formatting, scanning, and proofreading was provided with great attentiveness and unflagging energy by Lori Brown, Jennifer Hanson, Carol Ray, and Sylvia J. Screptock.

Beyond the Toledo Museum of Art, individuals who have assisted with expertise include Ellenor Alcorn, New York; Dela von Boeselager, Cologne; Gunnel Holmér, Växjö, Sweden; Simon Cottle and John Smith, London; E. Marianne Stern, Hilversum, The Netherlands; Kenneth M. Wilson, Punta Gorda, Fla.; Janet D. Jones, Lewisburg, Pa.; Christopher S. Lightfoot, New York; Gertrud Platz, Berlin; Jane Shadel Spillman, Dedo von Kerssenbrock-

Krosigk, Tina Oldknow, and William Gudenrath at The Corning Museum of Glass; Gail Bardhan at the Rakow Library of The Corning Museum of Glass; and Lisa Pilosi and Mark T. Wypyski, Sherman Fairchild Center for Objects Conservation, The Metropolitan Museum of Art. Karol Wight and Catherine Hess at The J. Paul Getty Museum and David B. Whitehouse at The Corning Museum of Glass are commended for allowing us to adopt many definitions of glass terms from their glossaries.

I am indebted to Richard P. Goodbody, New York, for his circumspection and professionalism throughout two long sessions to photograph the majority of the objects illustrated in this book. Colleagues and institutions that responded in unbureaucratic fashion to image requests included Thomas Matyk, MAK – Austrian Museum of Applied Arts/ Contemporary Art, Vienna; Patrick Murphy, Museum of Fine Arts, Boston; and Nori Hawkins, Chihuly Studio, Seattle. Lorene Sterner, Ann Arbor, prepared line drawings of two visually complex engraved vessels, the Worringen Beaker (No. 15) and the Brandenburg pokal (No. 47) with her customary skill and attention to detail. Misha Anikst, London, used digital proficiency to compose photomontages of the Venetian footed bowl (No. 29) and *lattimo* ewer (No. 31), so that readers can better enjoy the enameled decoration as a continuous frieze.

D. Giles Limited, London, organized design, production, and distribution. We are grateful to Dan Giles, Sarah McLaughlin, and designer Misha Anikst for their professional expertise. Their remarkable sensitivity to this book's exceptional subject is reflected in its overall appearance and, ultimately, its visual appeal to the reader.

Jutta-Annette Page
Curator of Glass
17 January 2006

1–19 **ANCIENT MEDITERRANEAN**

These three glass vessels were probably preserved as part of the grave goods buried with members of the ancient Egyptian nobility nearly 3,500 years ago. They may have been used by the individuals in whose tombs they were ultimately buried. Magically, it was believed they would provide the tomb owner with their fragrant contents in death, as they did in life. Their compact sizes and characteristic shapes suggest that they contained costly perfumes and scented ointments. The contents would have been used for personal adornment and also, because of the magical properties of certain ointments and incense, for anointing statues of gods, participants in religious ceremonies, and the bodies of the deceased.[1] The shapes are based on the traditional shapes of carved stone vessels. The bottle (1A)[2] held a scented liquid and was probably closed with a linen-and-wax stopper, while the miniature column-shaped vessel (1C)[3] held kohl, the traditional Egyptian eye cosmetic made from galena (lead sulfide) and applied with a long, thin rod, usually made of bronze, but sometimes of glass. The footed jar (1B)[4] may have contained a scented unguent or salve. The practice of leaving perfumes and ointments in tombs is known to have existed 2,000 years earlier, well before any ruler united the numerous small kingdoms of the Nile River valley. Before glass vessels were made to hold kohl, similar long, narrow tubes were made of wood or stone.

The forms of these vessels delight the eye with their striking shapes and rich, bold colors. The color of the kohl tube and the jar resembles lapis lazuli, the dark blue stone imported from Afghanistan that was highly prized in other ancient lands, including Egypt. Other glass colors replicate such semiprecious stones as turquoise, cornelian, agate, and jasper. The unguent bottle (1A) was colored to imitate turquoise. This is a most unusual glass — an exceptional color that is amazingly translucent. The wavy polychrome decorations that are unique to glassmaking are fresh and bright, bringing a brilliant palette to a wealthy patron's personal object. In a vast land of sand with

buildings formed of mud brick, official and religious architecture — as well as homes — were decorated with carved or modeled relief sculpture and painted with bright colors. Personal objects were frequently inlaid or painted. Glass was a rare and precious commodity at this time, its variety of colors giving small objects much of their aesthetic appeal.

The palm-column kohl tube (1C) survived intact and unbroken, but examination of the surface shows that the vessel deteriorated through prolonged contact with soil and moisture, changing the original dark blue surface to a silvery iridescence; such weathering is characteristic of excavated glass. Egyptian glass that retains its original fire-polished surface remains an exception.

These three vessels were made by the core-forming process, the technique most commonly used to work glass before the discovery of glass-blowing. From about 1600 until the end of the first millennium B.C.E., glass objects were made by core-forming, by casting (see No. 2 and Fig. 2.1), or by the mosaic-glass technique (see Nos. 5 and 6). Archaeologists believe that core-forming technology started when an artisan pressed a core of iron-rich clay and animal dung around a metal rod, to support the object as it hardened in the furnace. The core was shaped to approximate the exterior shape of the vessel. Once the core dried, a so-called parting agent — perhaps a coating of finely crushed limestone — was applied to the core surface to make it easier to detach the completed vessel. To make the vessel, hot glass was applied to the core. Some scholars believe that threads of hot glass were trailed over the surface of the core and the shape then smoothed and flattened by rolling the hot object over a flat stone or metal surface, called a marver, then reheating and working the object until the desired form and surface were achieved. Other scholars suggest that, instead, powdered glass was picked up on the core and heated, repeating this process many times to fuse the desired thickness and profile of the vessel. Still other scholars are debating whether

core-forming took place in simple furnaces, as seen today in Turkey or Egypt,[5] or in an open fire, with the finished objects removed from the rod and annealed by burying them in the ashes.

Once the body of the vessel was completed, trailed decoration of contrasting colors could be wound onto the surface and marvered in, to create a smooth vessel wall. The feathery pattern of trails was created by dragging a sharp point alternately up and down over the surface. Once the surface decoration was complete, the glass-maker warmed rods of glass and attached them to the shoulder as handles (visible here on the bottle and jar, 1A and 1B).

Trails of color and small pads of glass were added to create a foot or rim; and the process of heating and reheating, to work the material into the desired shape, involved considerable effort. The petals of the palm-column kohl tube (1C) or the application of the spirally twisted trail of medium blue, white, and yellow glass on the rim of the jar (1B) required precise manipulation to avoid deforming the detail with excess manipulation. The feet of all three vessels were pulled out from the body of the vessel, where additional glass had been added during the forming process. S.M.G.

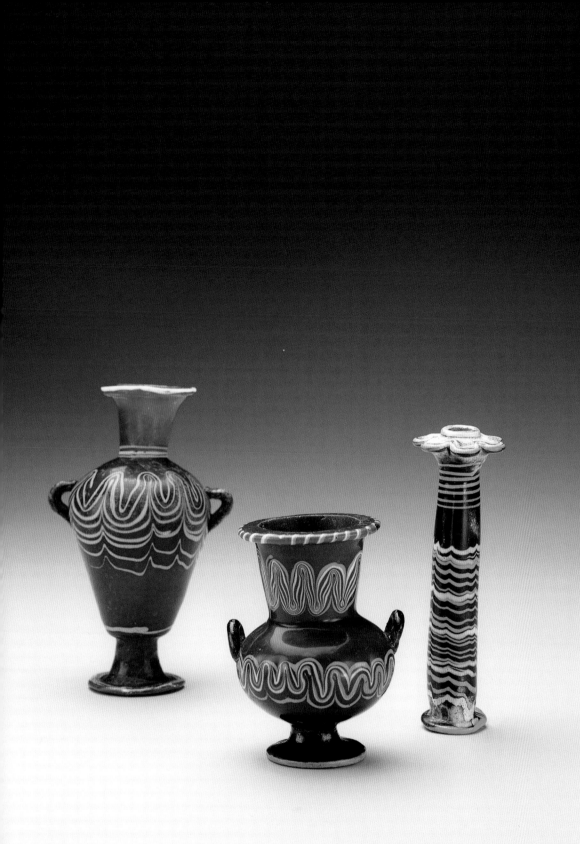

From left to right:

1A. UNGUENT BOTTLE (*AMPHORISKOS*)

Ancient Egyptian, New Kingdom, Eighteenth Dynasty, probably the reigns of Amenhotep III to Akhenaten
About 1400 to 1350 B.C.E.
Translucent bubbly aquamarine glass with dark blue, opaque white, and opaque yellow trails; core-formed, trail-decorated, marvered and tooled; applied handles and foot.
H: 12.3 cm (4 ¾ in.)
Provenance: Fahim Kouchakji, New York, N.Y.
Purchased with funds from the Libbey Endowment, Gift of Edward Drummond Libbey, 1951.405

1B. FOOTED JAR (*KRATERISKOS*)

Ancient Egyptian, New Kingdom, Eighteenth Dynasty, probably the reigns of Amenhotep III to Akhenaten
About 1400 to 1350 B.C.E.
Medium blue glass with trails of opaque light medium blue, opaque white, opaque yellow, and opaque turquoise; core-formed, trail-decorated, marvered and tooled, applied handles and foot.
H: 8.2 cm (3 ⁷/₃₂ in.)
Provenance: J. Pierpont Morgan, Jr. (1867–1943), New York, N.Y.; Joseph Brummer (1883–1947), New York, N.Y. (1944–48).
Purchased with funds from the Libbey Endowment, Gift of Edward Drummond Libbey, 1948.16

1C. KOHL TUBE

Ancient Egyptian, New Kingdom, late Eighteenth or Nineteenth Dynasty, probably the reigns of Amenhotep III to Rameses II
About 1400 to 1225 B.C.E.
Dark blue glass with opaque white and opaque orange-yellow trails; core-formed, applied rim and base, trail-decorated, marvered and tooled.
H: 11.2 cm (4 ⅜ in.)
Provenance: Private collection, Alexandria, Egypt; Heidi Vollmoeller, Zürich, Switzerland.
Purchased with funds from the Libbey Endowment, Gift of Edward Drummond Libbey, 1966.114

While the ancient Egyptians prized brightly colored glass vessels that imitated semiprecious stones (see No. 1), the people who lived in the later empires of the Near East and Western Asia appreciated the transparency and brilliance of rock crystal. This glass *phiale*, or shallow bowl, was cast, cut, and polished to imitate rock crystal.[6] The flared rim and smooth lip belong to a shape that evolved from much earlier, elaborate lobed (or petal decorated) bowls made of gold, silver, and bronze at least as early as the eighth century B.C.E., probably in Assyria. The shape was used both to drink wine and to pour offerings to the gods.

The *phiale* was probably cast in a multi-part mold by slowly and continually adding ground glass as the glass fused and filled the bowl's ever-narrowing profile.[7] The result was a blank of colorless glass with a slight yellowish tinge. Depending on the temperature achieved in the fire, the surface would have been more or less finished, although there is no evidence that any of the lobed decoration was formed in the mold, which would have eliminated at least some of the time-consuming cutting of the design. Scholars have suggested that an alternative way to make a bowl of this shape was to slump a disc-shaped blank of glass over a former mold.[8] The blank was then finished by grinding and polishing both interior and exterior surfaces, to create a highly polished vessel that must have been almost indistinguishable from rock crystal. The exterior of this bowl was relief-cut to form thirty-two rounded petals. Each petal has a deeply cut central groove that radiates from the boss at the center of the base and terminates at the shoulder, which is defined by a horizontal groove.

Toward the end of the third millennium B.C.E., when glass was first being made, small objects such as glass beads and rods were fashioned in the city of Ur, the legendary birthplace of Abraham in southern Mesopotamia (modern Iraq). The leaders and wealthy citizens of this prosperous city-state drank from precious vessels of stone, shell, silver, and gold. There too, archaeologists have found the raw materials of glassmaking—lumps and ingots of fused glass—which were being cold-worked (that is, without the use of fire to shape the glass) to create small objects by grinding and polishing. The glass itself was probably made elsewhere and brought to Ur for fabrication. In this early period, no vessels of glass are known, but the tradition of working glass into pendants or beads was being established.[9]

Five hundred years later, the same casting technique was used to produce simple amulets found at sites around the Near East. Examination of the back of the Astarte pendant (Fig. 2.1)[10] confirms that hot glass, softened in a furnace, would have been forced into an open mold and the taffy-like material then pressed into the mold with a metal tool. This assumption can be made because it is known that ancient furnaces could not reach sufficient levels of heat to make the glass fluid enough to pour. There is some evidence that some glass objects were made by filling small molds with crushed glass, which was then heated. Most surviving pendants of this type are made of cast opaque turquoise glass. The Toledo Astarte is aquamarine, the same unusual color used to make the New Kingdom Egyptian bottle (No. 1A).

It is difficult to trace objects made using this early casting technique into the first millennium B.C.E. The most direct descendant and probably the most extraordinary surviving early glass *phiale* was excavated in a Phrygian tomb (Tumulus P) at Gordion, in modern-day Turkey, which has been dated to the late eighth century B.C.E.[11] The bowl is not complete, but it is a remarkable example with ribs cut on both interior and exterior. Several hundred years later, about 500 B.C.E., tribute-bearers carved on palace wall reliefs at Persepolis offer drinking vessels that are similar in shape to this *phiale*.[12] The tribute vessels were probably made of gold or silver, but they also might have been of rock crystal or glass. Slightly closer to the date of Toledo's *phiale*, the Athenian playwright Aristophanes (450–385 B.C.E.) mentions in his play *The Acharnians* (74) the use of gold and

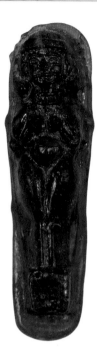

Fig. 2.1. *Pendant in the form of a woman*, possibly the Near Eastern goddess Astarte. Western Asia, possibly northern Syria. About 1500 B.C.E. Blue glass; cast in an open mold, L: 7.7 cm (3 in.). Gift of Edward Drummond Libbey, 1923.195.

glass drinking vessels at the court of the Persian King. The play was first performed in 425 B.C.E., and archaeological evidence found at Olympia suggests that glass was being worked, if not manufactured, in Greece by this time.[13] The Toledo *phiale* is related by form and decoration to a group of vessels made in Achaemenid Persia late in the fourth century B.C.E., probably before Persepolis was captured by Alexander the Great in 330 B.C.E.[14]

S.M.G

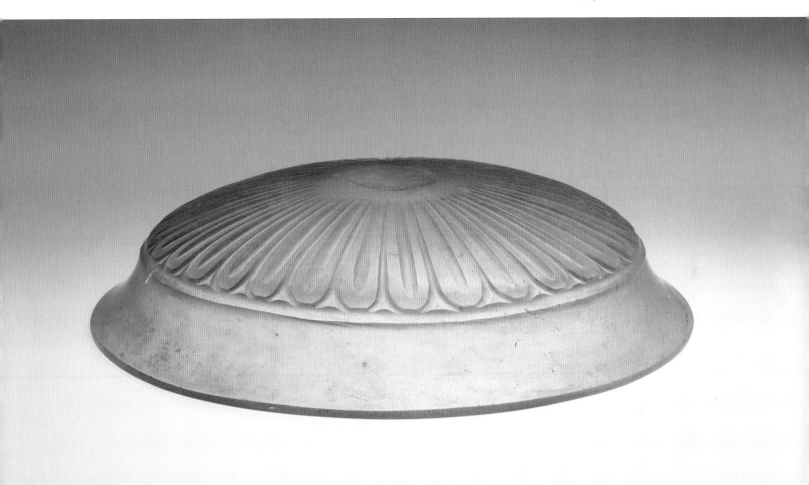

BOWL (*PHIALE*)
Western Asia, probably Persia or Ionia
Late fourth century B.C.E.
Colorless glass; cast, lathe- and
relief-cut, polished
Diam. (rim): 17.3 cm (6 ⅝ in.); H: 4.1 cm
(1 ⅝ in.); Weight: 210.6 g (7.43 oz.)
Provenance: Gawain McKinley,
New York, N.Y.
Purchased with funds from the Libbey
Endowment, Gift of Edward Drummond
Libbey, 1979.74

These seven core-formed vessels represent a colorful series of perfume containers not unlike the three Egyptian objects introducing this section (see No. 1). In fact, they are similar to the Egyptian objects in color, size, and manufacturing technique. They, too, were used to hold perfumed oils and seem to have been used in funerary rituals, wherein the containers were placed with the body in the grave. All of these similarities probably explain why many early glass historians mistakenly attributed such vessels to Egyptian manufacturing centers. Huge numbers of these core-formed vessels, however, have been found wherever ancient Greek merchants touched shore, from northern France to southern Russia, and almost none have been found in Egypt.[15] The shapes are all miniature versions of ancient Greek ceramic or metal vessel forms.[16]

These glass containers were produced over a period of five centuries. The undecorated blue-green *alabastron* (3B)[17] and the two small *amphoras*, or *amphoriskoi*—one with a white body (3A)[18] and one with a red body (3E)[19]—are the three earliest vessels here. This group is slightly smaller in comparison to their contemporary clay counterparts and was manufactured between around 550 B.C.E. and before 400 B.C.E. In contrast to the four later vessels (3C, D, F, and G), the earlier ones are somewhat simpler in form and decoration. The larger *alabastron* (3F),[20] the robust *oinochoe* (3G),[21] the massive lentoid flask, or *aryballos* (3D),[22] and the elegant and rare *stamnos* (3C)[23] represent vessels manufactured later, from around 350 B.C.E. until about 200 B.C.E. These are larger in size and proportion than the earlier core-formed vessels. The size of the *alabastron* is impressive, and the lentoid flask is among the largest of all known examples. The *stamnos* is a shape rarely made in glass and virtually unknown in such fine condition. All of these later vessels have delicate trail decoration applied to the surface and worked in by marvering. This type of decoration characterizes the second group of vessels; the shapes are more refined and they were apparently often produced in extreme sizes, both large and miniature. Where the handles of earlier forms of the *alabastron* and the *amphoriskos* could easily hold a chain or a thong to allow the owner to carry it or hang it on a hook, the handles on similar later shapes are so small or attenuated that they must have been purely decorative.

The products of these glass craftsmen are both chronologically and geographically challenging. We do not yet fully understand where and when the glass industry began again after its decline in Mesopotamia in the late eighth century B.C.E. There is a gap of nearly a century before the dates suggested by archaeological finds in the Greek world. Glass historian David Grose observed that the large number of glass objects found around the Aegean suggests that the industry must have begun somewhere in East Greece. The island of Rhodes has often been proposed as a place where perfumes were produced and therefore a likely location for the development of a glassworking industry. Many core-formed vessels have been found in Rhodian burial sites, but it has been pointed out that this may be more a matter of archaeological chance than evidence of a manufacturing center.[24]

The later vessels illustrated in this group of seven are most frequently found in South Italy, prompting the suggestion that they were also produced there or possibly in Macedonia, just north of present-day Greece.[25] Again, without archaeological evidence of factory production, it is difficult to be sure. Most incredible is that this second group of core-formed vessels ushers in the first wave of Hellenistic glassmaking from about 325 to 250 B.C.E. (see No. 4). No example of the third and last group of core-formed vessels is illustrated here.[26] The technique continued to be used, producing rather attenuated and sloppy forms in the late Hellenistic period (150 B.C.E. through the reign of Emperor Augustus [r. 27 B.C.E.–14 C.E.]). Manufacture of many forms used in the earlier periods was suspended; *amphoriskoi* and unguent bottles predominate. The time-consuming core-forming process came to an end with the advent of glassblowing about 50 B.C.E.

S.M.G.

From left to right:

3A. JAR (AMPHORISKOS)
Eastern Mediterranean, possibly from Rhodes
Late sixth through fifth centuries B.C.E.
Opaque white glass with deep amethyst trails; core-formed, trail-decorated, marvered, and tooled, with applied handles
H: 11.4 cm (4 ½ in.)
Provenance: Thomas E. H. Curtis, Plainfield, N.J.
Gift of Edward Drummond Libbey, 1923.153

3B. BOTTLE (ALABASTRON)
Eastern Mediterranean, possibly Rhodes
Late sixth through fifth centuries B.C.E.
Blue-green bubbly glass; core-formed, tooled, undecorated, with applied handles
H: 14.2 cm (5 ⅝ in.)
Provenance: Thomas E. H. Curtis, Plainfield, N.J.
Gift of Edward Drummond Libbey, 1923.342

3C. JAR (STAMNOS)
Eastern Mediterranean or Italian
Mid-fourth through early third centuries B.C.E.
Deep blue bubbly glass with opaque white and opaque yellow trails; core-formed, trail decorated, marvered, and tooled, with applied handles (one restored)
H: 8.3 cm (3 ¼ in.)
Provenance: Thomas E. H. Curtis, Plainfield, N.J.
Gift of Edward Drummond Libbey, 1923.106

3D. FLASK (LENTOID ARYBALLOS)
Eastern Mediterranean or Italian
Mid- to later fourth century B.C.E.
Golden-brown bubbly glass with opaque white, opaque turquoise, and opaque yellow trails; core-formed, trail-decorated, marvered, and tooled with applied handles
H: 13.3 cm (5 ¼ in.); W (max.): 10.2 cm (4 in.)
Provenance: Thomas Howard-Sneyd, London, United Kingdom.
Purchased with funds from the Libbey Endowment, Gift of Edward Drummond Libbey, 1985.66

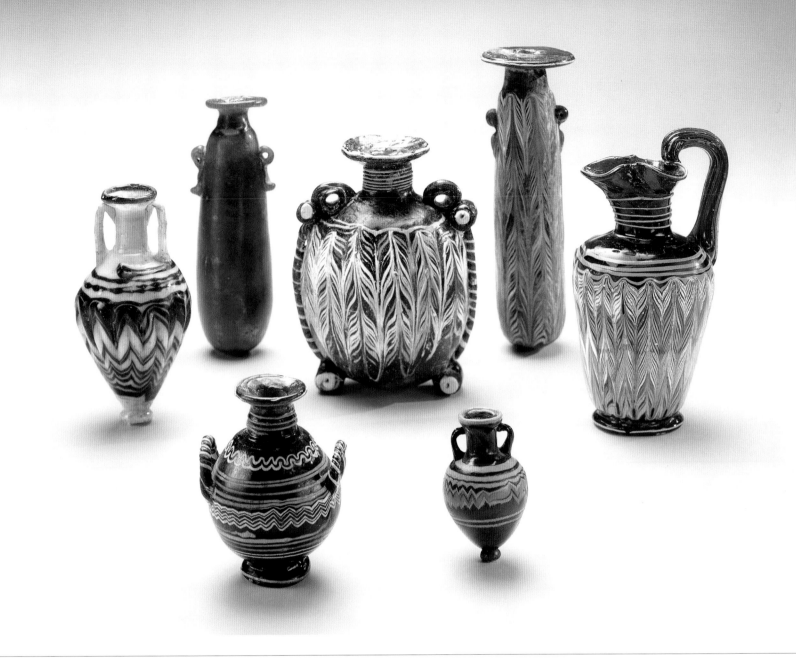

3E. JAR (*AMPHORISKOS*)

Eastern Mediterranean, possibly Rhodes
Fifth century B.C.E.
Opaque brick red, streaked with brown and pur-
plish-brown glass; opaque yellow and opaque
turquoise trails; core-formed, trail-decorated, mar-
vered, and tooled, with applied handles
H: 6.4 cm (2 ½ in.)
Provenance: Thomas E. H. Curtis, Plainfield, N.J.
Gift of Edward Drummond Libbey, 1923.161

3F. BOTTLE (*ALABASTRON*)

Eastern Mediterranean or Italian
Mid-fourth through early third
centuries B.C.E.
Deep blue bubbly glass with opaque white, opaque
light blue, and opaque yellow trails; core-formed,
trail decorated, marvered, and tooled, with applied
handles
H: 16.7 cm (6 ⅝ in.)
Provenance: Thomas E. H. Curtis, Plainfield, N.J.
Gift of Edward Drummond Libbey, 1923.157

3G. PITCHER (TREFOIL *OINOCHOE*)

Eastern Mediterranean or Italian
Mid-fourth through early third
centuries B.C.E.
Deep blue bubbly glass with opaque white, opaque
turquoise, and opaque yellow trails; core-formed,
trail-decorated, marvered, and tooled with applied
handle
H: 15.0 cm (5 ¹⁵⁄₁₆ in.)
Provenance: Thomas E. H. Curtis, Plainfield, N.J.
Gift of Edward Drummond Libbey, 1923.152

23

One of the treasures of the Toledo Museum's ancient art collection, this elegant vessel would have commanded attention in the era following the conquests of Alexander the Great.[27] The shape of this transparent bowl is unparalleled because of its early date and formal subtlety. It appears to be one of the earliest examples of magnificent Hellenistic glass tableware produced before the invention of glassblowing. The Toledo *krater* dates among the earliest examples of very large, elegant glass forms made by casting large and impressive blanks of glass, which were then lathe-cut and polished. The robust and more-than-hemispherical–shaped body was cut and polished to make an astoundingly thin vessel wall; the entire vessel is supported by a solid and somewhat more conservative stem and foot. It is almost as if the glassmaker did not want to risk making the stem too thin; a narrower stem and foot might not support its substantial body and could prove unstable, especially when filled with food at the table. The overall grand proportions and the thinness of the lathe-cut wall are beautiful and impressive.[28] Lathe-cut grooves accent the strong curves of the profile around the foot and stem, and add texture and richness to the overall design. The broad and delicate lathe-cut band highlighting the shoulder (the upper third) of the bowl provides a focal point and a delicate flourish to the otherwise unbroken sweep of the *krater's* profile.

Large vessels like this footed bowl were the first in a series of tableware produced for a luxury market that developed in the third century B.C.E., following the death of Alexander and the division of his kingdom into wealthy territories. Core-formed vessels like the ones discussed previously (nos. 3C, D, F, and G) were the more common products, made on Rhodes or along the Ionian coast, and heralded this period. According to literary sources, Alexandria (founded by Alexander after his conquest of Egypt in 332 B.C.E.), became the center for the production of luxury wares in the early Hellenistic period. As in large urban centers today, craftsmen from across the Mediterranean were drawn to the bustling sea-

port. Glassmaking—especially cast wares in monochrome and color and with more complex decoration—seems to have become a specialty of this center, although there is little archaeological evidence to support such a theory. Despite the political vacuum created by the death of Alexander in 323 B.C.E., the ancient world remained stable, and commerce and manufacturing continued on an impressive course. Applying innovations in glass manufacturing and responding to increasing refinement in taste, glassworkers of the third and second centuries B.C.E. strove to create vessels matching the size and delicacy of the Toledo *krater*. Such quality appears to have been consistent among glass objects found at Greek sites in South Italy, often identified as Canosa,[29] or among other vessels recently thought to be from around the same area.[30]

As a new concept developed in tableware—entire services in glass for serving and consuming food and drink—glassworkers busied themselves making luxurious objects that resembled containers of more costly materials, such as silver and gilded silver. The tradition that produced the Toledo *krater*, although influenced by the earlier Persian technology of producing colorless glasses (see No. 2), was a purely Hellenistic one and flourished through the third and second centuries B.C.E. The size of this *krater* reflects an early attempt to cast a very large glass blank, which could then be turned on a lathe to create a major glass object. The slow process of filling the multi-part mold and creating a blank form that was then slowly cooled to eliminate stress was only one step of the production. The blank would then have been turned on a lathe and polished to create the final form. The amount of so-called chatter, or vibration, that occurred while producing this object was a constant concern for the lathe-worker. The task of carving out a simple hand-sized drinking bowl was difficult enough; cutting the vessel wall so thin and creating the elegant profiles and grooves that decorate the body and accent the stem and foot would have added substantial risk of cracking, chipping, or breaking the bowl. To finish the

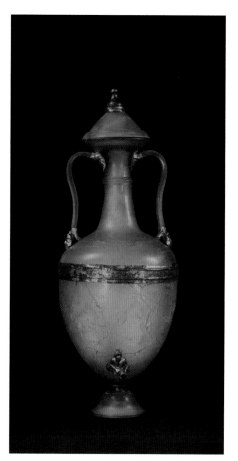

Fig. **4.1.** *Amphora with Lid*, Hellenistic Greek, about 200–150 B.C.E. Colorless glass; cast and cut, with gilded mounts, H: 59.6 cm (23 ½ in.). Antikensammlung, Staatliche Museen zu Berlin, Inv. 30219,254. Photography: Ingrid Geske.

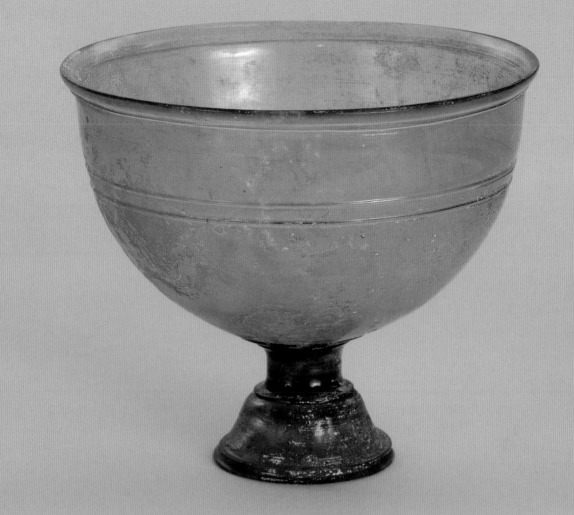

process of making this bowl, the entire surface would be polished, again using a lathe or a rotary grinder. The slight bit of dark weathering crust that now adheres to the surface of this vessel highlights the *krater*'s fine rotary polish and gives it an almost metallic appearance. The process, shape, and decoration clearly reflect similar vessels made of precious metal.

An even larger object should be mentioned in relation to Toledo's bowl—an *amphora* with lid now in the Antikensammlung, Berlin (Fig. 4.1). This vessel, said to have been found in Olbia, in what is now southern Ukraine,[31] is the most extraordinary vessel of cast colorless glass from the period. The *amphora* consists of not one but two separately cast pieces of glass,

which were joined by a metal strap around the container's mid-section. The lower part of the body resembles the profile of a footed bowl. The grooves cut on the shoulder and the base of this *amphora* are nearly identical to those on the base of the Toledo *krater*. Despite their discovery at opposite ends of the ancient world, the two vessels appear to have been made around the same time and in the same workshop. Dated here to the mid- to late third century B.C.E., some scholars think these two vessels more likely date to the second century or even to the early first century B.C.E. The most recent date suggested for the Berlin *amphora* is 120–80 B.C.E.[32]
S.M.G.

FOOTED BOWL (*KRATER*)
Hellenistic Greek, from the Eastern Mediterranean, probably Egypt
Late third century to second century B.C.E.
Colorless glass with a yellow-green tinge; cast, lathe-cut, rotary polished
H: 17.7 cm (7 in.); Diam. (rim): 21.9 cm (8 ⅝ in.); Weight 748.4 g (26.4 oz.)
Provenance: Mme. Perrer, Beirut, Lebanon; George Asfar, Beirut, Lebanon; Robin Symes, London, United Kingdom; Private collection, London; Gawain McKinley, New York, N.Y.
Purchased with funds from the Libbey Endowment, Gift of Edward Drummond Libbey, 1980.1000

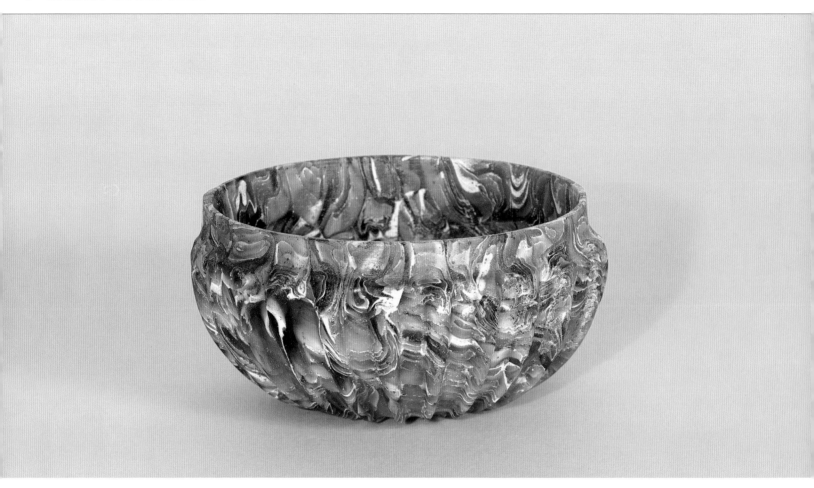

RIBBED BOWL
Graeco-Roman, probably Italy
Late first century B.C.E. to early
first century C.E.
Multi-colored glass canes; mosaic glass
technique, cast, tooled, wheel-cut,
rotary- and fire-polished
Diam. (rim): 11.7 cm (4 ⅝ in.); H: 5.7
cm (2 ¼ in.)
Provenance: Heidi Vollmoeller, Zürich,
Switzerland.
Purchased with funds from the Libbey
Endowment, Gift of Edward Drummond
Libbey, 1970.428

At first glance, this sturdy bowl appears to have been carved out of a solid block of white- and purple-veined stone.[33] It resembles amethyst or banded agate, semiprecious stones that were prized for vessels at the time of Emperor Augustus and slightly later. The bold vertical ribs stand proud of the surface, seeming to buttress the exterior of this remarkable object. In practical terms, the ribs probably offered the user a better grip on a favorite drinking vessel. This bowl belongs to the long tradition of cast glass drinking vessels seen earlier in the colorless Persian *phiale* of the fourth century B.C.E. and the Greek *krater* (see Nos. 2 and 4). It is part of a parallel production of hemispherical and conical drinking bowls made of both colorless and monochrome colored glass, as well as hemispherical drinking bowls made using the time-consuming mosaic-glass technique. The varieties of ancient glass vessels found in Italy are evidence of conspicuous consumption of "things Greek." Wealthy clients seem to have sought out imported — and important — tableware from throughout the ancient Mediterranean.[34]

During the consolidation of the Roman Empire and the lasting peace achieved by Emperor Augustus at the end of the first century B.C.E., the glass industry flourished. The craft that had begun on what had been the Syro-Palestinian fringe of the Greek world was now free to supply markets with fine glass vessels. Once the Roman glass industry was founded, it became fully mature and multi-centered within two generations, providing glassware to the farthest reaches of the Roman Empire and beyond. Thousands of fragments of mosaic glass vessels found in and around Rome during the mid-nineteenth and early twentieth centuries suggest that an enormous quantity of luxury glassware was produced. Scholars have studied the monochrome and mosaic cast material and categorized it into six main groups, with sixteen subgroups.[35] It is important to keep in mind that this is only one type of glass produced in the fifty- to sixty-year period between 30 B.C.E. and 30 C.E.

The ancient technique of mosaic glass is similar to that used to produce paperweights today.[36] Glass rods and strips of various colors were heated together to form a bar, which was pulled out like taffy to form a rod that reveals the internal design — such as a spiral or a rosette. The rod was then drawn out into thin canes that were sliced into circular sections or short lengths, which were assembled and slowly heated until they fused into a single vessel. Scholars and glass artists suggest that there were several ways to make these vessels. Some show evidence of having been cast in multi-part molds, then finished by grinding and polishing; others may have been made by fusing sections and lengths of cane into a flat glass blank, which was slumped either into or over a former mold.

The exterior of the rim on this ribbed bowl seems to have been lathe-cut, and there is a horizontal groove cut just below the rim on the interior. There are two more grooves cut on the interior, where the vessel wall curves in toward the bottom. The small *patella* cup, or carinated bowl (Fig. 5.1),[37] represents another of the endless variety of mosaic glass patterns. It also demonstrates the fact that glass workshops often copied a popular ceramic form, using casting and lathe-cutting. The number of surviving intact mosaic glass vessels and fragments is so astounding that it is possible to imagine that glasswares eclipsed the popularity of the fine *terra sigillata* ceramic wares that they imitated. S.M.G.

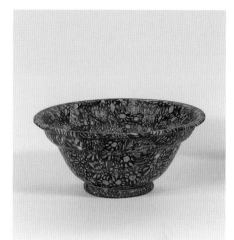

Fig. 5.1. Bowl (*Patella*). Graeco-Roman, probably made in Italy, late first century B.C.E. to early first century C.E. Glass canes; mosaic glass technique, cast, tooled; applied coiled base, interior rotary polished, Diam. (rim): 10.0 cm (4 in.). Gift of Edward Drummond Libbey, 1923.1393.

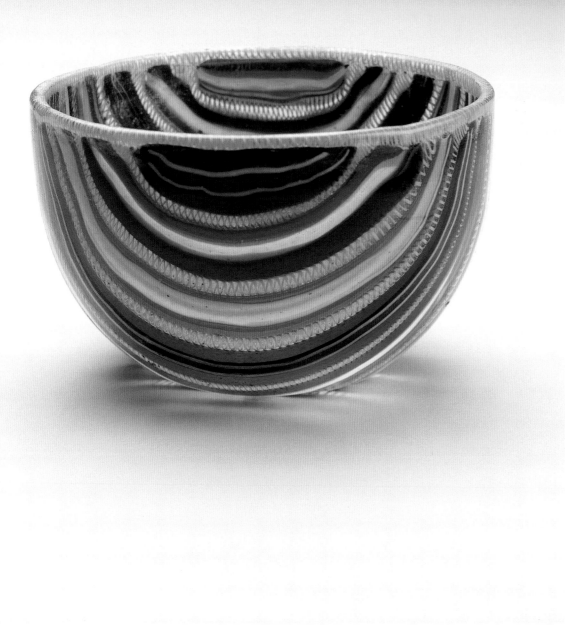

CAST STRIPED BOWL
Graeco-Roman, probably Italy
(said to have been found in Italy)
Late first century B.C.E. to early
first century C.E.
Multi-colored glass canes; mosaic
(ribbon) glass technique, cast, interior
fire-polished, exterior rotary-polished
H: 5.6 cm (2 ¼ in.); Diam. (rim):
8.4 cm (3 ⅜ in.)
Provenance: Giorgio Sangiorgi, Rome
(by 1914 to 1965); Sergio Sangiorgi,
Rome (1965–67).
Purchased with funds from the Libbey
Endowment, Gift of Edward Drummond
Libbey, 1968.87

The colors of this striped bowl still evoke the delight that a table replete with colorful glass drinking vessels would have provided a dinner guest in the early Roman Empire.[38] Although clearly not made of precious metal or rare stone, the colors are intense and not of nature. They are a tribute to the technology of the early Roman glassworkers who exploited the bold colors possible in glass to create visually striking vessels (see also No. 5). Simple forms like this hemispherical bowl, with their spectacular array of colors, could have been distributed throughout the Empire but seem to have been a favorite product of the workshops around the city of Rome itself.

The Toledo Museum owns a large and important group of mosaic glass vessels and fragments from the first century B.C.E. and early first century C.E.[39] These objects allow a better understanding of the range of forms and patterns popular during this brief but incredibly prolific period in Roman glassworking. Ribbon- or band-glass manufacture, a variation of the mosaic-glass technique, involves grouping bands of colored canes or flattened rods together, casing them in colorless glass, and fusing them into a variety of forms. The rough vessel usually was finished by wrapping a colorless glass cane with spiral-twisted rods around the rim. Sometimes cast in a multi-part mold or by slumping a pre-made disc over a former mold, these vessels were produced in considerable quantities. Both this cast bowl and the gold-band bottle (Fig. 6.1) come from the important collection of ribbon glass assembled by Giorgio Sangiorgi in Rome in the early twentieth century. His collection, which also included hundreds of mosaic glass fragments probably collected in the nineteenth century, lends credibility to the notion that these vessels were produced locally in and around Rome.

The gold-band bottle (Fig. 6.1)[40] takes the ribbon-glass variation to another level of luxury. In addition to the bands and canes of colored and colorless glass used to create the characteristic undulating patterns, one band of colorless glass has gold foil trapped between its layers.

When the bottle was manipulated and shaped, the thin foil fractured and flowed with the surrounding glass. Typically, gold-band glass is represented in only a few forms, in emerald green, deep transparent blue, and amethyst, with opaque white used, in some cases, as an accent. As in most gold-band vessels, the exterior of this small bottle was carefully polished and retains a sharp profile reminiscent of metal vessels with lathe-cut grooves and ridges. The delicate, modulated grooves decorate the lip and profile of the bottle's shoulder and define the girth of its body; they even enliven the underside.

Both the bowl and the bottle must have delighted the ancient eye in a way that we cannot appreciate today. To ancient Romans during the reign of Augustus, the brilliant blues, reds, and greens — achieved in ancient glass by the addition of metallic oxides — must have been a wonder. S.M.G.

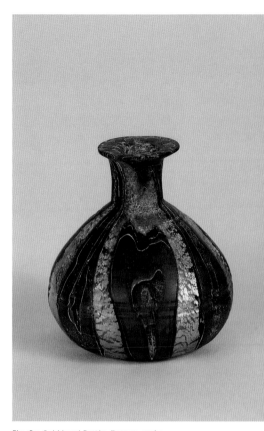

Fig. 6.1 Gold-band Bottle. Roman, probably made in Italy (said to have been found in Italy), early to mid-first century C.E. Three bands of golden brown outlined in opaque white, of dark blue banded with opaque white, and of white with purple and colorless glass encasing gold leaf; mosaic glass technique; cast, lathe-cut grooves, rotary-polished, H: 5.7 cm (2 1/4 in.). Purchased with funds from the Libbey Endowment, Gift of Edward Drummond Libbey, 1967.9.

"Surely this must be a bottle turned out of a block of the finest agate from the East." That comment must have been what the Roman glassmaker intended as a reaction to this bottle (7A),[41] and indeed it is a successful imitation of agate. The randomly graded color and veining closely resemble the natural agate and sardonyx that were favorite semiprecious hardstones of the Roman elite and their Greek predecessors. The quantity of extant vessel fragments with this design suggests that thousands of bottles and bowls were made in this characteristic pattern. Footed and ribbed bowls for the table, as well as personal bottles for scented oils and unguents, were produced. Sometimes the veining closely mimicked semiprecious stone, sometimes a bold blue vein or other color was added to enliven the pattern.

The form of this bottle belies a major innovation that would have worldwide implications for the production of glass for the next 2,000 years: the discovery of glassblowing. The bottle's decorative pattern and shape are related to those of the gold-band glass bottle previously discussed (Fig. 6.2), but it is important to note the slightly rounded and softened form of this faux-agate bottle. There are no lathe-cut grooves on the body or rim. The gold-band bottle was cast using the mosaic-glass technique and lathe-cut to finish and decorate it, but this faux-agate bottle was built up of mosaic-glass canes, which were picked up with a blowpipe and inflated to create the vessel. The invention of glassblowing enabled the glass workshops to produce an object with complicated coloration and banding in a fraction of the time required by the mosaic-glass technique. The trade-off was the reduction in labor and time against a profile that is not as sharp and a rim that is uneven. Ironically, the fashion for blown luxury glasses like this faux-agate bottle was quite short-lived, because tastes changed by the middle of the first century C.E. and glassworkers became increasingly proficient at forming vessels both with the help of molds and without. The interest in mosaic glass of all types came to an end, and production of blown forms, cut glasses, and mold-blown vessels would explode across the Empire.

The more delicate form of the second bottle (7B)[42] illustrates a band-glass bottle of subtle color variation. Its hues recall amethyst and sapphire, but such gems are not found together in nature. The colors may have reminded the owner of exotic stones described by authors but owned only by the wealthiest of citizens or rulers in distant places. Elusive *myrrhine* vessels are mentioned by authors as among the rarest of materials. Pliny the Elder relates that when T. Petronius, a man of consular rank, was about to die because he fell out of favor with Emperor Nero, he broke his *myrrhine* ladle to deprive Nero of possessing it. Petronius had paid three hundred thousand sesterces for it (*Natural History,* 37.20). Nero, as was fitting for an emperor, was reported to have paid a million sesterces for a single *myrrhine* bowl. *Myrrhine* has variously been identified as banded agate or fluorospar, among other exotic minerals. The simple profile of this small bottle was a popular form produced in one color. Imagine a set of these bottles in use for a lady's toilette, where transparent deep blue, opaque white, bright aquamarine, and pale green bottles would complement bottles made of banded glass.
S.M.G.

From left to right:

7A. BOTTLE
Ancient Roman Empire, probably Italy
Early to mid-first century C.E.
Translucent golden-brown and opaque white glass canes; mosaic-glass technique, multiple sections of cane picked up, tooled into an irregular pattern, and blown
H: 11.6 cm (4 5/8 in.); Diam. (max.): 8.4 cm (3 3/8 in.)
Provenance: Thomas E. H. Curtis, Plainfield, N.J.
Gift of Edward Drummond Libbey, 1923.1478

7B. BOTTLE
Ancient Roman Empire, probably Italy
Early to mid-first century C.E.
Alternating sections of two canes, the first in a purple ground with parallel opaque white glass bands; the second in a blue-green glass with parallel white bands. Mosaic glass technique, multiple sections of cane picked up, tooled into an irregular pattern, blown and tooled at shoulder and rim, rotary-polished
H: 7.1 cm (2 3/4 in.); Diam. (max.): 5.0 cm (2 in.)
Provenance: Thomas E. H. Curtis, Plainfield, N.J.
Gift of Edward Drummond Libbey, 1923.1475

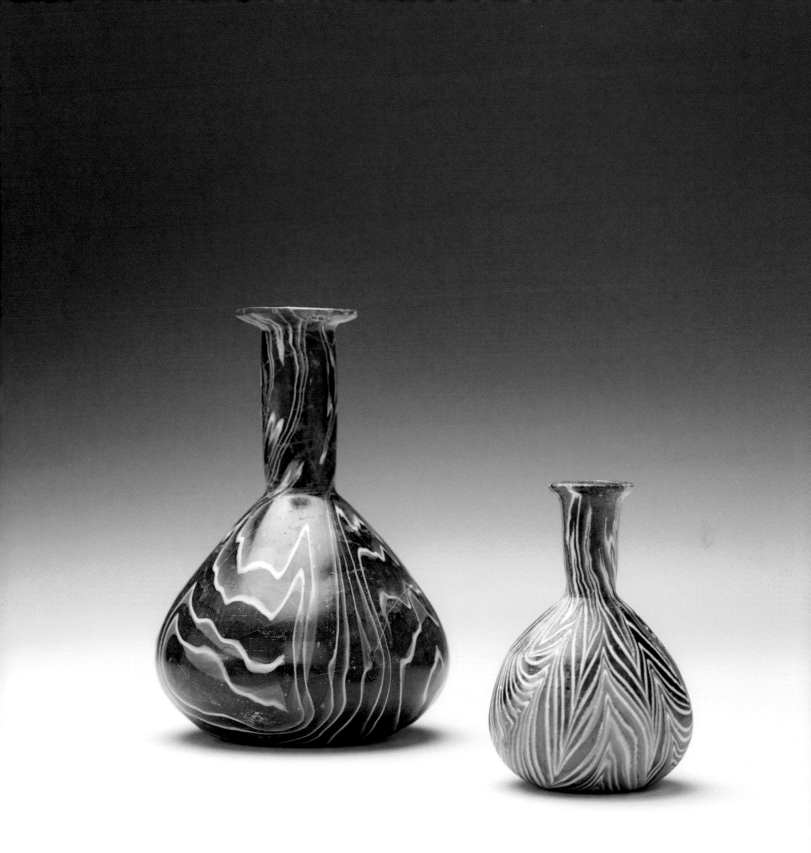

Cameo glass was the most remarkable technical and artistic achievement of Italian glassworkers of the early Roman Empire, between about 25 B.C.E. and 50–60 C.E. Hellenistic Greek gem-cutters made cameos by carving the colored layers of semiprecious stones, such as onyx. Roman glassworkers in Italy, probably in Rome and possibly in Naples, perfected a way to produce blanks of glass by layering two or more contrasting colors, which were then carved. Fewer than twenty complete or restored early Roman cameo vessels survive;[43] plaques and medallions are more numerous. The Toledo Museum of Art holds several dozen fragments of glass cameo-carved vessels, gems, and plaques, all of which were collected in Italy by the expatriate American painter Charles Caryl Coleman (1840–1928).[44]

In spite of painstaking study of ancient cameo glass vessels during the past thirty years, there is still disagreement about how ancient glassworkers made cameo-glass objects. Flat plaques and gems were apparently made by the simplest possible method — the white and colored layers were cast separately, by fusing crushed glass in a flat mold, after which the slab-like layers were placed on top of each other and heated until they fused together. Close examination of vessels, however, seems to show that sometimes they were blown and cased but other times cast in the same manner as cups and bowls (see Nos. 2, 4–6).

This small mask is a fragment, but its curved back indicates that it comes from a vessel, perhaps a cast glass cup.[45] The colored glass layers for cameo carving were applied in specific areas, probably by re-heating the dark brown cast glass cup blank and then applying blobs and trails of molten glass where desired. The fragment shows that the white glass for the area of the face was applied to the background, then thick layers of dark brown for the wig were applied over the face, and a white trail applied where the diadem encircles the wig. The artist carved the face, the intricate corkscrew locks of hair, and finally attached a ribbon of gold over the white diadem. The inner side of the face and the upper part of the wig were carved in high relief, free of the surface — a tour de force visible only to the person handling the cup.

Theater masks usually appear in Roman art as elements of landscapes and still lifes overflowing with symbols of Bacchus and his followers. Masks were fashionable imagery in mosaics and wall paintings,[46] as well as on tableware of the early imperial period, from the reign of Augustus to at least the middle of the first century (see Fig. 8.1).[47] Spectacular, intact examples include the pair of silver *kantharoi* from the Hildesheim treasure[48] and the sardonyx cup now in the Cabinet des Médailles of the Bibliothèque Nationale, Paris.[49] Most masks on luxurious Roman drinking cups represent characters from tragic, comic, and satyr plays written by Greek

Fig. 8.1. Cup. Ancient Roman Empire, reported to have been found in Asia Minor, about 10–50 C.E. Silver, hammered relief decoration., H 7.0 cm (2 ¾ in.); Diam. (rim): 8.8 cm (3 ½ in.). Purchased with funds from the Libbey Endowment, Gift of Edward Drummond Libbey, 1961.9.

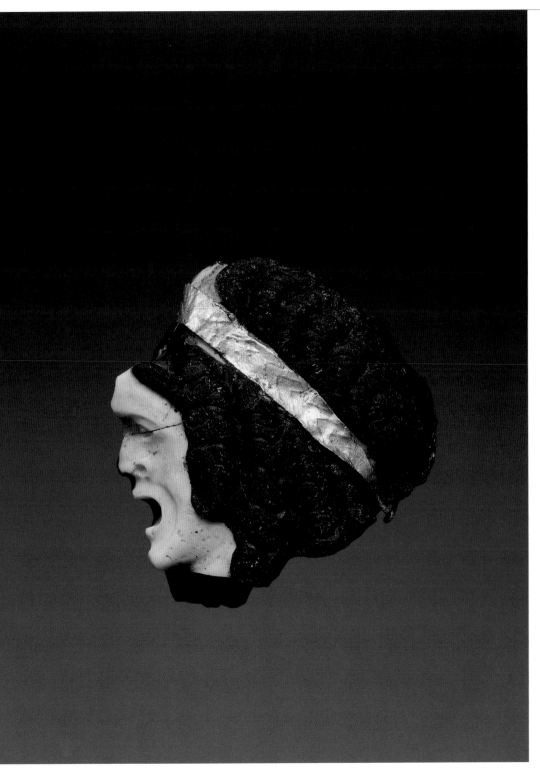

FRAGMENT OF A CAMEO GLASS VESSEL: MASK OF A TRAGIC ACTOR

Ancient Roman Empire, probably made in Italy, likely in Rome
About 20–50 C.E.
Brown and white glass; cast and relief-cut; sheet gold
H: 3.5 cm (1 ⅜ in.)
Provenance: Charles Caryl Coleman, Rome, Italy; Thomas E. H. Curtis, Plainfield, N.J.
Gift of Edward Drummond Libbey, 1923.1641

poets in the fifth and fourth centuries B.C.E. These antique plays were fashionable in elite literary circles of the early Empire, because by this time, mime—which took its name from the imitation of real life—and pantomime had become the dominant forms for popular theater; neither used masks.

The Toledo Museum's cameo mask fragment is unusual because it is a *tragic* mask. The woman wears the high, luxuriant hairdress of twisted locks above the mask, called an *onkos*,[50] and is identified as a queen by the diadem. Even in profile the contorted wide opening for the mouth, wrinkled skin, and protruding cheekbones give an impression of fear and pathos. Without additional evidence—such as the masks of other characters in the same play that must have been on the shattered cup—it is impossible to give her a name. We can only speculate that the original cup may have been associated with the philhellenic literary tastes of the court of Nero (r. 54–68), who gave tragic recitations, sang, and even danced the roles of gods, heroes, and heroines of famous Greek playwrights, as well as of the tragedies of his tutor, Seneca.[51]

S.E.K.

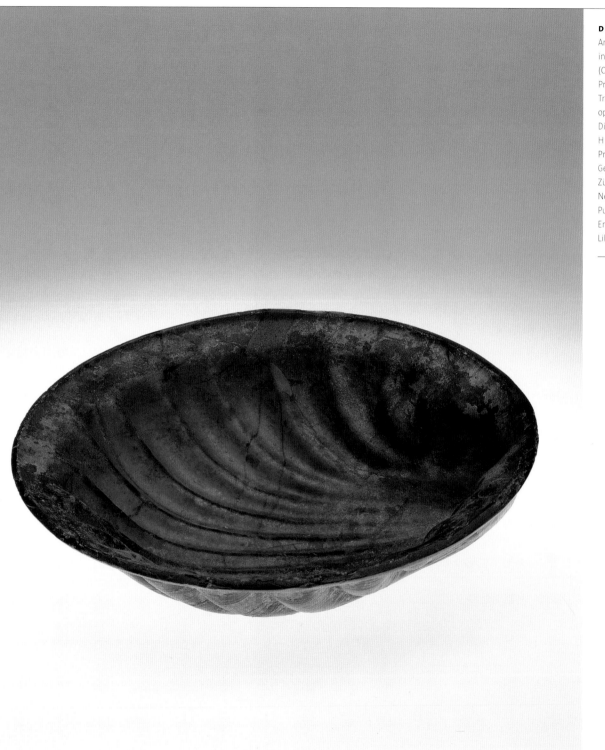

DISH IN THE SHAPE OF A SHELL
Ancient Roman Empire, perhaps made
in Colonia Claudia Ara Agrippinesium
(Cologne)
Probably first half of fourth century C.E.
Translucent deep blue glass; blown in an
open mold, tooled
Diam.: 15.8 cm (6 $7/16$ in.);
H: 5.0 cm (2 in.)
Provenance: Margarita Haagen, Aachen,
Germany; Elizabeth Haagen Mueller,
Zürich, Switzerland; Gawain McKinley,
New York, N.Y.
Purchased with funds from the Libbey
Endowment, Gift of Edward Drummond
Libbey, 1981.93

The bivalve-shell shape of this dish is a clever serving form, possibly suggesting its use to hold a savory fish sauce popular in Roman times. The form would also represent a revival in the later Roman era, harkening back to the far more stable and sumptuous early Empire. Both shape and rich blue color are reminiscent of serving vessels made of various metals and glass in the first century.[52] The bronze shell-form dish (Fig. 9.1)[53] was raised by hammering a disc of cast metal, then turning it on a lathe to finish the decoration. The ribs that look naturalistic in the glass vessel appear stylized and skeletal in bronze. Although both are serving vessels, the bronze dish is based in the rich tradition of costly tableware produced in gold, silver, and bronze. Monochrome *patella* cups (see Fig. 5.1) and other vessels with sharp lathe-cut profiles or elaborate lathe-cut grooves and decorations (see No. 6) were produced in great numbers. As early as the late second or early first century B.C.E., there was even a series of monochrome glass dishes made in the shape of a shell and an extraordinary mosaic-glass shell dish now in a private collection. These dishes continued to be made in Italy until as late as the eruption of Mt. Vesuvius in 79 C.E., but the fourth-century date of Toledo's glass shell dish can be established on both archaeological evidence and stylistic grounds.

In terms of style, the earlier shells — whether of metal or in glass — tend to be more naturalistic looking: the hinged back of the shell retains flanges and the rippled outer rim remains naturalistic in form. For the Toledo dish, however, the flanges were eliminated and the entire shell was encased in a regular diameter formed by the cracked-off rim. Practically speaking, when the glassblower blew the parison into the open mold, he continued to expand the gather and over-blew it slightly. He then scored the edge with a sharp or wet tool, allowing the excess glass to be cracked off, or broken away, from the finished object. Often the rim was left rough, but occasionally it was lightly ground.[54]

In fact, the deep blue glass itself and the cracked-off rim establish this shell dish firmly in

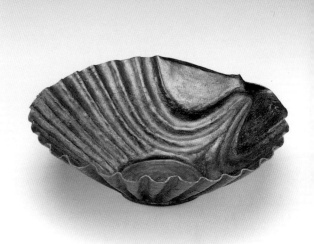

Fig. 9.1. Dish in the Shape of a Shell. Ancient Roman Empire, perhaps Italy, first century C.E. Bronze; raised and lathe-spun, W. (max.): 7.2 cm (2 ¹³/₁₆ in.). Gift of Dennis and Joyce Kapp, 1983.17.

the fourth century C.E. There are several series of head flasks and elegant pitchers with hollow handles and rouletted, trailed-on decoration[55] that represent the end of the mold-blowing tradition in the fourth to fifth centuries. Their color is the same as the Toledo shell and they share the same rim finish. All of these vessels show evidence that they were cracked off from a blowpipe.

As for archaeological evidence, other examples of the Toledo type of shell dish are known.[56] Most are from Cologne, but a few have been found at Intercisa, Hungary. The Toledo example, which came from a private European collection, could well have come from Germany, either Cologne or somewhere nearby. All the shell dishes excavated from northern Europe are associated with fourth-century material. The Rhineland, Cologne in particular, was a major glassmaking center for centuries during the Roman Empire and was especially active during the later Empire.[57] The diversity of glass forms produced in the Rhineland is staggering, especially the mold-blown conceits and trail-decorated fancies. It is to this region, for example, that we attribute mold-blown flasks in the shape of monkeys playing flutes or a pair of blown flasks manipulated into a pair of lady's slippers with applied colorful trail decoration.[58] A rich blue shell form, such as this one, seems rather tame in comparison. S.M.G.

This glass cup is immediately notable for its bold inscription.[59] The Greek — *euphrainou epho parei* — is a toast, which means "For what reason have you come? Rejoice!" — or, more succinctly, "Enjoy the here and now!" It would have been appropriate at any meal or gathering.[60]

The explosive spread of free-blown and mold-blown glass was witnessed with astonishment by contemporaries (see also No. 11). During the reign of Emperor Tiberius (r. 14–37) the historian Strabo marveled at the suddenly low cost of glass vessels: "At Rome a [glass] bowl or drinking cup may be purchased for a copper coin" (*Geographika* 16.2.25). Before Pliny the Elder completed his *Natural History,* published in the year 72, he wrote, "the use [of glass has] expelled silver and gold drinking vessels [from the market]" (36.199). Glass had the advantage of not changing the taste of food or drink. The fictional rich businessman Trimalchio — a contemporary of Emperor Nero (r. 54–68) — explains his preference baldly: "[Glass] doesn't stink like bronze, and if it weren't so breakable, I'd prefer it to gold. Besides it's cheap as cheap." (Petronius, *Satyricon*, 50).

This speed with which the related technologies of blowing and mold-blowing glass spread around the Roman Empire explains the second remarkable feature about this drinking vessel — that almost two-dozen examples of this precise cup (and of a taller variant) have been found from Britain to Ukraine, including two from the town center of Atuatuca Tungrorum (modern Tongeren, Belgium), which was destroyed during the Batavian revolt in 69–70 C.E.[61] Today we take for granted the fact that tableware manufacturers make multiples and export them around the world. Roman glass workshops also profited from international trade, which was promoted by the new era of peace inaugurated by the first emperor, Augustus (r. 27 B.C.E.–14 C.E.), and his successors. Glassworkers migrated to Italy and other provinces from the Eastern Mediterranean, where blowing and mold-blowing were invented, carrying the raw glass and tools needed to make product. The conspicuous relief inscriptions on some early mold-blown vessels bear the names of factory owners of Syro-Palestinian and Greek origin — Ennion, Jason, Meges, Neikaios, Aristeas — and it is likely that the name was meant to promote the maker, in exactly the same way as did signatures molded into the designs of ancient Arretine and Samian pottery tablewares of the period.[62]

The most popular mold-blown glass designs were almost all imitations of prestigious silver and gold tablewares, which were also the models for decorated molded pottery. By blowing glass into molds with a given design, it was possible to mass-produce identical, crisp, relief-decorated vessels (see also Nos. 9 and 13). Few molds survive, and none has been identified from the first century C.E. Clay or cast metal molds for blowing glass — like those used for mold-thrown pottery — could be made directly from an original or from a workshop model, but there were two technical problems. First, molds wore out quickly because of the heat and needed to be replaced often. Second, glass does not shrink like clay as it hardens, so molds must be made in two or more parts in order to remove them from the glass vessel. Perhaps in part because of these technical challenges, intricately patterned, full-size mold-blown glass tablewares like this cup remained popular for only about a generation during the second and third quarters of the first century C.E.
S.E.K.

CUP WITH INSCRIPTION
Ancient Roman Empire, probably Syria or Palestine, perhaps coastal region
Found at Pizzighettone, near Cremona, Italy
Mid-first century C.E.
Yellowish-green glass; blown into a three-part mold with two vertical sections joined to a cup-shaped base section
H: 7.0 cm (2 ¾ in.); Diam. (rim): 7.5 cm (3 in.)
Provenance: Giorgio Sangiorgi, Rome (to 1965); Sergio Sangiorgi, Rome (1965–67).
Purchased with funds from the Libbey Endowment, Gift of Edward Drummond Libbey, 1967.6

This two-handled jar with M-shaped handles was used to bury cremated human bones and ashes.[63] Glass urns to hold the ashes of the dead became a new fashion in Italy and the western provinces of the Empire about the middle of the first century C.E.[64] Many survive in remarkably good condition because they were acquired for this sole purpose and were protected from soil and the elements by being placed in stone, lead, or clay containers at the burial site. This jar was reported to have been found in the 1930s in a rock-cut tomb excavated near the town of Krefeld-Gellep (ancient Gelduba), but this seems unlikely. Gelduba was a Roman *castellum*, or auxiliary fort, on the lower Rhine, a short distance downriver from Cologne (ancient Colonia Claudia Ara Agrippensium). More than six thousand graves have been excavated in the cemeteries associated with the fort and its large *vicus*, or civilian settlement of traders and craftsmen, but not one of these tombs included a glass urn.[65] Glass urns with M-shaped handles are, however, regularly found in and near Cologne.[66] The jar and lid seem to fit each other, but it is obvious that they were made of two different batches of decolorized glass. The lid has a yellow-green natural tint, while the jar is bluish green.

In the Roman Empire, glass-*making* and glass-*working* were separate and distinct activities. Glass was *made* by fusing raw materials in only a few locations around the Mediterranean, including the coast of the Eastern Mediterranean and the Bay of Naples. Pliny (*Natural History* 36.194) describes the process and mentions the use of white sand from the Belus River on the Syro-Palestinian coast and from the Volturnus River in Campania. Most Roman glass is remarkably consistent in composition, with natron from Egypt serving as the alkali. Raw glass chunks, or ingots, were transported to the craftsmen, who *worked* small quantities into vessels and objects.[67]

Both glass products and glassworkers had spread from the Eastern Mediterranean and Italy into the provinces by the second half of the first century C.E. Along the Rhine, workshops

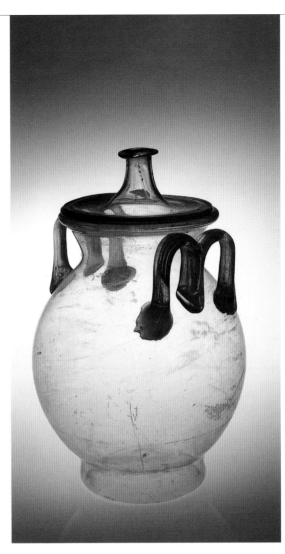

JAR AND LID
Ancient Roman Empire, perhaps made in Colonia Claudia Ara Agrippinesium (Cologne)
Late first century to early second century C.E.
Colorless glass; free-blown, tooled, applied M-shaped handles
H: 32 cm (12 ⁵⁄₈ in.); Diam. (rim): 16 cm (6 ³⁄₈ in.)
Provenance: A. Weber, Cologne, Germany; Gawain McKinley, New York, N.Y.
Purchased with funds from the Libbey Endowment, Gift of Edward Drummond Libbey, 1977.14

served the legionary fortresses, auxiliary forts, and small army posts from Praetorium Agrippinae (modern Valkenburg, near Leiden) at the mouth of the river to the Alpine passes. A huge range of shapes quickly appeared—bowls and dishes for serving food, drinking cups, ewers and flasks for serving liquids, storage jars, lamps, and many types of cosmetic jars. Regional shapes and styles of decoration developed not only in the Rhineland but also throughout the Empire, some in response to local products that required glass containers (e.g., honey, perfume, or medicine), others in response to local fashions.

However, even in towns such as Cologne, which became the largest center in the northwest provinces producing luxury and household glassware and where glassmaking furnaces have been excavated,[68] workshops remained small.[69] The productivity of the workers must have been as impressive as that of their modern European descendants: at six to ten minutes for a bottle or beaker, a gaffer and assistants could blow eighty or more vessels per day,[70] adequate to keep households stocked with new—and replacement—glass vessels.
S.E.K.

This glass pitcher is remarkable for its elegant form, large size, and heavy weight.[71] The tall, conical body imitates silver ewers fashionable during the fourth and early fifth centuries. To make the sharp, geometric form, the glassworker rolled the parison on a marver to form the conical body, then used gravity to stretch the hot glass to make the slender neck. With the help of assistants, he attached a separately blown circular foot, the neck coil, the rim coil, and finally the combed handle at a sharp angle to join the rim and form a thumb rest. The coils were added in emulation of the details that often articulate the forms of silver jugs.[72]

Ancient ewers in precious metal, glass, and clay were made with two types of mouth: round, like this example; and trefoil-shaped.[73] Surviving table services indicate that ewers (Greek, *xestes*; Latin, *ministerium*) had two functions. Trefoil-mouthed ewers were paired with handled pots (Greek, *chernibon*; Latin, *trulla*) for servants to pour water, probably warmed and scented, to wash the hands of dinner guests. Round-mouthed ewers like this example were used to dip wine from the central mixing bowl and serve it into drinking cups.[74]

One of the remarkable characteristics of glass is that it can be blown very thin, creating a remarkably lightweight container. By contrast, this ewer is surprisingly thick-walled and heavy. The explanation may be due to the unfortunate workings of politics on the market. In 301, Emperor Diocletian (r. 284–305) attempted (in vain) to control rampant inflation with an Edict setting prices. The Edict classified glass into three groups—Alexandrian glass, Judaean glass, and window glass.

Damaged traces of the Greek parallel to the Latin text describe prices for colored glass. The Edict lists the maximum legal prices for *unworked* glass, followed by the prices of the same glass made into tableware.[75] "Alexandrian" and "Judaean" are believed to be common "trade" names rather than designating glass imported from these two places (see No. 10 on the separation of glass-*making* and glass-*working* in antiquity). "Judaean" glass may refer to the invention of glassblowing in the Syro-Palestinian coastal region and to ordinary household wares made of naturally colored bluish green and greenish glass. Because "Alexandrian" glass is listed at twice the price of "Judaean" glass for unworked ingots and at half again the price for vessels, the term may describe decolorized glass. For reference, the Edict sets the price for a pint of ordinary olive oil at twelve denarii and a pint of ordinary wine at eight denarii. Official wages vary, from an unskilled farmhand at 25 denarii per day to a skilled figure painter at 150 denarii per day, but it is clear that glass vessels could be bought cheaply. However, the Edict decrees that finished products as well as unworked glass chunks are to be sold by weight, without consideration of size or capacity or decoration. A savvy glass manufacturer would instantly have understood that the Edict allowed him to sell a heavy glass vessel like this ewer for a higher price.
S.E.K.

16, 1 FOR GLASS

1A	Alexandrian glass, one pound	24 DENARII
2	Judaean greenish (*subviridis*) glass, one pound	13 DENARII
3	Alexandrian plain glass cups (*in calcibus*) and smooth (*? vasis levibus*) vessels, one pound	30 DENARII
4	Judaean plain glass cups and smooth (?) vessels, one pound	20 DENARII
5	Window glass (*specularis*), best [quality], one pound	8 DENARII
6	(Window glass) second [quality], one pound	6 DENARII

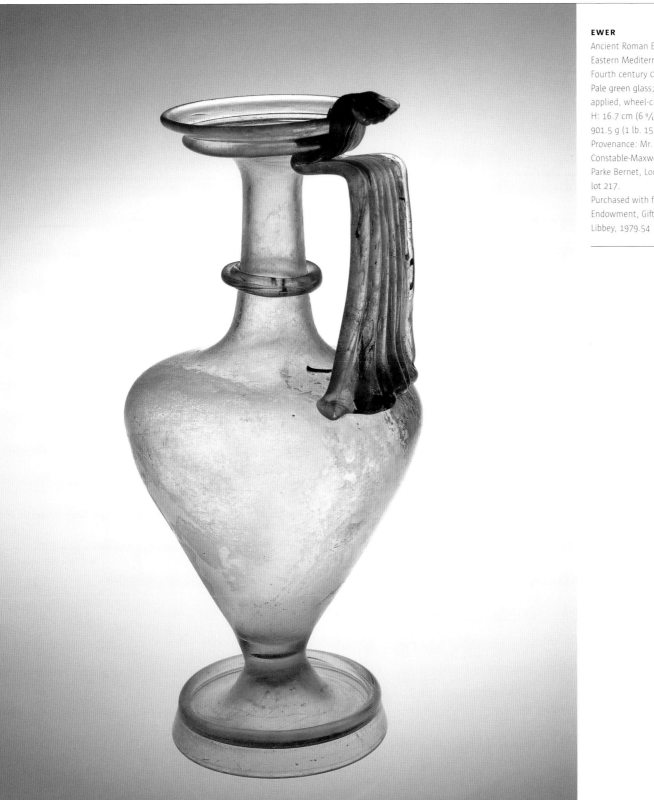

EWER

Ancient Roman Empire, probably from the
Eastern Mediterranean provinces
Fourth century C.E.
Pale green glass; mold-blown, tooled,
applied, wheel-cut
H: 16.7 cm (6 ⁹⁄₁₆ in.); Weight:
901.5 g (1 lb. 15.8 oz.)
Provenance: Mr. and Mrs. Andrew
Constable-Maxwell, London; sold, Sotheby
Parke Bernet, London, 4–5 June 1979,
lot 217.
Purchased with funds from the Libbey
Endowment, Gift of Edward Drummond
Libbey, 1979.54

Cups, jars, and jugs in the form of human heads were popular in the ancient Roman Empire, as in earlier Greek and Etruscan art. Most represent mythological figures, particularly Bacchus, the god of wine (13B),[76] and his ecstatic, non-human followers the silens, satyrs, and maenads. Even cups such as this sculptural image of an exotic African man (13A),[77] upon close examination, represent members of Bacchus's retinue, as is clear from the wreath of ivy leaves and berries tied around the thick coils of hair. The connection with Bacchus probably explains the use of these vessels at banquets, where the gift of the god was enjoyed, and also at funeral rites, where the deceased was honored with libations and consigned to the protection of the gods. Initiates trusted Bacchus as their guide and savior, because he had visited the Underworld and returned.

The most puzzling head-shaped vessel is also the earliest, a small jug in the form of a woman's head (13C).[78] More than a dozen examples are known. Find spots range around the Eastern Mediterranean, from Rhodes to Syria. However, the hairstyle — wavy locks pulled tightly from a center part, a twisted knot (called a *nodus*) over the center of the forehead, and a braid-wrapped knot at the nape with curls drawn forward along the sides of the neck — is specifically from the city of Rome. The hairstyle was introduced about 40 B.C.E. by women associated with the first emperor, Augustus — his sister Octavia, his wife Livia, and his daughter Julia.[79] So it has been tempting to identify this as a portrait of a woman, perhaps Livia (58 B.C.E.–29 C.E), who was represented as Venus Genetrix long before she was officially deified in 42 by her grandson Emperor Claudius.[80] One problem with this theory is that the facial features do not resemble Livia, or any other woman of the imperial family. This, however, may be due to the unsatisfactory mold, which was made in two vertical halves, so that the protruding mold seam runs through the center of the face. This type seems to be the very earliest glass head-shaped flask, and may indicate that

the moldmaker was experimenting with how to design a mold that could be opened. Perhaps he was working from a profile portrait, such as a coin. A second, equally puzzling, problem is how these head-shaped flasks may have been used. There were severe legal penalties for damaging or behaving improperly near Roman imperial images, so it is difficult to imagine circumstances where it would be appropriate to pour liquid from a portrait, however divinized. And since the emperors and their families were usually worshipped together, why are there no parallel head-shaped vessels of Augustus, Tiberius, Gaius, or Claudius — or their wives? An attractive alternative is that this jug represents Dionysos. The mold seam may exaggerate the hair above the forehead so that it resembles the old-fashioned *nodus*; the long hair is otherwise dressed in a style common for images of the god, with twisted side locks gathered into a chignon and curls along the sides of the neck. Dionysos often wears earrings — which the imperial ladies rarely do — and is shown with "Venus" rings on his neck. There is, unfortunately, no distinctive attribute such as an ivy wreath or *mitra*.

The cup in the shape of the head of an African man can be dated before the eruption of Mt. Vesuvius in 79 C.E. by finds in Herculaneum and Pompeii,[81] in addition to examples found in London, Cologne, Lebanon, and Romania. Marianne Stern has identified four different series that represent an African man — each series produced in a different mold, one of which is inscribed in the mold with the Greek maker's name Tryphon and another that is inscribed in Latin by its maker, C. Caesi Bugaddi.[82]

The flask depicts the head of the god of wine, known as Dionysos in the Greek-speaking eastern provinces of the Roman Empire and as Bacchus or Liber in the West. The head can be identified as Dionysos by the beardless, youthful face and the wreath of ivy leaves and berries with a ribbon (*mitra*) across the forehead. The features are unusually well-modeled, with fleshy, sensual features and heavy curls of hair

that resemble portraits of Antinous, who was loved by Emperor Hadrian and deified after his mysterious death in the Nile River in 130 C.E. Statues of Antinous as Dionysos were dedicated throughout the Empire by the grief-stricken Hadrian, so it is plausible to date the original of this glass image to the middle of the second century. The mold formed only the head, and the glassblower shaped some parisons into cups with handles[83] and others into flasks like the Toledo example (3B), by over-blowing the rim of the mold in order to pull out the tall neck. Find spots in Romania, Ukraine, and Turkey suggest that the glass-workshop was located in the eastern Mediterranean.

Small glass flasks in the shape of heads are very common: the Toledo Museum owns more than two dozen, most less than four inches tall and most with two heads, back to back. Most faces are those of very young, chubby boys with curly or knobby hair, but it is not certain whom they represent — probably either Eros / Cupid, the god of love, or Dionysos / Bacchus, the god of wine. Larger, more elegant examples such as the three vessels featured here must have been enjoyed as both vessels and sculptures.

S.E.K.

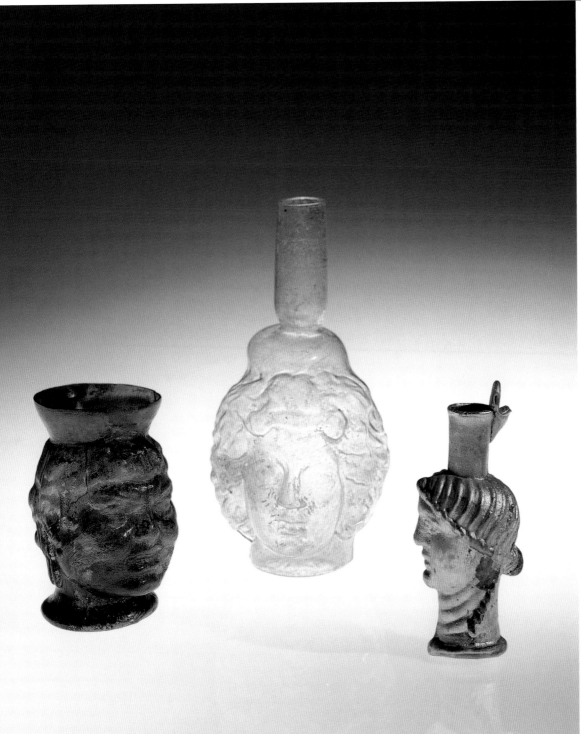

From left to right:

13A. CUP IN THE SHAPE OF THE HEAD OF AN AFRICAN MAN
Ancient Roman Empire,
probably made in Italy
Second half of the first century C.E.
Manganese-colored purple glass; blown in
a full-size, three-part mold of two vertical
sections and a disc-shaped base section
H: 9.5 cm (3 ¾ in.); Diam. (rim):
5.7 cm (2 ¼ in.)
Provenance: Thomas E. H. Curtis Collection
(until 1916)
Gift of Edward Drummond Libbey, 1923.457

13B. FLASK IN THE SHAPE OF A HEAD OF DIONYSOS / BACCHUS
Ancient Roman Empire, Eastern
Mediterranean
First half of the third century C.E.
Colorless glass; blown in a full-size, three-
part mold of two vertical sections and a
separate disc-shaped base section
H: 26.6 cm (10 ⅜ in.); Diam. (max.):
8.5 cm (3 ⅜ in.)
Provenance: Shlomo Moussaieff, London;
Mr. and Mrs. Andrews Constable-Maxwell;
Sotheby Parke Bernet, London, 4–5 June
1979, 71, no. 113.
Purchased with funds from the Libbey
Endowment, Gift of Edward Drummond
Libbey, 1979.53

13C. JUG IN THE SHAPE OF THE HEAD OF A WOMAN OR DIONYSOS
Attributed to the Workshop of the
Floating Handles
Ancient Roman Empire, Syro-Palestinian,
perhaps made in Sidon
First half of the first century C.E.
Blue-green glass; neck and body blown in a
full-size, two-part mold of two vertical sec-
tions, each including one half of the base
H: 11.0 cm (4 ⅜ in.);
Diam. (base): 3.3 cm (1 ¼ in.)
Provenance: Giorgio Sangiorgi, Rome
(by 1914 to 1965); Sergio Sangiorgi, Rome
(1965–67)
Purchased with funds from the Libbey
Endowment, Gift of Edward Drummond
Libbey, 1967.8

Christ stands between two balding, bearded men—St. Peter (on the right) and St. Paul. He raises his right hand in a traditional gesture of speech and with his left hand unrolls a scroll into the reverently covered hands of St. Peter. The scroll is inscribed DOMINUS LEGE(m) DAT ("the Lord gives the law").[84] The iconographic scene of Christ giving the law (*traditio legis*) was invented in Rome in the middle of the fourth century, probably to adorn the apse of the basilica of St. Peter, the greatest of the six churches in Rome founded by Constantine the Great, the first Christian emperor (r. 306–337).[85] Begun in 323 and completed by 329, the apse was positioned above the tomb of St. Peter. The image celebrates Sts. Peter and Paul as the princes of the Apostles, both martyred and buried in Rome, adding their legitimacy to the power and majesty of the ancient capital city.[86] The apse mosaic showed them standing in front of city gates that represented Jerusalem and Bethlehem, which in turn symbolized the Jewish (St. Peter) and Gentile (St. Paul) churches. On this gold glass, only the palm trees overarching the gates remain.[87] Christ is depicted as youthful but wearing a beard and rather long hair that curls above his shoulders. The Apostles show the features that had already become their standard portrait types: Peter with short, curly beard; Paul balding with a longer, pointed beard.

Gold glass is one of the most complex and ostentatious late Roman techniques. The earliest examples are roundels dating to the late second and third centuries, most of which were made as flat discs decorated with bust portraits of one or more individuals, to be worn as pendants or mounted on the shafts of standards carried in processions by members of clubs and guilds.[88] To make gold-glass vessels, an open form like a cup or a bowl was blown and annealed. Then gold leaf was attached to the top, or inside, of the wall of the bowl. Part of the decoration consisted of gold leaf cut into bands, geometric patterns, and letters. The design was completed by incising, scratching, and scraping through the gold to the background. To finish

FRAGMENT OF A SHALLOW BOWL: CHRIST GIVING THE LAW TO STS. PETER AND PAUL

Ancient Roman Empire, probably made in Rome
Mid- to late fourth century C.E.
Colorless glass; blown, gold leaf
Diam. (max.): 12.4 cm (4 7/8 in.)
Provenance: Giorgio Sangiorgi, Rome (by 1914 to 1965); Sergio Sangiorgi, Rome (1965–67).
Purchased with funds from the Libbey Endowment, Gift of Edward Drummond Libbey, 1967.12

Fig. 14.1. Fragment of a shallow bowl. Ancient Roman Empire, probably made in Rome. Mid- to late fourth century C.E. Colorless glass; blown, gold leaf, enameling, Diam.: 6.4 cm (2 1/2 in.). Purchased with funds from the Libbey Endowment, Gift of Edward Drummond Libbey, 1967.11.

the object, it was reheated and a second parison was inflated over the gold, fusing it with the layer beneath, to protect the image.[89]

The fragment with a charioteer (Fig. 14.1)[90] shows a secular subject decorated with colored enamel—an uncommon, tour de force addition to the extravagant use of gold foil. The man can be identified as a charioteer by his distinctive clothes (*tunica manicata*, strap cuirass, and boots) and as victorious by the palm branch in his left hand and the gold letters in the background, VICENTI NIKA ("Vicentius wins!"). The name of the horse is written in cursive around the man's right foot on the gold baseline: IMBICTVS ("Unconquered," as pronounced in Late Latin). The red enamel used to color Vicentius's tunic and Invictus's reins and leg guards makes it plain that the driver and his team of horses raced for the *factio russata*, the red team. The Kunsthistorisches Museum, Vienna, owns a pair to this fragment.[91] Even the inscription, VICENT(I N)IKA is the same, but the horse's name is FANESTRO and the charioteer's tunic is blue. It can be presumed that the workshop that made these two gold glasses probably prepared at least a set of four, representing the winning horses and charioteers of the four rival chariot-racing teams, or parties—green, white,

blue, and red—whose fans were famous for their exuberance and loyalty.[92]

Both of these gold-glass roundels are ancient fragments. The edges were carefully snapped off with a tool, and scholars believe that such pieces were originally part of vessels that were used, or re-used, by embedding them in the walls of catacombs—both pagan and Christian—in Rome and elsewhere.[93] A substantial number of the hundreds of surviving fragments include inscriptions to drink ("BIBITE," "PIE ZESES"), which support use at feasts, perhaps specifically funeral banquets honoring the deceased.[94]

S.E.K.

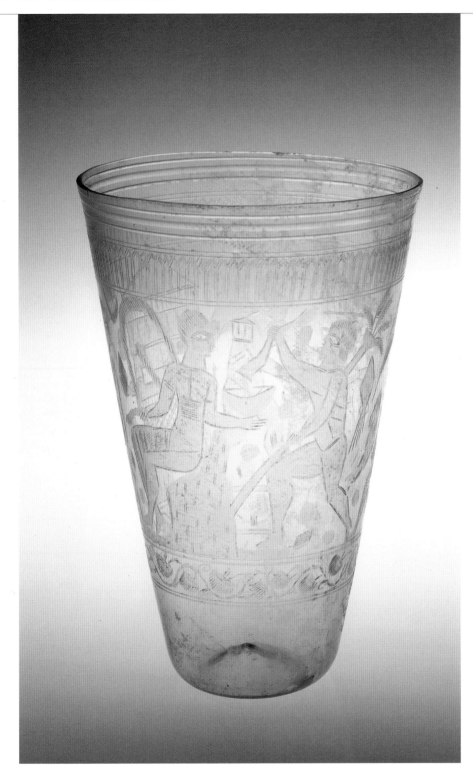

BEAKER

Ancient Roman Empire, said to have been found at
Worringen, a suburb of Cologne (ancient Colonia Claudia
Ara Agrippinesium)
Late third to mid-fourth century C.E.
Colorless glass; free-blown, wheel-engraved
H: 20.2 cm (8 in.); Diam. (rim): 13.8 cm (5 7/16 in.)
Provenance: Carl Damian Disch, Cologne, Germany (from
about 1840; *Catalogue de la collection du feu M. Charles
Damian Disch (Propriétaire de l'Hotel Disch), vente
publique... le 12 mai 1881*, 130, no. 1361); Alexander
Basilewski, Paris, France; Fahim Kouchakji, New York, N.Y.
Purchased with funds from the Libbey Endowment, Gift of
Edward Drummond Libbey, 1930.6

In the Western provinces of the Empire, espe-
cially Italy, Britain, Spain, and the cities along
the Rhine, glass engraved with figures became
fashionable in the third and fourth centuries.
This remarkably large and well-preserved conical
drinking cup belongs to a sizeable group of
bowls, bottles, and drinking vessels engraved
with both polytheistic and Christian figural
scenes. This beaker's composition is enigmatic.
The elements are clear: a four-story building,
two winged figures flanking a large bowl, a
young (beardless) nude man moving to the left,
and two women sitting on rocks — one fully
clothed, the other partly nude with an arc of fly-
ing drapery.[95] In the background are fish and
columned buildings, two with domes. Noticing
the abundant architectural motifs, scholars
have tried valiantly to identify both the location
and the mythological figures.[96]

The central action is the man pouring a liq-
uid, probably wine, from a *rhyton* (drinking
horn) into the cup held by the partly draped
woman. Marianne Stern proposed that one and
the same glass-cutter decorated this beaker and
two vessels in the British Museum, one of them
a flask engraved with closely related scenes of
winged figures and fish around a bowl and a
(bearded) man pouring wine from a *rhyton* into
the cup of a woman reclining on a rock, along
with palm trees, fish, and domed buildings.[97]
Two fragments of a hemispherical cup found in

Rome, engraved by a different hand, similarly depict two winged figures on either side of a cauldron, buildings with columns, and the head of a bearded man facing left.[98] The same iconographic elements have been recognized on other monuments — two sarcophagi, two frescoes, and a mosaic. The most informative comparison is the large fresco in the courtyard that served as the entrance hall of the imposing, multi-story House of John and Paul, built into the slope of the Caelian Hill, now underneath the fifth-century Church of Sts. John and Paul, Rome.[99] Probably painted when the house was remodeled in the third century, the mural almost certainly reproduces a complex and well-known original. It represents two women — one modestly but fashionably clothed (a mortal as Proserpina?) and one partly draped (Ceres? Venus?) — reclining on a rocky promontory in a seascape filled with small boats and winged cupids fishing. The nude woman extends a

shallow bowl toward a partly draped man, his right foot raised on a low rock, who holds a *rhyton* and a *situla* (pail): Bacchus.

The most straightforward explanation is that the young man is Bacchus, Roman god of wine, drama, and religious mysteries. The diagonal shape behind Bacchus, which has been called a palm tree, is more likely the god's customary attribute the *thyrsos*, a stalk of wild fennel wound with ivy and grape vines. In Roman times, Dionysos / Liber / Bacchus was associated with mother Demeter / Ceres and daughter Kore / Libera / Proserpina, in such famous circumstances as the mysteries experienced to initiate the faithful men and women at the pilgrimage sanctuary of Demeter at Eleusis, in Greece, and at the Temple of Ceres, Libera, and Liber that this triad shared on the Aventine Hill, in Rome. In late antiquity, images of Dionysos appear frequently on silver plate, most often with dancing maenads and satyrs but sometimes with

Ariadne/Libera, whom he saved and married after she was abandoned by Theseus. Winged figures are associated with Bacchic rituals, and both Bacchus and Erotes take part in wedding celebrations.[100] There is also a connection with fish, specifically the red mullet.[101] The salvation imagery of the Worringen Beaker — whether it associates the deceased with Proserpina, returned from the Underworld, or with Ariadne, married to the god — and its superb condition may be linked, if the vessel was made for burial or as an offering after its use at the funeral feast. S.E.K.

Fig. 15.1: Drawing: Lorene Sterner, Ann Arbor, Mich., 2005.

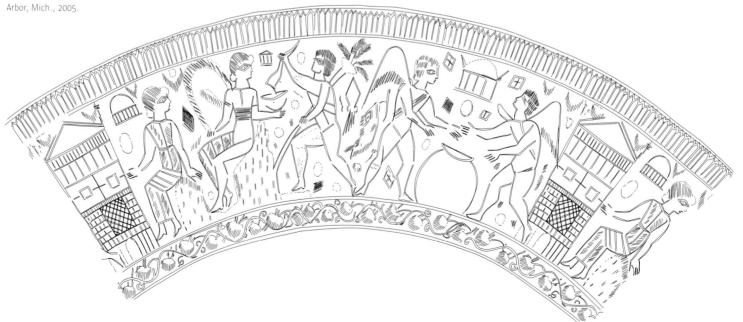

One is immediately struck by the rich surface of this vessel, the variety of cutting, and the play of light off the facets.[102] A clever cascade of alternating cuts and grooves has been created by a variety of wheels, each different in cross-section and diameter. The glass-cutter almost entirely removed the original glass surface of the form. Only the band below the rim and a few triangular segments at the shoulder remain of the original surface; all the rest was skillfully ground away to create a complex pattern. Is it architectural, landscape, or simply pattern for its own sake? Are we viewing a road, a walkway with a building colonnade in the distance, or are we inside a building looking at a wall with an arcade of windows and a clerestory above? The question is impossible to answer but the design is brilliant and beautifully executed.

The form of this vessel was blown in an open mold, and the rim was cracked off and left unworked. The first row of square facets, below the rim, was probably cut with a wide stone wheel; an even larger wheel created the circular facet in the next register, which forms the openings in the arcades. The arches and piers were cut with narrow wheels, perhaps made of metal, their cutting action enhanced with abrasives mixed with water or oil. The oval facets below were accomplished with a smaller stone wheel, while the vertical-cut band was done by a series of wheel cuts.

This vessel has been called a lamp because conical lamps were used in a *polycandelon*, a large bronze ring suspended from the ceiling in a building, where multiple fixtures could be hung to illuminate a large open space. Such conical lamps are known in quantity from fourth-century sites all over the Roman Empire,[103] but particularly in Egypt[104] and along the Syro-Palestinian coast, where they were manufactured.[105] (The earlier Roman examples were more elongated forms with decorative blue blobs on their sides and a few horizontal wheel-cut grooves delineating registers on the body. None of the earlier examples approach the sophistication of this Toledo lamp.)

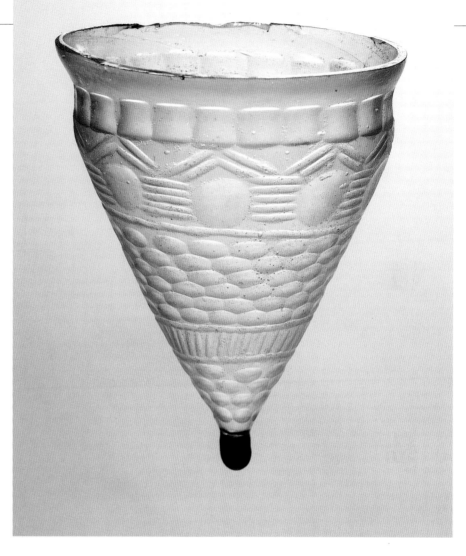

Many of the earlier vessels were found with metal wick-holders attached to their sides, confirming their use as lamps. But conversely, many conical vessels without metal devices may have been drinking forms, not lamps. Thus, context is our only guide: examples found in a small kitchen area suggest one use, while those unearthed in the nave of a basilica offer another. Unfortunately, the find spot of this vessel is unknown — although it is likely to have been a tomb because of the excellent condition — and the decoration lends no clues. The design would be a wonderful way to break up the light from an oil lamp and disperse it through the room.

BEAKER OR LAMP
Ancient Sasanian Empire
Late fourth to early sixth century C.E.
Colorless glass with greenish tinge, transparent deep-blue blob; blown in an open mold, blob applied at tip, wheel-cut and polished
H: 13 cm (5 1/16 in.); Diam. (rim): 10.8 cm (4 1/4 in.)
Provenance: Margarita Haagen, Aachen, Germany; Elizabeth Haagen Mueller, Zürich, Switzerland; Gawain McKinley, New York, N.Y.
Purchased with funds from the Libbey Endowment, Gift of Edward Drummond Libbey, 1981.96

Presumably, the two wide bands of smaller facets would rest below the ring of a *polycandelon* and spread the flickering light below. On the other hand, how spectacular it would be to hold one's wine in this beaker and have light stream through the body of the wine-dark bowl and its faceted wall above. The rich color from below and the dazzling spectrum of light from the shoulder and the lip would delight the eye and recall rock crystal, a favorite material in the ancient Near East. One small aspect of this vessel might favor its use as a lamp, but it is hardly decisive: the fact that the rim was left unfinished when it was cracked off from the blowpipe. Many cups and beakers finished this way were used in the Roman Empire, and the sharp edge does not seem to have been of concern to the Roman consumer. Nevertheless, chips in this rim are not inconsequential and they are original. While this would be of no concern if the vessel were meant as a lighting fixture, they might provide a careless drinking guest an unexpected cut during an evening's indulgence.

The overall decoration of this vessel is unusual, but it is reasonable to propose that it was made in what is now Iran, in a Sasanian workshop. A few tall beakers and bowls with arcades and registers have been attributed to the Sasanian Empire, and there are faceted lamps that share this vessel's overall "carpeted" surface, although the designs are less complicated.[105A] The Roman and Sasanian Empires often clashed in the centuries from 224 to 642 C.E., but trade goods usually moved freely along established routes. In the first half of the third century, Dura Europos, a major Roman city on the Syrian frontier along the Euphrates River, was a stop along the Silk Road. Wheel-cut vessels, precursors to this lamp, were found there in quantity and seem to have been popular throughout the Sasanian Empire.[106] Subsequently, variations evolved and continued to be made through the Sasanian period into the Islamic period, as late as the tenth century. The interest in wheel-cutting and facet-cutting became one of the artistic hallmarks of the Islamic glass industry. The Toledo lamp is a brilliant spark at the outset of a glassmaking journey that was destined to burst forth in subsequent centuries, when the relief-cutting tradition (see No. 22) developed into one of the greatest contributions of Islamic glassmakers. It is this glass-cutting skill and enameling—found especially on decorated lamps for mosques and other public buildings (see No. 25)—for which ancient Islamic glassmakers are still best remembered.

S.M.G.

Over the centuries, millions of glass fragments and vessels have been found along the Syro-Palestinian coast, either washed out by nature or dug up by people. Collared jars have been found at sites all along the Syro-Palestinian coast, including Beth Shearim, Megiddo, Samaria, Jerusalem, Jalame, or Amman[107] and made from the late fourth century onward. There are literally hundreds of simple collared jars like this one in museums and collections worldwide (including dozens of them in the Toledo Museum's study collection) and yet not a single jar matches this one in complexity.

Although glass had been blown and manipulated in this region for several centuries, glassmakers there seemed to revel in their abilities during the late fourth and fifth centuries, as Roman influences began to ebb. Because major patronage for sophisticated glass had decreased, vast quantities of mediocre and poor quality material began to be produced. Few forms and little color variation became the norm, and quality control decreased dramatically. Given these circumstances, it is astounding to see such a jar as this survive.

This is the most elaborate trail-decorated jar known from the late Eastern Roman Empire.[108] A tour de force of the glassmaker's technique, it demonstrates the artist's exceptional skill in working the hot glass and manipulating it quickly without deforming the overall shape and the incredibly complex applied decoration. Keep in mind the speed with which the glassmaker would have had to add the individual bits of glass to create all of the handles and decorative embellishments. Although one can readily see most of these details, it is worth noting the process that was followed to create them. A masterpiece of tooling and manipulation such as this could have been destroyed at any stage of production. First, the simple jar supporting this elaborate "web" was blown, the foot was formed, and the vessel was transferred to the pontil rod. Then the rim would have been formed, along with the horizontal rib below it. The rib would have been tooled, out-folded, then

flattened, and the rim was rounded by reheating it. Small gobs, or bits, of glass were applied quickly above, at the shoulder, and pulled up and touched to the out-folded rib, then touched onto the lip before pulling away. Imagine this process being repeated nine times around the rim and again nine times around the base. Next, using pincers, the excess glass at each end and in the middle was squeezed to form a small decorative tab, creating the decorative handles and feet. With a small wad of the contrasting dark blue glass, the glassmaker first touched it to the belly of the jar and spun the vessel three times. Below that, he quickly took the gob and held it close, just below the midline, and pulled it up and down while turning the jar, to create the zigzag pattern and completing the elaborate decoration on the body of the vessel.

The complex but rapid process of adding the nine handles and the decorative pendant feet would have taken equally great skill and would again have required speed to insure that no part of the vessel that was already formed would soften and become misshapen. The gaffer was able to do so by watching the color of the glass while it reheated in the furnace and by turning the blowpipe or pontil rod back and forth, spinning the glass to keep it moving centripetally and thereby maintaining the shape of the softened vessel and all of its added parts. Given its weight and the need for multiple reheatings, the elaborate handle would have been added last; it may have been made separately and then added to the body. The handle consists of a heavy coil that loops back and forth from one side to the other like a woven basket. Its form may have been intended to mimic reed work. On this handle, a smaller trail was attached to the outside of the rim and touched the coil beneath in three folded loops, leading up on either side to a large, solid square finial at the center. Another trail was also laid over the top of the entire handle and crimped.

This jar, though exceptional in its form and decoration, is not unique in the late glassworker's desire to display his manipulative dexterity.

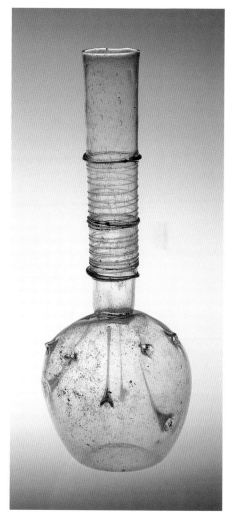

Fig. 17.1. Bottle with internal tooling. Ancient Roman Empire, Syro-Palestinian coast. Fifth century C.E. Pale blue-green glass; blown, trail-decorated, and tooled, H: 18.5 cm (7 $^{13}/_{16}$ in.). Gift of Edward Drummond Libbey, 1923.1239.

Two other examples of late Roman glass vessels from this region, a small intriguing perfume bottle (Fig. 17.1) and a double kohl tube (Fig. 17.2) give some idea of the diversity of forms that still existed and reveal the playfulness of the glassmaker's craft. The bottle, a simple form with trail decoration on the rim, is a type as well known as the simple collared jar described above. A closer look at its interior reveals a trick of glassblowing beyond the simple trails on the neck. A series of trails pierce the interior space from one side of the body to the other, seemingly impossible, but in fact quite simple to do. By partially inflating the gather, then piercing the wall from the outside with a pointed tool and touching the opposite interior wall before removing the tool (twelve times in this example) further inflating of the gather would create the interior threads.

The other conceit from this late period is the double kohl tube (Fig. 17.2), which developed from the simple unguent bottles made in the first century. In the Eastern Roman Empire during the third and early fourth centuries, these vessels often included a small base and their handles became more elaborate. First the vessel bodies were doubled, then doubled again, to hold four varieties of unguents and kohl. Then the glassworkers turned their attention to elaboration of the handles. This example, a wonderful cascade of flowing trails that must have hung near a lady's dressing table, would have been as much a statement about her taste for the latest fashion as it was a cosmetic container. S.M.G.

Fig. 17.2. Double kohl tube with tiered handle. Ancient Roman Empire, Syro-Palestinian coast, fifth–sixth century C.E. Light blue-green glass; blown, trail-decorated, and tooled. L: 33.7 cm (12 ⅛ in.). Gift of Edward Drummond Libbey, 1923.1294.

JAR WITH BASKET HANDLE
Ancient Roman Empire, coastal
Syria or Palestine
Late fourth to fifth century C.E.
Colorless glass with greenish tinge,
applied trails of dark greenish blue
glass; blown, trail-decorated and tooled
H: 18.5 cm (9 ³⁄₁₆ in.)
Provenance: Thomas E. H. Curtis,
Plainfield, N.J.
Gift of Edward Drummond Libbey,
1923.1211

The surface of this thick-walled glass bowl has been described as a cool limestone color, hardly descriptive of an object made of glass; yet its polished form and crisp wheel-cut facets confirm the glass body hidden beneath the weathered surface.[109] Its condition is an accident of nature and is typical of glass found in northern Iran and Iraq, where extreme changes in weather from season to season cause glass to deteriorate and, over time, acquire a heavy weathering crust. In the case of this vessel, the surface is perfectly preserved; in other examples; the glass completely devitrifies and, when the object handled, it is reduced to a gritty dust.

This bowl is the antithesis of the facet-cut lamp discussed above (No. 16). Here, form and design are distilled and compact. There is no question about its use or origin: this is a drinking vessel, a favorite among the Sasanian elite. To hold it empty and rotate it in the hand would create a kaleidoscopic effect, like a mirrored ball on a dance floor. When the bowl was partly filled with wine, the effect would probably have been even more entertaining.

Sasanian glassworkers produced colorless faceted glass bowls in three or four sizes and in an unintentional range of colors, from transparent green to a pale honey tone, many of which were meant to imitate rock crystal. These bowls — along with various other shapes such as plates, shallow bowls, ovoid rhyta, bottles, footed beakers, long document cases, and small unguent bottles — were produced in different centers over many decades. None was as prized as this type of pristine, facet-cut drinking bowl, a shape that was widely distributed over the ancient world. Examples have been excavated as far away as China and Japan. The two most extraordinary finds are from the tomb of the Japanese emperor Ankan, who ruled from 531 to 535,[110] and the one placed in the Shōsō-in treasure house, which held the personal collections bequeathed to the Todai-ji temple at Nara by the Japanese emperor Shōmu upon his death in 756. Both Nara bowls look today as if they were just made. They are completely unweathered, and

they are so similar in color, shape, and surface that they may have been made in the same workshop. These two bowls are among the few objects that give any indication of how spectacular such facet-cutting looked originally, with thousands of diminutive reflections mirrored and refracted in the facets when rotating the bowl.

The proportions of the Toledo bowl are bold and elegant. The shape is slightly more than a hemisphere and the bowl rests on a single large facet, surrounded by a row of seven large facets. Above this are four rows of hexagonal facets, all roughly equal in size, which break up the bowl's surface, leaving only a bit of the smooth original skin in the form of an arcade that defines the lip above the uppermost row. The lip was probably rounded by reheating the glass after the blank was first blown, rather than being ground smooth after the facets were cut into the surface. This bowl is the culmination of centuries of facet-cutting experience. Perhaps this distilled brilliance explains why Sasanian bowls were transported thousands of miles across Asia, to be presented as precious gifts in foreign courts to leaders of imperial rank.

S.M.G.

BOWL WITH HEXAGONAL FACETS
Ancient Sasanian Empire
Fifth to early seventh century C.E.
Colorless glass; blown in an open mold,
facet-cut, polished
H: 8 cm (3 $^5/_{32}$ in.); Diam. (rim): 11 cm
(4 $^{11}/_{32}$ in.)
Provenance: Margarita Haagen, Aachen,
Germany; Elizabeth Haagen Mueller,
Zürich, Switzerland; Gawain McKinley,
New York, N.Y.
Purchased with funds from the Libbey
Endowment, Gift of Edward Drummond
Libbey, 1981.95

In the centuries before its conquest by the armies of Islam in 636, the city of Jerusalem was home to a volatile mixture of populations. Protected by distance from the barbarian armies that overran the northern and western provinces of the Roman Empire, Syria and Palestine basked in centuries of prosperity, thanks to several circumstances: the immigration of rich Romans fleeing the invading Vandals, Goths, and Huns; the expansion of Christian monastic and imperial settlements; and streams of pilgrims visiting the Holy Land. Religious turmoil was the norm. After Emperor Constantine (r. 306–337) converted to Christianity, the Roman government coped, in varying degrees of forbearance, with worshippers from polytheistic temples, Jewish congregations, and both orthodox and heretical sects of Christianity. In the background, objects of daily life — tableware, lamps, and textiles — sprouted religious symbols that broadcast the owner's affiliation. On Jewish objects appear the menorah, Torah shrine, *shofar* (ram's horn), and *etrog* (a fruit used in the harvest festival of Sukkoth). On Christian objects, there were crosses, saints, and fish. Other symbols — palm branch, tree of life, peacock, ivy, fish — held different meanings to Jew, Christian, and pagan.

The image of a seven-branched menorah, accompanied by a *shofar* to the left and an incense shovel to the right, identifies this dark brown glass jar (19A) as Jewish.[111] The other five panels show an *amphora* (two-handled vase), concentric lozenges, a plant, a stylized date palm, and more concentric lozenges — which may symbolize bound sacred books.[112] A surprising number of these brown glass jars survive in excellent condition. Some have been excavated in tombs with matching glass jugs. Exact counterparts to the jars and jugs with Jewish symbols are decorated with explicitly Christian symbols, including three different forms of crosses that may reflect crosses at pilgrimage churches.[113] The workshop that made these glass vessels was probably near Jerusalem, where they would have been sold to Christian pilgrims who took them

home as far away as Gaul, after filling them with oil from the Holy Sepulcher, water from the Jordan River, or soil from other sacred places.[114]

The dual sets of symbols suggest that an enterprising glass workshop catered to at least Jewish and Christian clientele, and likely to polytheistic customers as well. The technology of blowing into full-size molds (see also Nos. 10 and 13) lent itself to this flexibility. The glassblower blew the body of the vessel into a mold that had designs in low relief on its inner surface, in order to create an intaglio (sunken) design on the outside. The neck and rim were tooled to shape. The mold panels were easy to make, probably by hammering the design into thin, rectangular metal sheets, which were movable and could be assembled to form a six- (or sometimes eight-) sided mold. Workshop sloppiness — or haste — is suggested by the fact that the decoration of some vessels is upside down.[115] There is no way of knowing whether the artisans were Christians or Jews, but they clearly had no qualms about producing objects to sell to customers of either faith.

Images of saints and crosses in low relief identify the tall hexagonal jug as Christian (19B).[116] The stylized figure with a cross on its torso and another cross above the head may represent a saint (possibly a monk wearing a hood) or possibly Lazarus, who was represented in Early Christian art in funeral wrappings but is usually shown standing at the entrance to his tomb. It has been suggested that this and similar jugs are associated with early Christian veneration of ascetic saints who lived in remote areas of the mountains of Syria, such as St. Simeon Stylite (521–596), who lived on top of a column (in Greek, *stylos*) for sixty-eight years.[117] The other four panels show a vessel out of which a plant (or snake? or incense?) twines upward, two stylized trees or palm branches, and a lattice pattern. Blown in a mold that formed both body and base, the glassblower expertly applied the handle coil to the shoulder and then attached it to the upper part of the neck, wrapped the excess around the neck, and

pinched a thumb rest. The gold and pink iridescence is due to thin surface layers of devitrification, or weathering, similar to the "rainbow" effect seen on soap bubbles or oil-slicked water.

S.E.K.

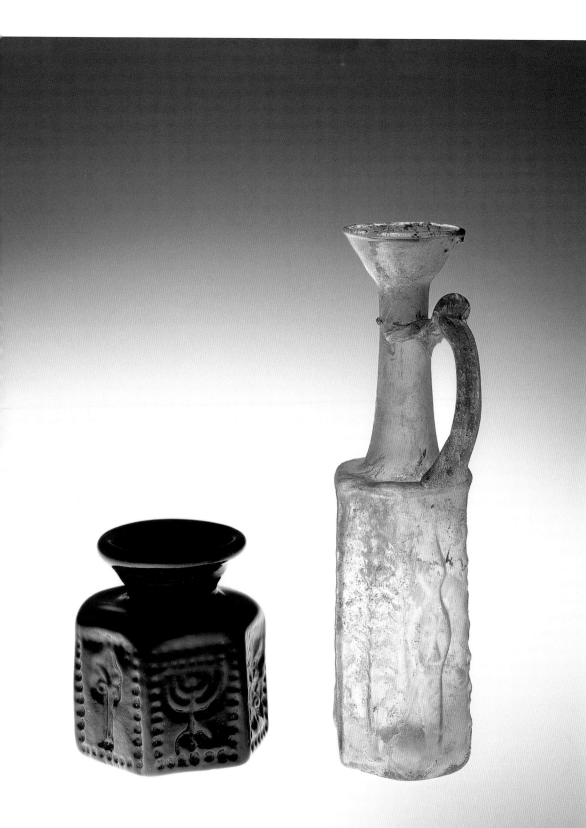

From left to right:

19A. HEXAGONAL JAR WITH JEWISH SYMBOLS
Ancient Roman Empire, probably made
in or near Jerusalem
Late sixth to early seventh centuries
Dark brown glass; body blown into a dip
mold, rim and neck free-blown
H: 8.5 cm (3 ⅜ in.); W. (base):
7.5 cm (3 in.)
Provenance: Thomas E. H. Curtis,
Plainfield, N.J
Gift of Edward Drummond Libbey,
1923.1359

19B. HEXAGONAL JUG WITH CHRISTIAN SYMBOLS
Ancient Roman Empire, probably from Syria
Late sixth to early seventh centuries
Transparent decolorized glass with a
greenish tinge; body blown into a two-part
mold, mouth and neck free-blown
H: 19.7 cm (7 ¾ in.)
Provenance: Fahim Kouchakiji,
New York, N.Y.
Purchased with funds from the Libbey
Endowment, Gift of Edward Drummond
Libbey, 1948.13

20–27 ISLAMIC WORLD

These three objects with applied decoration represent a type of glass that became fashionable in the Syrian region shortly after the advent of Islam in the seventh century C.E. Drawing inspiration from the late Roman / Byzantine heritage in Syria (Damascus was the chosen capital of the first ruling Islamic dynasty of the Umayyads),[1] but also following the models of the recently defeated powerful Sasanians (C.E. 224–651) in Iran and Iraq, Islamic artists and craftsmen absorbed, adopted, adapted, and developed their own ideas, slowly distancing themselves from the artistic idioms they had inherited.[2] Glassmaking, a traditional and relatively complex craft passed on from generation to generation, most likely developed more gradually than other arts; consequently, shapes and decorative ideas lingered for some time in these workshops.

Today we cannot judge whether objects of this type were affordable only to the upper classes or if they could be bought relatively cheaply in the souks of Damascus and around the Greater Syrian region. The substantial number of extant works that survive intact, however, confirms that their owners looked after them carefully and that they were apparently much in vogue.

The so-called cage-animal flasks (20C)[3] are most peculiar objects because they combine the late Roman elements of the *balsamarium* (a container for ointments, perfumes, and the like) with the encircling hot-worked openwork pattern of the *pseudodiatreta*.[4] The former had a zoomorphic shape but lacked the cage around their tubular vials. The latter represented an economical version of the celebrated, and very expensive, cut-glass *vasa diatreta* (cage-cups).[5] These early Islamic cage-animal flasks can therefore be regarded as distant and rather poor relatives of the *diatreta* vases. Nonetheless, when their surface is in nearly pristine condition, like this one, the glassworker's creativity in constructing the object and the use of trails in two contrasting colors to build the cage and to highlight some details (such as the animal's ears and tail), result in a charming, captivating vessel. Flasks such as these fit well in one's hand and

any liquid can be easily poured from them. Thus it seems likely that these objects were used for perfumed water rather than, as it has often been suggested in the past, for cosmetic purposes.[6]

Also in extremely good condition is the globular vase (20A),[7] decorated with applied "hides" of two contrasting colors; the pattern has been defined in this way in an effort to link this type of glass to the manufacture of the cage-animal flasks. Indeed, there is little doubt that the two productions were contemporaneous and probably the work of either the same or neighboring workshops. After close examination, details related to the shape of the containers, to the use of colors, and the technique of trailing are revealing. There is also archaeological evidence that links objects decorated with "hides" to seventh- and eighth-century Syria.[8] Two types of globular bottles with "hides" are known. One has a short, narrow neck that would have been intended to let out only a few drops of liquid at a time; the second, like this example, has a much wider neck and a flaring mouth and must have served as a pouring vessel.

Of nearly identical profile, dimensions, and color is the vase with applied medallions (20B),[9] which is consequently eligible for an attribution to the same area and period. Judging from the deeply bulging interior walls corresponding to the placement of the roundels on the outside, it seems likely that each medallion was made by applying a lump of hot glass to the surface of the bottle and impressing a cylindrical die into it, like impressing a seal into hot wax. The main interest of this vase lies in the presence of the five identical stout birds that dominate each roundel. That the job was done in a hurry is testified by the fact that the impression seems to have been made at random, so that only two of the five birds have their feet on the bottom of the medallion, whereas the other three are not positioned upright. Their identification is somewhat uncertain: they feature a crest and an elaborate curly tail but their plump body suggests a kind of hybrid between a peacock and a partridge. Both birds, especially the partridge,

were absorbed in the repertoire of early Islamic art from both Mesopotamia and Syria and, together with the frequent presence of a Pegasus-like winged horse on similar vessels,[10] bring late-Sasanian inspiration into the picture (Fig. 20.1).

Playful and at the same time rather complex and sophisticated, these three vessels testify to a formative phase in the history of Islamic art, when craftsmen were looking for inspiration in the earlier artistic traditions. Their cultural and religious environment, as a matter of fact, changed quite dramatically from the Late Antique period to the Islamic, although their artists found inspiration in the previous tradition.

S.C.

Fig. 20.1. Dish. Sasanian, sixth-seventh century. Silver, Diam: 20.5 cm (8 1/16 in.). Purchased with funds from the Libbey Endowment, Gift of Edward Drummond Libbey, 1949.35.

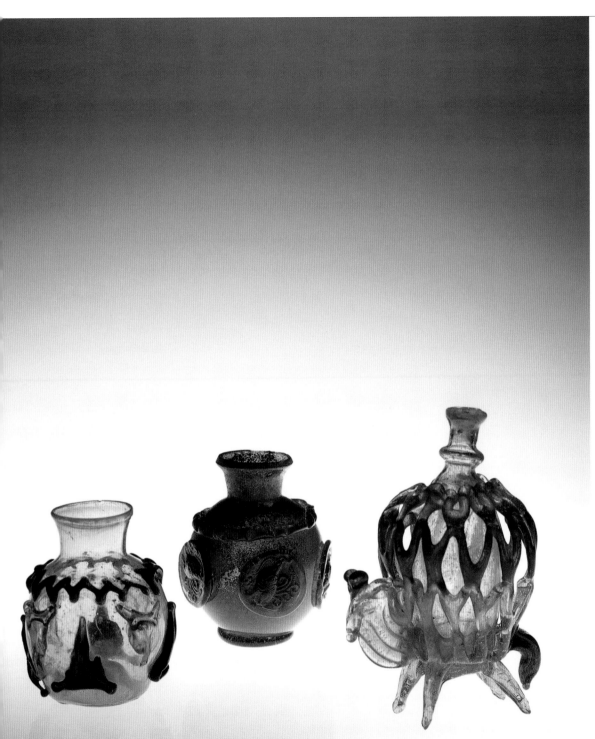

20A. VASE WITH "HIDES"
Syria
Seventh–eighth century
Greenish colorless and purplish-brown
glass; blown and tooled on the pontil
with applied trails
H: 8.2 cm (3 ¼ in.); Diam: 7 cm (2 ¾ in.)
Provenance: Thomas E. H. Curtis Collection,
Plainfield, N.J.
Gift of Edward Drummond Libbey,
1923.2028

**20B. VASE WITH "BIRD"
MEDALLIONS**
Syria or Iraq
Seventh–eighth century
Pale brownish colorless glass; blown
and tooled on the pontil with applied
medallions
H: 8.9 cm (3 ½ in.); Diam: 7.4 cm (3 in.)
Provenance: Thomas E. H. Curtis Collection,
Plainfield, N.J.
Gift of Edward Drummond Libbey,
1923.2015

**20C. ZOOMORPHIC FLASK
WITH SURROUNDING CAGE**
Syria
Seventh–eighth century
Brownish colorless and vivid turquoise-blue
glass; flask blown and tooled; cage and
animal features applied and tooled on
the pontil
H: 12.7 cm (5 in.); L: 8.5 cm (3 ⅜ in.)
Provenance: Thomas E. H. Curtis Collection,
Plainfield, N.J.
Gift of Edward Drummond Libbey,
1923.2044

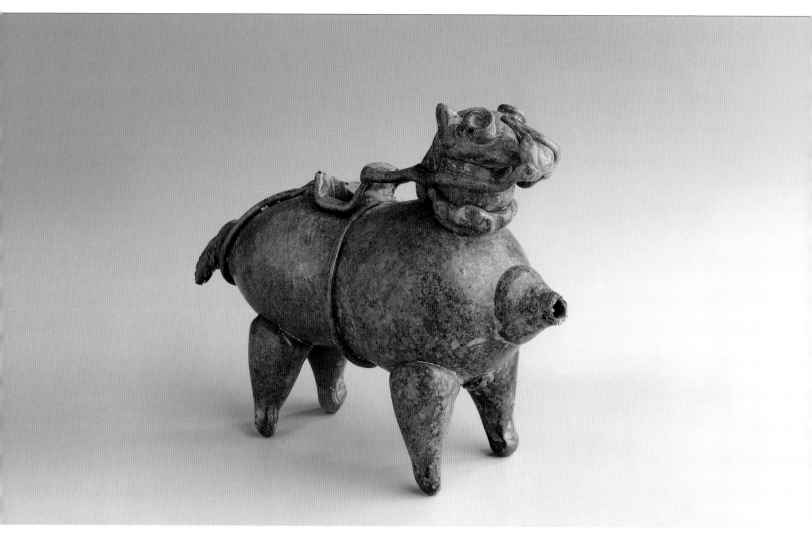

ZOOMORPHIC RHYTON
Iran or Central Asia
Possibly seventh–eighth century
Greenish colorless glass; blown and
tooled with applied decoration
H: 13.9 cm (5 ½ in.); L: 17.8 cm
(7 ⅛ in.)
Provenance: Thomas E. H. Curtis
Collection, Plainfield, N.J.
Gift of Edward Drummond Libbey,
1923.2055

The first reaction to seeing and handling this unusual object is amazement that it has survived virtually intact for well over a millennium. Except for its broken spout and some chips on the "saddle" around the opening at the top, all of its applied features, down to and including the delicate harness encircling the body, are still unbroken. The object was obviously buried for a long time in a relatively dry environment, so that its surface has been heavily weathered into an even pale brown coating and gray pitting; fortunately, the process of corrosion did not go any further. Today, the viewer is forced to imagine this rhyton as an almost colorless vessel that would have allowed a colored liquid such as red wine to be visible inside. Its surface weathering, therefore, does not do justice to the original appearance.[11]

This horse represents a type of vessel known as a zoomorphic rhyton, that is, a variation of an ancient drinking horn usually ending in an animal's head.[12] In the typical rhyton, a liquid would have been poured into the vessel through the larger opening, and from there progressed into the drinker's mouth through an opening at the rhyton's narrow end. Here, the rhyton is turned into a three-dimensional animal shape where one opening is placed on the upper part of the vessel (corresponding to a hole in the saddle), and the drinking spout is at the horse's chest. When in use, the rhyton nestles comfortably with its four legs in one's hand, and the movement to the mouth seems rather effortless.

While the function of this vessel is clear, its attribution remains uncertain. In general, drinking-horns and their derivations — in metal, clay, and glass — ranging in time from the Achaemenid through the medieval Islamic periods, belong to the Iranian and Central Asian regions, roughly corresponding to the modern countries of Iran, Turkmenistan, Uzbekistan, Tajikistan, and Afghanistan.[13] Zoomorphic figures in particular, including many vessels with just one opening, as well as limited numbers of rhyta with two openings, are fairly common in medieval Iran (Fig. 21.1), especially in the twelfth and thirteenth centuries, although a sig-

nificant number can also be attributed to the Syrian area. The most common animals represented are birds, cows, and lions, while the horse shape is found only in extremely rare occasions in the late Sasanian and the early Islamic eras.[14]

An attribution of this object to the Iranian or Central Asian area and to the early Islamic period is corroborated by the recent discovery of an anthropomorphic rhyton, presently in the Eretz Museum, Tel Aviv. Admittedly, this female, or perhaps hermaphrodite, figure holding a snake in her arms also has no certain provenance, nor was it found in an archaeological context. It is easier, however, to propose a Central Asian attribution for the Tel Aviv rhyton on the basis of strong comparative iconographic evidence.[15]

The two objects are very different as finished works, but they share a number of very similar technical characteristics. They both have a gourd-shaped, free-blown body. They both have the same color, once the surface weathering of the horse is taken into consideration. The spout (and in the case of the horse also the four legs) is attached to the body after applying a blob of hot glass onto its surface and immediately inflating it. With the application of the hot glass to the body, the separation between the two walls melted away, thus allowing the liquid to flow freely from the body to the spout after the piece had cooled. This technique is similar to that employed on the so-called claw-beakers in medieval Europe, although it is so peculiar and rare in the Islamic world that, based on this simple observation, one could hardly object to an attribution of these two objects to the same glassworking tradition. Yet an accurate time and place for the making of this zoomorphic rhyton remains a mystery and any attribution must remain tentative for the time being, as is often the case with works that are so unique.
S.C.

Fig. 21.1. Zoomorphic Rhyton. Iran or Central Asia, seventh–eighth century. Earthenware with underglaze decoration, L 20 cm (7 ⁷⁄₈ in.). New York, The Metropolitan Museum of Art, 66.23, Harris Brisbane Dick Fund, 1966.

This egg-shaped bottle with a flattened body is missing only its original neck, which was most likely short and slightly flared, whereas its body and its relief-cut decoration remain in nearly pristine condition.[16] A faint cloudy weathering inside the bottle and tiny sparse bubbles in the glass allow for a good reading of the decorative pattern when the object is viewed at close range. As with most Islamic colorless relief-cut glass, however, the artist focused on rendering a faint, delicate, almost ethereal, pattern rather than drawing and carving bold outlines in high relief that would have given the object a sculptural effect. The result is therefore a colorless, weightless, insubstantial work that would fully come to life only when a colored liquid was poured into it so that the pattern was visible against a darker background.

The decoration on this vessel represents an excellent example of the individual elements and of the symmetric patterns that became common language in Islamic art from the early ninth century on, and were widespread in an area that encompassed Egypt in the west to Iran in the east. On this bottle, on the upper part of the two flattened sides, we can recognize two stylized affronted birds separated by a diamond-shaped element; on the lower part, two highly stylized birds, shown back-to-back, are joined by a horizontal line with an oval pendent in the middle. Along the two narrow sides of this flattened bottle are simple, heart-shaped open-palmette motifs, one at the top and one at the bottom; in the center are two leaf-like palmettes joined by a concentric circular element. The designer and the carver of this object cleverly created a four-pointed base, taking advantage of the pointed end of the heart-shaped palmettes at the bottom. The base is reminiscent of the so-called molar flasks that were so popular at the time in the Islamic world;[17] this base, however, is merely decorative and non-functional, since the four feet are so close to each other that the bottle cannot stand on its own and needs either to be placed on its side or to be supported by a mount.

The technical and decorative relationship between Islamic relief-cut glass and carved rock crystal is obvious, not to mention, of course, that the nearly colorless hue of this type of glass can be easily mistaken for the more precious hard stone. This is also, in many ways, a source of debate and argument among glass scholars, since it is usually assumed that colorless relief-cut glass with refined and elaborate decoration can be attributed to the Iranian region, whereas the highest quality carved rock crystal was produced for the Fatimid royal entourage in Egypt.[18] A simple solution to this quandary may be that the patterns and techniques of both productions originated in the ninth-century 'Abbasid capitals of Baghdad and Samarra, then subsequently developed in different mediums in the two areas. On the other hand, artistic cross-influences, the recent discovery of carved rock-crystal works from the Eastern Islamic areas, and a flourishing glass industry in Egypt offer a more complex view of this problem and add much more food for thought.

The best parallel in cut glass for this object is a taller bottle (ca. 17 cm) with identical shape in the Benaki Museum, Athens. This bottle has a rather different decorative program, although both share the same heart-shaped, open-palmette pattern.[19] It is in rock-crystal objects, however, that more parallels can be found in terms of shape: several of these works are nearly circular or elongated flasks with a flattened body, and three of them have a very similar oval profile.[20] One of these, now in the Freer Gallery of Art, Washington, D.C.,[21] also includes the peculiar pattern of the leaf-like palmette joined to a concentric circular element, at the same time providing the best extant parallel for the Toledo bottle and asserting the close, though still mysterious, link between Egyptian rock crystal and Iranian relief-cut glass.

S.C.

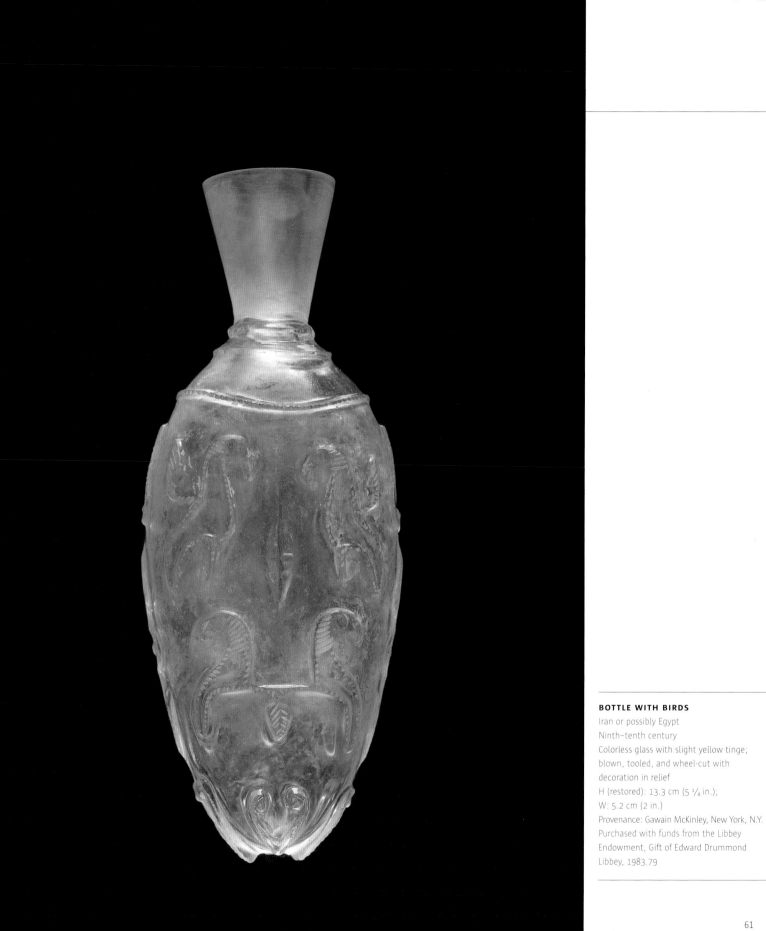

BOTTLE WITH BIRDS
Iran or possibly Egypt
Ninth–tenth century
Colorless glass with slight yellow tinge;
blown, tooled, and wheel-cut with
decoration in relief
H (restored): 13.3 cm (5 ¼ in.);
W: 5.2 cm (2 in.)
Provenance: Gawain McKinley, New York, N.Y.
Purchased with funds from the Libbey
Endowment, Gift of Edward Drummond
Libbey, 1983.79

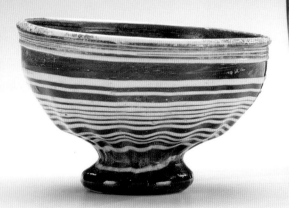
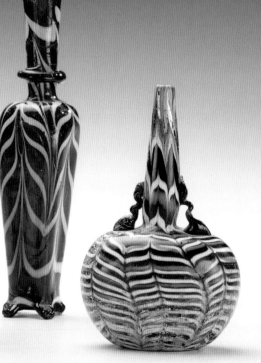

From left to right:

23A. FOOTED BOWL
Probably Syria
Thirteenth century
Translucent purple glass; opaque white
applied and marvered trails; mold-blown
and tooled on the pontil
H: 6.1 cm (2 9/16 in.); Diam (rim): 10.1
cm (3 7/8 in.)
Provenance: Galerie Heidi Vollmoeller,
Zürich, Switzerland.
Purchased with funds from the Libbey
Endowment, Gift of Edward Drummond
Libbey, 1969.367

23B. SMALL FLASK
Egypt or Syria
Eighth–ninth century
Translucent blue glass; opaque white
applied and marvered trails, blown and
tooled on the pontil
H: 13.8 cm (5 7/16 in.)
Provenance: Thomas E. H. Curtis
Collection, Plainfield, N.J.
Gift of Edward Drummond Libbey,
1923.2203

23C. SPRINKLER (QUMQUM)
Probably Syria
Thirteenth century
Translucent purple glass; opaque white
and green applied and marvered trails,
blown and tooled on the pontil
H: 9.7 cm (3 7/8 in.)
Provenance: Thomas E. H. Curtis
Collection, Plainfield, N.J.
Gift of Edward Drummond Libbey,
1923.2359

Glass objects like these, with a dark matrix and white or pale-colored marvered trails, attest to the continuity of production in the Syrian and Egyptian areas of the Islamic world. The effect of "marvered" glass is achieved by applying trail of a contrasting color around the parison in a spiraling motion; the trail is then pushed against the glass by rolling the parison against a smooth surface while the glass is still hot, so that it becomes flush with the surface; finally, the parison is inflated free-hand or in a mold and the trail is "combed" with a toothed tool to create a wavy or a festooned pattern.[22] The color combination and peculiar surface patterning make this type of glass rather distinctive, fitting with the occasionally whimsical taste for vivid patterns and colors that distinguished Islamic glassworkers in the Near East throughout the early and the medieval period, or from the eighth through the thirteenth century.

Blown glass with contrasting marvered trails was already known in the Near East in late antiquity, but the contrast of colors was not as dramatic due to the use of a pale-colored translucent matrix that sometimes almost blended with the white and pale-red trails. Early Islamic glassmakers appear to have developed the idea more fully and began to create much more distinctive objects.

The diminutive, squarish perfume or ointment flask in dark blue glass and white marvered trails (23B)[23] is a good example of this transitional period between Late Antique and early Islamic glass. The base glass is definitely darker than the earlier, pre-Islamic works whereas the wavy patterning seems to show little control and an uneven thickness of the white trail, suggesting that perhaps the glassmaker was experimenting with the technique. Archaeological evidence corroborates the attribution of these peculiar small flasks to the early Islamic period in Egypt or to the Eastern Mediterranean coasts.[24]

The controlled, regular patterns and the well-established shapes of the sprinkler (23C)[25] and of the footed bowl (23A),[26] point instead to a later, more mature development of this type of glass, at the same time demonstrating that the technique was popular for quite a long time. The slightly flattened globular bottle with a narrow neck, ending in an opening just wide enough to let a few drops of perfumed water fall at a time, represents one of the most characteristic shapes that developed in Syria in the late twelfth or early thirteenth century and that remained in fashion through the fourteenth.[27] This type of vessel is usually called a *qumqum* (Arabic) or *omom* (after its pronunciation in the Egyptian dialect). What makes this small *qumqum* remarkable is the very unusual combination of white and pale green opaque trails that create lively three-colored bands all over its surface taking into account also the purple matrix of the glass.

The small footed bowl has a more controlled, almost austere, appearance when compared to the other two objects. Here, the white-over-purple trail was not "combed" into a festooned pattern but was instead left as a simple spiraling pattern; it is, however, the vertical ribbing, attained in a one-piece mold, which creates the effect of an uneven, wavy surface.

These three objects represent both the continuity of production of "marvered" glass and the variety of their shapes and decoration. Given the distinctiveness of the surface of this type of glass, none of the extant works, and perhaps none of the works that were ever produced, gives any clue as to their patronage through an inscription. Their attribution is therefore based on archaeological evidence as well as art-historical considerations. It seems possible to suggest, however, that they were made for an upscale but wide-ranging market rather than for the fulfillment of courtly commissions.

S.C.

Bottles with a near-spherical body and a long narrow neck became popular in the Medieval Islamic world. The shape is especially common in glass, although it is not restricted to this medium and may have been inspired by metal prototypes, rare examples of which survive in silver worked in repoussé and decorated with niello and gilding.[28] The popularity of this type of vessel in the Middle East has to do with its practical function as a container for liquids that had to be poured in relatively small quantities at a time, such as rosewater.

The two bottles under discussion here belong to a well-defined group of vessels produced in Iranian glass factories over time, probably from the late eleventh century to the advent of the Mongols in Iran around the middle of the thirteenth century. In glass, the shape is also well known from an earlier period in the Syrian area, through a few bi-chromatic examples decorated with tong-stamped patterns, the two sections in blue and colorless glass joined by means of the so-called *incalmo* technique.[29] The two bottles featured here are larger and taller than the earlier Syrian types and their decoration was impressed instead in a single- or double-part mold and was subsequently further inflated (optic-blown) in order to enlarge the body (and therefore the bottle's capacity) and to create a shallower relief and a less defined pattern that must have been agreeable to both glassworkers and patrons.

According to the extant material, which, luckily, is relatively abundant compared to other medieval glass types, the decorative patterns created for these kinds of bottles are limited. The most common patterns include concentric geometric figures with a circle in the center (the so-called *omphalos* pattern), curly vegetal scrolls, and large flowers with multiple layers of petals, creating a ripple effect. We also find the peacock[30] and the honeycomb[31] patterns, visible on the present objects. The range of colors is also typically limited to pale but distinct greens, purples, and deeper colors such as brown and dark blue, while almost colorless objects are

exceedingly rare. In general, it can be surmised that the patterns are typically Iranian, in that the moldmakers drew inspiration from pre-Islamic and early Islamic designs that were widespread in the area. The honeycomb pattern has a long history in the Iranian decorative idiom and some of the most remarkable late Sasanian and early Islamic works in wheel-cut colorless glass (see No. 22), including a few bottles with the same profile and smaller dimensions, are testimony to the status of this overall ornamental design with their mirror-like, highly reflecting surface.[32]

The image of the peacock, with its raised tail, stands out as the only figural decoration of this group of bottles, all others bearing either vegetal or geometric designs or a combination thereof. There are two basic patterns: one in which the peacocks are confronted and separated by what can be interpreted as a stylized tree of life (as in the blue bottle shown here, 24A) and another in which all the birds look in the same direction within a row of circular medallions.[33] Once again, late Sasanian and early Islamic models — especially textiles featuring birds within medallions surrounded by a "pearl" border similar to the sunken dots that frame the main band on the blue bottle illustrated here — can be mentioned as the main source of inspiration.[34] That the bird-within-medallion motif was fashionable also among the glass workshops of the early Islamic period is evident from the applied decoration of the small vase (see No. 20B and Fig. 20.1).

Attributing these molded bottles to northern Iran in the late eleventh to early thirteenth centuries is uncertain, since none of these vessels bears an inscription that links it to a specific place, date, patron, or maker,[35] but there is enough evidence to support it. Many of these objects are today in collections in Iran and are reported to have been found in the northeastern region of Mazandaran, especially the area around the city of Gurgan along the shores of the Caspian Sea (including the present bottle with peacocks that supposedly comes from

Shahi [modern Ghaem Shahr]).[36] In addition to this circumstantial evidence, a kiln-waster of identical shape in luster-painted pottery was actually found at Gurgan.[37] It seems, therefore, that the type was a favorite in Seljuq and post-Seljuq Iran, when perfumed water perhaps became an essential household item and glass production enjoyed its last great flourishing in the region.

S.C.

24A. BOTTLE WITH PEACOCKS
Iranian area
Medieval Islamic period, about twelfth to
thirteenth century
Dark blue glass blown in a two-part mold
and tooled on the pontil; applied trail
around the neck
H: 24.4 cm (9 ⅝ in.); Diam:
9.6 cm (3 ¾ in.)
Provenance: Said to have been excavated
near Shahi, Iran; World Antiquities Ltd.,
New York, N.Y.
Purchased with funds from the Libbey
Endowment, Gift of Edward Drummond
Libbey, 1962.27

24B. BOTTLE WITH HONEYCOMB
PATTERN
Iranian area
Medieval Islamic period, about twelfth to
thirteenth century
Brown glass; blown in a single-part mold
(post technique), tooled on the pontil
H: 22.5 cm (8 ⅞ in.); Diam: 10.5 cm (4 ⅛ in.)
Provenance: Said to have been found at
Abadan-Tepe, Iran; Mohammad Yeganeh,
Frankfurt-am-Main, Germany.
Purchased with funds from the Libbey
Endowment, Gift of Edward Drummond
Libbey, 1971.162

One of the most familiar shapes in the production of enameled and gilded glass from the Mamluk period in Egypt and Syria (1250–1517) is that of the vase-like mosque lamp, which can perhaps better be described as a lampshade, since the lighting apparatus proper, a small saucer containing a wick that floated in a mixture of oil and water, was suspended in the middle of the vessel by means of short metal chains hooked to the rim. The profile and construction of this type of lamp, however, is not an original Mamluk creation, as it seems to hark back to a functional type of domestic vessel that could be suspended in a niche on the wall by means of chains passing through the loops, placed on a flat surface, or carried around as a lantern. Early medieval lamps, notably from the Iranian area, testify to the popularity of these undecorated lamps in the Islamic period.[38] The lighting technique, however, was slightly different since, in these early lamps, the wick was inserted in a short, narrow glass tube attached inside, at the base of the vase.

Mamluk mosque lamps are so oversize, emphasizing not only the skills of the painters but also those of the glassblowers, that the interior volume of the vase allowed for the saucer to be suspended inside, thus making the cleaning and refilling process faster and less cumbersome. One has to consider that dozens, sometimes more than one hundred such lamps, were suspended from the ceilings of Islamic religious buildings (hence the term "mosque" lamp) in Mamluk lands, thus creating a splendid lighting effect just a few feet above a man's height. The person in charge of the illumination of the mosque, therefore, must have been very busy servicing these lamps at the end of each day.

The best period of production of mosque lamps includes the better part of the fourteenth century, when large size was combined with the most accomplished calligraphic, vegetal, and geometric painted patterns. They present not only Qur'anic inscriptions, most notably and appropriately a verse from the so-called *surat al-nur* ("Chapter of Light," Qur'an 24:35), but they often also include the name of the patron, his title, and eulogies in his honor. This combination of religious and secular inscriptions on the same object is by no means unusual in Islamic art, but here it takes a special meaning when one realizes that the name of Allah as well as that of the ruler literally glowed in synchrony through the glittering gilded lamps. Given the exceptionally large number of public and private commissions of religious buildings in Mamluk Cairo, it is not surprising that many lamps have survived carrying the names of several sultans and a myriad of emirs at their service. Among the sultans, the most frequent names are those of al-Nasir Muhammad ibn Qalaun, al-Nasir al-Hasan ibn Muhammad Nasir al-Din, and al-Malik al-Zahir Abu Sa'id Barquq (the three longest-reigning rulers of the fourteenth century).

Among the many emirs, it seems that Sayf al-Din Shaykhu (ca. 1307–1357), the patron of the present lamp,[39] was particularly keen in furnishing his buildings with endless rows of mosque lamps. Most certainly this lamp comes from his mosque or from his *khanaqa* (a hospice for mystics) and tomb, two impressive buildings that face each other in medieval Cairo that were erected between 1349 and 1355.[40] Shaykhu was one of the most powerful emirs at the Mamluk court, to the extent that he was the first officer to be granted the title of Great Emir by a sultan. He was lucky enough to see his major building project finished before he was murdered in 1357.[41] All of the known lamps made in his name include around the neck a verse from the Chapter of Light ("God is the light of the heavens and the earth, the likeness of His light is as a wick-holder wherein is a light; [the light in a glass, the glass as it were a glittering star…]"). Around the body is the secular inscription "For the excellency, the most noble, the high, the lord, the well-served, Sayf al-Din Shaykhu." Shaykhu's emblem of office, a red cup against a gilded field between two horizontal red and black bands, appears within roundels around the neck and on the underside of this lamp.

Many of the lamps in Shaykhu's name were still *in situ* at the end of the nineteenth century, when Western collectors and dealers began seeking enameled and gilded glass. Many examples were shipped out of Egypt at that time, entering collections in Europe and in the United States, and of these, more than twenty lamps survive in good condition today.[42] The Toledo lamp, acquired in 1933, was formerly in the hands of the Swedish scholar and collector Fredrik Robert Martin (1868–1933), who was among those who had an early appreciation for these objects.

S.C.

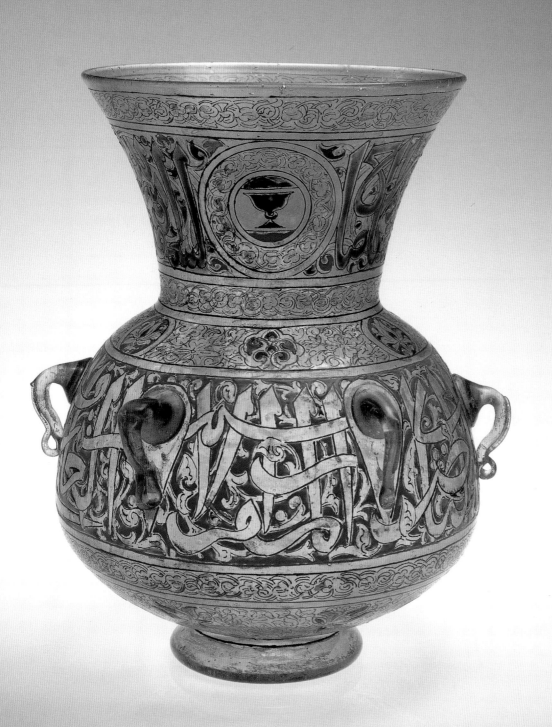

Glassworkers in fourteenth-century Mamluk Cairo must have enjoyed popularity, fame, and wealth, if one considers the amount of outstanding and oversize objects in enameled and gilded glass that survive to this day and often bear the name of a reigning sultan or of one of his emirs. Mosque lamps (see No. 25) represent one of the most common shapes, but the variety of available types, ranging from bottles to pilgrim flasks, from vases to bowls, beakers, plates, dishes, and even candlesticks and traystands, finds no match in any other period or area of the Islamic world.[43] It is not clear whether these objects were mass-produced, created as individual commissions, or made in a limited series. With the exception of mosque lamps, which were all made alike in large numbers because of their intended function, it is difficult to find among the extant objects any two works that present identical shape, decoration, and additional details. Often the glass shapes, and sometimes details in the decoration, are related to contemporary inlaid metalwork, another craft that reached new heights under the Mamluks; in other cases the glassworkers seem to have found inspiration in ceramic types rather than in more common glass shapes. Without a doubt, enameled and gilded glass in fourteenth-century Cairo was inventive, original, large, lavishly produced, a true tour de force, and was highly prized not only in Mamluk Cairo but also in Europe, in other Islamic countries, and even in China.[44]

The present bowl is no exception.[45] In addition, its nearly pristine condition and its imposing dimensions make it one of the most memorable examples of this type. Most of the gilding was rubbed off, but it is still easy to appreciate the lavish contrast between lapis blue and gold that dominates the color scheme. Whether the bowl is seen from the top or from the bottom, it is also possible to fully understand its decorative scheme. The large outer band presents a rhythmic alternation of large, cloud-shaped calligraphic medallions and small roundels incorporating a single red five-petaled rosette against a

LARGE BOWL
Probably Egypt
Mamluk period, mid-fourteenth century
Brownish colorless glass; blown, tooled on the pontil, enameled and gilded on the interior; applied foot
H: 17 cm (6 ¹¹⁄₁₆ in.); Diam: 36.8 cm (14 ½ in.)
Provenance: George Eumorfopoulos, London (until 1940); Mrs. George Eumorfopoulos, London (Sotheby's, April 1944).
Purchased with funds from the Libbey Endowment, Gift of Edward Drummond Libbey, 1944.33

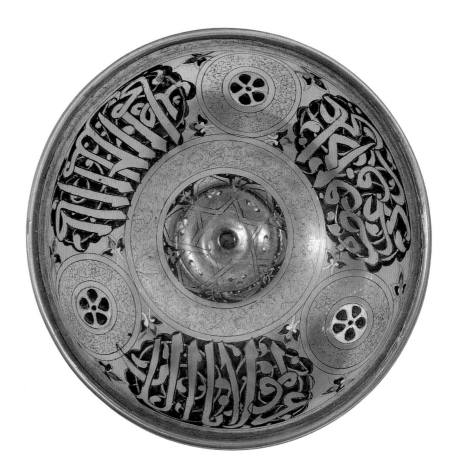

Fig. 26.1.

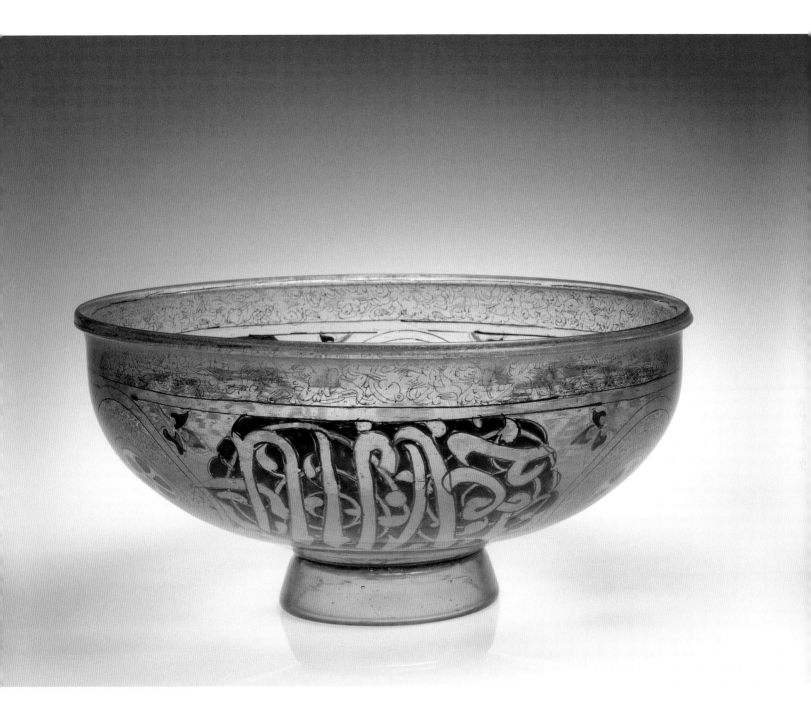

white background; the geometric six-pointed star in the center gives radial unity to the entire composition. Sparing use of red, white, yellow, and green enamels to delineate the leaves of the vegetal scrolls in the background represents an oft-seen additional touch that highlights even more the importance of blue and gold.

This bowl has also a documentary importance as one of the few extant glass objects not dedicated to a Mamluk sultan or emir but rather to the ruler of a less powerful dynasty with strong diplomatic ties to the Mamluks. The Rasulids, whose emblem was a five-petaled rosette, controlled a region that corresponds approximately to modern Yemen and therefore shared a boundary with the Mamluks, who ruled over the holy cities of Mecca and Medina, north of Yemen in the Arabian Peninsula.[46] More importantly, the Rasulids enjoyed the control of the southern entrance into the Red Sea, and it was essential for the Mamluks to keep the trading route to and from the Indian Ocean open and running. The object, more likely a diplomatic gift from Cairo than a Rasulid commission, carries the name of the sultan al-Mujahid ʿAli ibn Dawud (r. 1321–63).

One last thought pertains to the function of this object. It seems obvious to view it as a large bowl standing on a low foot that was used for the presentation of exotic fruit or other food. Two details, however, suggest another function. The inscription, "Glory to our Lord, the sultan al-Malik al-Mujahid ʿAli ibn Dawud, may His victory be glorious," is legible only if one looks directly into the interior of the bowl (see Fig. 26.1), whereas it appears not only upside-down but also reversed if the object is viewed in profile. By extension, the inscription is also legible if its shadow is projected onto another surface below. In addition, the rim of the bowl is unusually thick and extends outward, almost suggesting that a metal ring may have originally been used to support it. Is it possible that this large bowl was, in fact, a lamp suspended from a metal ring and chains and that it projected the Rasulid sultan's glorious name on the floor below? This

may be only a hypothesis, impossible to corroborate at the moment, but it enhances our fascination with Islamic enameled and gilded glass, which represents some of the most spectacular productions in the history of this craft.

S.C.

Glass production in the late Islamic era is rather different from the great artistic, technical, and technological achievements of the early medieval period in Iran and of the late medieval period in Egypt (see Nos. 20–26). It is probably not too far-fetched to say that the decline of the industry across the Islamic world—equally spurred by local economic conditions, lack of demand, and the rising European, mostly Venetian, industry—brought this craft almost to a standstill in the fifteenth and sixteenth centuries. Archival sources mention high-end glass production in Ottoman Istanbul during the sixteenth to seventeenth centuries, although such works have yet to be properly identified and the import of large quantities of glass from Venice is equally attested.[47] In seventeenth-century Iran under the Safavid dynasty, it seems that "greedy and avaricious" Venetian glassmakers, who were willing to defeat the Serenissima's ban to work abroad, revived the industry in Shiraz and Isfahan and taught local craftsmen how to make utilitarian vessels as well as more fanciful ones, albeit with little artistic value.[48] It was under the Mughal dynasty (1526–1858) in the Indian subcontinent, a region with hardly any history of artistic glassmaking, that Islamic glass achieved the most remarkable results in the late Islamic era. This is probably due to better patronage and higher-end demand as compared to the rest of the Islamic world at this time.[49]

The opalescent, jade-like green glass plate (27D)[50] represents one of the best examples of the Indian glassmaker's ingenuity in imitating a material that was both fashionable and highly prized by the Mughal court and its entourage, perhaps following in the footsteps of medieval Iranian craftsmen reproducing rock-crystal objects (see No. 22) or fifteenth-century Venetian artists imitating hard-stone vessels. Whereas jade was a hard stone typically carved using lapidary techniques, the surface of glass presented an opportunity to create painted and gilded decoration (opalescent glass is softer than transparent glass and thus is unsuitable for

carving). In this way, the traditional floral repertoire of Mughal artists was incorporated into these objects, ranging from poppies (as evident on this plate) to irises and lilies, to more stylized generic flowers and leaves, creating a vivid contrast with the background surface. This large shallow plate of traditional shape, almost certainly used to present food such as dried fruit, sweetmeat, or nuts in an affluent home or on its veranda, has suffered some loss of the original gilding but still provides an excellent example of Mughal-period glassmaking and its decoration.

A limited number of green, as well as white, jade-like glass objects are known, especially as compared with the much larger numbers that survive of vivid blue, green, or colorless hookah bases and spittoons from the same period,[51] two notable examples of which are provided by the wheel-cut and gilded "hubble-bubbles" in Toledo.[52] One (27C) is colorless, the other a vivid amethyst purple (27A),[53] but the decoration of both objects stems from the same late Mughal artistic tradition as the opalescent green plate. The globular hookah base presents an overall pattern of flowers and scrolls that develops in all directions at the same time, maintaining the unmistakable balance and symmetry of Islamic art. The purple base shows instead a more rigid, almost academic, composition of flower vases arranged within a colonnade with pointed arches. These objects exemplify the two traditional shapes of Mughal hookah bases: one globular, the other bell-shaped. The former, which initially developed from natural shapes such as coconut shells, became popular in glass by the end of the seventeenth century, reproducing inlaid metal examples. Globular hookah bases need a support to stand, so it seems likely that more practical bell-shaped bases that developed in the 1720s eventually replaced the globular type. Both shapes were popular in the second half of the eighteenth century, therefore it is difficult to offer precise attributions: judging from their decoration, the globular base was probably created one or two decades earlier than the bell-shaped base.

Fig. 27.1. *Sahadeva Brings Raja Yudhisthira News of Victory*, from a *Razmnama* manuscript, 1598–99. Paras (Mughal, active 1500s). Watercolor on paper, H (image): 20.0 cm (7 ⅞ in.). Museum Purchase, 1926.17.

28–36 EUROPEAN RENAISSANCE

During the thirteenth century, fine glassware emerged as one of the foremost luxury products manufactured in Venice. The Council of Ten, the highest governing body of the Republic, had been able to keep the Venetian glass industry and its guild under its direct supervision since 1291, when it isolated glass-making on the island of Murano in the Venetian archipelago, to ensure better fire safety and to enforce governmental control. As a result, the working environment on Murano was rich in technological knowledge, had the best raw materials at its disposal, and provided ready access to an extensive trade network for its products. The Murano craftsmen focused their efforts on creating glass objects that closely resembled rock crystal and, around the first half of the fifteenth century, succeeded in developing *cristallo*.[1] This was a clear glass with a slightly gray or brownish tinge and high ductility, which allowed it to be manipulated into intricate shapes. Through the centuries that followed its invention, the complex methods involved in its preparation, working techniques, and designs continued to be refined. In 1457, the Venetian glassmakers Angelo Barovier and Niccolo Mozetto were granted a special dispensation to make *cristallo* glass during the *cavata*, the official rest period of the Venetian glass industry when factories refurbished equipment and restocked supplies. On his death in 1460, Barovier, one of a dynasty of glassmakers recorded in Venice since at least 1331, was credited with being the best Venetian producer of *cristallo* vases.

For centuries thereafter, extensive foreign trade continued to promote production of Venetian glass, which was rich in variety and open to artistic and technological change. Late fifteenth-century Venetian tableware was largely inspired by earlier metal forms. The mold-blown ribs of the small goblet (28B)[2] and the large serving bowl (28A)[3] in the Toledo Museum's collection, for example, recall fluted Gothic vessels in silver and gold. Applied gold leaf and enameling underscore the rich appearance of these glass vessels. The large-scale molded bowl with pincered and gilded ribs, a type of which few have survived, was a particularly impressive vessel to show off food at table.[4] Such tableware not only added a dazzling display to the *credenza* of a wealthy household, stocked with the most luxurious food stuffs to be offered to privileged guests, but more importantly it also attested to the prestige and refined taste of the owner. These highly desirable objects were often made as special orders.

The small footed plate (28C) bears the joint coats-of-arms of the duchy of Brittany and of the royal family of France;[5] most likely, the arms refer to Anne of Brittany (1477–1514) and Louis XII of France (r. 1498–1515), who were married in 1499 at the royal château in Nantes. In general, glass objects with joint coats-of-arms are thought to be wedding or diplomatic gifts, presents that reinforced the importance of the newly formed dynastic connection. These arms also could be those of Anne's daughter, Claude de France (1499–1524) who, as consort of Francis I and heiress of Brittany after her mother's death in 1514, would have borne the same arms. The tazza is one of four different dishes that probably once formed a large set made for use at the French court. The set is among the oldest Venetian glasses of French provenance known today.[6]

Venetian glasses had been acquired by the French aristocracy at least as early as the fifteenth century. According to an inventory, Jean duc de Berry is known to have purchased such luxury glass between 1413 and 1415.[7] More remarkably, France appears to have been the first country to persuade Italian glassmakers from Altare, a small town in the duchy of Montferrat, near Genoa, to immigrate to its territory. In France, the patterns and manufacturing processes were seldom disseminated by the Muranese themselves, who were not allowed to leave Venice without permission from the Council of Ten. The artisans from Altare, however, had perfectly assimilated the Venetian techniques, and the authorities at Altare were willing to permit them to make Venetian-style glass abroad. An Italian glassmaker named Ferro or Ferri is said to have entered the service of René d'Anjou (1409–1480) in Provence in 1443.[8] During the 1500s, numerous French cities emerged as *façon de Venise* glassmaking centers. For example, King Henry II established a factory in Saint-Germain-en-Laye; Ludovico Gonzaga created a center in Nevers, which would blossom in the following centuries; and Henry IV set up workshops in Paris, Nantes, and Rouen.[9]

The tazza in New York and this tazza in the Toledo Museum of Art show distinct symptoms of an inherent glass deterioration called "crizzling," which is due to a chemical instability of the glass formula. It has therefore been suggested that the set is of French, rather than Venetian, manufacture.[10] However, since it is known that Venetian Renaissance glasses occasionally also show symptoms of crizzling, this condition cannot be used as a definitive basis for attribution.

The technical complexity and scale of the table service of which this tazza is a part attest to the refined taste and splendor at French courts at the beginning of the sixteenth century. The service was probably a special order from Venice or was perhaps made as a diplomatic gift. The existence of a service made of glass is documented in the court inventories: "une 'grand tasse' avec son etuit," a coupe with cover, eight tasses or small bowls, three with covers, a "pot," and a decanter. The text does not specify a coat-of-arms, but indicates that they were gilded around the borders and enameled.[11] The set certainly would have represented the latest taste in glass in France.
J.A.P.

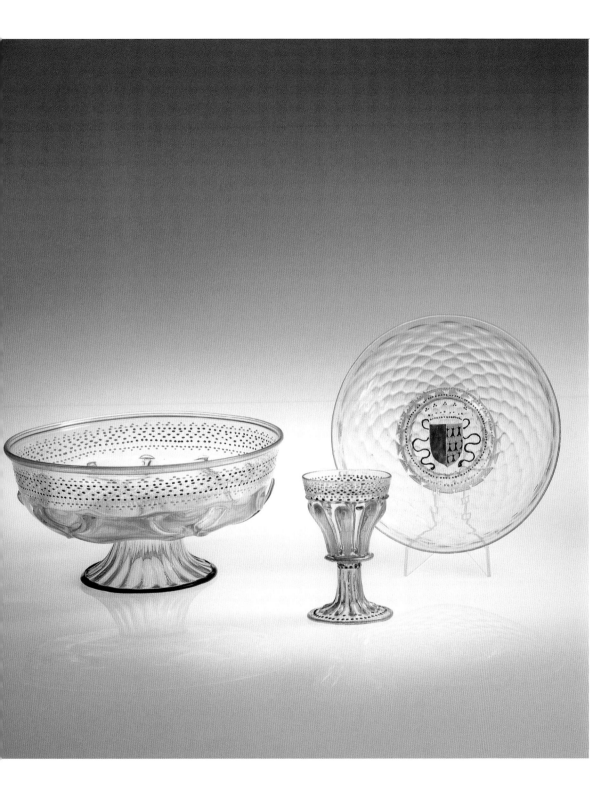

From left to right:

28A. FOOTED BOWL
Italy, Venice
Late fifteenth century
Colorless glass; mold-blown, applied,
tooled, gilded, enameled
H: 14.3 cm (5 ⅝ in.); Diam (rim):
28.6 cm (11 ¼ in.)
Provenance: Blumka Gallery, New York, N.Y.
Purchased with funds from the Libbey
Endowment, Gift of Edward Drummond
Libbey, 1958.17

28B. GOBLET
Italy, Venice
Late fifteenth century
Colorless glass; mold-blown, gilded, enameled
H: 12.4 (4 ⅞ in); Diam. (rim):
8.1 cm (3 ³/₁₆ in.)
Provenance: Collection Engel-Gros, Paris,
France; Adolph Loewi, Los Angeles, Calif.
Purchased with funds from the Libbey
Endowment, Gift of Edward Drummond
Libbey, 1955.18A

**28C. TAZZA WITH THE JOINT COATS-
OF-ARMS OF FRANCE AND BRITTANY**
France
About 1498–1524
Colorless glass with a brownish tinge;
blown, pattern-molded, enameled, gilded
Diam.: 24 cm (9 ½ in.)
Provenance: Collection Frédéric Spitzer,
Paris, France (catalogue, 1891, vol. 3, 101,
no. 58); Arnold Seligman, Rey & Co., New
York, N.Y.
Museum Purchase, 1932.1

By the time this vessel was created in Venice in the late fifteenth century, enameling had been part of the technological repertory of the city's glasshouses for two centuries. The technique had been introduced to Venice from the East by Byzantine glassmakers in the thirteenth century. At times enameling went out of fashion, but it gained new popularity in the mid-fifteenth century in Italy. The forms of the most sophisticated glasses were strongly influenced by the forms of vessels in precious metal and semi-precious stones. Their colors also emulated more valuable materials, such as lapis lazuli, emerald, and agate. Dark blue glasses, resembling lapis lazuli, were mostly colored with imported cobalt (*zaffer* or *saffera*), but ground lapis lazuli was sometimes also added, especially to enamels.[12]

An elaborate footed bowl, such as this example,[13] reflected the refined taste of its educated owner and would have been used on special occasions. The wide, straight-sided bowl was blown of translucent dark blue glass and applied to a short solid stem and a *merese* of colorless glass above a gilded blue hollow knop with pronounced ribs. The trumpet-shaped foot is an old repair, a wooden replacement covered in dark blue velvet. Below the lip of the vessel, between borders composed of a row of small white enamel dots and narrow gold leaf bands, is a field of gold leaf incised with a scale pattern accentuated by red enameled dots. A band of triangular pendentive frets in gold leaf concludes this embellishment. The same ornamental decoration is repeated near the bottom of the bowl. The central portion is decorated with a figural frieze painted in gold and polychrome enamel, depicting groups of young men (some holding spears and shields), women, and horsemen who accompany an armored and crowned male figure sitting in a cart drawn by two white horses. This continuous procession encircling the bowl moves through a stylized lush green landscape with trees against a background of hills, some of which are occupied by fortified cities with turrets. The translucent blue vessel ground above the scene serves as a

representation of the sky and is embellished with small dots and scrolls painted in gold.

The enamel painter appears to have first sketched the scene on the bowl with a medium that eventually burned off in the vessel's final firing. The outlined shapes were filled in with white, blue, green, violet, or red enamel paint. Noticeable care was taken to reserve spaces between the enameled fields, preventing the colors from running and mixing. Once the base colors were applied, details such as shading, faces, and folds of drapery were added with a fine brush in dark brown enamel. The gilder and the enameler were separate specialists hired by the owners of the large furnaces on Murano, who produced the blanks and then also fired and marketed the objects.[14] Although potteries and glasshouses operated in close proximity on Murano, it remains impossible to ascertain if a painter on pottery may have tried his hand at decorating glass.[15]

The decorating style, which is more closely related to graphic art than painting, can also be found on a tall blue glass goblet with a bucket-shaped bowl painted with a narrative figural scene in The Metropolitan Museum of Art, which seemingly was executed by the same hand.[16] The friezes have a rather stiff and linear layout, arranged to allow for continuous viewing of the scenes. The treatment of the figures, trees, and sky is nearly identical and rendered in the same technique and colors as those on the Toledo footed bowl. Also, the charging horseman and the soldier armed with spear and shield appear on both vessels, despite the quite different subject matter. The decorator seems to have freely combined elements from different sources to achieve the desired composition.

The Toledo footed bowl belongs to a small group of about a dozen surviving glasses from the last quarter of the fifteenth century, which are decorated with figural friezes depicting triumphal processions. They are often called *coppe nuziale* (wedding cups), because their imagery relates to the symbolic convention rooted in the traditional cavalcade that went to

FOOTED BOWL
Italy, Venice
Late fifteenth century
Dark blue and colorless glass; blown, mold-blown, enameled, gilded
H: 19.1 cm (7 ½ in.); Diam. (rim): 14.9 cm (5 ⅞ in.)
Provenance: George Eumorfopoulos, London, United Kingdom (sold, Sotheby's, London, 5–6 June 1940, lot 220).
Purchased with funds from the Libbey Endowment, Gift of Edward Drummond Libbey, 1940.119

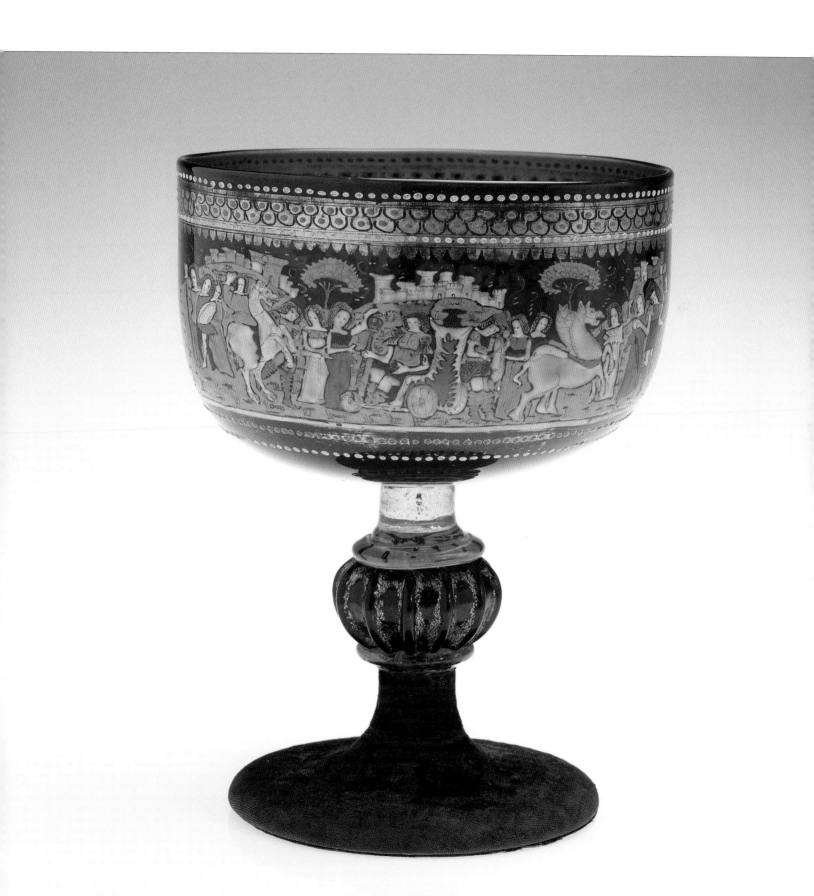

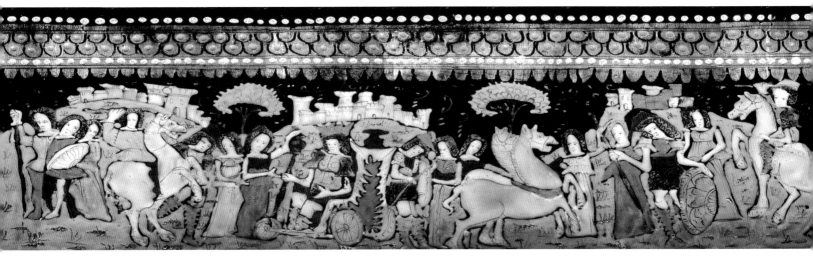

fetch the bride and escorted her to her new home. The decorative themes derive from contemporaneous printed and literary sources, most notably the *Trionfi* by Francesco Petrarca (1304–1374)[17] and the *Hypnerotomachia Poliphilii* by an anonymous Italian author.[18] A set of panels on a wedding chest (*cassone*) painted by Pesellino (1422–1457) for Piero de Medici exemplifies the iconography of the complete Petrarcan cycle, which includes a panel showing the Triumphs of Fame, Time, and Eternity.[19] Fame, here a female figure, is seated in a circle of glory on a cart that is also drawn by two white horses.[20] Her procession is led by captives, and she is accompanied by military leaders as well as heroes of mythology and literature. Mantegna's *Triumph of Caesar* cartoons seem to have helped spread the idea of a frieze-like "antique" composition rather than a frontal view, mixing classicism with the contemporary pageant.[21]

This blue footed bowl is one of only two surviving Venetian Renaissance glasses that are embellished with a *Triumph of Fame*.[22] An argument can be made that these enameled vessels, which probably were fitted originally with glass covers, were not used to serve drinks but sweetmeats and other confections because of their capacious bowls, uncharacteristic for Italian drinking glasses. Sweet delicacies were served in special *confettiere* at two key moments in the marriage process: on the ring day (*di dell'anello*), the presentation of the wedding ring that was celebrated by a reception at the house of the bride's father, and on the day of the ceremonial transfer of the bride to her new home (*noces*), when the groom offered a banquet and also served his guests numerous confections. A credenza service of 1473, for instance, consisted of *vasi*, *bacili*, and *confettiere*.[23] In addition, there may have been a third important occasion in a young woman's life when sweets were offered in celebration: the birth of a child. The motif of the *Triumph of Fame* was also deemed appropriate at this propitious moment, celebrating both the ancestry and future achievements of the newborn.[24]

Elaborately enameled vessels such as this footed bowl did not continue to be popular for long. At the beginning of the sixteenth century, glass with fired enamels fell out of fashion with Italian customers. It is a development that coincided with the rise of *istoriato maiolica*, ceramic dishes painted with ever more complex figural scenes, often derived from contemporary print sources.[25]

J.A.P.

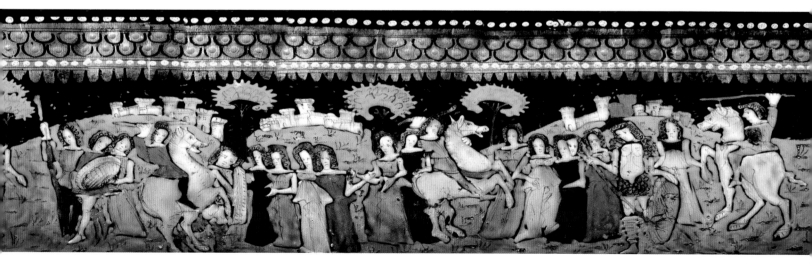

Tall *cristallo* carafes in the shape of the so-called pilgrim flasks were often used in pairs to serve both red and white wine, or water and wine, on special occasions from the end of the fifteenth through the early sixteenth centuries. A silk cord may have originally been threaded through the applied glass loops. Paintings of this period depict sets of flasks filled with water and wine being carried on a tray by a maid into the birthing room as a refreshment for the new mother. A number of these vessels are shown decorated with coats-of-arms. A well-known pair of armorial flasks with the joined arms of the Sforza and Bentivoglio families is in the Museo Civico, Bologna. They may have been commissioned in Venice for the marriage of Ginevra Sforza and Giovanni (II) Bentivoglio in 1492.[26] The assumption is that these objects were made when the two families were first joined through marriage, but they may also have been made for a second family occasion in 1506, which was dynastically of equal importance: the birth of the first child. The occasion would have been specially marked if that child was a boy.[27] An example of an armorial flask that does not fit this tradition is one in the Louvre that is enameled with the arms of Catherine de Foix, queen of Navarre (1470–1516/17). This flask is dated to the end of her reign and was possibly an isolated diplomatic gift.[28] Flasks with gilded and enameled medallions decorated with knot patterns or arabesques on either side, such as this one, are more common and emulate metal vessels of similar shape in gilded silver or pewter.
J.A.P.

ENAMELED FLASK
Italy, Venice
Late fifteenth to early sixteenth century
Colorless glass; blown, applied, tooled, enameled, gilded
H: 34.6 cm (13 ⅝ in.)
Provenance: Walker Collection, United Kingdom; Arthur Churchill Ltd., London, United Kingdom.
Purchased with funds from the Libbey Endowment, Gift of Edward Drummond Libbey, 1948.225

The Venetian merchants who dominated East–West trade in the fifteenth century introduced Chinese porcelain to Western Europe. When Venetian glassmakers saw the white porcelain wares of China's Ming Dynasty (1368–1644), they were inspired to copy that precious material in glass.[29] Venetian glassmakers had already developed an opaque white glass, called *lattimo*, or milk glass, as early as 1359, by adding tin oxide, or lead and arsenic, to a batch of molten glass.[30] The resulting white or creamy, slightly translucent, glass could then be decorated with enamel and gold, and became known as *porcellana contrafacta* (counterfeit porcelain). The production of *lattimo* intensified between 1490 and 1512, stimulated by the import of Chinese porcelain wares to Venice. Giovanni Maria Obizzo, known to have operated a glass manufactory on Murano from 1488 to 1525, specialized in the decoration of the highly desirable *lattimo* glasses, admired for their pellucid whiteness.[31]

This jug, a fine example of *lattimo* blown glass, has a bulbous body, a cylindrical neck, a slightly flaring rim, and an applied flaring base with a turned-up rim.[32] Two opaque white concentric trails decorate the neck below the rim near the shoulder. An opaque green, S-shaped handle with gold leaf decoration was applied to

LATTIMO **GLASS JUG**
Italy, Venice
Late fifteenth to early sixteenth century
Opaque white and green glass; polychrome enamels; blown, applied, enameled, gilded
H: 20.3 cm (8 in.)
Provenance: Baron Adalbert von Lanna, Prague (sold, Lepke, Berlin, 21–28 March 1911, no. 707); Henry Heugel, Paris, France; and the Heugel family, by descent; Heim, Paris, France.
Purchased with funds from the Libbey Endowment, Gift of Edward Drummond Libbey, 1969.287

the neck below the rim and attached to the shoulder with a white glass pad. The handle was added after the body was decorated with polychrome glass enamels. The decoration is an elaborate frieze of mythological creatures cavorting in a seascape that features an undulating grassy shore under a soft blue sky. To the left of the handle, a bearded Triton balances a female nude (a Nereid?) on his tail and a jug on his shoulder, while a satyr holding a burning oil lamp leads the way. The next pair, a Triton wielding a long, conical instrument (a *cornuce*?) and also carrying a Nereid on his tail, follows a maiden (a Siren?) with a billowing scarf astride a pair of hippocamps led by a Triton with a bifurcated tail, wearing a mask(?) with wings. The final creature in this marine procession is a youth with a griffin's body holding a tall, unlit torch(?) or sword in his left hand. The scene is set off by rows of red enameled dots on a gold leaf background above a band scratch-engraved with scale decoration, each loop enhanced with a central red dot. The pattern is repeated near the rim of the jug. A row of alternating red and blue dots enhances

the trail near the shoulder. The neck is decorated with vignettes of confronted mythical animals with pronounced snouts emerging from seashells; they are connected by a black chain around their necks and the pairs are separated by stylized floral pedestals. The foot is embellished with a row of large red and blue enamel drops, highlighted in yellow, and the foot rim is enhanced with gold leaf. There was a pewter lid mounted onto the handle, but it was not original to the object and has since been removed.

The marine theme illustrated on this jug is characteristic of a period that delighted in *all'antica* decoration. A renewed interest in depicting the pagan sea gods of antiquity was echoed in contemporary arts and especially in prints, which may have served as sources for this jug's decoration. Closer in composition than Andrea Mantegna's famed *Battle of the Sea Gods* are engravings by Girolamo Mocetto (1470–1531), entitled *Frieze with Tritons and Nymphs* and *Frieze with Neptune and Tritons*. These scenes may have served, at least in part, as models for the decorator who painted this jug.[33] A bronze frieze with similar subject mat-

ter was designed in 1506 by Alessandro Leopardi for the base of a flagpole in the Piazza San Marco, Venice. It has been described as evoking "... nereids, tritons, and syrens who had seemingly floated out of the pages of Ovid and Virgil, Thetis, Glaucus and Scylla, Peleus and Palemon, Phorkys and his daughter Euriale."[34] In a city that depended on marine travel for commercial and political success, it was highly appropriate that the imagery on this vase included ancient sea gods: they represented water's untamed nature, which could either cause disastrous floods or ensure a safe and speedy journey.

J.A.P.

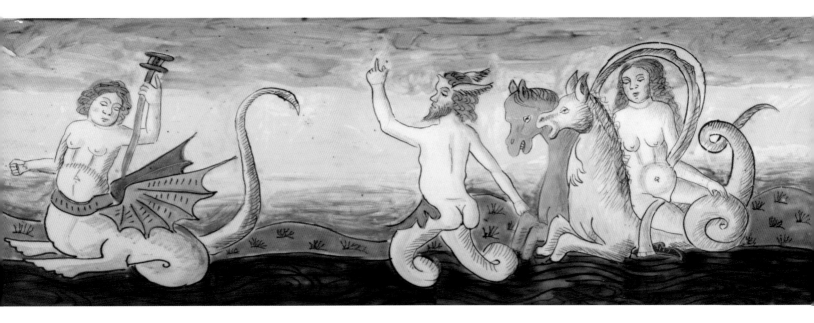

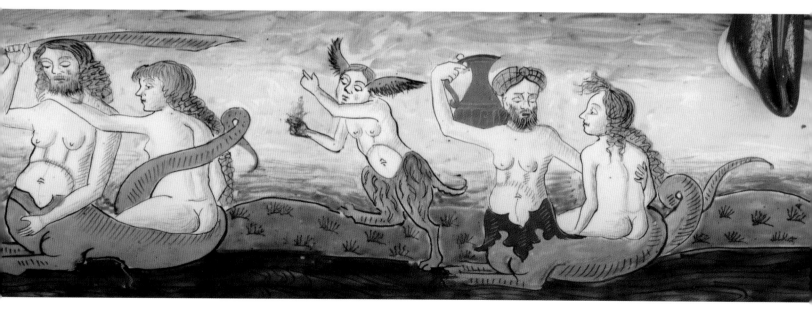

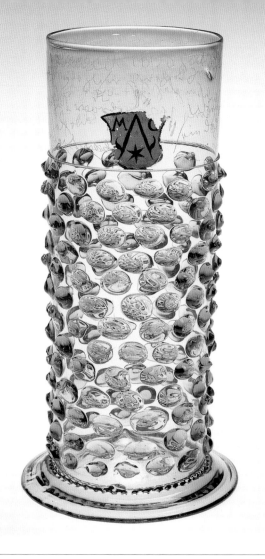

Glassmaking centers in Northern Europe from the late Middle Ages to the Renaissance (around the tenth to the fifteenth centuries) were usually located in heavily forested regions, because glass furnaces at that time were fueled with wood. As a result, the glass made in these shops is often called "forest glass" (German, *Waldglas*). Some of the most important glassmaking centers were located in Lorraine, the Spessart region, and Hessia as well as in Germany, or in the Bohemian Forest. The forests not only supplied fuel for the furnaces but also the raw materials for the production of potash, a key ingredient in the glass batch. The coloring of *Waldglas* — usually pale green, yellow, or brownish in tinge — varied according to the type of plant material burned to produce the potash. Metal oxides present in the sand used for the batch also affected the color of the glass. Whereas much of this glass for daily use was functional and undecorated, some of the more sophisticated table glasses made in the northern forest glasshouses were large and elaborate, with applied blobs, prunts, and trails to make it easier to handle these sizable drinking glasses. The distribution from the often remote glasshouses to the consumer was handled in two ways: by means of itinerant peddlers, who sold their wares at local fairs and during festivals, or by shipments of large quantities of glassware up the Rhine River, from the Spessart and Lorraine regions and then to foreign markets.

This fine pole glass (German, *Stangenglas*) is blown of transparent green glass and has a cylindrical body that is somewhat tapered toward the base and has a high kick (the concave area under a vessel) with a central pontil mark underneath.[35] The vessel wall is decorated with a pattern of thirteen offset rows of oval prunts (German, *Nuppen*) that end far below the rim beneath a thin applied trail of glass. The openwork foot was made by reheating the base and pulling the softened edge with pincers to form a row of peaks. The glassblower then wrapped thin trails around this serrated edge,

which fused to form a slightly domed foot with a lacy-looking inner row of small gaps. Glasses with openwork feet were made primarily in Germany, especially in the Rhineland, in the first half of the sixteenth century.[36]

This glass is inscribed beneath the rim in German, barely legibly, in diamond-point script: "Am 16. Febrer 1620 hatt mir mein Schwager Casper Vögelin [...] diese Beyden Gläser veehrt in [...] etlicher & zur try Freund [...] in diesem Glas ist mir A° 1620 verehrt worden, seien doch solch Anno 1432 diese beiden Gläser gemacht worden." ("On February 16, 1620, my brother-in-law Casper Vögelin made me the gift of these two glasses... by many and true friends... in this glass has been given to me in the year 1620, as these two glasses were made in the year 1432.") The inscription surrounds a small heraldic half-round shield, painted in gold lacquer and outlined in black. The left corner of the shield shows the letter "M" and the right corner a "C," which flank an implement forming an upside-down V-shape, with a black six-pointed star at its base. Still unidentified, the coat-of-arms may be that of a family or a professional fraternity.

The year 1432 as a production date for the glass, as the inscription claims, is impossible. Although the pole glass with prunts first appeared as a type of drinking vessel in Bohemia in the fourteenth century, it became increasingly popular in Western Europe in the fifteenth and sixteenth centuries and only then acquired its straight-sided form. The *predella* of an altarpiece by Martin Schaffner in the cathedral at Ulm, Germany, from 1521 provides an early illustration of such a cylindrical prunted glass.[37] The Toledo Museum's *Stangenglas* is a rather finely worked and rare example that is probably contemporaneous to the painting. Only one other pole glass that is very similar in form, quality of glass, and construction is known today.[38] The inscription on the Toledo example indicates that the glass was accompanied in 1620 by another vessel. Both of these glasses appear to have served as a welcome, or

TALL POLE GLASS (*STANGENGLAS*)
Germany
About 1520–30
Transparent green glass; blown, applied prunts, diamond-point engraved
H: 21.5 cm (9 ¼ in.)
Provenance: Otto Wertheimer, Paris, France.
Purchased with funds from the Libbey Endowment, Gift of Edward Drummond Libbey, 1953.122

friendship, glass and were passed around during communal drinking on celebratory occasions, a practice Casper Vögelin and his brother-in-law seem to have followed. By the seventeenth century, the production and use of *Waldglas* had declined dramatically, but its green tinge remained popular for glasses used to serve Rhine wine (see No. 43).
J.A.P.

French sixteenth-century glassmakers closely followed Venetian models and techniques, but the French tended to make their glasses for the table somewhat larger. This wine glass has a bucket-shaped bowl and a ribbed, mold-blown hollow stem that is tooled into three evenly spaced bulbous knops, with an applied conical foot with a folded foot-rim.[39] The bowl is painted on opposite sides with rather naively executed busts of a bearded soldier facing right wearing a *bourgenet* helmet and a blond girl facing left, her hair swept up in a "classical" coiffure terminating in a ponytail, and wearing a red cloth draped loosely around her shoulders to reveal a very low neckline. The spaces between the figures show two classical panels bearing the French words "DE BON❤" and "LE VOVS DONNE" (meaning "Given to you by a good heart"), surrounded by vertically radiating scrolls. Below the rim is a gilded band flanked by white enamel dots that is inscribed in Latin, DOMINE . LABIA . MEA . APERIES . ET . OS . MEUM . ANNVNCIBIT [sic = ANNUNCIABIT] ("Lord, open thou my lips and my mouth shall announce [Thy praise]"), which is used here in a transferred sense. The enamel is slightly bubbly, indicating that it had been allowed to overheat, and the glass itself shows signs of crizzling.

The vessel belongs to a small group of enameled and gilded glasses blown *à la façon de Venise* in the mid-sixteenth century that are among the oldest known vessels made in France by Italian glassmakers.[40] The provenance of the group is an open question, but enameled glasses may have been made in Saint-Germain-en-Laye, in Poitou, Nevers, or Montpellier. All of these objects are decorated in enamel with religious or secular subjects, and they bear French and / or Latin inscriptions. The clothing worn by the figures on the glasses, much of which was fashionable during the reign of Henry II (r. 1547–1559), is helpful in dating the vessels.[41] The soldier with his Spanish helmet and fashionable beard, facing his idealized lady, underscores the chivalric meaning of the enameled inscription and indicates that the goblet was a gift, possibly for a wedding or a betrothal.

J.A.P.

GOBLET
France
Mid-sixteenth century
Colorless glass with a brownish tinge; blown, mold-blown, tooled, applied, gilded, enameled
H: 17.5 cm (6 ⅞ in.); Diam. (rim): 12.9 cm (5 ¹⁄₁₆ in.)
Provenance: Walker Collection, London; Arthur Churchill Ltd., London, United Kingdom.
Purchased with funds from the Libbey Endowment, Gift of Edward Drummond Libbey, 1948.222

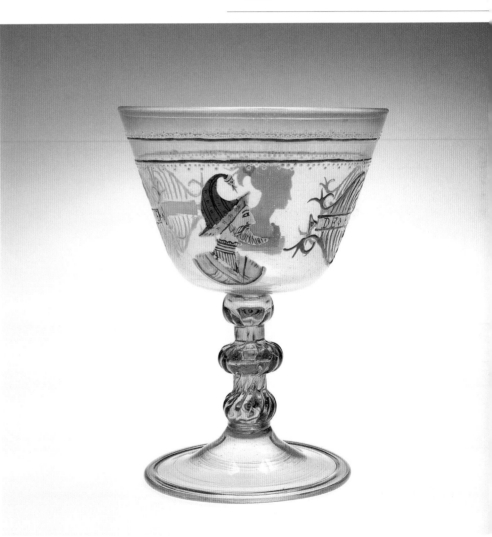

Vetro a filigrana, or filigree glass, has been a staple of the Venetian glassmaking repertory since the second quarter of the sixteenth century and remained fashionable for more than two hundred years. The technique was already known in Rome from the late first century B.C.E., when canes consisting of twisted opaque white threads embedded in colorless glass were used to make cast and slumped mosaic-glass bowls and plates (see No. 6). It is not known whether ancient examples of mosaic glass served as inspiration for Italian Renaissance glassmakers. It has also been tempting to attribute the inspiration for the lace-like appearance of the patterns of filigree to Italian needlework of the sixteenth century. However, in lace-making the word reticella first appeared on the title page of Cesare Vecellio's Corona delle nobili et virtuose donne (1592), where it referred to all patterns worked over a grid or a netlike structure.[52]

According to an inventory of 1527, the Venetian glassmaker Francesco Zeno invented a type of blown glass vessel called vetro a retortoli ("glass with twisted nets").[53] That same year, Filippo and Bernardino Catanei of the Sirena glasshouse requested and were granted by the Venetian government a ten-year license to make filigree glass in a variety of patterns.[54] Their application mentioned one version with vertical threads (vetro a fili), another with twisted nets (vetro a retorti or vetro a retortoli), and the most complex variety, vetro a reticello, which involved a fine network of crisscrossing threads with air traps. Other glassmakers soon excelled at this technique. The most famous maker of reticello in 1545 was Francesco Bartolussi, padrone of the Fornace al Nave, the glasshouse at the Sign of the Ship.

By the late sixteenth century, filigree glass became the most important Venetian luxury glass for export, and the Venetian government is known to have reprimanded a glassmaker who did not comply with its directive to focus his production on filigree.[55] The rising popularity of filigree glass from the 1540s onward is echoed by ceramics during that same period, which developed a lighter, more delicate style on a white ground, as exemplified in fine bianco-sopra-bianco (white-on-white) decoration.[56]

Elegant filigree glassware became a nearly instant success among the European aristocracy. In Ferrara, Duchess Isabella d'Este, an art connoisseur par excellence, ordered drinking glasses with filigree decoration in 1529.[57] The Venetian Senate proudly presented a diplomatic gift in 1708–09 of a large group of filigree tableware, including glass forks and knives, to King Frederick IV of Denmark and Norway (r. 1699–1730). The king was so pleased that he had it put on display in a room specially fitted with elaborate shelves to hold his glass and porcelain collection at Rosenborg Castle in Copenhagen, where it remains on view. This filigree tableware collection represents more than thirty different patterns.

The most complex type of vetro a filigrana, naturally also represented in the royal gift, was network glass (vetro a reticello), in which tiny air bubbles are trapped between a double network of canes. The drinking tazza (35B) is a fine example of this most desirable type of Italian wineglass.[58] It is typical in that the same bubble of vetro a reticello was used to fashion the base, the knop (sandwiched between two mereses of colorless glass), and the bowl, creating a coherent appearance throughout the vessel.

Filigree glass was also mold-blown in a variety of patterns, from rows of bold bosses to figural reliefs that created ever more undulating surfaces in a vibrating network of patterns. The shell-shaped vase all'antico (35A)[59] recalls ancient metal and ceramic vessels with shell forms (see No. 9).

Fadenglas, as filigree glass was called in German, became part of the luxury goods traded widely by wealthy German merchants who had established an important trade center (the Fondaco Tedesco) in Venice. Naturally, this fine glassware could also be found in their own households. The Fugger family of Augsburg, which controlled an expansive empire of European trade and banking, even registered filigree goblets in use at their offices in Breslau (modern Bratislava) in 1546.

The filigree ewer in the Toledo Museum collection (35C)[60] was one of these treasured Venetian imports to Germany. Its history can be verified by the metal mounts, which were made in Nuremberg. The ewer began to take form first as a filigree bubble with a pattern of narrow vertical network stripes, then was expanded and tooled to form an ovoid body with a narrow neck and a flared trefoil rim with a folded edge. The flared foot was applied after the body and spout were formed. Such complex filigree vessels often combine network bodies with colorless mereses (disc-shaped pads connecting body and base) and clear glass handles. On this ewer, the original glass handle was replaced with an elaborate, chased and gilded silver handle in the form of entwined male and female figures. The precious metal handle is attached to the glass by rivets fitted into holes drilled at the rim and the shoulder. The handle is stamped beneath with the mark of Nuremberg[61] and a star, probably the mark of the goldsmith Heinrich Straub, active from 1608 to 1636.[62] Finally, a metal collar decorates the neck and a matching metal rim was fitted around the base to protect the edge of the foot. Both are studded with colored gems. A companion to this ewer, nearly identically mounted, is now in the Los Angeles County Museum of Art.[63] In its original household, this elaborate pair would have graced the serving buffet of an elegant and fashionable, probably Northern European, owner.

J.A.P.

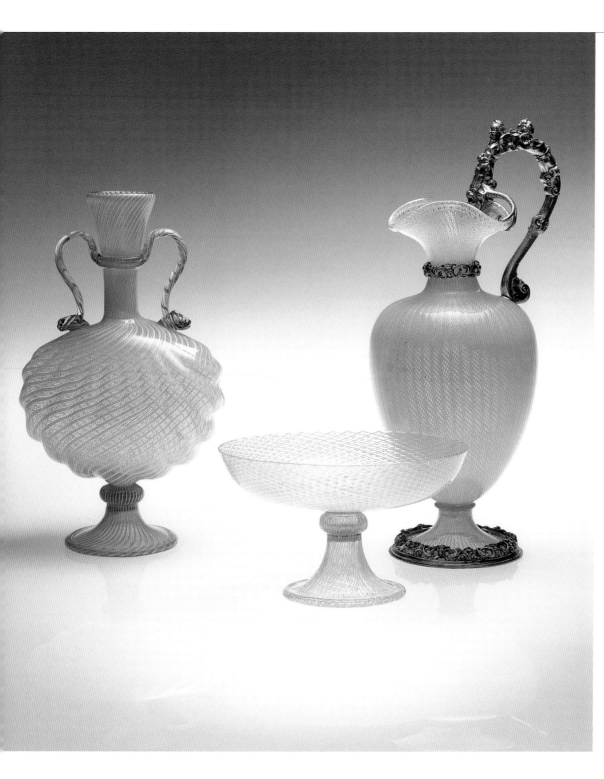

From left to right:

35A. SHELL-SHAPED FLASK
Italy, Venice
Sixteenth century
Colorless and opaque white glass; blown in
a two-part mold, applied, tooled
H: 24.8 cm (9 3/4 in.)
Provenance: Julius H. Campe, Hamburg,
Germany.
Gift of Edward Drummond Libbey, 1913.420

35B. DRINKING TAZZA
Italy, Venice
Late sixteenth century to early seventeenth
century
Colorless and opaque white glass; blown,
applied, tooled
H: 9.6 cm (3 3/4 in); Diam. (rim): 15.6 cm (6
1/4 in.)
Provenance: Julius H. Campe, Hamburg,
Germany.
Gift of Edward Drummond Libbey, 1913.415

35C. EWER
Italy, Venice
Second half of sixteenth century
Colorless and opaque white glass; blown,
tooled; silver-gilt mounts with jewels and
enamel decoration, probably by Heinrich
Straub, Nuremberg (active 1608–1636)
H: 29.5 cm (11 11/16 in.)
Provenance: Collection Baroness Mathilde
de Rothschild, Frankfurt-am-Main, and
Baron Albert von Goldschmidt-Rothschild,
Grüneburg Castle, Frankfurt-am-Main,
Germany.
Purchased with funds from the Libbey
Endowment, Gift of Edward Drummond
Libbey, 1960.36

Scented water, essences, and perfumes had multiple uses during the Tudor and Stuart periods in England (roughly the late 1400s through the early 1700s). At a time when eating utensils were few or non-existent, scented water was customarily used to cleanse diners' hands before, during, and at the end of a meal. Servants poured the liquid from ewers over the hands of their lords or ladies while holding a basin (often matching) beneath. Less commonly, small vase-shaped casting bottles with pierced metal tops were used to sprinkle a more highly scented essence, for which a towel sufficed to catch any spills.[64] Small casting bottles such as this one were more likely intended for the personal toilette of an elegant English lord or lady, such as an example mentioned in the will of Elizabeth, Countess of Devonshire,[65] or another belonging to the lady of the house at Hardwick Hall in 1601 ("a Casting bottle guilt with my Ladies arms").[66] They were considered precious objects, listed among the silver plate of a wealthy household and often featured in inventories and bequests. Along with toothpicks, bodkins, pomanders, and shoehorns in gold or silver, they were often exchanged in the annual ritual of New Year's gift-giving.[67]

Only six surviving examples in silver or silver-gilt are known. The vessel bodies were made from a variety of materials and were fitted into metal mounts, with chains for handling. The most common material in the sixteenth century other than silver was rock crystal: several examples are listed in the inventory of Queen Elizabeth I.[68] A few known examples were made of agate and *lignum vitae*.[69] Casting bottles of glass are also listed in court inventories, and blue glass appears to have been a favored color. The 1542 inventory of King Henry VIII's possessions included "a Coffer of Crymson velvet embrawdered with crimson veluet and garnysshed with stone and / small Perle conteyning... a little Casting bottell of collowred glasse garnysshed with golde," that was recorded amongst the "Jewelles and other Goodes Founde in the Kinges Secrete Juelhous

in Thold Gallory Towards the leades of the Privy Garden at Westminster."[70] Intriguingly, the 1542 inventory of Whitehall Palace lists "Item oone Casting bottell of blewe Glasse,"[71] though in the 1547 inventory, two further casting bottles "of blewe glasse" are mentioned.[72]

The Toledo Museum's casting bottle,[73] recently acquired for the collection, appears to be the only surviving casting bottle with a blown glass body. It consists of an ovoid glass receptacle that is mounted on a spreading silver foot engraved with a band of shaded arabesques within a molded border. Three vertical silver straps with scalloped edges and engraved stylized flowerheads enlace the vessel and are hinged to the metal base. The waisted collar enclosing the neck is engraved with arabesques above a band of stiff foliage, with two applied lugs to attach a chain (now missing). The domed cover is pierced and engraved with a stylized flowerhead. Like much small silverware, casting bottles from this period are by no means always hallmarked, so that attributions have to be based on characteristics of style and technique.[74] The construction of the mounts on this bottle, with scalloped straps formed of sheet metal, as well as the decorative engraving, are akin to other English-made mounted objects. A silver example in the British Museum, dating from about 1550–65, has a pierced, shallow-domed cover identical to that on the Toledo Museum example.[75] According to spectrographic analysis carried out by the London Assay Office in 1987, the silver mount on the British Museum's glass casting bottle appears to be within the parameters of metallic composition found in sixteenth-century silver.

The Toledo Museum's casting bottle is unusual not only because it encloses a glass body but also because it was made from dichroic glass, a type of glass that appears to be two distinctly different colors depending on the type of light under which it is viewed. In this case, the color of the glass changes from nearly opaque light blue in reflected light to translucent yellowish-green in transmitted

Fig. 36.1.

light (Fig. 36.1). Dichroic glass was developed in antiquity in the first and second centuries C.E., when glassmakers added powdered gold and silver to the glass batch. The most famous surviving example is the so-called Lycurgus cage cup in the British Museum, which changes from opaque green in reflected light to translucent red in transmitted light.[76] The technique and formula fell into disuse until revived by Venetian glassmakers in the mid-sixteenth century. A group of five pilgrim flasks, dating to the second half of the sixteenth century, is blown of blue dichroic glass with similar appearance to this casting bottle, but their walls are considerably thicker and those with metal fittings have simpler mounts.[77] Another glass example, in a lead mount, is in the collections of the Musée du Louvre.[78] Yet another, in The J. Paul Getty Museum, features an engraved pewter mount that recalls the work of Isaac Briot.[79] While some of the metal mounts of these flasks appear to have been made in France, the glass was most likely manufactured in Venice, which at that time excelled in the production of glass imitating semiprecious stones. The body of this unusual casting bottle, which mysteriously changes color from blue to yellowish green, was apparently deemed worthy of being fitted into a costly English mount like a semiprecious stone vessel to enhance its status as a rare and admired object.

J.A.P./E.A

CASTING BOTTLE
Probably Italy, Venice (glass); England (mounts)
About 1580
Translucent blue dichroic glass; blown, chased silver mount
H: 12.6 cm (5 in.)
Provenance: Spink & Son Ltd., London; Christie's, New York, 25 October 1988, lot 420; Charles Poor, Washington, D.C. Purchased with funds from the Libbey Endowment, Gift of Edward Drummond Libbey, 2005.286A–B

37–51 EUROPEAN BAROQUE AND ROCOCO

Venetian glass became lighter in weight and less colorful during the sixteenth century. Drinking glasses, to be held in the hand rather than admired on a sideboard, were appreciated for their inherent beauty, the craftsmen's unsurpassed skill, and expressive forms that were not achievable in other materials. It was a privilege of affluent Europeans—including prosperous merchants, innkeepers, and large landowners—to possess the most fashionable and elaborate Venetian products. Murano-made *cristallo* glass vessels, like windowpanes, were an exceptional commodity in the mid-sixteenth century even in the households of artisans living in Venice, who had to make do with vessels of more modest materials such as earthenware and wood.[1] The Venetian industry produced a large range of glassware of varying quality, including utilitarian bottles, storage jars, and ordinary drinking glasses, as well as windowpanes and mirrors, which made up the bulk of Venetian glass exports.[2]

Since the second half of the fifteenth century, it had become customary for Murano glasshouses to attract customers by selling their products on their island. A visit to the workshops became a standard part of the itinerary for official visitors. Once a year, during Pentecost, a fair was held in the Piazza San Marco in Venice, where the glassmakers set up stalls to sell their wares. European nobles, who shared similar tastes and desired these luxury tablewares, eagerly ordered Venetian glass through their respective ambassadors and envoys. Archduke Ferdinand II of Austria, for instance, an avid connoisseur and collector of fine glassware, specified that the forty-four smaller glasses he ordered should be undecorated, perfectly transparent, and only as thick as a knife's edge.[3] Earlier, Duchess Isabella d'Este had complained about the large feet on the glasses sent to her from Venice by her agent in 1496. She also demanded that the gold rim should end exactly at the edge of the bowl.[4] The Venetian glassworkers had set the "gold standard" by which other glassware, as well as their own, was measured.

Often a sample glass, purchased earlier, was sent to Venice as model for an order. Drawings for glass are first mentioned in 1505, when Isabella d'Este commissioned four glass vases from *maestro* Angelino da Murano. In 1512, she followed up with another order for twelve lidded goblets, accompanied by drawings for their design. Venetian glassworkers were admired and recognized for their skill and technological invention, but elite customers considered them lacking in artistic imagination and innovation (*poveri d'invencione*).[5] Designs provided by noted artists became increasingly important to the most demanding clientele during the sixteenth century. Giulio Romano, Giovanni da Udine, Jacopo Ligozzi, and others obligingly provided drawings for new glassware.[6] The designs lent prestige to the objects, which in turn enhanced the *grandezza* of their owners. A number of drawings have also survived that were apparently not renderings of design ideas but instead documented actual glassware. Goblets with extremely delicate coiled threads, as thin as wrought metal wire, represented by this group of three wine glasses in the Toledo Museum,[7] feature in late sixteenth- and early seventeenth-century folios of drawings recording the collection of prince Luigi d'Este,[8] drawings by Giovanni Maggi of the collection assembled by Cardinal del Monte, and among the drawings in the Medici archives.[9] As quintessential Venetian luxury glasses, such delicate vessels could be expected to feature prominently in Italian palatial households and princely collections.

J.A.P.

From left to right:

37A. WINE GLASS
Italy, Venice
About 1650
Colorless glass; blown, mold-blown,
applied, tooled
H: 13.4 cm (5 $\frac{9}{32}$ in.)
Provenance: Julius H. W. Campe, Hamburg,
Germany.
Gift of Edward Drummond Libbey, 1913.425

37B. WINE GLASS
Italy, Venice
About 1650
Colorless glass; blown, mold-blown,
applied, tooled
H: 18.5 cm (7 $\frac{1}{4}$ in.)
Provenance: Julius H. W. Campe, Hamburg,
Germany.
Gift of Edward Drummond Libbey, 1913.427

37C. WINE GLASS
Italy, Venice
About 1650
Colorless glass; blown, mold-blown,
applied, tooled
H: 14.9 cm (5 $\frac{7}{8}$ in.)
Provenance: Julius H. W. Campe, Hamburg,
Germany.
Gift of Edward Drummond Libbey, 1913.428

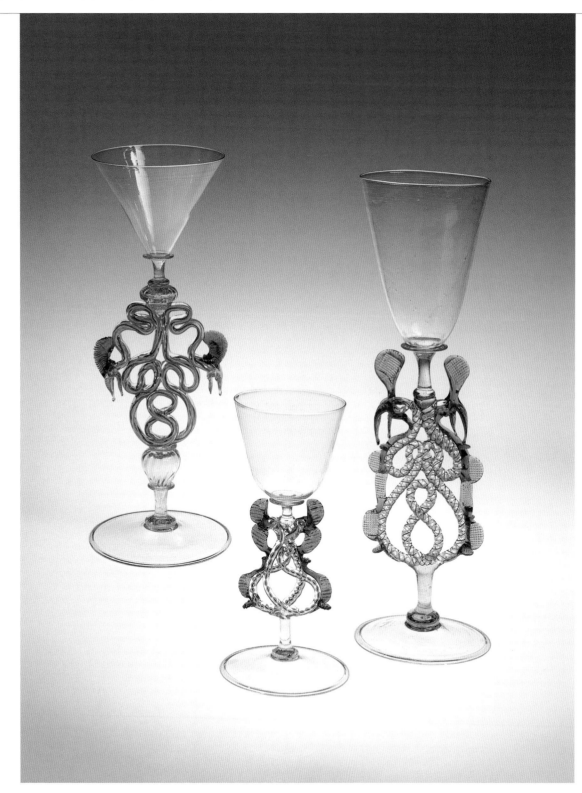

From left to right:

38A. WINE GLASS
Southern Netherlands
About 1625–1650
Colorless, transparent red, yellow, and
opaque white glass; blown, tooled
H: 31 cm (12 3/16 in.)
Provenance: Dragesco-Cramoisan, Paris,
France.
Purchased with funds from the Libbey
Endowment, Gift of Edward Drummond
Libbey, 1994.5

38B. WINE GLASS
Southern Netherlands
About 1650–1700
Colorless and transparent blue glass;
blown, tooled
H: 17.5 cm (6 7/8 in.)
Provenance: Joseph M. Morpurgo,
Amsterdam, The Netherlands.
Purchased with Funds from the Libbey
Endowment, Gift of Edward Drummond
Libbey, 1953.110B

38C. WINE GLASS
Southern Netherlands
About 1650–1700
Colorless, transparent blue and red
glass; blown, tooled
H: 22.2 cm (8 3/4 in.)
Provenance: Julius H. W. Campe,
Hamburg, Germany.
Gift of Edward Drummond Libbey,
1913.434

After the second half of the seventeenth century, Venetian glass experienced a fundamental change. Glassmakers explored the physical capability of the *cristallo* formula to be tooled into complex shapes. The results were composite vessel forms with complicated applied decorations, joining mold-blown knops with undulating and pincered serpent and dragon stems. *Vetri a serpenti* (serpent glasses), like these three examples in the Toledo Museum's collection, became the signature wares of the seventeenth-century glass industry in Venice.[10]

Immigrant glassmakers capable of producing such vessels in the Venetian style were the highest paid and most sought-after employees in all European glasshouses. This was especially true in the Netherlands, where Venetian glass was a highly desired luxury; a Venetian-style glass manufactory was established in Antwerp as early as 1537.[11] At the Rozengracht glasshouse in Amsterdam, an Italian master, Sr. Nicolas Stua, was hired in 1667 to blow *"coppen met serpenten"* (serpent glasses) for a wage of two rijksdaalders per twenty cups with covers, and half that sum for twenty cups without covers, which was the same rate he received for twenty ordinary fine goblets with lids.[12] Netherlandish glass production never exceeded the flow of Venetian imports, however, and the luxury glass that Amsterdam merchants exported to the Far East may well have been a mix of Venetian glasses and *façon de Venise* glasses made in the Netherlands.[13]

Amsterdam glasshouses had taken over almost the entire Mediterranean trade by the early seventeenth century and expanded their horizons much further with the establishment of the Dutch East India Company (Verenigde Oostindische Compagnie [VOC]) and the Dutch West India Company (West-Indische Compagnie [WIC]) in 1602 and 1621, respectively.[14] After the opening of its brand-new Exchange Bank in 1609, Amsterdam was the undisputed center of world trade for almost a century. Asian manufactures were imported into Europe for the first time in the seventeenth and early eighteenth

centuries in quantities and at prices that made them available to a broad but discerning middle class. This high-volume influx of Asian goods eventually transformed the visual culture of Europe. Asian producers had an amazing capacity to satisfy this new market, which was not only growing rapidly but was also demanding diverse styles of vessels. In some cases, the design influence shifted direction, from West to East. It is apparent in the style of handles on the Kangxi vase shown here (Fig. 38.1)[15] that the design was adapted from a luxurious Venetian or *façon de Venise* serpent glass. This is but one example of how deeply iconic Venetian forms permeated other markets and influenced even the look of non-Western, non-glass products.

J.A.P.

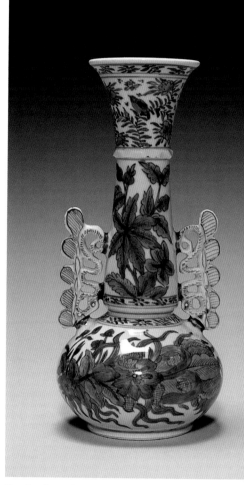

Fig. **38.1.** *Vase*, 1675–1700. Chinese (Kangxi Period, 1662–1722). Porcelain, H: 24.5 cm (9 ½ in.). Purchased with funds from the Libbey Endowment, Gift of Edward Drummond Libbey, 2004.90.

The type of glass known as "ice glass" represents a novel glassmaking technique that may have been inspired by a fascination with ice and the accompanying vogue for serving chilled foods in sixteenth-century Renaissance Italy. Glass vessels with a surface resembling cracked ice appeared in Spanish inventories in the second quarter of the sixteenth century, but it is not known when they were first produced in Venice.[16] By the second half of the century, so-called ice glass was part of the Venetian glassmaking repertory. The fractured appearance of the vessel's surface was achieved by dipping the initial hot glass bubble (parison) into water; the resulting thermal shock caused the surface to form deep stress cracks. When the vessel was further inflated and shaped, the cracks expanded to produce the jagged appearance of cracked ice. A second method, in which the parison was rolled in crushed glass, reheated, and formed, produced a very similar effect. This cylindrical beaker with flaring walls (39A) received its cracked appearance by the water-dipping process.[17] After the vessel was shaped, a thick trail of glass was applied to the edge of the slightly concave base to serve as a foot-ring, then tooled with a rigaree pattern. Finally, three lion-mask prunts, alternating with three small prunts stamped with a raspberry pattern, were applied around the center of the wall. A small pontil mark remains under the base. Like most of the ice-glass vessels surviving today, this beaker has developed several deep cracks along its walls.

It is interesting to note that philosophical discourse and annals of travel in the sixteenth and seventeenth centuries reflect a preoccupation with ice and iced drinks in Italy. The visual similarity between ice and rock crystal led to the concept that ice should be viewed as a preliminary material manifestation of rock crystal. This concept was articulated in Sir Thomas Browne's comment "That Crystall was at first Water, then Ice, and at last by extream [sic] cold hardned [sic] into a stone, was the opinion of the ancient Philosophers…."[18] Like crystal, chilled food and drink were among the luxuries found on the tables of the wealthy. By the last decades of the sixteenth century, refined Italian diners considered ice indispensable (a "fifth element") to the enjoyment of food and especially wine.[19] Northern Protestant and Calvinist moralists, especially in the Netherlands, frowned upon the practice of consuming chilled foods as an unnecessary and wasteful expenditure,[20] while many medical faculties on both sides of the Alps considered it generally unhealthy.[21]

Venetian glassmakers, who had devised a clever method for giving their cristallo the appearance of ice, produced highly desirable vessels for a broad market. This tall, capacious beaker was made to suit the Northern European preference for serving beer or wine in large portions. Another good example of this tradition is a late seventeenth-century German silver beaker made for a fishers' guild, which has a chased pattern resembling condensation drops, attesting to the growing popularity of chilled drinks in Northern Europe (39B).[22] In the Netherlands, glasshouses working in the Venetian style produced similar vessels as part of their standard factory wares. For example, the Amsterdam glasshouse of Jan Hendriksz. Soop, founded in 1601, became a well-known glassmaking establishment and a source of local pride. It was probably his glassworkers who supplied the Dutch East India Company with fifty glass objects, including some made of ice glass, as gifts for the Japanese emperor in 1608.[23]

J.A.P.

From left to right:

39A. BEAKER
Probably Italy, Venice, or Southern Netherlands
About 1550–1600
Colorless glass with grayish tinge; blown, ice-glass technique, applied, stamped
H: 21.3 cm (8 3/8 in.)
Provenance: Julius H. Campe, Hamburg, Germany.
Gift of Edward Drummond Libbey, 1913.423

39B. BEAKER OF THE FISHER GUILD
Regensburg, Germany
1568
Silver; raised, engraved, gilded
H: 12.7 cm (5 in.); Diam. (rim): 9.5 cm (3 3/4 in.)
Provenance: Alfred Pringsheim, Munich, Germany; Rosenberg & Stiebel, New York, N.Y.
Purchased with funds from the Libbey Endowment, Gift of Edward Drummond Libbey, 1955.15

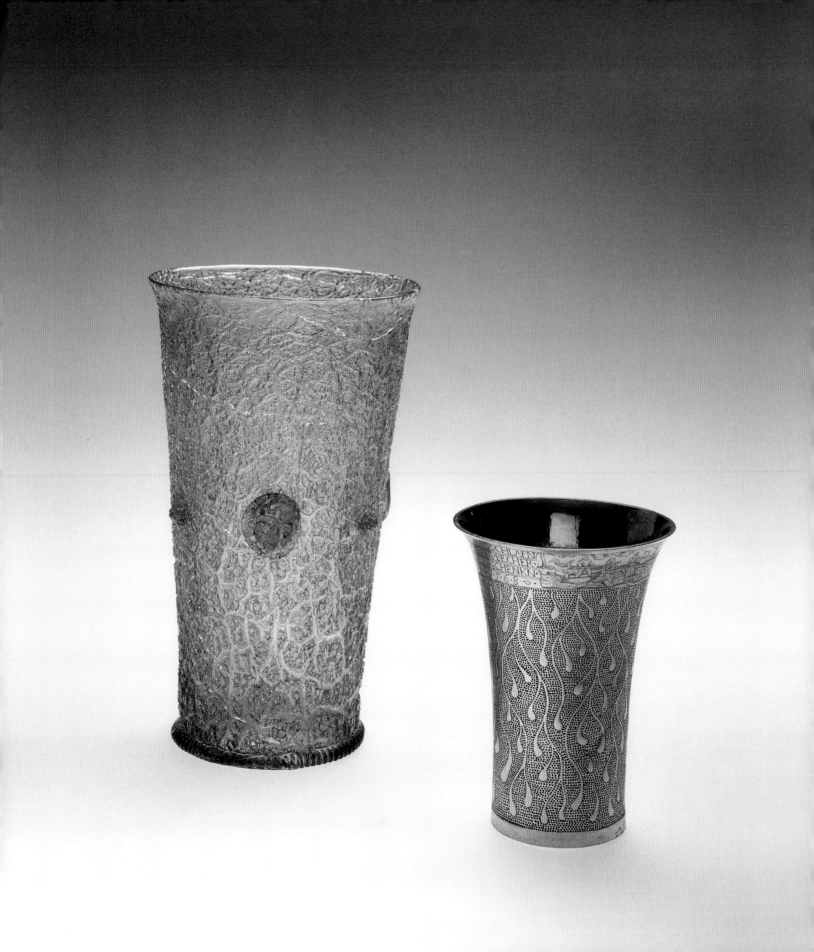

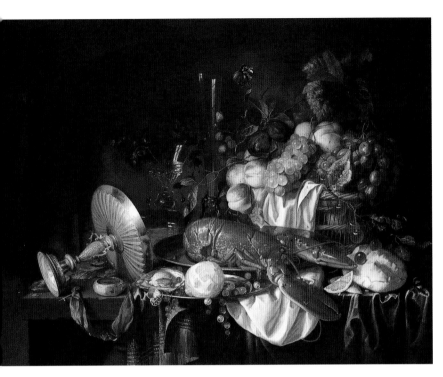

Fig. 40.1. *Still Life with a Lobster*, late 1640s. Jan Davidsz. de Heem (Dutch, 1606–1684). Oil on canvas, 63.5 x 84.5 cm (25 x 33 ¼ in.). Purchased with funds from the Libbey Endowment, Gift of Edward Drummond Libbey, 1966.116.

This elegant flute,[24] a quintessentially Dutch type of drinking vessel made in the Venetian style, reflects a time in Continental and English history when politics and religion were deeply entwined. Engraved with a diamond-tipped stylus on its thin-walled, funnel-shaped bowl is a portrait of the English King Charles II (1630–1685). Encircling the rim above is the slightly misspelled English inscription "God Bless King Charlis [sic] the Second." When Charles returned to London from exile in the Catholic Spanish Netherlands after the collapse of Oliver Cromwell's Protectorate, to claim the British throne on his thirtieth birthday—May 29, 1660—he restored the English monarchy, although the kingdom's executive powers were largely left in the hands of Parliament.

During the following era, known as the Restoration, Charles was tolerant in religious matters, but his attitude was more a result of political wisdom than a sense of fairness or principles. The first decade of his reign was beset by many problems, both nationally and abroad. The Great Plague of 1665 and the Great Fire the following year left much of London in ruins. English political relationships with the Protestant Northern Netherlands remained tumultuous, culminating in two wars fiercely fought over issues of commerce and territorial rights. The capture of New Amsterdam, renamed New York, in 1664 was one of Charles's few gains from the Dutch. In 1677 Charles arranged for his niece, Mary, to marry William of Orange, Stadholder of the Dutch Netherlands, partly to restore the political balance in Europe following his brother James's second marriage to a Catholic, Mary of Modena, and partly to re-establish his own Protestant credentials.[25] This or numerous earlier Dutch–English diplomatic events could have provided the opportunity for the production of a Dutch glass celebrating the English king.

The Dutch had proudly included Venetian-style glass made in local glasshouses among their diplomatic gifts since the early seventeenth century.[26] At Charles's coronation in 1660, the burgomaster of Amsterdam, Johan Huydecoper, represented his city at the festivities in London, and it is possible that he brought with him a supply of glasses, including flutes.[27] The image so carefully engraved on this flute seems to have been derived from a portrait of the younger Charles, possibly one engraved by the Dutch artist Pieter Nason (1612–1690) that was readily available in print.[28] The slightly misspelled inscription may hint at a Continental rather than an English origin. Diamond-point engraving was not limited to professional decorators associated with a glasshouse. On both sides of the Channel, diamond-point engraving was also executed by accomplished amateurs.[29]

It is not likely, however, that such a flute glass blank would have been made in England. Luxury glass production halted in England with the onset of the Civil War (1642–48), and the local glass industries languished for the next twenty years until their near collapse.[30] With the Restoration in 1660, imports of Venetian

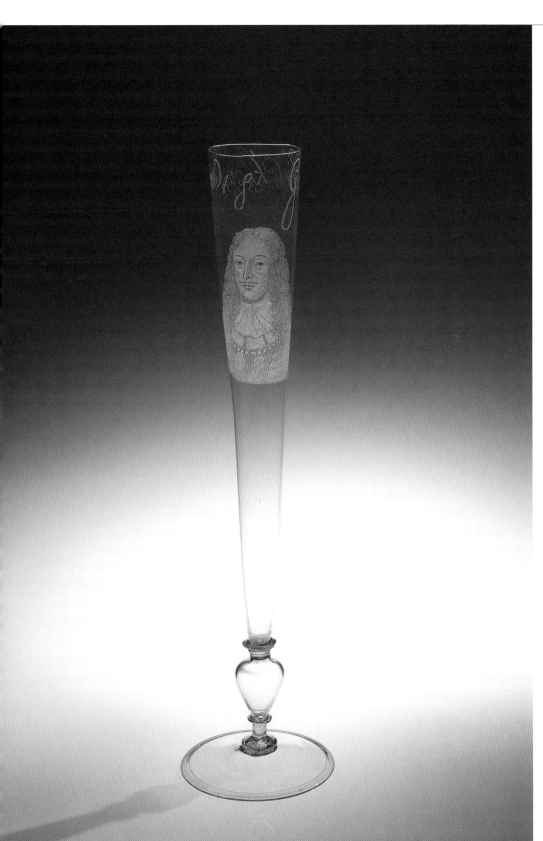

FLUTE WITH A PORTRAIT OF CHARLES II
Probably Northern Netherlands
1660–1685
Colorless glass; blown, diamond-point
engraved
H: 40.3 cm (15 ⅞ in.)
Provenance: Jhr. van der Poll,
Noordwijkerhout, The Netherlands; Nystad
Antiquairs N.V., The Hague, The
Netherlands.
Purchased with funds from the Libbey
Endowment, Gift of Edward Drummond
Libbey, 1966.116

and Venetian-style glass resumed but were soon tightly controlled by the new Worshipful Company of Glass-Sellers, London. This organization was established by royal charter in 1664 in order to preserve high quality standards in domestically produced and imported tableware.[31] Like ice glasses (see No. 39), extremely tall flutes such as this one were not favored types of luxury tableware in England. As the former were considered Italian, the latter were viewed as reflecting Dutch customs. It has been suggested that the wearing of fashionable garments with wide ruffs, which began about 1625, may have made drinking from a tall flute (as well as eating with a fork) sensible.[32] When the British scholar Richard Lassels (1603–1668) visited the Venetian glasshouses on his Grand Tour, he observed: "For the Dutch they have high glasses, called Flutes, a full yard long. . . . For the Italians that love to drink leisurely, they have glasses that are almost as large and flat as silverplates, and almost as uneasy to drink out of."[33] Tall flutes remained popular as luxury drinking glasses for wine in the Netherlands throughout the seventeenth century (see Fig. 40.1).[34] In England, tastes changed rapidly during the prosperous 1660s, and the introduction of the new lead glass, with its unprecedented sparkling brilliance, made locally produced glassware more attractive to British consumers (see No. 48).

J.A.P.

GOBLET WITH THE SACRIFICE OF ISAAC

Although enameling had gone out of fashion in Italy by the 1530s, Venetian glassmakers continued to custom-make objects enameled with family coats-of-arms and other motifs for the Northern European market.[35] An increase in glass exports from Bohemia, especially to Germany, reflects the establishment of numerous new glasshouses on the properties of Bohemian aristocrats throughout the sixteenth century. In the second half of the century, Venetian-style glassmaking technology was introduced into Bohemia through Austria and the Netherlands by way of itinerant Italian glassworkers from Venice and Altare. As a result, Bohemian glassmakers were able to compete successfully with expensive Venetian imports.

In neighboring Saxony, glassmakers had to contend with new local smelting industries for firewood, and escalating prices for this fuel motivated them to seek more advantageous working conditions in Bohemia. Among these Saxon immigrants were the Schürer and Preissler families, who founded glassmaking dynasties that would dominate Bohemian glass production for centuries. They were particularly instrumental in improving the melting processes of potash-glass manufacturing by further purifying the batch and decolorizing it with *Braunstein* (an ore rich in manganese dioxide).[36] The improved potash glass was well suited for Venetian-style techniques such as optic molding, filigree decoration, and diamond-point engraving. The Falkenau (Falknov) glassworks, founded in 1530 by Paul Schürer, became so renowned that in 1561 Archduke Ferdinand of Tyrol purchased a number of elaborately enameled drinking vessels for use at the Hapsburg court in Prague.[37] Several members of the Schürer glassmaking dynasty were awarded hereditary status as Counts of Waldheim by Emperor Rudolf II of Hapsburg in 1592.

This goblet is an example of fine glass tableware made in one of the Bohemian glasshouses working in the Venetian style at the end of the sixteenth century.[38] It was blown of pale greenish glass with filigree deco-

GOBLET
Bohemia
About 1600
Pale greenish glass; enameled, gilded
H: 20 cm (7 ⅞ in.); Diam. (rim):
11.1 cm (4 ⅜ in.)
Provenance: Frederic Neuburg,
Leitmeritz, Bohemia (no. 37); F. von
Parpart (sale, Berlin, 1912, no. 837, pl.
45); Rosenberg & Stiebel, New York, N.Y.
Purchased with funds from the Libbey
Endowment, Gift of Edward Drummond
Libbey, 1950.12

ration (*vetro a retorti*). It has a thistle-shaped bowl, a stem consisting of a hollow, lenticular knop between small *mereses*, and a trumpet-shaped foot with a folded-up edge. The rim is embellished with a wide band of gold leaf and enameled with polychrome dots forming a zig-zag pattern. Painted below this decoration on one side of the goblet is a figural scene depicting the Sacrifice of Isaac from the Old Testament, as told in Genesis 22. Abraham, facing right with his sword raised above his head, prepares to deliver the fatal blow to his son Isaac, who kneels on an altar. Above them, the Angel of the Lord hovers in a cloud, ready to intervene. A goat, destined to serve as the sacrificial substitute, can be seen feeding on a shrub to the right of the altar, while an incense

burner billowing smoke flanks the scene to the left. The animated Old Testament scene probably derives from a contemporary woodcut illustration of the same subject, such as one by Andrea Andreani of 1580.[39] Numerous glass vessels decorated with religious scenes survive, but only a rare few illustrate the theme of the demise (and redemption) of children.[40] One such example is in The J. Paul Getty Museum, a tankard with a frieze depicting the Massacre of the Innocents, dated 1578, probably from Northern Bohemia.[41] The opposite side of the goblet's bowl is enameled with the monogram "HLX" in a blue shield. This vessel, as was often customary at the time, may have been originally fitted with a lid.

J.A.P.

Bohemian glassmakers of Central Europe, building on their reputation for flawless transparent glass, became renowned in the sixteenth century for fine cobalt-blue glass tableware that rivaled the quality of Venetian soda-lime glass production.[42] Made from a potash-lime formula and decolorized with manganese, the blue mineral mixture for coloring this glass was produced from ore containing cobalt, mined in the mineral-rich Erzgebirge, a mountainous region between Bohemia and Saxony. *Zaffero*, or *saffara* as it was known in Venice (not to be confused with the English word "sapphire"), was a highly desirable raw material imported by German merchants based in the Fondaco dei Tedeschi, the German trade center in Venice.[43] A tariff document of 1572 lists glassware from Venice as one of the luxury export articles traded for this mineral, a date that coincides with the greatest production period of Bohemian cobalt-blue glass, between 1570 and 1615.

Transparent cobalt-blue vessels like this enameled jug are evidence of the great range and specialization of Bohemian glasshouses operating in a manufacturing process known as *"procédé de Bohême,"* in which a single glasshouse produced high quality glass gems, mosaic tesserae, mirrors, window glass, and luxury tableware.[44] Christoph Schürer is documented as having produced glass vessels from a batch entirely colored blue in 1540 at his glasshouse at the sign of the owl (*Eulenhütte*) near Neudek (Nejdek) in the Erzgebirge, then part of Saxony. The production of blue glass spread from there to other Bohemian glasshouses owned by members of the Schürer family.

The petite blue jug featured here was created during this prime period of Bohemian cobalt-blue glass production.[45] Enameling, which had gone out of fashion in Italy by the 1530s, continued to be popular north of the Alps for another century. Cobalt-blue glass jugs, tankards, bottles, wine glasses, drinking horns, and vases were often enameled. Brightly colored decorations of animals, inscriptions, and geometric and floral motifs in red, white,

green, and yellow contrast well with the dark blue background. Dated vessels of similar shape and color range from 1586 to 1608.[46]

This jug has a typical spherical body and cylindrical neck. It was decorated with a thin applied trail around the shoulder and a second one below the rim. A wide, domed foot-ring serves as base, and an S-shaped handle, attached below the rim and applied onto the shoulder, allows for a firm grip. The chased and gilded silver cover with thumb-rest protects the

contents. The scale pattern on the neck and body recalls gilded and enameled decorations common in Venetian glass during the early sixteenth century. Here, the pattern is outlined in white enamel, embellished with colorful central dots, and framed by thin horizontal lines painted in white, followed below by bands of colored circles or minute dots. Although the bellied tankard is a German type of drinking vessel, the enameled patterns remain Venetian in origin.
J.A.P.

JUG
Probably Bohemia
About 1595–1600
Transparent blue glass; blown,
applied, gilded, enameled; unmarked
gilded silver cover
H. (overall): 18.7 cm (7 ⅜ in.); Diam.
(base): 8.3 cm (3 ¼ in.)
Provenance: A. Vecht, Amsterdam,
The Netherlands.
Purchased with funds from the Libbey
Endowment, Gift of Edward Drummond
Libbey, 1953.119

The Dutch *roemer* (German *Römer*) is a type of wine glass that evolved in Germany (especially in the Rhineland) and the Netherlands over several centuries, reaching perfection in the seventeenth century. The shape of the *roemer* is a hemispherical bowl and a cylindrical trunk tooled from the same parison, with an applied hollow foot built up by coiling threads of molten glass around a conical core. Applied to the characteristically cylindrical trunk (too thick to be called a stem) are pads of glass stamped while still hot with a raspberry-like pattern, to provide the user with a firm grip. *Roemer*s are usually colored in tones of green and were popular in the Netherlands for drinking white wine (Fig. 43.1).[47] Such vessels were made in the Netherlands and also imported on a large scale from Germany. In 1667, glassblowers at the Rozengracht glasshouse in Amsterdam worked twelve hours a day producing wine *roemer*s but only three hours a day making beer glasses.[48] In 1685, the Laubacher Hütte in Germany received an order from Amsterdam for 20,000 "*Heilbronner Römer*" and 10,000 "*Schenkrömer*," two *roemer* types that are today no longer identifiable.

Many *roemer*s, including the example in the Toledo Museum,[49] are engraved with inscriptions reflecting Protestant and Humanist attitudes. The northern provinces of the Netherlands embraced Protestantism after declaring independence in 1581, while the southern provinces remained under Spanish Catholic rule. The calligraphic, diamond-point engraved inscription around the bowl bears the motto in Latin, *Semper Idem* ("Always the same"). According to the signature under the base—*W. van Heemskerk, Æ⁵ 63, A°. 1676*—the Toledo Museum's *roemer* was decorated by Willem van Heemskerk at the age of sixty-three, in the year 1676. Willem Jacobsz. van Heemskerk (1613–1693) was a cloth merchant in Leiden, a respected syndic of the Drapers' Guild, an amateur poet, a dramatist, and an accomplished calligraphic engraver. Heemskerk inscribed a variety of glasses with mottos, admonishments of moderation, and moralistic messages, including the apt inscription in Dutch "Everything, including crystal, has the value it merits."[50] Most of the ninety-six glasses by Heemskerk known today are stemmed drinking glasses, flasks, and plates. *Roemer*s engraved by him are relatively rare, and the earliest is dated 1648. From 1674 on, Heemskerk added his age to the signature.[51]

For centuries, the art of calligraphy was an important aspect of education of both men and women and was especially perpetuated by French schoolteachers in exile from the Southern Netherlands. Perfection was awarded with prizes: In 1684, the Latin School in Amsterdam awarded its annual gold quill award to the pupil with the best handwriting, and the best teacher could win the coveted "*Prix de la Plume Couronnée*."[52] Calligraphy was executed with a natural quill or a steel nib on paper; on a copper plate with a hard metal scribe, from which it could be easily printed; and with a diamond-tipped scribe on glass. Calligraphy features prominently on some contemporary Dutch prints (Fig. 43.2).[53] Engraving inscriptions on tableware were often intended as gifts to friends and family. In 1685, Heemskerk engraved a plate on the occasion of the marriage of his son Joost to Anna Coninck with the inscription, "Steadfast faithfulness that does not waver, is a soul and body saver."[54] He also inscribed a flask for his son Willem, in whose house the elder Heemskerk lived until his death in 1692, "Suffer and abstain. Zeal is rewarding."[55] The use of such texts on glasses seems to have simultaneously reminded drinkers of their desire for luxury and warned them of the dangers of decadence or overindulgence.

J.A.P.

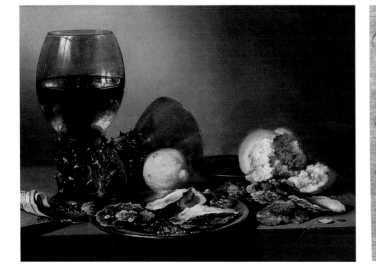

Fig. 43.1. *Still Life with Oysters*, dated 1642. Pieter Claesz. (Dutch, born Westphalia, 1596/97–1660). Oil on wood panel, 35.6 x 51.1 cm (14 x 20 ⅛ in.). Purchased with funds from the Libbey Endowment, Gift of Edward Drummond Libbey, 1950.233.

Fig. 43.2. *Vanitas Vanitatum et Omnia Vanitas*, watermarked 1591–93. Jan Saenredam, after Abraham Bloemaert (Dutch, 1564–1651). Engraving, 37.3 x 32.4 cm (14 ¹¹/₁₆ x 12 ¾ in.). Gift of William J. Hitchcock in Memory of Grace J. Hitchcock, 1987.206.

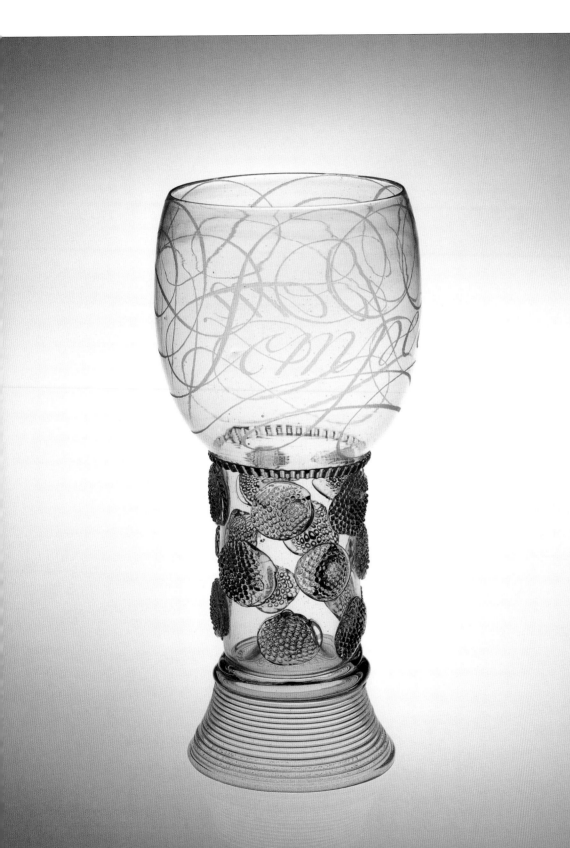

ROEMER
Probably Germany
Willem Jacobsz. van Heemskerk
(1613–1693), engraver
Mid-seventeenth century
Transparent green glass; blown, applied,
diamond-point engraved
H: 19.6 cm (7 ¾ in.)
Provenance: A. Nijstad, Hzn., The Hague,
The Netherlands.
Purchased with funds from the Libbey
Endowment, Gift of Edward Drummond
Libbey, 1953.89

Glass drinking vessels painted like stained-glass windows probably came about as an artist's creative solution to increase sales and escape financial distress. The artist who first painted the scenes on drinking glasses was probably Johannes Schaper (1635–1670), one of the most innovative and accomplished decorators of stained-glass panels and faience earthenware vessels in seventeenth-century Germany.[56] He moved about 1655 from his native Harburg (near Hamburg) to Nuremberg, a city that had been largely spared during the devastating Thirty Years War (1618–48) and had maintained its position as a major German trade center with international connections.

Schaper began to decorate glass vessels with transparent glass enamels about 1660. Pressed to cope with mounting bills for his growing family, he sought to broaden his customer base and began to decorate small vessels with *Schwarzlot,* the transparent black lead enamel used since the Middle Ages to paint outlines and shadows (often enhanced

Fig. 44.1. *Beaker with Portrait of Robert de Gravels*, about 1663–64. Germany, Nuremberg, probably Johann Schaper, enameler. Colorless glass, enameled; H. 8.3 cm (3 ¼ in.). Purchased with funds from the Libbey Endowment, Gift of Edward Drummond Libbey, 1913.455.

with scratch-engraved details) on stained-glass panels. This transfer of technology from flat to curved glass surfaces was a logical but not necessarily obvious step. Stained and painted glass panels or windows were boldly colored, occupied large surfaces, and were traditionally viewed from a distance, whereas the more detailed and often continuous scenes on drinking glasses were frequently diminutive and invited close examination.

Schaper's small, often covered, beakers represent a highly individualized, made-to-order production that was mostly used for drinking wine. The glasses consistently reveal Schaper's high level of artistic skill. The undecorated drinking glasses were purchased from a variety of outside sources. They were typically decorated with scenes after contemporary prints, which reflect the taste of the individual patron and sometimes allow insights into a given beaker's origins and use. An early *Schwarzlot-*painted beaker from about 1663 to 1664 in the Toledo Museum's collection (Fig. 44.1),[57] for example, depicts one of Schaper's patrons, the French envoy to the Bavarian Court in Regensburg, Robert de Gravels, whom the artist met during a long sojourn in that city.

A relatively small number of Schaper's vessels survive that were also decorated in transparent, brightly colored enamels. To allow for a great range of coloring, these would have been fired at low temperatures in small muffle kilns. Three of these survivors are now in the Toledo Museum's collection. Typical subjects for Schaper's enamel decoration are romantic Italianate landscapes with ruins, so-called *paysages d'invention* ("invented landscapes") that were mostly derived from contemporary print sources and provided the backdrop for scenes reflecting the patron's preferences. A small cylindrical beaker on ball feet signed "Joh. Schaper" from about 1665 (44A) is painted with figures in an Italianate river landscape after an engraving from 1649 by Stefano della Bella (1610–1664).[58] The figural scene centers on a young woman kneeling before a child,

dressed in theatrical costume with a large plumed hat; she seems to be encouraging it to listen or dance to music being played by a violinist standing nearby. On the vessel's reverse, the continuous landscape features an imaginary view of the Basilica of Sts. John and Paul, Rome. The joyful scene with the healthy child reflects the period's deep concern for the well-being and survival of children, at a time when there was high infant mortality. The glass may have served as a gift to a new mother or to toast the birth of a child.

On another beaker of similar form (44B), a romantic landscape is combined with a scene loosely derived from an illustration to Ovid's *Metamorphoses*, engraved after a design by Hendrik Goltzius (1558–1616).[59] The print depicts the god Mercury, disguised as a shepherd playing the flute, using his music to lull to sleep the hundred-eyed Argus, who lies under a tree.[60] In his version of the scene, Schaper isolated the reclining figure of Argus and omitted the many eyes of the mythical, ever-watchful giant. In doing so, he effectively obliterated the meaning of the source and reduced its central figure to a generic shepherd or traveler, who becomes a human focal point in an idealized landscape. Travel and trade were at the center of Nuremberg's wealth, and many of Schaper's clients would have had occasion to wish for the successful completion of journeys while drinking from a travel-themed beaker.

The production of these delicate drinking vessels, which was eventually adopted by numerous other German decorators, continued throughout the seventeenth century. The third beaker of the group, a late seventeenth-century vessel by an unknown painter (44C), is embellished with less artistic skill than Schaper's works, but its imagery carries a more pointed meaning. This beaker is decorated with two scenes depicting *The Revenge of the Hares*, probably inspired by popular prints after designs by the German artist Georg Pencz (about 1500–1550).[61] On one side, set against a hilly landscape with a castle in the background,

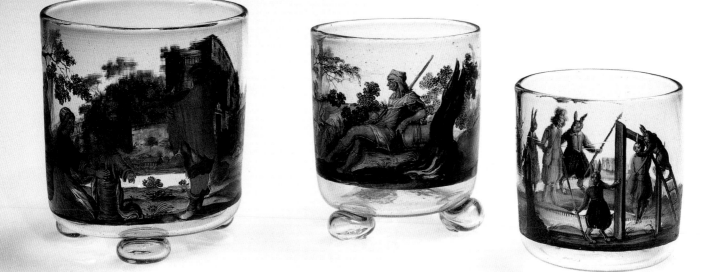

two hares armed with lances lead a captive hunter, his hands tied behind his back. The opposite side shows the hares as executioners, one pointing at the hunter hanging from a gallows, while the other hare reaches for him from a ladder, possibly to cut the victim down. Images of the "world turned upside down" were popular throughout the Baroque period, often serving to clothe a critical commentary on social or political conditions in the mantle of caricature. The beaker with *The Revenge of the Hares* allowed its owner to drink a toast to successful retribution of the perpetually oppressed in general, while potentially having a very specific cause in mind.

J.A.P.

From left to right:

44A. BEAKER WITH AN ITINERANT VIOLINIST

Germany, Nuremberg
Probably Johann Schaper (1635–1670), enameler
About 1665
Colorless glass with brownish tinge; blown, enameled
H: 8.5 cm (3 5/8 in.); Diam. (rim): 8 cm (3 1/4 in.)
Provenance: Baron von Forstner, Halle; Consul Rosenberg (sale, Lepke, Berlin, 1919, no. 675); Frederic Neuberg, Leitmeritz, Bohemia (no. 98); Rosenberg & Stiebel, New York, N.Y.
Purchased with funds from the Libbey Endowment, Gift of Edward Drummond Libbey, 1950.35

44B. BEAKER WITH A RESTING SHEPHERD

Germany, Nuremberg
Probably Johann Schaper (1635–1670), enameler
About 1667–1670
Colorless glass with brownish tinge; blown, enameled
H: 7.9 cm (3 1/8 in.); Diam. (rim): 7 cm (2 3/4 in.)
Provenance: Baron von Forstner, Halle; Consul Rosenberg (sale, Lepke, Berlin, 1919, no. 670); Frederic Neuberg, Leitmeritz, Bohemia (no. 99); Rosenberg & Stiebel, New York, N.Y.
Purchased with funds from the Libbey Endowment, Gift of Edward Drummond Libbey, 1950.38

44C. BEAKER WITH HARES EXECUTING HUNTERS

Germany, probably Nuremberg
Last quarter of the seventeenth century
Colorless glass with brownish tinge; blown, enameled
H: 6.5 cm (2 9/16 in.); Diam. (rim.): 6.5 cm (2 9/16 in.)
Provenance: Baron von Forstner, Halle; Frederic Neuburg, Leitmeritz, Bohemia (no. 100); H. Rose, Wiesbaden; Consul Rosenberg, Berlin (sale, Lepke, Berlin, 1919, no. 670); Rosenberg & Stiebel, New York, N.Y.
Purchased with funds from the Libbey Endowment, Gift of Edward Drummond Libbey, 1950.37

Gold-ruby glass was held in high esteem in the seventeenth and eighteenth centuries and was considered a special material, distinct from any other type of glass. It was exceedingly difficult to manufacture and was limited to a small luxury-goods market. During the Baroque period the rich, deep red color that most closely resembled the fire of rubies was achieved by adding gold to colorless molten glass. Gold—in the form of fine dust—and tin were separately dissolved in *aqua regia* ("royal water," a mixture of hydrochloric and nitric acids) and the two solutions were then combined in water. The resulting purple precipitate (small solid particles containing gold) was strained from the water and added to the glass melt, which was then allowed to cool to a certain point. The glass was carefully reheated until the rich, translucent ruby-red hue emerged, a phenomenon known to glassmakers as "striking." This process required careful calibration: if heated too little, the color would be uneven and marked by striations; if overheated, the glass would turn an unappealing liver color.

The technically delicate manufacture of gold-ruby glass reflected well on the capability of a glasshouse, but was generally not a lucrative undertaking. It was at the Prussian court of the Frederick William, Elector of Brandenburg (r. 1640–1688) that the most significant advancements in the development of gold-ruby glass were achieved. Under his patronage, between 1678 and 1683 the Hessian chemist and glassmaker Johann Kunckel (born between 1632 and 1637, died 1703) was able to investigate and improve earlier European recipes for gold-ruby glass at a glassworks for high-quality potash-lime glass in Potsdam, near Berlin. Potsdam, and later the town of Zechlin, Prussia, became the primary centers of gold-ruby glass production, although to Kunckel's dismay, glassworks in Southern Germany and Bohemia soon also began to make gold-ruby glass using the same technique. The exact location of the Southern German glassworks is not known; its products

are often marked by striations, indicating a tendency to use the batch before it was properly heated and blended. In Nuremberg, the accomplished glass decorator (German, *Hausmaler*) Abraham Helmhack (1654–1724) is recorded to have decorated ruby glass tableware in 1717.[62] Many vessels attributed to this region are fitted with mounts made by Augsburg and Nuremberg silversmiths. The Toledo jug is a typical example of Southern German production.[63] The chased and gilded silver cover bears the mark of the Augsburg silversmith Tobias Baur (about 1660–1735), who was known for exquisitely fitted tableware intended more for display than for everyday use.

This gold-ruby jug has slight dark red striations and was blown to form a spherical body and a conical neck, with an applied base-ring.[64] The C-shaped handle was attached to the neck just below the rim and then applied to the shoulder, its trail folded up. The silver cover was mounted to the jug with a hinged strap construction. The top of the handle was decorated with beaded wire and pierced fleur-de-lis, and its openwork thumb-rest was shaped to resemble a siren or mermaid. The domed cover was deeply chased with gadrooned and beaded decoration and topped by a small, tiered finial. The silversmith also provided a mount to encase the rim of the jug's glass base ring: it is a stepped silver band with serrated edges. The jug's body is decorated with both matte and polished copper-wheel engraving.

On one side of the body, two men in Northern Renaissance costume carry a large bunch of grapes that hangs from a pole between them. The opposite side is engraved with a rudimentary landscape flanked by tall, tiered trees, and the neck bears a floral frieze of scrolled tendrils and large blossoms. The scene depicts Joshua and Caleb, two of Moses' spies sent from Kadesh in southern Palestine to explore the land of Canaan (Numbers 13). They return with news of Canaan's abundance, demonstrated by the large size of the grape cluster they bear. Only Caleb and Joshua

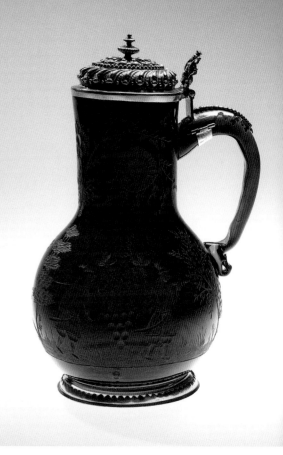

JUG
South Germany
About 1700
H. (with cover): 22.4 cm (9 in.)
Transparent gold-ruby glass; blown, applied, copper-wheel engraved; cover and foot gilded and chased silver
Provenance: Julius H. W. Campe, Hamburg, Germany.
Gift of Edward Drummond Libbey, 1913.444

advised the Hebrews to proceed immediately to take the land, and for their faith, they were rewarded with the promise that they and their descendants should possess the land. The image, which appears frequently on sixteenth-century tableware, was probably inspired by contemporary Bible illustrations. Such motifs of religious derivation were easily assimilated into popular table culture of the period, in this case identifying the vessel as a wine jug.
J.A.P.

This goblet belongs to a small group of six sur-
viving glasses from the early eighteenth century
with inlaid glass medallions decorated in the
Zwischengold ("gold between glass") technique.
A sheet of gold foil was applied to the reverse of
the glass surface, scratch-engraved and decorat-
ed with polychrome transparent paint, then set
with a cement-like adhesive into depressions cut
into the goblet's wall, and the join covered with
a painted band of gold.[65] Such elaborately embel-
lished glasses were luxury commodities and
could only be afforded by an exclusive clientele.
Their fragile and delicate decoration was prone
to deterioration through exposure to moisture,
which hardly made them suitable for regular use
at table and accounts for their rarity today.

Not surprisingly, at least four of the surviv-
ing glasses with *Zwischengold* medallions origi-
nate from castles owned by noble Saxon fami-
lies.[66] The Toledo Museum's Four Continents
goblet[67] was formerly in the collection of the
Dukes of Anhalt-Dessau in Saxony. Two beakers
and a wine glass remain in Castle Favorite,
near Rastatt, Germany, an architectural gem
built by the Margravine Franziska Sibylla
Augusta of Baden-Baden and completed by
1720.[68] The majority of the glasses purchased
for her new summer residence came from
Northern Bohemia, where she was raised, and
were ordered in sets of six or twelve.

The imagery on the surviving vessels with
Zwischengold medallions largely derives from
classical subjects. The glasses in Castle Favorite
and at Corning show putti in various bacchic
pursuits, possibly relating to the Four Seasons.
A larger wine glass with three medallions in
Stuttgart depicts putti representing the trials
of love, derived from a popular emblem book.[69]
The Toledo Museum's goblet with medallions
representing the Four Continents is the most
elaborate of the group and was probably
inspired by contemporary prints.

This wine glass has a wide, funnel-shaped
bowl, which was applied to a faceted, double-
baluster stem enclosing gold and red spiral
threads. The stem rests on a slightly domed foot

Fig. **46.1.**Europe.

Fig. **46.2.** Asia.

Fig. **46.3.** Africa.

Fig. **46.4.** America.

This tall representational drinking cup is a stellar example of German Baroque glass-cutting, especially that of relief (German, *Hochschnitt*) and intaglio (German, *Tiefschnitt*).[72] The brilliant, colorless glass blank was probably supplied by the court glasshouse in Potsdam (capital of the state of Brandenburg, near Berlin), which was renowned for its high-quality output from 1674 to 1734. Brandenburg had an abundance of sand and firewood, key ingredients for glassmaking, and imported its technology from neighboring Bohemia and Silesia (see No. 45). This vessel was most likely engraved in the Berlin workshop of Gottfried Spiller (1663–1728), who trained as a gem-cutter with his famous uncles, Martin and Friedrich Winter, in Rabisau, Silesia. In 1680, Frederick William, Elector of Brandenburg (r. 1640–1688), appointed Martin Winter to be an official engraver at the court in Berlin. His twenty-year-old nephew, Gottfried Spiller, came to Berlin to work with him a few years later.[73] In 1687, Winter initiated construction of a mechanized cutting workshop in Potsdam that was driven by water power, a new technology that dramatically improved the ability of the cutting-wheels to accommodate the decoration of thick-walled goblets with complex, knopped stems. Spiller succeeded his uncle as head of the Potsdam workshop in 1702.

The jewel-like treatment of the engraved bands on the Toledo Museum's pokal attests to the fact that Gottfried Spiller was an expert engraver who was skilled at working on both hard stones and glass. Only two vessels signed by Spiller are presently known: one is a mounted rock-crystal pitcher from about 1715, the other is a glass beaker.[74] His uncle Martin Winter had a fondness for engraving animated putti in deep intaglio after contemporary sources. Such images may have been among the models supplied by a famous iron engraver and die-cutter working at the court, Gottfried Leygebe (1630–1683).[75] Dancing putti or amoretti have been associated with imagery relating to weddings and childbirth since the Renaissance, and print sources with this subject were widely available to Winter and Spiller as inspiration. Spiller excelled at large-scale figural friezes, often depicting children in Bacchanalian processions, executed in carefully modeled detail.[76]

In the 1670s, Bohemian glassmakers developed a potash-lime formula that included a considerable quantity of chalk (carbonate of lime) to provide stability. The new glass was clearer and more brilliant than Venetian *cristallo* and, because it was also harder than English lead glass, it was eminently suited for gem-cutters to engrave decorations in deeply modeled relief. On the other hand, the Baroque glassmakers' obsession with purity of ingredients also resulted often in a chemical imbalance of the glass batch, causing the glass to "crizzle," an overall crackling of the surface that can be observed in this vessel.[77]

This massive, thick-walled pokal was blown of colorless potash-lime glass (*Kreideglas*) and consists of a large conical bowl on a stem with a solid double knop and a flared foot. The matching, slightly domed lid is topped by a heavy finial of similar construction to the stem, but with the addition of a third, smaller knop. The pokal is decorated overall in both high relief (*Hochschnitt*) and low intaglio (*Tiefschnitt*) cutting. Acanthus friezes, cut in high relief and left matte against a polished ground, embellish the lid, the base of the bowl, the knops of the stem, and the top of the foot. Below the rim of the bowl and above the lip of the lid are bands of alternating square and octagonal emerald-cut "jewels" on a matte ground, followed by a row of polished *printies* (small polished concave dots).

The figural relief on the bowl of this pokal depicts six putti arranged in pairs in a stylized meadow. One of these, standing frontally and wearing a loose sash, holds a quill and a scroll with musical notes, representing a composer. Continuing clockwise around the bowl, another putto looks at him from the left, holding a trumpet and a mask in his right hand. Next is a dancer with castanets or cymbals tied to his fingers, who turns his attention to a cello play-

POKAL
Germany, Potsdam-Berlin
Workshop of Gottfried Spiller
(1663–1728), engraver
About 1715–25
Colorless potash-lime glass; blown, applied, cut, engraved
H: 42.8 cm (17 1/8 in.); Diam. (rim): 12.5 cm (4 15/16 in.)
Provenance: Dukes of Anhalt-Dessau, Dessau Castle and the Gotisches Haus at Wörlitz, Germany; Frederic Neuburg, Leitmeritz, Bohemia (no. 194); Rosenberg & Stiebel, New York, N.Y. Purchased with funds from the Libbey Endowment, Gift of Edward Drummond Libbey, 1950.43

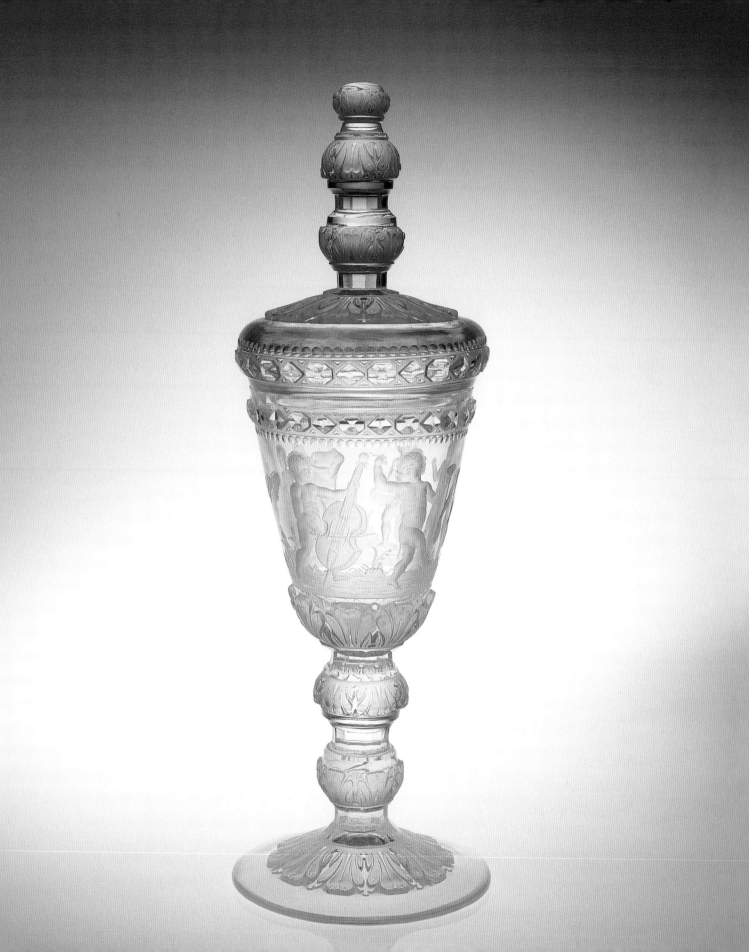

er. A lute player seated on a rock close to him turns toward a sixth putto, who stands while playing a lyre.

At the time this pokal was made, Spiller was operating his own independent glass- and gem-cutting workshop in Potsdam. By then, the cultural climate at the Berlin court had become more austere under the "Soldier King," Frederick William I of Prussia (r. 1713–1740), who eliminated many of the court's artistic endeavors as frivolous expenditures. The Brandenburg glass workshops, as a lucrative Prussian luxury industry, were not affected by these austere measures—in fact, the King protected them by severely regulating glass imports. He eliminated the court orchestra, however, because he viewed his military band as sufficient for courtly affairs. In contrast, his wife, Sophia Dorothea of Hanover (1687–1757), who loved music and was a patron of the arts and philosophy, established one of the most important porcelain and glass collections in Europe at her summer residence, Monbijou Palace, in the center of Berlin. The more light-hearted milieu of the Queen's court is reflected in this quintessential Baroque pokal with its joyous musical frieze, proving that the Potsdam glasshouse—and Spiller's cutting shop in particular—still carried on the tradition for large and elaborately engraved glasses with charming motifs.

This pokal was most likely a princely gift. The famous royal Saxon collections at Dessau Castle, from where it originated, also included other works by Spiller depicting dancing putti. One of these was a covered beaker from about 1690 with the monogram of Philip William, Margrave of Brandenburg-Schwedt (1669–1711), who married Joanna Charlotte of Anhalt-Dessau (1682–1750), a Saxon princess, in 1699.[78] A goblet with a baluster stem and a frieze of musical putti, most likely carved by Spiller, is still in the duchy's collections in Weimar.[79]

J.A.P.

Fig. **47.1**. Drawing: Lorene
Sterner, Ann Arbor, Mich., 2005.

This rare group of early English tableware represents a period in glassmaking history that has been termed the "lead glass revolution."[80] The vessels show a remarkable blend of glass-working techniques with Venetian Renaissance tradition and English technological innovation. With the Restoration of Charles II as king in 1660, England entered a period of economic prosperity, scientific exploration, and rapidly expanding trade with the colonies in North America and with the Far East. British inventors focused on ways to replace imports with their own products, as well as to create distinctive luxury commodities that would appeal to broad markets. Invention as imitation was the guiding principle underlying these investigations.[81] British glassmakers set out to create a formula for "chrystalline glass resembling rock crystal."[82] The goal was to create a type of glass that could better withstand extended sea travel than soda-based glass, that was cheaper and more readily available than the Venetian imports and, above all, that had improved visual properties.

The new lead glass that emerged from this quest was founded on technological changes in England dating back to the previous century. In 1610, English glassmakers were required by decree of King James I (r. 1603–1625) to shift from using wood as the primary fuel source to coal. This shift forced a change in furnace design that protected the molten glass in a covered crucible from the contaminating fumes of the coal fire, while exploiting the new furnace's potential for higher melting temperatures. During the early Restoration, the Royal Society encouraged British glassmakers to study several groundbreaking publications that described new technological developments; when they did so, dramatic improvements ensued.[83] In 1674, the merchant George Ravenscroft obtained the first British patent to produce lead glass (also called "flint glass") at his glasshouse in London's Savoy district and secured the distribution network of the powerful Glass-Sellers' Company, London. As a result,

Ravenscroft has long been regarded as the sole inventor of such glass in England.[84] However, experiments with lead-glass formulas were being pursued at roughly the same time in the Netherlands, Sweden, and Ireland.[85] Infringements on Ravenscroft's monopoly were almost immediate. Initially, glassmakers' obsession with purity of ingredients resulted in a fatal manufacturing flaw, which became quickly apparent: the early lead glasses were prone to *crizzling*, a chemical imbalance in the batch that caused the glass to appear first cloudy and then to develop small disfiguring, and increasingly fatal, cracks. By 1676, Ravenscroft believed he had improved the formula and began to apply a seal to his glass vessels, showing the raven's head from his family crest. Soon, other English glasshouses were producing lead glass marked in a similar fashion. In contrast to contemporary hallmarks on English metal wares, which were a mark of regulation and governance, the seal on glassware simply signified the maker and was a self-imposed guarantee of quality.[86] Ravenscroft stopped making lead glass in early 1679, two years before his patent expired, and thereafter concentrated on producing plate glass.

This early English lead-glass group in the Toledo Museum of Art includes a rare posset pot (48B) from the Ravenscroft Savoy glasshouse.[87] The small drinking glass has a cylindrical body blown in a straight-sided, ribbed dip-mold in traditional Venetian fashion, with C-shaped handles attached on opposite sides, and a curved spout applied near the base of the body. The Ravenscroft seal was added to the base of the spout. These pots were made for the consumption of posset, a drink consisting of sweetened milk curdled by the addition of alcohol in the form of ale or wine and thickened with breadcrumbs. Posset was usually served hot and sucked through the spout of this special container.[88] A rare survivor of its kind, this glass posset pot is nonetheless in peril: like nearly all of the glasses with the raven's head seal known today, it shows signs of incipient crizzling.

From left to right:

48A. PUNCH BOWL
England
About 1710
Colorless lead glass; blown, applied, tooled
H: 18.7 cm (7 ⅜ in.); Diam. (rim): 33 cm (13 in.)
Provenance: Reported to have been found in a farmhouse in Buckinghamshire; Arthur Churchill Ltd., London, United Kingdom. Purchased with funds from the Libbey Endowment, Gift of Edward Drummond Libbey, 1950.276

48B. POSSET POT
England, London, Savoy Glasshouse of George Ravenscroft (1618–81)
About 1676–1678
Colorless lead glass; mold-blown, applied, stamped with seal
H: 8.6 cm (3 ⅜ in.); Diam. (rim): 8.9 cm (3 ½ in.)
Provenance: Earls of Stafford, Wentworth Woodhouse, Yorkshire (sale, London, 1948); Arthur Churchill Ltd., London; Captain W. Horridge, Plaish Hall, Cardington, Shropshire (sale, Jackson-Stops, 1959, no. 82); Delomosne & Son. Ltd., London, United Kingdom. Purchased with funds from the Libbey Endowment, Gift of Edward Drummond Libbey, 1960.3

48C. DECANTER WITH STOPPER
England
About 1680
Colorless lead glass; blown, applied, tooled
H: 28.4 cm (11 ⅛ in.)
Provenance: Arthur Churchill Ltd., London, United Kingdom. Purchased with funds from the Libbey Endowment, Gift of Edward Drummond Libbey, 1948.223

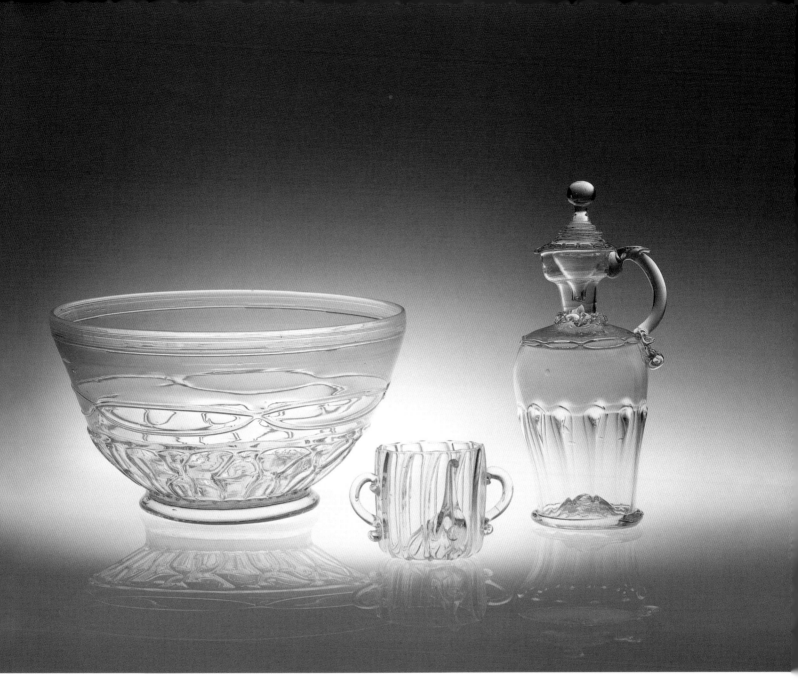

The stunning refractive qualities of lead glass were only tentatively explored by early English glasshouses, whose decorating techniques for luxury glass were still deeply rooted in Venetian traditions. The elegant decanter with hollow blown stopper (48C)[89] has mold-blown ribbing and applied decorations with a softer appearance than Venetian soda-lime glass. On the large bowl (48A),[90] which was probably intended to serve punch after dinner, the ribbed decorations above the base are pinched, or nipped, to produce a diamond pattern that was called in England "nipt diamond waies." The loosely applied chain-link band above, formed by intersecting trails, was also part of the standard Venetian repertory. These three vessels exemplify the technical virtuosity and the stylistic range of luxury English tablewares made during the nascence of lead-glass production. Soon, immigrant cutters and engravers from Central Europe applied their considerable skills to the medium and brought the refractive qualities of this glass to perfection. In the eighteenth century, English lead glass with geometric facet-cutting rose to prominence and would dominate the market in northwestern Europe, the American colonies, and the Far East for nearly two hundred years. J.A.P.

This pair of mounted cups, a unique survival, represents the collaboration of two very successful English craftsmen: the silversmith Thomas Heming (1722 / 23–1801) and the glasscutter Thomas Betts (died 1765).[91] The design depends on the striking appearance of richly textured, gilded silver mounts against the faceted and polished surface of the glass. Embellishing colored glass with gilded silver was an innovation that appears to have had scant precedent in England.[92] However, the taste is reminiscent of the French preference for deep blue Chinese porcelains of the Ming (1368–1644) and Qing (1644–1911) Dynasties that were fitted with gilded bronze mounts made by the great Parisian *bronziers*. Such creative marriages of materials were the work of the *marchand-merciers*, Parisian merchants who brought together luxury goods and served as retailers, decorators, and tastemakers.[93] It was a completely practical and characteristically English solution for the designer of these cups to utilize materials readily available in London—cobalt-blue glass rather than Chinese porcelain, and gilded silver rather than gilded bronze—to achieve a similar effect. At the time, English potters and enamelers were seeking alternatives to expensive oriental, French, and Venetian luxury products by using ores found locally in Britain. A source of cobalt discovered in Fife was welcomed as a potential substitute for the high-quality blue mineral from Saxony that glassmakers all over Europe had preferred for centuries (see No. 42). The cobalt was also used for painting, japanning, enameling, and bleaching.[94]

These two thick-walled, faceted glass cups are attributed to Thomas Betts, a successful glass-cutter who had a shop in the fashionable shopping district opposite Pall Mall, in London.[95] His trade card enumerated his various products, mainly tableware such as cruets, salts, dessert stands, and candelabra, with the significant addendum, "He being the real workman for many years." This distinguishes Betts as both a manufacturer and a retailer, and it

was clearly a selling point. Betts operated one of about a dozen glass-cutting workshops in London. He bought undecorated white (colorless) glass from the Whitefriars glasshouse, near Fleet Street, and colored glass from other suppliers, such as the glasshouses in Southwark.[96] Betts had a workshop behind his showroom for engraving and polishing glass, and also had tools to make the metal mounts and other fittings required to assemble complex creations, such as chandeliers or girandoles. The probate inventory made at the time of his death gives a sense of cluttered production and storage areas. The shop and storage rooms were filled with trays containing branches for chandeliers, half-finished cruet sets, and stacks of dishes waiting for assembly or finishing. The document offers a rare glimpse of the work floor of a busy London workshop. Among the items listed are "one cutt blue cup mounted in metal gilt" and "one pair cut blue cups with metal handles and choaks [covers or lids?] not finished," possibly describing cups similar to the present pair.[97] They were objects of luxury equal to a blue glass *tun* (a large cask) with gilded metal mounts on a gessoed wooden base with small wheels, sold by Betts for serving liqueur during the dessert course in an elegant English home.[98]

Before about 1756, Betts seems to have run a hand-cranked glass-cutting lathe in the garret and back rooms of his shop. The work was dirty and dangerous, since the fine particles thrown off by the cutting were rich in poisonous lead. Later, Betts established a workshop outside London to the southeast, where he had a water-driven glass-cutting operation. This was a rarity at that time in England, where most glass-cutting workshops used hand machinery until the introduction of steam power in the late eighteenth century. Betts's annual turnover was about £5,000, and his estate was valued at more than £10,000. The probate inventory reveals the comfortable life he made for himself as a master craftsman and entrepreneur.[99] His high-end operation allowed

him to collaborate with Thomas Heming, one of the foremost goldsmiths in London and Principal Goldsmith to King George III. Heming's Rococo design for this pair of mounts, with snakes curling around the branch-like handles, complements the bold cutting of the large cups. The elegant curved flutes decorating the lids—a technical feat on the part of the mid-eighteenth century cutter requiring unprecedented skill and control of the cutting wheel—are enhanced by the undulating wrought metal grapevines that make up the knops.

J.A.P./E.A.

CUPS WITH COVERS
England, London
Thomas Betts, glasscutter; Thomas
Heming, silversmith
About 1752–53
Cobalt-blue lead glass; blown, cut;
gilded silver mounts
H (with cover): 32.1 cm (12 5/8 in.);
Diam. (foot): 14 cm (5 1/2 in.)
Provenance: Col. Herbert Hall Mulliner,
Rugby, England (d. 1923/24); Sir Henry
Price; S. J. Phillips Ltd., London.
Purchased with Funds from Florence
Scott Libbey Bequest in memory of her
Father, Maurice A. Scott, 1968.73

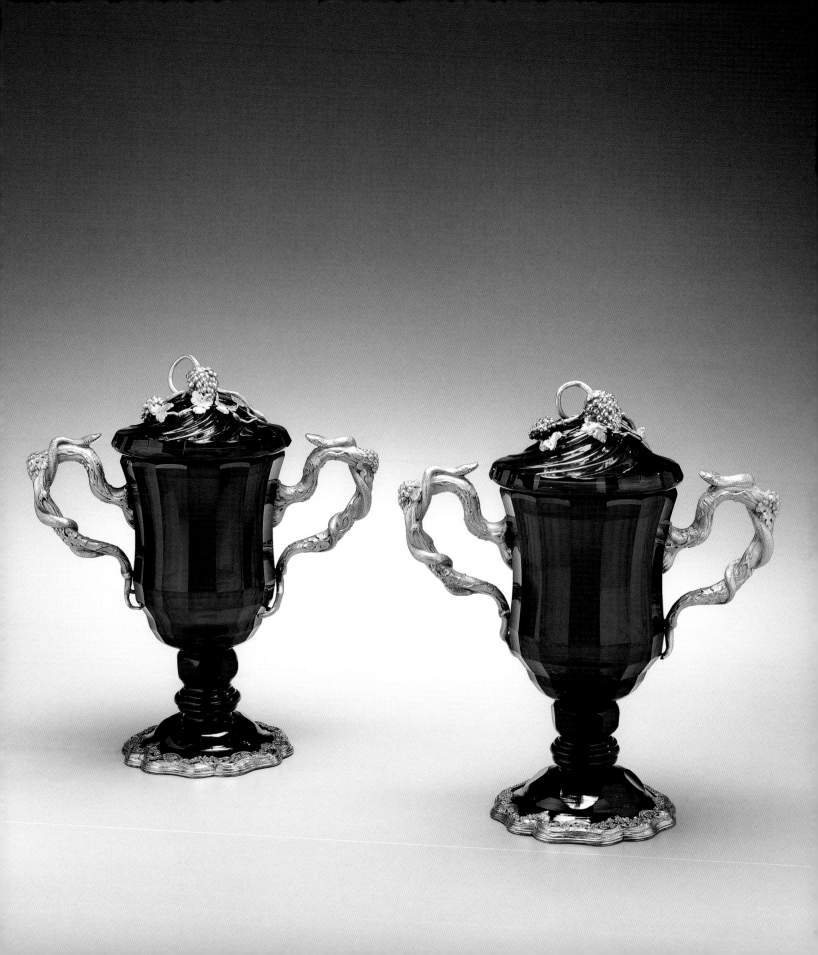

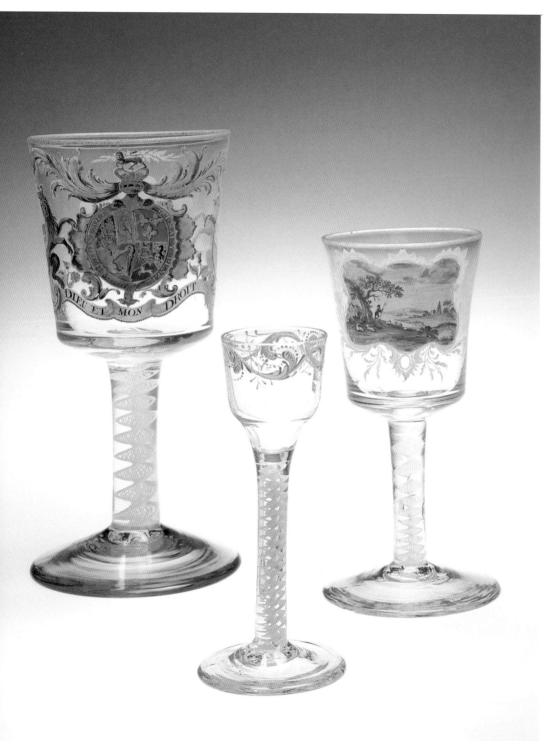

From left to right:

50A. ARMORIAL GOBLET
England, Newcastle upon Tyne
William Beilby (1740–1819), enameler
About 1762–63
Colorless and opaque white lead glass;
blown, enameled, gilded
H: 22.9 cm (9 in.)
Provenance: Private collection, London
(sale, Sotheby's, London, 9 February
1954, no. 75); Delomosne & Son, Ltd.,
London, United Kingdom.
Purchased with funds from the Libbey
Endowment, Gift of Edward Drummond
Libbey, 1954.16

**50B. WINE GLASS WITH ROCOCO
DECORATION**
England, Newcastle upon Tyne
Beilby workshop, enameling
About 1770
Colorless and opaque white lead glass;
blown, enameled
H: 14.3 cm (5 ¹³⁄₁₆ in.)
Provenance: George S. McKearin,
Hoosick Falls, N.Y.
Purchased with funds from the Libbey
Endowment, Gift of Edward Drummond
Libbey, 1953.13B

**50C. GOBLET WITH A LANDSCAPE
VIGNETTE**
England, Newcastle upon Tyne
William Beilby (1740–1819), enameler
About 1765–70
Colorless and opaque white lead glass;
blown, enameled
H: 17.8 cm (7 in.)
Provenance: Delomosne & Son, Ltd.,
London, United Kingdom.
Purchased with funds from the Libbey
Endowment, Gift of Edward Drummond
Libbey, 1963.15

The new English lead glass produced in the last quarter of the seventeenth century (see No. 48) attracted consumers from the beginning because of its reflective transparency. So as not to detract from the brilliance of these lead-glass vessels, opaque enamel twists were limited to the stems of wine glasses and gilding was confined to small areas such as edging on rims and feet, while the vessels' bowls and bodies were decorated with small engraved mottoes, heraldic subjects, and figural and floral motifs. By the middle of the eighteenth century, the venerable glass industry in the area of Newcastle upon Tyne, in northeast England, became a center for a different kind of embellishment: decorations painted predominantly in opaque white and, in lesser numbers, polychrome enamel. The most accomplished objects originated from a small shop near the church of St. Nicholas (later the cathedral) in the center of town, owned by the Beilby family since 1760.[100] William Beilby, Sr. (1706–1765), a jeweler from Durham, resolved that several of his talented children receive training in artistic trades. When his third son, William Beilby, Jr. (1740–1819), was fifteen years old, he was sent to serve an apprenticeship under the Birmingham painter and drawing master John Hasledine (1721–1808).[101] There, William probably acquired not only his drawing and painting skills but also learned the art of enameling. William entered the Beilby business in 1762, which prospered due to the Beilbys' considerable skill. They produced designs for metal engravings, book illustrations, and ornamental prints, as well as enameled decorations on glass. The blanks for the glasses were probably procured from Airey, Cookson & Co., one of the major English glasshouses operating in Newcastle.[102] However, it is not certain whether the enameling and subsequent firing of the glassware were executed in the Beilby shop or at a local glasshouse. The motifs were either conceived in-house or supplied by the client.[103]

William later worked as a drawing master in Newcastle and continued to execute accomplished pencil drawings and watercolors of romantic landscapes and botanical studies throughout his career. In 1767, he opened a drawing school in Newcastle, which may have affected the output of the enameling business.[104] Much of what is known about the Beilby family workshop and its occupants has been gleaned from the *Memoir* of the famous wood-engraver Thomas Bewick (1753–1828). At the age of fourteen, Bewick was apprenticed to William's older brother, Ralph Beilby (1743–1817), a prominent and prolific metal engraver operating from the same address as the family shop. Bewick noted that William had been assisted in his endeavors for some time by his brother Thomas (1747–1826) and by his youngest sister, Mary (1749–1797).[105] When Thomas Beilby departed for Yorkshire around the end of the 1660s, Mary began playing a more significant role in the workshop, until she suffered an incapacitating stroke at the age of twenty-five, in 1774.[106] Following the death of their mother four years later, William retreated permanently from the Beilby family business and left Newcastle to pursue the career as drawing master and book illustrator in Battersea, London.[107]

The Beilby glass production was intended for a broad-based market consisting mostly of British and Dutch consumers. The vessels remained largely unsigned, and it is therefore difficult to attribute glasses with any certainty to a specific family member. Smaller wine glasses expertly painted in white enamel, faintly tinted blue, with simple naturalistic motifs, seem to have made up the bulk of the shop's output, such as the small wine glass with an ogee-shaped bowl and enamel-twist stem (50B).[108] Many of them were probably decorated by Thomas or Mary, or even by brother Ralph.[109] There is a notable exception, however: four of a group of eight commemorative goblets with the British royal crest from the time of King George III (r. 1760–1820) include William Beilby's signature enameled on the bowl. The impressive, yet unsigned, royal goblet in the Toledo Museum of Art belongs to this group, consisting of a large bucket-shaped bowl on a straight white enamel-twist stem and a wide, conical foot (50A).[110] Like the others, it is decorated on one side with the king's coat-of-arms surrounded by a band with the motto of the Order of the Garter, "HONI SOIT QUI MAL Y PENSE" ("Shame on him who thinks evil of it"), flanked by the English lion and the Scottish unicorn above the motto "DIEU ET MON DROIT" ("God and my [birth]right"). On the opposite side of the bowl is the badge of the Prince of Wales, with the three ostrich feathers emanating from a coronet above the German motto "ICH DIEN" ("I serve"). Rococo scrolls and floral festoons in white enamel surround both heraldic crests. The glass may have been commissioned to celebrate the birth of the crown prince (the future George IV) on August 12, 1762.[111]

Equally rare are flint-glass goblets painted with polychrome vignettes of pastoral and classical landscapes, such as the one in the Toledo Museum (50C).[112] As books and prints of travel and nature became popular items for the middle classes during the second half of the eighteenth century, glasses and other decorative arts were manufactured in England with landscapes that reflected a romantic a romantic preoccupation with nature. The Beilby workshop, which produced prints, drawings, and metal engravings of this sort, had in William a talented artist who was able to transfer such idealist imagery into enameled decorations on glass. This landscape goblet is similar to the royal goblet, but considerably smaller. The vignette is delicately painted in opaque polychrome enamels and depicts a shepherd leaning on his crook, looking out into a landscape with a river or lake. A building with a pyramidal tower nestled among the rolling hills in the background may be a romantic architectural folly. A few of these rare drinking vessels, such as the one illustrated here, include on the reverse of the bowl a butterfly in white enamel, which is thought to be a mark of the imaginative Beilby workshop. J.A.P.

This charming snuff box with a micromosaic of an animated monkey clasping a cherry[113] is the work of the Italian artist Giacomo Raffaelli (1753–1836), who was celebrated for his works in *pietre dure* (hard-stone inlay), as well as for his stone and glass mosaics. He is also credited with the invention of micromosaics, a specialty he developed at his studio in the Via S. Sebastianello in Rome. In 1775, he first displayed decorative plaques and panels composed of so-called *smalti filati,* thinly drawn rods of opaque glass that were cut into tiny *tesserae,* assembled into pictures, and set into a resin-like layer to adhere them to a copper base. The roundel with the monkey is made up of several thousand *tesserae* per square inch, an impressive feat of mosaic in miniature. The background is rendered with cubical *tesserae* in regular horizontal rows, while the animal is represented with shaped and multi-tinted *tesserae* for a more naturalistic rendering. The artist proudly signed his work with a burin on the reverse, "*Giacomo Raffaelli fecit in Roma 1794.*" By this date, Raffaelli was already internationally renowned for his expertise and received numerous royal commissions and academic honors. Compared to lesser mosaicists of his time, whose works were mostly sold as souvenirs to the tourist trade, Raffaelli was financially secure, because his fame afforded him a steady stream of international commissions. Few other artists in Rome ever matched his skill in works of such varied media as micromosaics, bronze, and *pietre dure*. His work in micromosaics ranges from small plaques decorating boxes for snuff and sweetmeats to a life-size rendering of the *Last Supper.*[114] The earliest micromosaic work known to date by Raffaelli is a sweetmeat box from 1779 in the British Museum. Its lid shows the so-called *Doves of Pliny,*[115] copying a famous Roman stone mosaic at Emperor Hadrian's Villa in Tivoli that was unearthed in 1737. This ancient original, which shows four birds drinking from an urn, was derived in turn from a famous lost Hellenistic Greek mosaic by the artist Sosos

from Pergamon, celebrated by Pliny the Elder in the first century C.E. as the most perfect illusionistic work of its kind.

Generally, mosaics made of tiny glass *tesserae* were intended for close, individual viewing. The tradition of owning such objects for personal use first appeared in Byzantine art, where small icons were used for private worship or intimate religious adoration (so-called kneeling icons). Icons of this type were fabricated mostly in the court ateliers of Constantinople, especially during the Palaiologan Period (1261–1453, named for the dynasty begun by Byzantine emperor Michael VIII Palaeologus). The images on these icons were made of tiny chips of precious stones, gilded copper rods, and *smalti* (enameled glass) tesserae affixed to a wood panel with a mastic-like bedding and wax filler.[116] Such precious panels, depicting saints and scenes from the life of Christ and the Virgin, were often fitted into chased and gilded silver frames studded with semiprecious stones. Sometimes they also incorporated reliquary containers.

In the second half of the fifteenth century, numerous mosaic icons were given to St. Peter's Basilica in Rome. Two of these icons remain there today, while others are in the church of Santa Maria in Campitelli, Rome, and in the Basilica of Santa Croce, Florence.[117] These icons may well have been known to Raffaelli and could have served him as inspiration. However, the size of Rafaelli's *smalti* tesserae, their range of color, and the subject matter of his works all differ greatly from Byzantine mosaic antecedents.

The image of the monkey may have been provided by the Bohemian artist Johann Wenceslaus Peter (1745–1829), a gifted interpreter of animal subjects who had moved to Rome in 1774. Raffaelli is known to have purchased works from him repeatedly, including the rendering of a monkey holding a bowl in its paw.[118] The idea of the monkey holding a cherry derives from a Sufi tale in the *Book of Amu Daria*: A monkey sitting in a tree saw a cherry

inside a clear glass bottle lying on the ground. Inspecting the bottle closely, the monkey inserted a front paw and grasped the cherry in its fist. The hunter who had set this trap captured the monkey because it did not give up the fruit. Only a sharp tap on the elbow prompted the surprised animal to release its prize and withdraw its paw from the bottle. Rafaelli's interpretation of the tale in micromosaic depicts the monkey as a captive, indicated by the belt and the metal ring around its waist, while the cherry in its paw alludes to the cause of its demise. The subject is a subtle reminder to use the tempting content of the snuffbox judiciously.
J.A.P.

MICROMOSAIC SNUFF BOX
Italy, Rome
Giacomo Raffaelli (1753–1836)
Signed and dated 1794
Polychrome opaque glass; cut, assembled
Diam. (rim): 7.9 cm (3 ⅛ in.); H. (overall): 2.54 cm (1 in.)
Provenance: Peter Francis, Belfast, Northern Ireland.
Mr. and Mrs. George M. Jones, Jr. Fund, 2004.57

**AMERICAN AND EUROPEAN
NINETEENTH CENTURY**

During the American colonial period, British poli-cy ensured that British goods dominated the American market and discouraged manufacturers in the colonies who might dare to compete. When the Revolutionary War ended British rule with the Treaty of Paris in 1783, entrepreneurs like John Frederick Amelung (1741–1798) seized the opportunity. For eleven years Amelung had worked in Germany at the Grünenplan mirror glass factory managed by his brother in the Duchy of Brunswick, but in 1783 that glassworks was in decline. Encouraged by prominent Americans who believed that economic inde-pendence depended upon the success of domes-tic manufactures, Amelung secured the financial support of merchants in the nearby city of Bremen, Germany. He hired glassworkers, bought equipment, and set sail for the United States, landing in Baltimore in August 1784.[1]

By purchasing an existing factory near Frederick, Maryland, Amelung was able to com-mence operations very quickly: in February 1785 he advertised window glass and green and white hollowware. He acquired a large tract of land and erected several glasshouses in order to expand production to fine tableware and mirror glass. An advertisement of 1788 lists tumblers, wine glasses, decanters, goblets, and cans.[2] In 1789, in another advertisement, Amelung offered "hearty and sincere Thanks to a patriotic Public, for the Encouragement he has received in giving Preference to the American-manufactured glass," but competition with imported glass was fierce.[3] Besides spawning interest in a domestic glass industry, the Revolution also opened the profitable American market to continental European glassmakers. In the late 1780s and 1790s, in addition to British glass, enormous quantities of German and Bohemian glass were shipped across the Atlantic.

Struggling to match the quality and price of imports, and faced with tremendous operating expenses, Amelung developed an aggressive mar-keting strategy. In 1787 he published a pamphlet in which he urged the United States government not only to enact high duties on imports but also to provide direct funding to support industrial enterprises such as his.[4] While he successfully petitioned the Maryland legislature for aid, the United States Congress rejected his request. Amelung established agencies in New York, Philadelphia, and Baltimore to take orders and handle sales. He also sought favorable coverage in the press. A letter endorsing Amelung's work, published in 1789, for example, reported that "through his vast exertions he is now enabled to supply the United States with every species of glass, the quality of which is equal if not superior to that imported, while he actually undersells all foreign traders in that article."[5] Finally, for indi-viduals in the United States and abroad who held positions of influence in the commercial and political spheres, Amelung produced magnif-icent presentation glasses as tangible proof—and advertisements—of his accomplishments.

In 1789 Amelung journeyed to Mount Vernon, in northern Virginia, to give the nation's newly elected president, George Washington, a pair of goblets engraved with the Washington family coat-of-arms.[6] Although these particular goblets have not been located, seven goblets and tumblers do survive that bear the name of Amelung's New Bremen Glassmanufactory, signi-fying their function as marketing tools. Together with engraved glasses made for members of the Amelung family, these objects document the style and quality of glass achieved at the Maryland factory.

The Mauerhoff goblet, which originally had a cover, is one of these objects. Inscribed "G. F. Mauerhoff" and "New Bremen. State of Maryland / Frederik County. 1792.", it is the only Amelung glass inscribed with the name of the county as well as the state in which the glass-works was located.[7] This geographic specificity—in addition to the goblet's provenance in a Dutch collection—suggests that Mauerhoff was a European whom Amelung hoped would invest in his enterprise. Although Mauerhoff has eluded identification, he may have been related to the Francis Mayerhoff who immigrated in 1800, operated a mercantile business in New York, and then opened the Columbia Glassworks in north-eastern Pennsylvania.

New Bremen engraved glasses are dated as early as 1788, but the first newspaper notice of decorated glass occurs the following year, when Amelung advised the public that "he also cuts Devices, Cyphers, Coats of Arms, or any other Fancy Figures on Glass." According to a 1791 advertisement, such engraving cost from four to forty pence over and above the price of the glass itself.[8] The Mauerhoff goblet is one of four objects dated 1792.

As seen in other Amelung presentation glasses, the Mauerhoff goblet exhibits a Rococo rather than Neoclassical sensibility. An asym-metrical arrangement of scrolls, sprays, and stylized flowers frames the name. On one side, a bird perches on a sheaf of wheat; on the other, a globular device caps a scroll. The design is enhanced by a combination of matte and polished elements. With a capacious, rounded bowl, a stem composed of a wafer above a strong, hollow baluster, and a high, domed foot, the goblet is typical of New Bremen ware and similar to eighteenth-century examples made in Osterwald, Scherborn, and Winzenburg in north central Germany. These factories were not far from Grünenplan and doubtless supplied Amelung with artisans. The "round hand" style of lettering seen on the Mauerhoff goblet also parallels engraved glass from that region of Germany.[9]

In spite of his ambitious efforts to market and promote his wares, Amelung failed to garner the support he needed, and the glassworks closed in 1795. While some of his workers contin-ued to make glass on a limited scale at the New Bremen glassworks and elsewhere in Maryland, others traveled to different states to find work or open factories of their own, thereby spreading a German tradition in American glassmaking well into the nineteenth century.

A.P.

GOBLET
New Bremen Glassmanufactory of John
Frederick Amelung, Frederick County,
Maryland
1792
Colorless non-lead glass; blown and
engraved
H: 20.1 cm (7 $^{15}/_{16}$ in.); Diam. (rim): 10.8 cm
(4 $^{1}/_{4}$ in.)
Provenance: F. P. Bodenheim, Amsterdam,
The Netherlands (by 1933); Nijstad
Antiquairs, N.V., The Hague, The
Netherlands.
Purchased with funds from the Libbey
Endowment, Gift of Edward Drummond
Libbey, 1961.2

129

From left to right:

53A. FLASK
J. Shepard & Co., White Glass Works,
Zanesville, Ohio
1822–38
Deep olive amber glass blown in a full-
size mold
H: 17.3 cm (6 ¹³⁄₁₆ in.)
Provenance: Edwin AtLee Barber,
Philadelphia, Pa.
Gift of Edward Drummond Libbey,
1917.409

53B. FLASK
South Boston Flint Glass Works, Phoenix
Glass Works, or New England Glass
Works, Massachusetts
1815–25
Light green lead glass; blown in a full-
size mold
H: 18.7 cm (7 ⅜ in.)
Provenance: Edwin AtLee Barber,
Philadelphia, Pa.
Gift of Edward Drummond Libbey,
1917.387

53C. FLASK
Union Glass Works, Kensington (near
Philadelphia), Pennsylvania
1826–35
Medium blue lead glass; blown in a full-
size mold
H: 18.5 cm (7 ⁵⁄₁₆ in.)
Provenance: Edwin AtLee Barber,
Philadelphia, Pa.
Gift of Edward Drummond Libbey,
1917.38

It is no accident that the production of mold-blown pocket flasks with pictorial or didactic decoration—called "figured" flasks[10]—coincided with a shift in American drinking habits. In the colonial period small amounts or "drams" of alcoholic beverages were typically consumed throughout the day—upon rising, at mealtimes, and at bedtime. By the early nineteenth century, however, what could be called communal binge-drinking increased dramatically. Distilled spirits, chiefly whiskey, flowed freely at public events and gatherings, such as elections, court sessions, militia musters, and holiday celebrations. These opportunities, coupled with the notion that "imbibing lustily was a fitting way for independent men to celebrate the country's independence,"[11] expanded the demand for portable drinking vessels like pocket bottles or flasks. When the first figured flasks were made, about 1815, per capita consumption of alcohol was on the rise (see Fig. 53.2). Their popularity peaked in the 1820s and 1830s, and then began to wane in the later 1840s as the temperance movement gained momentum.[12]

Although pocket bottles were among the staple goods of the few American glasshouses operating in the second half of the eighteenth century, they formed a significant proportion of the output of numerous glasshouses by the 1820s. Thomas W. Dyott, a Philadelphia druggist and glass manufacturer, listed nearly a quarter of a million flasks for sale in a single advertisement from 1825.[13] Depending on their size, figured flasks sold from four to seven cents apiece, making them accessible to a wide spectrum of the market.[14] Flasks were not purchased by distilleries for distribution of their product but rather were obtained by individuals from glasshouses or their agents and retail merchants.

Not only were more pocket bottles manufactured in the nineteenth century than previously, but the styles also changed significantly. Henry William Stiegel and other eighteenth-century glassmakers produced pocket bottles that were pattern-molded with floral or geometric motifs. The new genre of figured flasks

carried symbols, slogans, portraits, and other pictorial images. Most had political or patriotic meaning, further reinforcing the theory that they evolved in response to changing cultural mores. Using glass flasks as vehicles for political or patriotic sentiments is a distinctly American development of the nineteenth century, although these vessels recall Roman head flasks and other ancient vessels with molded decoration (see Nos. 10 and 13).

Like examples from antiquity, figured flasks were blown in full-size, two-part molds.[15] This manufacturing technique had been employed only rarely by glassmakers during the intervening centuries.[16] Full-size molds facilitated mass-production, standardized sizes, shapes, and capacities, and provided opportunities for artistic expression. The owners and superintendents of glasshouses presumably chose the themes they wanted to depict, frequently in response to a commission, but it was the mold-makers, not the glassblowers, who implemented their vision and made this innovative type of glassware possible.

Little is known about American mold-makers in the period before 1850. Although some were on the staff of larger glass factories, others worked independently. Over four decades, they created more than 700 individual bottle molds, indicating not only the strength of the bottle industry but also the competition among manufacturers to create designs that would attract buyers.[17] The myriad patterns serve as a unique index to popular taste and culture of the period. These examples from the Toledo Museum's collection suggest the range of motifs that was common between 1815 and 1840.

New England is generally believed to be the source of the earliest figured pocket bottles. One of the first examples, marked by the New England Glass Company, was a flat, circular bottle depicting the American eagle within a series of concentric rings. Its bulky shape and heavy weight suggest that it may have functioned as a table decanter. Because the Toledo Museum's example (53B)[18] does not bear the New England Glass factory mark, it may be the work of a rival

Fig. 53.1. Flask, 1824–30. Coventry Glass Works, Coventry, Conn. Olive-amber glass; blown in a full-size mold, H: 18.8 cm (7 7/16 in.). Inscriptions: Obverse LA FAYETTE (above) and T.S. (below); reverse DE WITT CLINTON (above) and COVENTRY (below). Provenance: Edwin AtLee Barber. Gift of Edward Drummond Libbey, 1917.366.

company in the Boston area. The origin and dating of many flask designs are problematical because of the scarcity of factory marks and the common practice of pirating designs.

Freemasonry was widespread in the early years of the Republic, so it is not surprising that Masonic arches and other symbols were among the first to appear on pocket bottles.[19] Such customized flasks were a natural extension of the tradition in England and America of ordering drinking glasses and ceramic mugs and pitchers with Masonic imagery. Besides being used at social gatherings and celebratory feasts, Masonic flasks also assured recognition when used at public events. As seen on the example made at the White Glass Works (operated by J. Shepard & Co. as inscribed on the reverse), in Zanesville, Ohio (53A),[20] Masonic flasks frequently featured the American eagle on one side; this symbol of the nation was by far the most common image in flask design. The crisp pattern and fine clarity of the flask's amber glass demonstrate the quality achieved by Ohio's bottle glasshouses in the 1820s.

The fashion for flasks bearing the likenesses of patriots and politicians apparently grew out of the celebrated tour of the United States that the Marquis de Lafayette made between 1824 and 1825. As a young French aristocrat, Lafayette had fought in the American Revolutionary War alongside General George Washington. Fifty years later Lafayette received a hero's welcome as he traveled across the nation during a period of thirteen months. The resulting "Lafayette mania" was unprecedented in American consumerism and was arguably the beginning of the trade in souvenir and commemorative glassware that continues to this day. On the marked example from the Coventry Glass Works (Fig. 53.1),[21] the portrait bust of Lafayette is sketchy, almost generic; other glasshouses, like that of Thomas W. Dyott, produced well-modeled likenesses. Besides Lafayette, American glassmakers honored such other military and political figures as George Washington, Benjamin Franklin, Andrew Jackson, Zachary Taylor, and William Henry Harrison.

Fig. **53.2.** *Village Tavern*, 1813–14. John Lewis Krimmel (American, born Germany, 1789–1821). Oil on canvas, 42.8 x 56.9 cm (16 ⁷/₈ x 22 ¹/₂ in.). Purchased with funds from the Libbey Endowment, Gift of Edward Drummond Libbey, 1954.13.

The head of Liberty, derived from the American half-dollar introduced in 1809, is one of the most artistically successful flask designs. On the flask in the Toledo Museum collection that has the mark of the Union Glass Works located just north of Philadelphia (53C),[22] Liberty adorns the obverse and an eagle embellishes the reverse. While most pocket bottles were blown of unrefined non-lead glass, both the Boston-area eagle flask (53B) and this flask were made of lead glass. The Union Glass Works flask is also unusual because of its blue color, since most flasks of this type were blown of aqua, olive, or amber glass.

Edward Drummond Libbey acquired these flasks and most of those in the Toledo Museum's collection from Edwin AtLee Barber, a scholar who became director of the Philadelphia Museum of Art. Although Barber is perhaps best known for his pioneering studies of American ceramics, he also wrote the first book on the history of American glass. His *American Glassware*, published in 1900, listed eighty-six flasks of historical design, prompting the study and collection of this category of glassware.[23]

A.P.

A portrait of DeWitt Clinton (1769–1828), governor of the state of New York, is encased within the base of this tumbler.[24] Manufactured by Bakewell, Page & Bakewell, the tumbler is an example of the technique called cameo-incrustation. Commonly known as sulphide glass, this type of ware developed from the Neoclassical taste for collecting small likenesses of famous persons. Ancient cameos, which featured portraits of emperors, heroes, and mythological subjects carved from semiprecious stone and layers of cast glass (see No. 8), inspired the prominent British potter Josiah Wedgwood (1730–1792) to introduce cameo-style medallions made of stoneware in the late eighteenth century. Wedgwood honored not only famous people from the past but also what he termed "illustrious moderns." James Tassie of Scotland

devised a similar product using opaque white glass. Because these portraits protrude without protection, however, they were easily discolored or chipped.

About 1785 an unknown Bohemian glassmaker offered a solution by completely encasing ceramic images in glass so that they would remain fresh in appearance and safe from damage.[25] Between 1812 and 1818, French manufacturers improved upon this idea. A process patented in 1818 by Pierre Honoré Boudon de Saint-Amans involved pouring molten glass into a copper mold, placing the ceramic image face down on the level surface, then covering it with more glass. The following year, London glass manufacturer Apsley Pellatt patented a different process in which the glassblower opened the end of a gather of glass to create a

TUMBLER
Bakewell, Page & Bakewell, Pittsburgh, Pennsylvania
About 1825
Colorless glass; blown, cut and engraved glass; clay cameo (sulphide) portrait of DeWitt Clinton
H: 10.0 cm (3 $^{15}/_{16}$ in.); Diam. (rim): 7.2 cm (2 $^{7}/_{8}$ in.)
Provenance: George S. McKearin, Hoosick Falls, N.Y.
Purchased with funds from the Libbey Endowment, Gift of Edward Drummond Libbey, 1959.53

bubble into which a cameo was inserted; he then inhaled on the blowpipe to collapse the bubble over the portrait.

Early in 1825 the firm of Bakewell, Page & Bakewell, in Pittsburgh, introduced this sophisticated type of decoration to American glassmaking. The company's production of cameo-incrusted tumblers—what it called "medallion" ware—was prompted by a commission to produce a set of commemorative tumblers for the Marquis de Lafayette, who visited Pittsburgh in May 1825 as part of his American tour (see further discussion of the tour at No. 53). While other glasshouses made mold-blown liquor bottles with the general's portrait, the Bakewell firm, renowned for its luxury glassware, created this high-style form of tribute, even though the hero's face would only be fully appreciated as the whiskey or other liquor was consumed. The first subjects that Bakewell, Page & Bakewell immortalized in this way were Lafayette, George Washington, and Andrew Jackson; cameos of Benjamin Franklin and DeWitt Clinton soon followed.

While Clinton was serving his second term as governor of New York, he was hailed across the United States as a champion of industry and commerce for his promotion of the Erie Canal, which opened in October 1825. This engineering wonder provided a relatively fast, safe, and inexpensive means of getting American grain, produce, and manufactured goods like glass from the Midwest to markets in the East, without having to cross the Appalachian Mountains by land. Bakewell, Page & Bakewell completed Clinton sulphide tumblers in time for the governor's visit to Pittsburgh in August 1825. A set of cut examples engraved with the initials "DWC" was apparently presented to Clinton at that time. The sulphide portrait in the base of the presentation tumblers, however, varies slightly from the one in the Toledo Museum's tumbler in that the former depicts the governor with short hair, while the Toledo example shows Clinton's hair in a queue—a hairstyle he never

affected (Fig. 54.1).[26] While it has been suggested that the image represents instead Clinton's uncle, George Clinton, or his father, James Clinton, both of whom did wear their hair in queues, painted profile portraits of those gentlemen do not resemble the sulphide image in other details. Although one other tumbler is recorded with the same version of the Clinton cameo, it seems likely that the artist simply made a mistake in his initial rendering of the governor's coiffeur, because the facial details are otherwise very similar.

The artist of that portrait was probably Joseph Wood, a painter of portrait miniatures in Washington, D.C., who had supplied the Pittsburgh glassworks with drawings of Jackson and Lafayette for its first sulphide-decorated objects. Broadly rendered with a minimum of detail, Wood's portraits have a powerful immediacy. In Pittsburgh his drawings were turned into bas-relief format, from which molds could be taken and the clay cameos cast. The work of converting the two-dimensional image into a three-dimensional mold was accomplished for the Bakewell firm by the multi-talented William Price. An English glassmaker who immigrated to Pittsburgh in 1800, Price initially worked for the glasshouse of James O'Hara and Isaac Craig. After a few years he left and established a clay tobacco pipe factory; his other ventures included a tableware pottery and a manufactory for ceramic crucibles and firebrick. Price also operated a foundry, where he made small castings in brass or iron. One artist somewhat sardonically stated that Price—known in his day as an eccentric but ingenious mechanic—claimed to have encapsulated the head of the devil in the bottom of a beer mug as his first essay in cameo incrustation.[27]

The glasshouse established in 1808 by Benjamin Bakewell not only pioneered the distinctive sulphide glassware but also was the first nineteenth-century American glassworks to produce fully cut glass. By the 1820s, the partnership of Benjamin Bakewell, his son Thomas, and Benjamin Page gained national

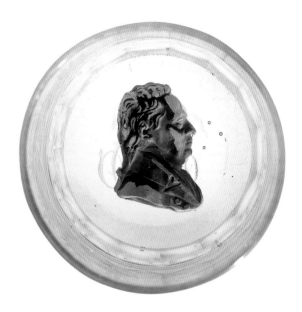

Fig. 54.1. Detail of sulphide portrait.

recognition for its fine cut and engraved glass that compared favorably with contemporary English and French glass in quality and style. The strawberry-diamond and fan design that encircles the tumbler was a motif that was universally used during that period. The delicately engraved rose-vine border around the rim, however, is characteristic of Bakewell glass of the 1820s and was probably introduced by the French glass engravers the firm engaged from the late 1810s. Of the thirty-three Bakewell sulphide tumblers recorded to date, only the Toledo Museum's tumbler has the engraved initials of what is assumed to be the owner on its bottom, though the initials "WRB" have not yet been identified.

A.P.

When the Boston Porcelain and Glass Manufacturing Company was established in East Cambridge, Massachusetts, in 1814, the incorporators hoped that by producing high-quality tableware they would profit from the shortage of European imported goods during the War of 1812. However, neither the glasshouse nor the porcelain works flourished. When the property was put up for sale in 1817, it was acquired by a newly formed corporation, the New England Glass Company. Destined to become one of the most important glass manufactories of nineteenth-century America, the New England Glass Company operated in East Cambridge for the next seventy years. After 1880 it was called the New England Glass Works, and when the business relocated to Toledo, Ohio, in 1888, it was renamed first W. L. Libbey & Son and later Libbey Glass Company. The firm continued to produce glass in Ohio under the leadership of Edward Drummond Libbey (1854–1925), who was also the founder of the Toledo Museum of Art.

The New England Glass Company concentrated on the production of flint glass—highly refined glass made with lead oxide. Flint glass was particularly suitable for decorative cutting, because it was less brittle than potash glass and because the high refractive index of lead imparted great brilliance. Advertisements indicate that the glassworks offered expensive cut glass from the outset.[28] According to an 1819 account, ninety-six persons were employed at the works. By 1832, when the company was producing some $200,000 worth of plain and cut glass, one hundred fifty men and thirty boys were on staff. Twelve to fifteen glassblowers worked at each of the two furnaces.[29] At that time, the glassworks was under the supervision of Thomas Leighton, who in 1826 had been lured away from the Midlothian Glassworks in Edinburgh, Scotland, an establishment operated by Bailey & Co., a partnership that included William Bailey and John Ford. Even as Leighton wrote Ford in 1828 seeking forgiveness for leaving "without giving you

Any Notice," and sending him information regarding glass molds, Leighton was encouraging other workmen from the Scottish concern to emigrate and join him at the New England Glass Company.[30] He cautioned, however, that they should consider coming only if they were "steady men," because "a drunkard is despised in this country by the citizens more than in any other country."[31] Among those who followed Leighton to East Cambridge was George I. Dale. By 1835 there were enough Scottish glassworkers at the New England Glass Company for a

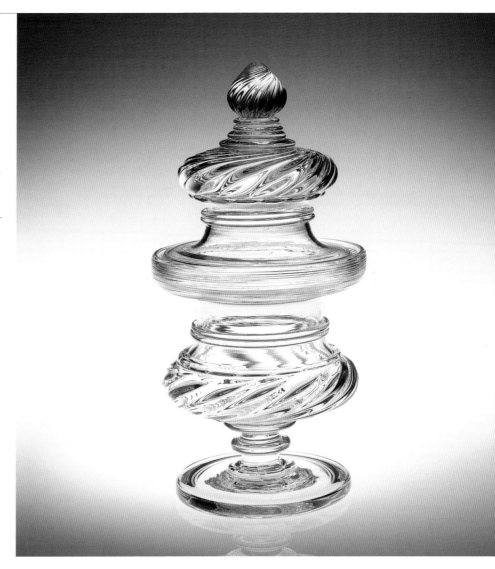

SUGAR BOWL
East Cambridge, Massachusetts, New England Glass Company
1830–40
Colorless lead glass; blown and molded
H: 25.2 cm (9 $^{15}/_{16}$ in.)
Provenance: Lura Woodside Watkins, Middleton, Mass.; George S. McKearin, Hoosick Falls, N.Y.
Purchased with funds from the Libbey Endowment, Gift of Edward Drummond Libbey, 1953.75

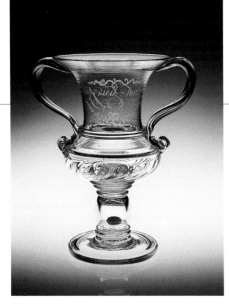

Fig. 55.1. Loving Cup or Urn, made to commemorate the marriage of glass-blower George Dale and Elizabeth Harrington, 1 November 1833. New England Glass Company, East Cambridge, Mass. Colorless glass; blown, molded, and engraved, H: 26.6 cm (10 ½ in.). Gift of Mr. and Mrs. Richard Dale Barker, in memory of his great-grandparents, Elizabeth and George I. Dale, 1992.35.

Harvard University professor to observe that "The men employed to make the glass are I believe all Scotch men."[32]

The two objects shown here from the Toledo Museum's collection—a sugar bowl and a related loving cup presented to Dale (Fig. 55.1)—date from the 1830s, when the influence of Scottish craftsmen was probably at its peak.[33] Because little Scottish-made glass from the first half of the nineteenth century has been identified, however, it cannot be said that these objects exhibit any particular Scottish characteristics. Surviving pattern books from the Edinburgh glasshouses indicate that Scottish cut glass was stylistically indistinguishable from cut glass made elsewhere in Great Britain; the same may be true of Scotland's plain and molded flint glass.[34]

There are marked similarities among the products of the major Massachusetts flint-glass companies of the 1830s located in East Cambridge, South Boston, and Sandwich. This is explained not only by a common source of inspiration from the United Kingdom, but also by the migration of workers from one factory to another. The attribution of the Museum's large sugar bowl to the New England Glass Company is based on its relationship to a smaller example with a firm history in the Leighton family.[35] The shape of the bowl (and inversely, the cover) is derived from that of classical urns. The interplay of horizontal and diagonal lines characterizes the design from finial to foot and creates an overall effect of controlled motion.

Several related sugar bowls attributed to New England Glass Company reveal various options for ornamental detail. One bowl is nearly identical to the Museum's except that it is slightly taller and, in lieu of a button-knop stem, has a hollow-blown ovoid segment that holds an 1832 five-cent piece.[36] Another example has a straight-sided body with horizontal ribbing that extends from the broad medial ribs all the way up to the rim.[37] One that was owned in the family of James Bryant Barnes, who was in charge of the pot room at the glassworks from 1818 until the mid-1840s, has wide applied chains of glass on the cover and on the base of the bowl instead of the swirled ribs, known as gadrooning, that characterize the Toledo Museum's bowl. Knops on the stem and cover of the Barnes example contain European coins of 1810 and 1816.[38] Irish sugar bowls with gadrooned decoration and coins in their stems may have inspired the Massachusetts glassblowers, but recorded examples are generally graceless by comparison to the New England bowls.[39]

Tablewares of similar styles were manufactured by several flint glass factories in the Boston area. Chains, for example. are more frequently associated with the South Boston glasshouse of Bristol-trained glassmaker Thomas Cains (1779–1865), because they appear on several examples that descended in his family. South Boston glass is also decorated with strong horizontal ribs and the occasional coin. A two-handled loving cup quite similar to the Dale example is attributed to the Cains establishment.[40]

The loving cup or urn made at the New England Glass Company for glassblower George Dale at the time of his 1833 marriage to Elizabeth Harrington (Fig. 55.1), replicates the shape, horizontal ribs, and gadrooning of the Toledo Museum's sugar bowl. The bold, ribbed handles complement the classical form. Inserted in the stem's hollow knop are two English silver coins dated 1817 and 1818. Similar urns contain an 1834 American quarter, an 1837 American quarter, and an English silver coin of 1816. One that descended in the Leighton family contains coins of 1835 and 1837.[41]

The distinctive sugar bowls made at East Cambridge were copied in unrefined aqua glass by an as-yet-unidentified bottle or window glasshouse.[42] Perhaps those bowls were made by glassblowers who had worked at the New England Glass Company but who found themselves unemployed in the 1830s, when economic stagnation caused the factory to cut back on production. As Thomas Leighton wrote to John Ford on 1 April 1838, "everything in the shape of business is almost at a stand in consequence of some difference between our Legislature and the Banks. How long it will continue we can not tell. We have been Obliged to reduce our hands from 300 to 60 and stop our Cutting establishment altogether." Leighton seems to have traveled to Scotland during this slow period. Upon his return, however, he found that "Bussiness [sic] is quite at a stand we have put out one of our furnaces and our Cutters work only 4 days a Week."[43]
A.P.

The engraver Paul Oppitz (1827–1894) is best known for his many remarkable works in English lead glass, executed in his workshop in London. This tall, covered goblet made of Bohemian potash-lime glass is one of his earliest pieces still in existence.[44] The goblet is said to have been created by the artist while training in his hometown, Haida (modern Noví Bor, in the Czech Republic).[45] According to family history, he submitted this goblet as his "masterpiece," in order to become licensed as a master engraver, shortly before his immigration to England in 1845.[46] He took the goblet with him, probably as proof of his abilities, a common practice among migrating craftsmen (see No. 57). Because Bohemia was experiencing an economic crisis at the time, its glass industry focused on low-end production that offered few prospects of work for highly skilled and ambitious engravers. Glass-working masters had trained a new generation of talent in the 1820s and 1830s, which brought engraving, especially in Northern Bohemia, to new heights of technical and creative achievement. The widespread economic depression between 1846 and 1848 and subsequent revolutions that ravaged Austria, Germany, and France greatly hampered the prospects of this new generation, and many young (and older) glass decorators immigrated to America and England, which had a wealthy and discerning customer base.

Oppitz became an engraver of great acclaim in England with the "Ailsa Jug," completed in 1862 for Dobson & Pearce in London and now in the Corning Museum of Glass. Named after its owner, Lord Ailsa, the jug was already famous at the time of its creation. Oppitz's splendid "Copeland Vase," decorated around 1872–73 and now in the Victoria and Albert Museum, is even better documented. This vessel became famous for its extraordinarily accomplished engraving after a design by John Jones, with complex Rococo ornament inspired by the French court architect Jean Bérain (1638–1711). The vase took Oppitz 243 days to complete.[47]

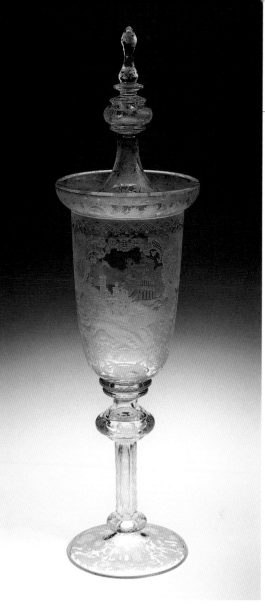

GOBLET
Northern Bohemian, Haida
Engraved by Paul Oppitz (1827–1894)
About 1845
Colorless potash glass; blown, applied, wheel-engraved, polished
H: 53.3 cm (20 ¾ in.)
Provenance: The artist; Leslie Oppitz, England (by descent); Mallett Antiques Ltd., London.
Purchased with funds from the Libbey Endowment, Gift of Edward Drummond Libbey, 2004.3 A, B

The high level of skill and accomplishment demonstrated in Toledo's goblet exemplifies the solid foundation for Oppitz's later acclaim. The bowl is engraved with views of two well-known Gothic castles in Germany on the Rhine, Schloss Rheinstein and Schloss Stolzenfels, owned by Friedrich Wilhelm Ludwig (1794–1863), Royal Prince of Prussia. Prince Ludwig rebuilt the semi-ruined castle Königstein after plans by Claudius von Lassaulx between 1825 and 1829 and renamed it Schloss Rheinstein. Renovation of Stolzenfels began in 1842 after plans by the German architect Friedrich Schinkel. Both castles, which became the prince's summer residences, received much public attention, and engraved romantic views were widely distributed. They became popular decorations on Bohemian glass.[48]

The remaining surface, including the goblet's cover, is densely decorated with Rococo Revival ornament. The goblet is unusual for the period because this "New Rococo" style, which emerged in France in the early nineteenth century, did not become fashionable in Germany and Bohemia until the second half of the nineteenth century. None of Oppitz's works is signed, which was common practice for Bohemian engravers working in England.
J.A.P.

By 1840, glass manufacturers in Bohemia had developed cased glass, also known as plated or overlay glass, where one or more layers of colored glass were fused onto a base layer of colorless glass. The outer layers were frequently cut away in patterns designed to emphasize the color contrasts and create striking optical effects. When engraved, cased glass provides a depth and range of shading not possible on glass of a single color. The woodland and deer-hunting scenes favored by Bohemian engravers were especially dramatic when rendered on cased glass. Such images remained popular for decades and were widely copied in other glass-making centers.

Bohemia's influence was strongest within the glass industry of neighboring Germany just at the time Louis Vaupel (1824–1903) was learning to decorate glass. First trained by his father, Georg Andreas Vaupel (1773–1842), a glass cutter, engraver, and painter at the Schildhorst glasshouse in the kingdom of Hannover, young Louis struggled to master his craft during the economically depressed 1840s, working as an itinerant glass engraver, a decorator for retail glass merchants, and an engraver at the Schmalenbucha glass factory. Even while serving four years in the Prussian army (1845–49), Vaupel engraved glass for a Potsdam merchant in his off-duty hours. He later returned to the Schildhorst glassworks, where he engraved and painted glass in the decorating shop headed by his half-brother Karl.[49]

A family quarrel and the realization that demand for luxury tableware was declining propelled Vaupel to seek his fortune in the United States. As an immigrant unable to speak English and with no knowledge of the status of the glass industry across the Atlantic, Vaupel was relieved when, almost immediately upon arriving, he received offers of employment in both Philadelphia and New York. In October 1850 he began engraving glass for Joseph Stouvenal in New York. The following year he set off for East Cambridge, Massachusetts, after meeting August Brauner, a Silesian-trained engraver who had decided not to accept a position at the New England Glass Company and urged Vaupel to take the higher-paying job in his stead.

At that time, the company was eager to compete with Bohemian imports and needed men like Vaupel with a background in German or Bohemian glassmaking. Under factory superintendent William Leighton, the New England Glass Company was producing cased glass by 1850, which, "in its variety of colors — ruby, mulberry, pink, blue, green, olive and white" was considered "all very beautiful."[50] When a journalist visited the glassworks two years later, he was "struck with the fact . . . that most of the exquisite, richly colored and decorated glass-ware, which is so much admired under the name of 'Bohemian Glass,' is manufactured at these works." He noted the "variety and beauty of the articles manufactured there" and was confident that the glass he saw "could not be surpassed in Bohemia or anywhere else in Europe."[51]

By 1854 Vaupel was designated the factory's "first engraver" and was assigned apprentices to train.[52] Although he received offers from other glasshouses and even considered returning to Germany, Vaupel spent his entire career in East Cambridge, engraving glass for the New England Glass Company into the 1880s and executing private commissions when factory work was slow. When Vaupel started with the firm in 1851 he was paid two dollars for a ten-and-a-half-hour day or less than twenty cents an hour; in 1877 he received thirty-five cents an hour.

The Toledo Museum's goblet,[53] which descended in the Vaupel family, reveals the scope of Vaupel's talents and, when compared to a flask he decorated in 1850, proves how far he had advanced in his craft within fifteen years or so.[54] On the goblet, the animals are dramatically posed and realistically engraved with muscular detail and fur. The hunters are equally naturalistic. Vaupel achieved a fine sense of perspective and depth in the landscape and meticulously engraved its details of ground and foliage. A large tree with exquisitely rendered bark separates the two scenes on the bowl.

According to family tradition, Vaupel spent more than 600 hours on the engraving during an eighteen-month period. Although he made a specific bequest of this "large ruby plated Goblet, rich cut & fine engraved with hunting scenes," he never mentioned this masterpiece in his memoirs or his diary, so its exact date is unknown.[55] Around the base of the bowl and on the bottom of the foot there are complex cut patterns, derived from Bohemian prototypes, that hint at the brilliant cut style that began to emerge in American glass during the 1870s.
A.P.

GOBLET
New England Glass Company, East Cambridge, Massachusetts
Engraved by Heinrich Friedrich Louis Vaupel (born Hannover, 1824–1903)
1865–75
Colorless glass cased with gold-ruby glass; blown, tooled, and engraved
H: 21.1 cm (8 3/8 in.); Diam. (rim): 11.1 cm (4 1/8 in.)
Provenance: H. F. Louis Vaupel; Louis Humboldt Washington Vaupel; John L. Vaupel, Jr.
Purchased with funds from the Libbey Endowment, Gift of Edward Drummond Libbey, 1974.52

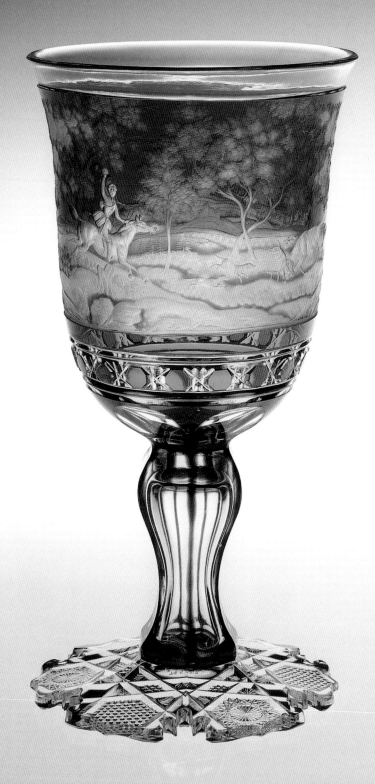

Glassmakers have always been attracted to the challenge of portraiture. They have engraved or painted likenesses on both tableware and ornamental objects, frequently on a custom-order basis. Portraits are especially effective when painted in enamel colors on white opaque, or opal, glass that simulates porcelain. When writing about painted opal glass at the Paris Universal Exhibition of 1867, the critic George Wallis doubted that such ware should be regarded "as coming within the true range of glass manufacture in an artistic sense," because he found it "more within the category of porcelain than of glass proper."[56] Initially inspired by the work of Bohemian glassmakers, many glass manufacturers exhibited painted opal glass at international fairs between 1851 and 1876.

Although painting on glass and porcelain was a popular amateur pastime in the United States during the 1870s and 1880s, the excellent quality of the portrait of the American poet Henry Wadsworth Longfellow on this plate indicates that it was painted by a professional decorator.[57] While some large glassmaking establishments employed glass painters on the premises, others relied on independent craftsmen who operated their own workshops. On blanks obtained from one or more factories, these artisans executed commission work for glasshouses, retail merchants, and private customers. With the exception of the Smith Brothers, who had an atelier in New Bedford, Massachusetts, such glass decorators are a largely unknown and unstudied group.[58]

Generally speaking, the plate or tray is an unusual form in American glass. The large, flat surface and short rim of this example resemble trays made by Bohemian and German glassmakers as part of liquor sets.[59] Nonetheless, it provides an excellent format for a painted portrait. Metal and ceramic commemorative plaques of this scale were favored wall decorations in nineteenth-century interiors, but there is no evidence that this example was ever hung.

The subject of this commemorative plate, Henry Wadsworth Longfellow (1807–1882),

was one of the leading American poets of the nineteenth century. From the mid-1860s Longfellow's reputation was firmly established by some of his best-known works, including *Hiawatha*, *The Courtship of Miles Standish*, *Tales of a Wayside Inn*, and his translation of Dante's *Divine Comedy*. Artists, sculptors, and photographers sought him out to make portraits, and prints or copies of their works were widely circulated and frequently published as frontispieces to books of his individual and collected works. Longfellow's physical appearance remained fairly constant throughout the last twenty years of his life.[60] When his wife tragically burned to death in 1861, the poet was severely burned as he struggled to smother the flames. He then grew a full beard to hide his disfigurement and his hair turned white soon after the accident.

Longfellow's portrait on this plate appears to have been based on an 1878 photograph taken by George Kendall Warren, and the Renaissance Revival style of ornamentation around the portrait suggests the work was created shortly thereafter.[61] The nineteenth century was a great age of historicism, with archi-

tects, glassmakers, cabinetmakers—as well as poets like Longfellow—all seeking inspiration from the past. Between 1865 and 1885 American designers and craftsmen created their own interpretations of the arts of the European Renaissance, which typically included ornamental details of classical Greek and Roman origin. The Longfellow plate has a design incorporating classical rosettes around its outer rim. The portrait is set against a panel, painted in soft red, with a high, scrolled pediment at the top capped with an acanthus leaf. At the bottom, a female classical mask is flanked with palmettes. The sense of solidity conveyed by the red panel is balanced by a surrounding pattern of fluid, delicate scrollwork of a dull gold color. In contrast, scrollwork and winged lions in the lower section are rendered in bright gold tones. The same motifs painted on the glass plate can be seen on a center table in the Toledo Museum's collection that dates to 1869–70 (Fig. 58.1). A masterpiece of Renaissance Revival style, this table by the Herter Brothers of New York features classical female masks, scrollwork, and winged lions with boldly curved bodies similar to the lions on the plate.[62]

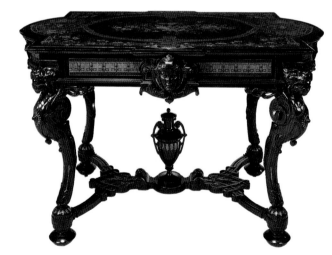

Fig. 58.1. Center Table, 1869–70. Herter Brothers, New York, N.Y. Ebony, rosewood, sycamore, kingwood, tulipwood, amboina, mother-of-pearl, and lacquer, H: 76.2 cm (30 in.). Gift of Dr. and Mrs. Edward A. Kern, 1986.65.

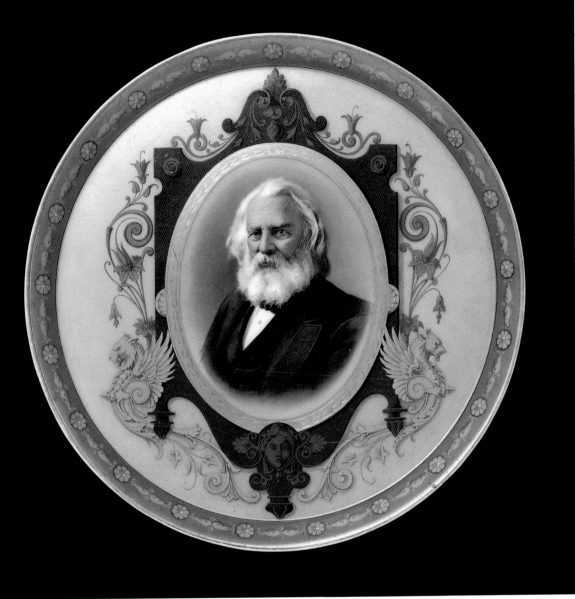

**LONGFELLOW COMMEMORATIVE
PLATE OR TRAY**
Massachusetts, probably New England
Glass Works, East Cambridge
1878–82
White opal glass; pressed and enamel
painted
Diam.: 35.3 cm (13 ¹⁵⁄₁₆ in.)
Provenance: Edward Drummond Libbey,
Toledo, Ohio.
Gift of Edward Drummond Libbey, 1925.50

It is possible that the tray commemorates Longfellow's death in 1882, but by then the Aesthetic Movement style that reflects Japanese design, among other influences, was coming into fashion. Decorative motifs expressive of the Aesthetic Movement can be seen on another Longfellow commemorative object, an earthenware "Longfellow Jug" designed in 1880 by Richard Briggs, a leading Boston ceramics and glass merchant.[63] Briggs commissioned Josiah Wedgwood and Sons to produce the jug in time for the Christmas season that year. The transfer-printed portrait of the poet that Briggs used is based on an image other than the Warren photograph.

Because the Toledo Museum's glass plate was once in the collection of Edward Drummond Libbey, the glass industrialist who founded the Toledo Museum of Art, it has been presumed to be originally owned by him and to have been made at the New England Glass Company, where Libbey first worked as a clerk in 1874.

Four years later, Edward's father William L. Libbey, who had been the company agent, assumed control of the establishment and in 1880 renamed it the New England Glass Works. Either Edward or William could have commissioned the work because of a particular interest in Longfellow's poetry. The poet lived in Cambridge, not far from the glassworks, but there is no evidence that he had any personal association with the Libbey family.[64]
A.P.

Classical antiquity exerted a strong influence on American design during the eighteenth and nineteenth centuries. About 1780, cabinetmakers, silversmiths, and other artisans developed a Neoclassical style, based on English models, which was inspired by the art of the ancient world. Objects were lighter and more linear than their Rococo counterparts of the mid-1700s, and ornamentation was more restrained. The interplay of geometric shapes became important. Delicate patterns of interlacing guilloche, swags of foliage, and medallions were adapted from Greek and Roman architecture and artifacts.

In the 1810s a heavier classical style evolved that was almost archaeological in its scientific approach. Craftsmen now emulated the shapes as well as the ornament of ancient objects. Cabinetmakers copied the *klismos* chairs depicted on Greek pottery. The lion's-paw foot that supported many Roman artifacts was adapted to a range of materials and functional objects, from sofas to salts. Celery glasses and flower vases replicated the shapes of first-century Roman marble urns. Foliage motifs such as anthemia and acanthus abounded. The fashion in the United States was now influenced by France, where classical design was boldly expressed as it served the political ideology of the empire of Napoleon I.

The adaptation of classical imagery to household furnishings received further encouragement in the United States during the 1830s and 1840s, with the rise of the Greek Revival style of architecture. Temple forms replete with porticos and columns sprouted in every city and town for residences as well as public buildings. A *néo-grecque* style emerged again in the mid-1860s as one among many historicist options.

Because of their essentially architectural forms, glass lighting devices were well suited to the expression of classical taste. The tall candlestick highlighted here[65] is supported by a pressed base of antique derivation, in a style characteristic of the 1830s. Four lion's-paw feet support four strong scrolls, and anthemia fill

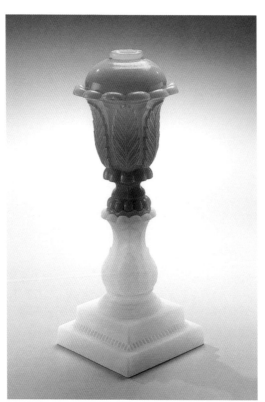

Fig. 59.1. Lamp, 1840–50. Possibly New England Glass Works, East Cambridge, Mass. Opaline glass; pressed, H: 30.0 cm (11 ¹³/₁₆ in.). Gift of Mrs. Harold G. Duckworth, 1968.40.

the space between. Around the top of the base, between the scrolls, are rams' heads. From this intricate base the free-blown shaft and unusually deep socket rise to a remarkable height. Stacks of applied and tooled rings separate the blown elements. While many glass candlesticks and lamps of this period have multiple applied rings and wafers at the juncture of the blown and pressed sections, the exuberant use of rings on this example is distinctive. This candlestick relates to two goblets that have similarly pronounced and graduated rings below the bowls. One goblet has a history of having been made at the Boston and Sandwich Glass Company by glassblower Edward Haines shortly after he arrived from England in 1828.[66] Lamps and candlesticks with similar scroll and lion's-paw bases, with shells rather than rams' heads, are attributed to that firm.

Designed to burn whale oil or burning fluid, the pressed glass lamp featured in Fig. 59.1[67]

has a font (the part that holds liquid fuel and supports the wick) that mimics a classical urn shape, set on a baluster stem. The double-stepped base gives the lamp an air of dignity and importance. Both font and standard carry a relief pattern of upright acanthus leaves, one of the most popular of the classical motifs adopted by nineteenth-century craftsmen. In its material, the lamp also refers to the ancient world. Opaline glass such as this was known as "alabaster glass" because of its resemblance to the translucent white gypsum that was carved into vases and ornamental forms in ancient times. The brilliant jade-green color of the font, however, reflects the influence of richly colored Bohemian glass imports during the mid-nineteenth century and attests to advances in chemical technology that permitted the manufacture of brilliantly colored glasswares.
A.P.

CANDLESTICK
Massachusetts
1835–40
Colorless glass; blown socket and stem;
pressed standard and base
H: 37.5 cm (14 ¾ in.)
Provenance: Mr. and Mrs. Harold G.
Duckworth, Springfield, Mass.
Gift of Mrs. Harold G. Duckworth, 1968.24

While the reputation of a flint glassworks might rest upon the quality of its cut glass, its solvency probably depended upon the success of its middle-market goods. The Pittsburgh glassworks established by Benjamin Bakewell was rightly renowned for its expensive cut glass (No. 54), but the company hastened to assure the public that it embraced "every thing in the glass line, of every price and of every grade of workmanship, from the most beautiful to the most plain and uncut."[68]

One way that early American glassmakers made their products appealing to the taste as well as the pocketbook of the middle class was by manufacturing lower-priced facsimiles of luxury cut ware. They achieved this by perfecting a process of blowing a gather of glass into a hinged, multi-part mold that would, in one step, define a vessel's shape, size, and pattern. Designs could be modeled after the geometric patterns of cut glass, thereby satisfying stylistic demands, while the use of molds assured a uniformity and speed of production that made these wares more affordable.

Ancient glassmakers practiced this mold-blown method of glass production with skill and wit (see Nos. 9, 10, and 13), but it was not until the early nineteenth century that glassmakers once again realized its potential. When and where this happened is unclear. Even though the process evolved in a distinctive way in the American glass industry, scholars agree that it did not originate in this country. The mold-blown process may have come from Ireland—where decanters, celery glasses, jugs, and other table forms were fashioned in molds of geometric patterns—but it is not known when this process first appeared in the Irish industry.[69] Because many glassblowers working in the New World trained in Irish factories, and much Irish glass was exported to the United States in the decades following the Revolutionary War, the Irish connection may be key to understanding the origin of this type of glassware in America.[70] Regardless of how the technique found its way into American glasshouses, it was quickly adopted,

altered, and expanded, resulting in a remarkable group of objects that marked the beginning of mass production and the mechanization of the glass industry. As such, mold-blown wares made in the United States represent a significant contribution to the history of glass.

To make mold-blown tableware, glassworkers used several different techniques: blow-off, blow-over, and blown three-mold. The nineteenth-century London glass manufacturer Apsley Pellatt described these processes in a treatise on glass. To make "blow-off" glass, the glassblower inflated a gather in a full-size open mold, then "urging the pressure by blowing, lifting it up repeatedly, and, . . . as it were, stamping it into the mould."[71] He greatly expanded the upper part of the gather, or "blow off," above the mold into a large, thin bubble that was then cracked off using a piece of wood. In the closely related "blow-over" method, the excess gather extended outwards rather than upwards and was considerably thicker, so the glass-cutter had to remove it at some risk when it was cold.[72] Both techniques left a rough rim that had to be ground and polished after annealing, and objects produced by these methods tend to have thick walls and smooth interior surfaces. Most are salts and shallow dishes; the "blow-over" sugar bowl shown here (60A)[73] is extremely rare.

A more common practice, known as "blown three-mold," was to blow a gather of glass into a hinged mold, generally of three parts, open the mold, attach the vessel to a pontil and finish it at the furnace. The interior surfaces of objects fabricated by this method have concave areas on the interior that correspond to the protrusions on the outer surface. Blown three-mold table glass was produced at many American glasshouses between about 1815 and 1845. Although nearly four hundred individual molds have been recorded, a single mold could spawn a variety of forms, because gaffers frequently manipulated and tooled the glass once it was removed from the mold.[74] Blown three-mold patterns have been classified into five groups, four of which are based on geometric

From left to right:

60A. SUGAR BOWL
Massachusetts, probably South Boston Flint Glass Works or New England Glass Company
1820–30
Colorless glass; blown in a full-size mold
H: 14.0 cm (5 ½ in.); L: (rim) 11.2 cm (4 $\frac{13}{32}$ in.); W (base): 6.9 cm (2 $\frac{23}{32}$ in.)
Provenance: Lura Woodside Watkins, Rockport, Mass.
Purchased with funds from the Libbey Endowment, Gift of Edward Drummond Libbey, 1953.14

60B. DECANTER
Sandwich, Massachusetts, Boston and Sandwich Glass Company
1830–40
Blue glass; blown in a full-size mold
H (with stopper): 22.9 cm (9 $\frac{1}{32}$ in.)
Provenance: Edwin AtLee Barber, Philadelphia, Pa.
Gift of Edward Drummond Libbey, 1917.247

60C. FOOTED BOWL
Sandwich, Massachusetts, probably Boston and Sandwich Glass Works
1825–40
Colorless glass; blown in a full-size mold
H: 15.3 cm (6 $\frac{1}{32}$ in.); Diam. (top): 24.5 cm (9 $\frac{21}{32}$ in.)
Provenance: George S. McKearin, Hoosick Falls, N.Y.
Purchased with funds from the Libbey Endowment, Gift of Edward Drummond Libbey, 1959.61

motifs such as pillars, diamonds, flutes, arches, sunbursts and rays. The fifth group includes more curvilinear motifs, such as rosettes, palmettes, bands of guilloche, and scrolls of the type seen on the decanter (60B).[75]

While blow-over or blow-off glass may have been made in the United States as early as 1810, somewhat earlier than blown three-mold glass, it is now clear that all three methods were used concurrently between 1815 and 1830. After 1830, blown three-mold glass predominated, at least in the United States.

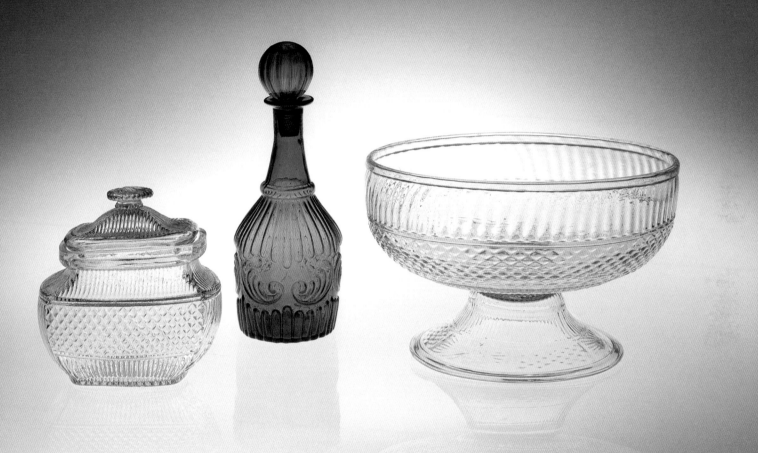

Because Pellatt described the blow-over and blow-off processes in detail in his 1849 treatise on glassmaking, those methods were probably still in use, perhaps even widespread.[76]

By embracing mold-blown production, glass manufacturers transferred the creative role of glassmaking from the glassblower to the mold-maker. Glasshouses either had moldmakers on staff or employed independent artisans to make the necessary brass, iron, or bronze molds. Unfortunately, little information has been dis-covered about the moldmaking industry that

would illuminate the design process. For the shape of the sugar bowl (60A), the moldmaker was apparently inspired by contemporary English ceramics; its decorative pattern, however, is modeled after cut glass.

Most American mold-blown tableware is made of colorless flint glass; colored examples like the decanter (60B) are scarce. Bottle- and window-glass factories offered blown three-mold glass in patterns that emulated cut glass, even as the aqua and olive colors dispelled the illusion. A great deal of mold-blown glass, like

the footed bowl from the Boston and Sandwich Glass Works (60C),[77] was produced in New England, but this type of glass was also manu-factured in other regions. Few specimens are documented; attributions are based on descrip-tive invoices and, in some cases, on fragments found at glasshouse sites. Obviously, mold-blown ware was inexpensive compared to cut glass, but it was also considerably cheaper than plain blown glass, as confirmed by several period invoices and price lists.[78]

A.P.

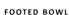

According to a book published in 1849 by Apsley Pellatt, the technique of making pillar-molded glass had been introduced by his late partner, James Green. Although Green had thought it a new invention, Pellatt reported that recent excavations in London yielded fragments of ancient Roman glass with similarly pronounced ribs.[79] Ancient artisans achieved pillar-molded ware by pressing a flat, grooved tool on a disk of hot glass, then slumping the disk over a mold to make the desired shape; most are small bowls (see No. 5).[80] Green, on the other hand, made his pillar-decorated glass by blowing. After an initial gather was allowed to cool to a certain degree of hardness, a second gather was applied. When blown into a ribbed mold, the gather was shaped by the mold only on this second, exterior coating: the interior of the vessel remained smooth. Furthermore, "the projecting parts [of the gather]" wrote Pellatt, "have a centrifugal enlargement given to them by a sharp trundling of the iron at, or immediately after, the moment the workman is blowing."[81] The ribs could be left straight or swirled, and the bold patterning was enhanced by the use of richly colored glass, as in this deep amethyst example.[82] Sometimes the ribs and body were in different colors.

The pillar-molded style complemented the Rococo Revival furnishings which were fashionable in the mid-nineteenth century. Because pillar-molded objects are often thick and sturdy, they have been associated with use on steamboats, but documentation for this tradition is lacking. Pellatt advocated the pillar-molded style for toilet bottles, salts, chandeliers, and lamp pedestals,[83] but most American glassmakers chose large, curvilinear shapes for this inexpensive method of decoration. Pitchers, decanters, footed bowls, celery glasses, show jars, and bar bottles are the most common pillar-molded forms in American glass. Footed bowls of such an impressive size as the Toledo Museum example are rare, especially in colored glass.

Pillar-molded glass was made at Pellatt and Green's Falcon Glass Works, London, and doubtless at other English factories in the 1830s, and

American glassmakers quickly adopted the style. Only rarely were glass forms imitated in ceramic, but Samuel Alcock, a potter working between 1830 and 1859, produced Parian porcelain pitchers that copy pillar-molded glass, even the rare two-color variety (Fig. 61.1). Trade catalogues of the Pittsburgh firms of M'Kee and Brothers, and Bakewell, Pears & Co. prove that pillar-molded glass continued to have market appeal into the 1860s.[84]

A.P.

FOOTED BOWL
United States, probably Pittsburgh,
Pennsylvania
1845–60
Purple lead glass; blown and molded
H: 17.9 cm (7 ¹/₁₆ in.); Diam. (rim):
28.3 cm (11 ¹/₈ in.)
Provenance: Leon Dreyfus, Erie, Pa.; James and
Eileen Courtney, Cleveland, Ohio (Garth's
Auction, Delaware, Ohio, 14 April 1984, lot 87);
Karl and Ann Koepke, Cleveland, Ohio.
Purchased with funds from the Libbey
Endowment, Gift of Edward
Drummond Libbey, 1987.40

Fig. 61.1. Pitcher, about 1840. Samuel Alcock & Co., Hill Top Pottery, Burslem, Stoke on Trent, Staffordshire, United Kingdom. Parian porcelain, H: 24.1 cm (9 ¹/₂ in.). Private collection.

This bowl and two pitchers represent one of the most visually satisfying—and enigmatic—types of early American decorated glass. Blown of unrefined window or bottle glass, these vessels have an applied outer layer of glass that was tooled and shaped into irregular peaks or boldly curving C-scrolls. Although at least several hundred examples are known, and their ornamentation is consistent enough to have been classified by Helen McKearin, the preeminent scholar of American glass in the twentieth cen-

tury, no period description or name of the style has been discovered in invoices, newspaper advertisements, or factory records.[85]

Because the ends of the scrolls and peaks are finished with a wide pad of glass, students of American glass in the early twentieth century likened the design to water lilies, and the group has since been known as "lily pad" glass. This designation is plausible because the plant unquestionably had enormous appeal for botanically minded Victorians, especially after the pub-

licity accorded the giant *Victoria regia* species in the early 1850s. In the fervor for naturalism that characterized the design of much decorative art made between 1850 and 1860, British glassblowers, as well as British and American silversmiths and potters, produced pitchers and goblets with molded, engraved, or enameled lily pad plants rising sinuously from their bases.[86] These examples, however, were intricate, realistic renditions, in marked contrast to the simple, abstract interpretations seen in American glassware.

Indeed, the American type of ornament may simply have evolved from traditional glass-making techniques rather than from any deliberate attempt to copy nature. English glassblowers of the late seventeenth century, for example, drawing upon *façon de Venise* styles, embellished decanters and wine glasses with spiked gadrooning—applied vertical ribbons of glass, pincered into tentacle-like forms. At least one Spanish tumbler of eighteenth-century origin has a superimposed layer of opaque white glass tooled into tall, regular peaks, in the manner of some later American objects.[87] In Norway in the mid-eighteenth century, bowls and mugs had applied and tooled diagonal leaves around their bases that created the impression of waves. A cream bucket attributed to Wistarburgh, a colonial-era glassworks in southern New Jersey, has similar wavelike ornament.[88] With its alternating tall and short elements, this bucket is perhaps the closest prototype for the nineteenth-century lily pad glass that was unique to the North American glass industry. Lily pad objects have been attributed to glasshouses in New York, Connecticut, New Hampshire, New Jersey, and Ontario.

Long before the Wistarburgh cream bucket was identified, however, the lily pad style was associated with the glass industry of nineteenth-century New Jersey that grew out of the pioneer venture. More examples with reliable histories, like this pitcher (62C)[89] and bowl (62A),[90] emanate from New York, however, rather than from New Jersey. In particular, the glasshouses in the New York towns of Redford and Redwood, famous for their crown window glass, are credited with a number of lily pad examples.

Because virtually all the known lily pad ware was fabricated with aqua, green, olive, or amber glass, it is clear that the style flourished at establishments where bottles or window-panes were the primary products. The role of tableware made at those factories is not fully documented, although from the time of Wistarburgh, such wares were produced for commercial sale and not necessarily made by glassblowers for their own use. In his published recollections, a clerk at the Redford Glass Company recalled that between 1836 and 1842, glassblowers William and Andrew Davidson made pitchers, lamps, and other articles that were sold from the company's office. During a period when the factory was shut down in the 1840s, another glassblower, Peter Strock, used the furnaces to produce hollowware. Among the forms he advertised were sauce dishes, bowls, and pitchers.[91] Usually, the decorative motifs seen in the hollowware from bottle and window factories were modeled after the fashions in refined glass, but the lack of high-style versions indicates that lily pad decoration did not find favor with the flint glass manufacturers.

The Toledo Museum's lily pad pitcher (62C), one of the largest known, is a masterful creation in which the tooled stems and pads, alternately tall and short, embrace and enhance the robust body. Their somewhat shaky irregularity contrasts with the even threading applied around the neck, while the plain disk foot provides a firm base that does not compete with the decorative impact of the body. The C-scrolls of the green pitcher (62B)[92] convey a different feeling—one of fluid circular motion—that is enhanced by the shape of the ribbed handle. On the bowl (62A), which is particularly deep, the glassblower crimped the foot, thereby reinforcing the sense of movement created by the lily pads. Here the tooled "tentacles" of glass extend nearly to the rim, and, when viewed from the top, form an especially dynamic design.

A.P.

Although ancient glassmakers developed a number of techniques to fashion objects of glass, glassblowing was the primary method of shaping glass from the first century C.E. until the late 1820s, when machine pressing was invented. European manufacturers used pincer presses and hand presses with plungers to form glass during the eighteenth century, but American glassmakers of the nineteenth century took the concept of pressing glass to the next level. By using machines they were able to produce very quickly large numbers of objects of uniform size, shape, and design. Moreover, the process allowed for the creation of complex patterns hitherto impossible in glass. Even though this technology revolutionized the glass industry, period sources fail to provide the story of its evolution. As the result of a destructive

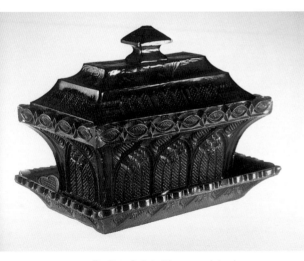

Fig. 63.1. Casket with cover and stand, 1835–40. Massachusetts. Opalescent deep blue glass; pressed. H (together): 13.3 cm (5 ¼ in.); L (stand): 17.8 cm (7 in.). Gift of Mrs. Harold G. Duckworth, 1968.34.

fire in the United States Patent Office in 1836, only summary descriptions of the earliest patents relating to machine-pressed glass remain as documentation of the new process. Newspapers and factory records offer few details, and the assertions and claims of individual manufacturers must be considered in the light of rivalries within the industry.

What is certain is that the technology was developed and brought to a high level of proficiency in the short period between 1825 and 1830. The first known patent referring to pressed glass was issued in 1825 to John Palmer Bakewell, of the Pittsburgh firm of Bakewell, Page & Bakewell. Bakewell's patent concerned the manufacture of glass furniture knobs by means of a bench press. James Bryce, who joined the glassworks as an apprentice at age eleven in 1823, mused in later life that, as a youth, he had perhaps made the first pressed glass in Pittsburgh and recalled that the early press was quite crude. When the American journalist Anne Royall visited the Bakewell firm in 1828, she saw glass molded "in the same way metal is cast," that is, with molten glass poured into a hinged mold and forced into shape with a hand-operated lever, piston, and plunger. Royall also observed what she called "the new fashion of stamping figures on the glass while it is warm."[93] This describes a technique by which a patterned mold was pressed onto a sheet of glass that then slumped into a receiver of the desired shape.

Between 1825 and 1830, patents for processes and machinery, as well as snippets of information from other primary sources, indicate that the New England Glass Company, the Boston and Sandwich Glass Company, and other prominent glasshouses were also busily experimenting with, and improving upon, machine pressing. In 1829 Deming Jarves of the Boston and Sandwich Glass Company patented the "stamping" process Royall recorded in Pittsburgh, with the aim of eliminating the costly molds and receivers otherwise required for each shape. Around the same time, the cap

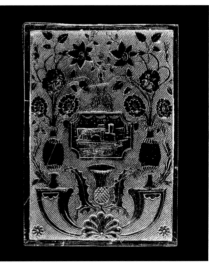

Fig. 63.2. Windowpane, 1833–36. John & Craig Ritchie, Wheeling Flint Glass Works, Wheeling, W.Va. Colorless glass; pressed. L: 17.8 cm (7 in.); W: 12.85 cm (5 ¹⁄₁₆ in.). Gift of Mrs. Harold Duckworth, 1968.53.

ring was invented as a way to control rim thickness and regularity. By 1830 there were presses that made it possible to fashion an open handle as an integral part of a pitcher. Within just a few years, a glassmaker, probably at the Sandwich factory, succeeded in pressing the Toledo Museum's remarkable tray (Fig. 63.3),[94] with its openwork rim and handles.

Because learning how to press glass required no more than four weeks' training, an entirely new class of cheap, unskilled labor entered the industry. The creation of molds, however, demanded a high level of skill and was therefore a costly facet of production. Moldmakers, not glassblowers, interpreted management's vision for product and pattern, but little is known about them or their design process.

During the 1830s, American glass manufacturers began to realize the full potential of the new technology. Furniture knobs, cup plates, and salts were the first pressed objects; a full range of tableware and ornamental shapes soon followed. In the beginning, pressed designs copied the angular, geometric patterns

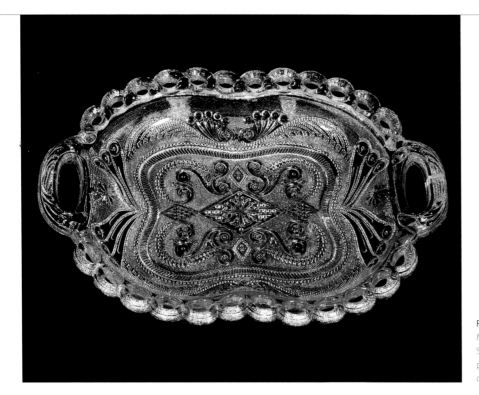

SUGAR BOWL

Probably Providence Flint Glass
Company, Providence, Rhode Island
1831–33
Deep cobalt-blue glass; pressed
H: 14.4. cm (5 ⅝ in.); Diam. (rim): 12.5
cm (4 ¹⁵⁄₁₆ in.)
Provenance: Mr. and Mrs. Harold G.
Duckworth, Springfield, Mass.
Gift of Mrs. Harold Duckworth, 1968.57

Fig. 63.3. Plate or Tray, 1835–40.
Massachusetts, possibly Boston and
Sandwich Glass Co. Colorless glass;
pressed. L: 29.8 cm (11 ¾ in.); W: 21.1
cm (8 ¼ in.). Museum Purchase, 1962.12.

of luxury cut glass, but a genre of so-called
"lacy" designs unique to pressed glass quickly
evolved. These were extremely intricate and
typically incorporated scrolls, hearts, flowers,
and other motifs against a stippled back-
ground. Stippling helped conceal the shear
mark made when the gather of glass was cut
off from the pipe or rod and dropped into the
mold. It also distracted the eye from any
unsightly cloudiness that resulted when hot
glass came in contact with a cool metal mold.

With their crisp, detailed designs, the four
objects illustrated here represent both the
finest in lacy style and the level of quality
attained by American glassmakers during the
1830s. The Providence Flint Glass Company was
a short-lived endeavor, operating only between
1831 and 1833. Besides the patriotic motif of
double-headed eagles above shields—one that
is also found on salts marked by the compa-
ny—the design on this blue sugar bowl[95]
includes floral baskets and classical acanthus
leaves. It is a rare example of colored glass

made in New England in the 1830s.

When viewed by backlight or other trans-
mitted light, the blue color of the three-part
casket (Fig. 63.1) reveals a fiery opalescence,
an appropriate transformation for an object
designed to evoke the romantic mystery of the
Gothic medieval past. In its decoration and its
form, which may represent a medieval jewel
box or even a tomb, the casket expresses the
Gothic Revival style that became fashionable
during the second quarter of the nineteenth
century.[96] The casket's decorative scheme is
dominated by pointed arches rendered as if
they were miniature stained-glass windows,
filled with quatrefoils and tiny lozenge shapes.
While Gothic motifs were featured in some
American cut and mold-blown glass of the peri-
od, the fine, intricate pattern of the casket
could only be achieved by means of pressing.

Flat, decorative windowpanes were easily
made by machine-pressing for use in cabinets,
door surrounds, and steamboat interiors. The
steamboat depicted on the Ritchie pane (Fig.

63.2),[97] for instance, suggests it was intended
to be used for an interior space on board ship,
where it would let in light without compromis-
ing passengers' privacy. The thistle motif
doubtless refers to the Scottish heritage of
John and Craig Ritchie, the owners of the glass
factory where this pane was made.

Ceramic examples probably inspired the mak-
ers of the glass tray (Fig. 63.3). English potteries
had produced oval stands with pierced rims of
this type from the 1780s. While the ceramic
forms served as stands for fruit baskets, the glass
version seems to have functioned as a serving
plate. Its design conveys a distinctive sense of
energy and movement, with the interplay of S-
scrolls and diamonds in the well and in the coni-
cal elements that burst forth at either end.
A.P.

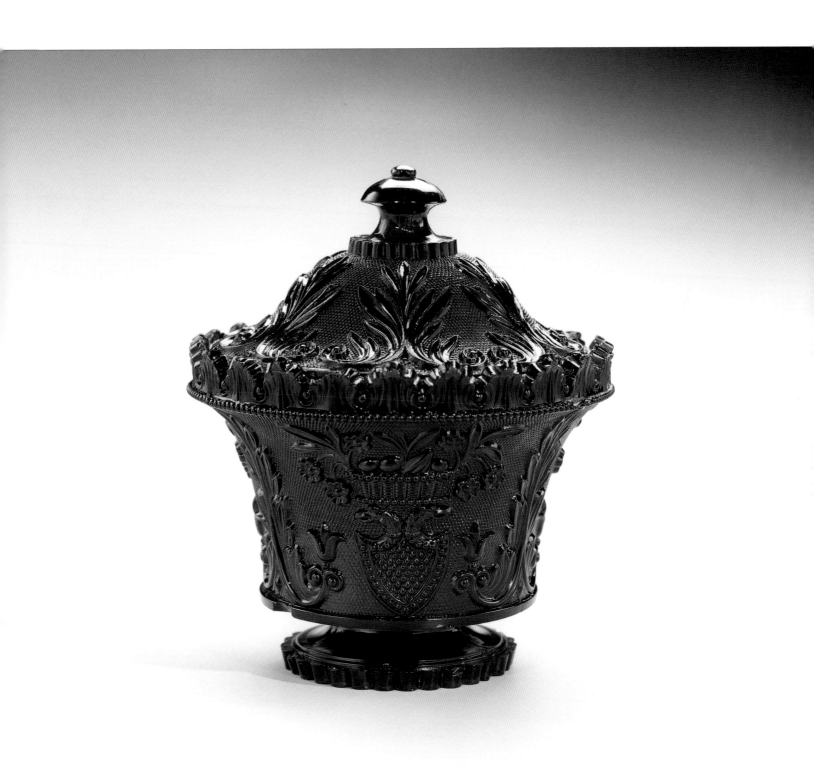

A decanter or bottle in the form of a bellows is but one example of a time-honored tradition of fashioning glass replicas of objects that would be utterly impractical in that medium. Devised as ornaments to delight and amaze, such whimsies were often showpieces or presentation items. For example, a bellows ornament made at the Portland (Maine) Glass Company is engraved with the name of the woman who received it as a wedding gift.[98] In spite of having an unusual stopper, the Toledo Museum's

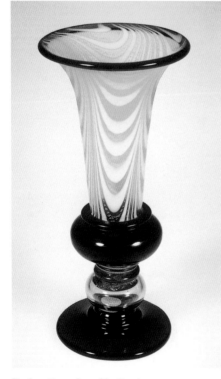

Fig. 64.1. Vase, 1849–1860. New Jersey. Pale green, opaque white, and amber glass; blown; looped decoration; stem containing 1849 Columbia half-dime. H: 23.4 cm (9 ¼ in.). Purchased with funds from the Libbey Endowment, Gift of Edward Drummond Libbey, 1948.49.

Mt. Washington bottle was surely never intended to function as a decanter.[99]

A bellows was a natural model for glassmakers. Suggestive of the fire that was integral to glass production, bellows also typically had a shape that conformed to the "free flow of a molten mass."[100] This remarkable example of a bellows-shaped bottle is the size of actual bellows used in late nineteenth-century households. Such bellows consisted of an air nozzle extending from the juncture of two wooden boards with central air holes and handle extensions; the boards were joined on each side with a gusset of pleated leather, held in place with a row of tacks. On a typical bellows flask, glassmakers suggested this pattern of tacks with applied rigaree decoration, as seen here. They also applied small disks of glass to the flat sides, to simulate air holes. Three colorless plumes on this Mt. Washington decanter may represent the symbol of the Prince of Wales and attest to the British background of its maker, John Liddell.[101] Although some bellows bottles were designed to be self-supporting on their "handles," more often they were mounted on a tall stem, to protect the protruding handles.[102]

The history of bellows bottles goes back several centuries. An Italian engraver depicted a glass bellows bottle as early as 1604, but most of the recorded examples date only from the nineteenth century.[103] Whimsical bellows bottles were especially favored in Great Britain; although traditionally attributed to the Nailsea Glassworks in Somerset, they were doubtless made throughout the country. Immigrant British glass craftsmen probably brought the taste for bellows bottles to the United States, where the form first appears in the mid-nineteenth century. Such examples are difficult to date precisely, however, and few have documented histories like this one made by John Liddell, a Scottish-born glassmaker, shortly after he immigrated to Massachusetts in 1884 at the age of thirty.

One of the largest known bellows bottles, this example by Liddell shows a masterful control of the combing technique. The circular ener-

gy created by the festoons seems to be released in the eight graduated knops of the improbable stopper. With its bold colors and precise looping, the decanter is a *tour de force* of conventional glassmaking techniques, yet at the time it was made, the Mt. Washington Glass Works was in the vanguard of the art glass movement. The factory superintendent, Frederick Shirley, had patented his Lava glass, the first American art glass, in 1878. During the 1880s, Mt. Washington produced many innovative art glass wares such as Rose Amber, Burmese, and Peachblow glass (all shaded glass), and a white opal glass suitable for enameled decoration. Mt. Washington had originally operated under the proprietorship of William L. Libbey in South Boston. In 1870 Libbey purchased a glasshouse in New Bedford and relocated the factory there, but two years later he left the firm to join the rival New England Glass Company in East Cambridge. John Liddell initially worked for Libbey in East Cambridge, but after less than a year of making primarily Amberina glass (see No. 67), Shirley hired him away to work at Mt. Washington.[104] At the time, the glassworks was flourishing and employed some 250 workers. The Toledo Museum also owns three examples of Mt. Washington's Burmese glass that were blown by Liddell.

Both British and American bellows-shaped decanters, bottles, and flasks were made in plain glass, but combed or looped decoration was preferred, probably to emphasize the virtuoso qualities of the vessel itself. Ever since ancient times, glassmakers have decorated glass by applying threads of white or colored opaque glass onto a base glass of a different color, incorporating them into the body by marvering (rolling), then combing the surface to create a swagged or feathered effect (see Nos. 3 and 7). The taste for this style of decoration extended to American bottle and window factories, where vases and pitchers blown of unrefined green, aqua, or amber glass were frequently embellished with fanciful loopings (Fig. 64.1).[105]

A.P.

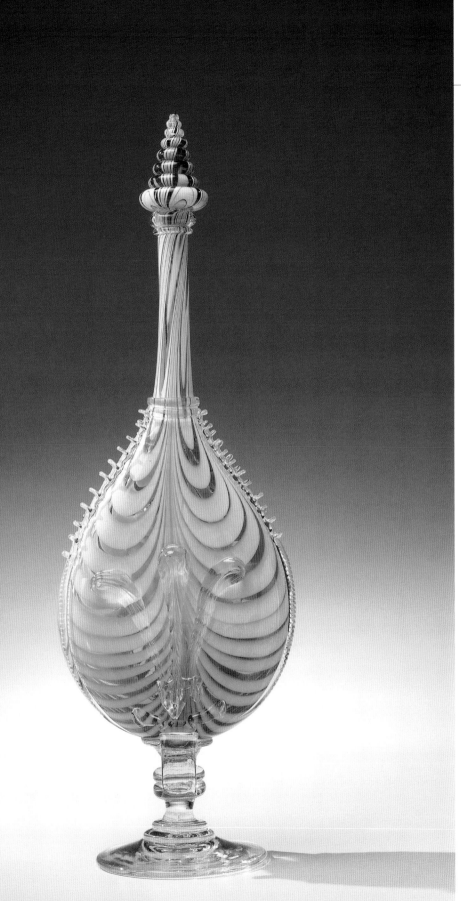

DECANTER

Mt. Washington Glass Works, New
Bedford, Massachusetts
About 1885
Made by John Liddell (glassblower at Mt.
Washington Glass Works, 1880s)
Ruby and opaque white glass, overlaid
with colorless glass; blown; looped,
applied, and tooled decoration
H: 50.0 cm (19 ¹¹/₁₆ in.)
Provenance: John Liddell; Alexander K.
Liddell (son of John Liddell) and Mrs.
Christina Dewar Newth, Toledo, Ohio.
Gift of Alexander K. Liddell and Mrs.
Christina Dewar Newth, 1954.12

The glass industry made great strides in the United States during the century between the American Revolution and the Centennial celebration in 1876. The 1880 census recorded 211 glassmaking establishments, employing more than 24,000 people and making products valued at U.S. $21,000,000.[106] Millions of glass objects were being produced annually—the Rochester Tumbler Company advertised a staggering production rate of 200,000 tumblers every six days.[107] As these numbers suggest, competition was severe. To capture the attention of merchants and the public at large, glass manufacturers were under tremendous pressure to emit a constant stream of new patterns. Many turned to the production of novelty ware in an effort to set themselves apart. As a result, a remarkable array of strange and wonderful designs entered the marketplace during the 1880s—some successful, others less so. In pressed glass, consumers could have owl plates, log-cabin pickle jars, and covered dishes in the form of railway cars. The same impetus for novelty drove the high-end glass business to emphasize unusual color effects, textures, and a self-consciously artistic approach.

Novelty had been an aspect of glassmaking since at least Roman times, when flasks were blown in such remarkable shapes as sandals.[108] European glassmakers continued that tradition, particularly with drinking-related objects. In the eighteenth century, ceramics manufacturers indulged in the conceit of serving dishes that resembled the food they were meant to contain. Potters borrowed freely from the agricultural realm for other forms, casting teapots that looked like pineapples, melons, and cauliflowers. Venetian glassblowers made faux fruit ornaments from the eighteenth century and possibly earlier. In the 1850s, paperweights resembling apples and pears were in vogue. In general, however, it was not commercially feasible to produce realistic facsimiles of natural forms in glass until the widespread use of full-size molds for blowing and pressing.

Joseph Locke, who had developed Wild Rose and Agata glass for the New England Glass Works (see Nos. 67 and 68) turned to the plant world for his mold-blown Maize art glass, first advertised in the summer of 1889. The ware mimics an ear of Indian corn, complete with rows of kernels in relief and husk leaves gracefully disposed around the base. According to the pictorial advertisement in the *Pottery and Glassware Reporter,* twenty Maize items were available, including a tumbler, a cream jug, a mustard pot, a cruet set, and a carafe. Pitchers like the one featured here from the Toledo Museum's collection[109] were the largest items made in Maize glass.[110] The ware was blown of opaque white or cream-colored glass, with the husk leaves painted in pale blue or green with gilded highlights.

It is interesting to trace the use of maize as a symbol in American glassware. When Maize glass was introduced into its production line, the New England Glass Works had just relocated to Toledo. If Locke seized upon maize as a suitable symbol of the company's new home in the Midwest, he was right on the mark: in 1861, Ohio's crop of Indian corn (maize), nearly sixty million bushels, ranked first in the nation.[111] He might also have selected it in response to the Centennial-inspired movement to generate designs of specifically American themes. Maize was first developed agriculturally in Mexico more than 5,000 years ago, and eventually became a food staple of indigenous peoples throughout North and South America. In 1891, Sarah Freeman Clarke, an artist and close friend of Ralph Waldo Emerson, wrote an article advocating the designation of Indian corn as the official national plant.[112] Finally, Locke may have gotten the idea for Maize glass from ceramic objects of corn design that had been popular for several decades. Parian porcelain vases rendered as ears of corn were produced by English and American potters from about 1850.[113] These were generally all white; realistically colored earthenware versions were offered in the 1870s by majolica manufacturers who carried the interpretation of naturalistic forms to astonishing heights (Fig. 65.1).

The production of Maize glass at its Toledo factory signaled Libbey's intention to continue the leadership role in art glass that the company had previously enjoyed on the East Coast. The line was not successful, however, and was made for only a short period of time. No examples of the three other new types of art glass advertised by the Libbey firm in 1889 and 1890 have been recorded.[114] After Locke left Toledo in 1891 and started his own art glass business in Pittsburgh, the Libbey Glass Company began to build a reputation for the manufacture of brilliant cut glass (see No. 72).

A.P.

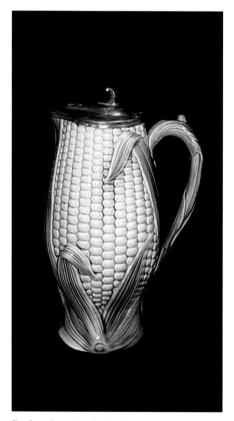

Fig. 65.1. Syrup jug. About 1875. Attributed to Edward Steele & Co., Hanley, Staffordshire, United Kingdom. Majolica ware, H: 20.3 cm (8 in.). Photo: Courtesy Charles L. Washburne.

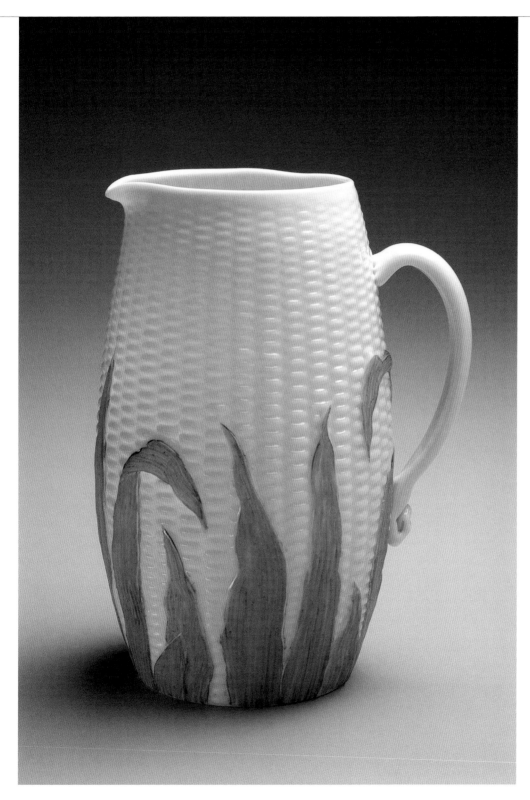

PITCHER
New England Glass Works or W. L. Libbey
and Son Glass Company, Toledo, Ohio
1889–90
Maize glass; mold–blown and enameled
H: 21.9 cm (8 ⅝ in.)
Provenance: Maud Feld, New York, N.Y.;
Ronald James, San Francisco, Calif.
Purchased with funds from the Libbey
Endowment, Gift of Edward Drummond
Libbey, 1968.8

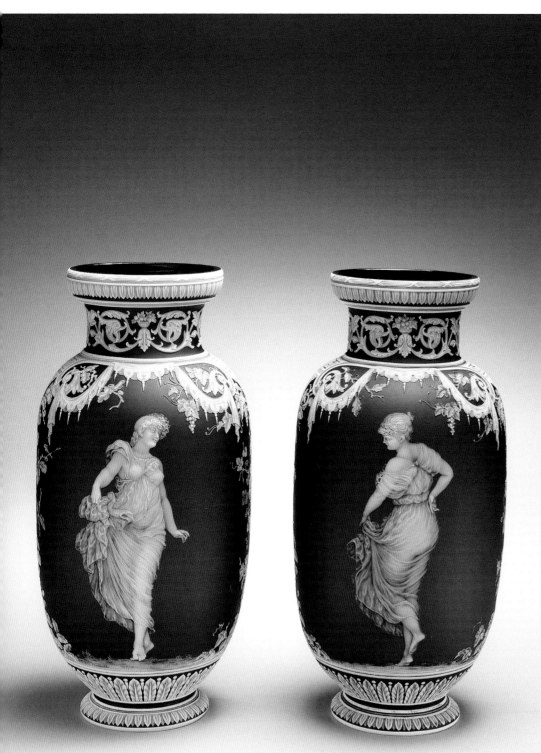

Cameo glass, one of the oldest and most complex decorating techniques for luxury glass (see No. 8), was the subject of an unprecedented revival in England in the late nineteenth century. The phenomenon was set in motion by the eminent Stourbridge glassmaker Benjamin Richardson (1802–1887), who offered a prize of £1,000 to the first artisan who could reproduce the famous ancient Roman Portland Vase in glass.[115] Two accomplished English glass entrepreneurs from Wordsley took up the challenge in 1873: the glassmaker Phillip Pargeter (1826–1906), who produced the blank at his Red House Glass Works, and his cousin, John Northwood I (1836–1902), a glass decorator and inventor already familiar with the cameo technique. They completed their vase in 1876, and it was exhibited (although cracked) at the Paris International Exhibitions of 1876 and 1878 to much acclaim, causing a sudden demand for cameo carved glass objects. Queen Victoria herself became enamored with cameo glass and frequently ordered items to distribute as gifts.

Northwood passed his knowledge on to the next generation of English glass decorators. Thomas Woodall (1849–1926) and his brother George Woodall (1850–1925), who engraved the Toledo Museum's pair of cameo glass vases, were apprenticed at the tender age of

**PAIR OF VASES WITH
GIRLS DANCING**
Thomas Webb & Sons, Amblecote, near
Stourbridge, United Kingdom
Engraved by Thomas Woodall
(1849–1926) and George Woodall
(1850–1925)
About 1895
Brownish-red glass cased with opaque
white glass; cameo carved
H: 32.5 cm (12 ¾ in.)
Provenance: Cure family, London;
Delomosne & Son, Ltd., London.
Purchased with funds from the Libbey
Endowment, Gift of Edward Drummond
Libbey, 1970.442 and 1970.443

about twelve at J. & J. Northwood.[116] Thomas Woodall is known to have assisted Northwood in preparing the blank of the facsimile Portland Vase for carving. The Woodall brothers must have been keen apprentices, as their work soon surpassed that of their mentor. The Woodalls eventually produced much of the finest cameo glass ever made for Thomas Webb & Sons, the firm in Amblecote, where they worked from 1874 until 1896, after which George left to carry out special commissions in cameo glass on his own. During their careers, the Woodalls contributed two important innovations to cameo glass technology: extensive use of the cutting wheel, which greatly accelerated the still time-consuming process, and overlaying white glass with a bluish tint over a dark base color, which allowed for a much greater variety of shading than was possible with untinted opaque white glass.

This pair of vases is an example of the Woodalls' advanced cameo technique.[117] Both vases are of ovoid shape with a short straight neck, an out-splayed and slightly inverted rim, and an applied flared foot. The dancing young women in diaphanous classical costume are designed to face each other when the vessels are placed together on a shelf or mantel. The figure on the left is shown frontally with her head turned to her left, in a three-quarter profile; she gathers her skirt with her right hand, exposing her bare feet and calves. The other maiden is depicted in a similar pose, except that she is seen from the back and grasps her skirt with her left hand, with her right arm placed on her hip. Both women dance under canopies of drapery with scalloped borders and pendants, suspended from scrolls and interlaced with fruiting grapevines and oak branches with acorns. The plants on each vase issue from the ground beneath a slender fluted column with a footed base and an acanthus capital, framing the figures on either side. The reverse of each vase shows a coat-of-arms (Fig. 66.1). The vases' necks are decorated with friezes of Renaissance-inspired grotesque orna-

ment, and the rims and bases are embellished with friezes of stylized acanthus leaves framed by solid bands. The vases are marked under the base: "T & G Woodall" and "G.C." for "Gem Cameo," identifying them as Webb's highest quality cameo wares.

The two vases were made at a time when the labor-intensive "Gem-Cameo" technique was used, mostly for special commissions, at Thomas Webb & Sons. Before long, cheaper technologies, such as acid-etching in England and thick enamel-painting in Germany and Bohemia, provided a similar look of relief decoration and undermined the market for expensive cameo-carved glass. By 1912, George Woodall mourned the diminished interest in cameo glass due to mass production of cameo look-alikes.[118]

Thomas Webb & Sons' price book from the period lists two vases (untitled) with the Cure and Cheyney arms as numbers W2838 and W2839, but does not list a price, a date, or a specific patron.[119] Because other price-book entries before and after these, such as W2830 and W2842, indicate 1895 as their production date, the Toledo Museum's vases can be attributed to that year. George Woodall most likely derived the motif of the dancer, which appears on several works from the mid-1880s to the 1890s, from an engraving with the same title published in *The Works of Antonio Canova in Sculpture and Modelling* (London 1876), a book that he is known to have owned. He also may have used his eldest daughter, Alice, as a model for the poses and facial features.[120]

The coat-of-arms on the reverse identifies the first owner of the vases, a member of the Cure family of London. The arms of Cure of Blake Hall, Essex, are quartered with Cheyney (or Cheynye) of Berkshire and Upavon, Wiltshire, with the motto on a scroll beneath *"FAIS CE QUE DOIT ARRIVE QUE POURRA"* ("Do what must be done come what may"). The joint arms probably celebrate a descendant of Capel Cure of London and his wife Frederica Cheyney, who both died in 1878. Their descendants would have quartered their mother's

arms, Cheyney (or earlier Cheynye), with their father's, as she must have been a heraldic heiress. One of their most prominent descendants, their grandson Sir Edward Henry Cure (1866–1923), became Grand Officer and Commander of the Crown of Italy, and served Queen Victoria at the British Embassy in Rome.[121] The elaborate Woodall vases, undoubtedly far exceeding the cost of £63 for a jar with comparable decoration made for stock sale, may have been commissioned in 1895 for this illustrious member of the Cure family.
J.A.P.

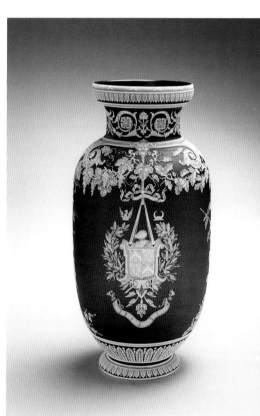

Fig. 66.1. Reverse of TMA 1970.442.

When Charles Colné, assistant secretary to the United States Commissioners, reported on the glass exhibited at the 1878 Paris Universal Exposition, he was dismayed to find the "artistic skill displayed by the European manufacturers . . . in marked contrast with our home productions." Especially with regard to the design of "articles of luxury," he felt that the United States was "sadly behindhand." Colné urged American manufacturers to travel "out of the now beaten path of ordinary goods" and take up instead "the making of beautiful fancy articles."[122] Glassmakers took this advice to heart. Within a few years, they developed a variety of "art" glasses that were eminently suitable to the production of "beautiful fancy articles."

Shaded and parti-colored glass formed the basis for much of this new art glass. Two Massachusetts glasshouses, the Mt. Washington Glass Company in New Bedford and the New England Glass Works in East Cambridge, simultaneously created a transparent glass that shaded from yellow-amber to ruby red. Frederick Shirley of Mt. Washington apparently made his "Rose Amber" first, but Joseph Locke at the rival firm filed for a patent for his version, known as "Amberina," in July 1883, before Shirley did. The innovative glass was made by mixing a small amount of colloidal gold into a transparent amber glass. After an article was made from this batch, it was allowed to cool, then selectively reheated at the glory hole. The glass became red in the reheated portions and gradually shaded down toward the pale amber base.

Locke's sketchbook and a price list reveal the range of forms and shapes available in Amberina glass, from berry bowls to champagne decanters. Because the effect of the shading was enhanced by optic molding, many examples had ribbed, diamond, or hobnail patterns. Few, however, combined shape and pattern as successfully as the Toledo Museum's graceful horn-shaped vase.[123] Its swirling ribs complement the horn's curved shape and the domed foot and, together with the shading of the colors, achieve a dynamic sense of movement. This dramatic effect is further heightened by the contrast between the tightly swirled ribs of the looped "tail" and the more widely spaced ribs of the body.

Although it has a sleek, modern appearance, this vase shape recalls the *rhyta* or drinking horns of ancient and medieval times.[124] Its twisted tail is reminiscent of the fanciful stems of *façon de Venise* wine glasses. The idea of transforming horn-shaped vessels into flower vases took hold during the second quarter of the nineteenth century, when classical cornucopias made of glass sprang from metal ram's-head mounts set on rectangular marble bases.[125]

When Edward Drummond Libbey assumed control of the New England Glass Works after his father's death in 1883, he found it overstocked with unsold Amberina glass and on the brink of financial ruin. He sold the entire inventory to Tiffany & Co. in New York, where it succeeded in capturing the public's attention. Amberina glass became an important product for the company in the 1880s, but it is not known exactly how long it was made. This unique vase, originally owned by William S. Walbridge, the brother-in-law of Edward D. Libbey, may have been designed as a gift in the early 1890s, after the company moved to Toledo. By then there was considerable competition from foreign as well as domestic manufacturers, who not only produced Amberina-type glass but also countless other kinds of art glass. Joseph Locke, Frederick Shirley, Louis Comfort Tiffany, and other successful glass designers seemed to understand that consumer demand warranted constant innovation. The Libbey Glass Company resumed production of Amberina glassware in 1917, hoping it would once again meet with "a genuine success because of its simplicity and artistic merit," but it was made for only a brief period.[126]
A.P.

VASE
New England Glass Works, East Cambridge, Massachusetts, or Libbey Glass Company, Toledo, Ohio
1883–93
Amberina glass; blown and molded
H: 20.1 cm (7 15/16 in.); W: 24.7 cm (9 3/4 in.)
Provenance: Alice Libbey Walbridge and William S. Walbridge, Toledo, Ohio; Marie Walbridge Greenhalgh, Berryville, West Virginia.
Gift of Marie W. Greenhalgh, in memory of her parents, Alice Libbey Walbridge and William S. Walbridge, 1958.63

Most objects made in nineteenth-century American glasshouses were drinking vessels and other utilitarian tableware. The majority of them were fabricated of inexpensive pressed glass. By the 1870s, however, glass began to be viewed as an artistic medium that could find expression in strictly ornamental forms. This trend was part of the style known as the Aesthetic Movement, which was reflected in architecture and the decorative and fine arts in the United Kingdom and the United States throughout the 1870s and 1880s. During this time, glassmakers were seeking novel ways to affect the appearance of glass in an effort to attract the public's interest and to compete in an ever-expanding industry. For centuries, manufacturers were drawn in two seemingly opposite directions: on the one hand, striving to create a pure, colorless, transparent material, and, on the other, to make colored opaque glass that mimicked stone, porcelain, or other materials. Because of advances in chemical and furnace technology, glassmakers of the late nineteenth century could produce glass in many guises.

Several of the most innovative types of American art glass were developed in the 1880s for the New England Glass Works by the ingenious Joseph Locke (1846–1936). At the age of nineteen, while he was an apprentice at the Royal Worcester Porcelain Works, Locke won a competition to design a glass fireplace that Tsar Alexander II of Russia had commissioned from Guest Brothers, glass etchers and decorators in Stourbridge, England. Locke went to work for Guest Brothers, but he was soon hired by Hodgetts, Richardson and Son in Wordsley, to manage an etching and decorating department. Under the tutelage of the master carver and engraver Alphonse Lechevrel, Locke learned the technique of cameo carving. Locke's remarkable, but unfinished, copy of the Portland Vase, the famous ancient Roman cameo glass in the British Museum, was exhibited in the display of Hodgetts, Richardson and Son at the 1878 Universal Exposition in Paris.[127] Between 1879 and 1882 Locke worked for two

Fig. 68.1. Plate in the form of a shell. About 1810. Josiah Wedgwood II, Staffordshire, United Kingdom. Earthenware with luster decoration. L. (max.): 21.6 cm (8 ½ in.). Gift of Mrs. Harold G. Duckworth, 1970.292.

other Stourbridge glasshouses. In 1882 he immigrated to the United States to take a position at the Boston and Sandwich Glass Company. Representatives of that Massachusetts firm planned to meet his ship in New York, but he landed instead in Boston. The New England Glass Works in East Cambridge learned of his arrival and immediately engaged his services. As a result, the New England Glass Works became a leader in the field of art glass.

As discussed above (see No. 67), Locke developed Amberina glass by the summer of 1883. Among the varieties of shaded glassware that followed this invention were opaque glasses treated to resemble Chinese "peachblow" porcelains. The version of peachblow that Joseph Locke patented for the New England Glass Works in March 1886 was called "Wild Rose." It was made by combining opal glass with gold-ruby glass. When reheated, the glass shaded from deep rose to white. The surface could be glossy or treated with acid for a matte, satin finish.

Within a year Locke devised a method of further embellishing Wild Rose. After annealing, the vessel was coated—either wholly or partially—with a metallic stain. A volatile liquid such

as benzene, alcohol, or naptha was then applied to the stained area, and when this evaporated, it left a delicately mottled surface pattern that was made permanent in a low-fire muffle kiln. Because of its resemblance to the naturally occurring stone called lace agate, this type of art glass was named Agata.[128] The mottled surface in tones of silver, gold, and mauve also recalls the variegated lusterware pottery made by Wedgwood in the early 1800s (Fig. 68.1) and the less refined, speckled lusterware associated with the Sunderland potteries.[129] Agata glass was produced at the New England Glass Works for only a short period, from January 1887 until the factory closed at the end of the year in order to move its operations to Toledo, Ohio.

The elegant shape of this vase expresses the naturalistic tenets of the Aesthetic Movement. Blown and tooled into the flared shape of a calla lily, it illustrates one of the most popular shapes in art glass. Lily vases are recorded in Amberina, Burmese, and other shaded art glasses and were made in several sizes. Mt. Washington's lily-form vases in Burmese glass were offered in seven sizes, from six to twenty-four inches tall.
A.P.

VASE
New England Glass Works, East
Cambridge, Massachusetts
1887–88
Agata glass; blown
H: 37.5 cm (14 ¾ in.)
Provenance: Ronald M. Jarzen,
Chicago, Illinois.
Purchased with funds from the Libbey
Endowment, Gift of Edward Drummond
Libbey, 1972.22

The glass retailer J. & L. Lobmeyr of Vienna has been a tastemaker in luxury glassware since the first half of the nineteenth century, when the firm became a leading force behind the reformation of the Austro-Bohemian glass industry. Founded by Josef Lobmeyr Sr. in 1823, the firm has continued to prosper for five generations. The owners' keen design sensibilities and uncompromising attention to quality have secured the firm an illustrious international clientele and the title "royal glaziers and glassware suppliers to the Austrian court."[130] The company adopted its current monogram in 1860, interlacing the initials of Josef Sr.'s two sons and successors, Josef Jr. and Ludwig. Ludwig, who led the firm from his brother's untimely death in 1864 until 1902, was a tireless innovator and was well attuned to the tastes of his time. He expanded the network of suppliers to numerous glassworks and decorating shops throughout Bohemia. Well-established glasshouses, such as Lötz in Klostermühle and Friedrich Egermann in Haida, provided exquisite tableware, but Johann Meyr in Adolph emerged as the primary supplier to Lobmeyr because of a family connection. Ludwig Lobmeyr designed many patterns himself, but he also relied on a pool of experts and personal friends, mostly professors from the Schools of Applied Arts in Vienna and Prague, all recognized architects, artists, and designers.

This plate exemplifies the eclectic style of historicism (*Historismus*) popular in Continental Europe.[131] The decoration combines monochromatic classical palmettes, luscious acanthus scrolls recalling Baroque motifs, and the delicate flowers, insects, and snakes abundant on porcelain and glass of the Empire and Biedermeier styles in Austria and Germany. It is richly decorated with transparent and opaque enamels. The center displays an arrangement of three fluttering butterflies interspersed with four small flying insects, painted in transparent enamels. This central design is framed by a narrow geometric border of short vertical rays edged by two dark green lines. The gilded

Fig. 69.1. "Blumen Serie aus Kristallglas mit Gold und durchsichtigem Email, die Schlangen in opakem Email gemalt. Blatt A. 1888" ("Flower Series in crystal glass with gold and transparent enamel, the snakes painted in opaque enamel, Folio A. 1888"), from Lobmeyr, *Werkzeichnungen*, vol. 17 I. Watercolor and ink on paper. Photograph courtesy Museum für Angewandte Kunst [MAK].

monogram of the Lobmeyr firm is integrated into this design beneath the largest butterfly, providing orientation. Six writhing snakes with bifurcated tongues, painted in dark green opaque enamel and surrounded by gilded vermiculation, decorate the next zone. This serpentine circle is framed by a slightly wider rayed band and a circle of stylized floral tendrils with bluebell-like flowers. The wide rim is ornamented with an intricate band of green acanthus leaves, the tips dramatically highlighted with transparent red enamel. The edge of the plate is enhanced by a rope-like band and a row of palmettes alternating with floral buds.

The translucent enameling on this plate reflects Ludwig Lobmeyr's efforts to distinguish his product from the thickly painted mass-produced wares with coats-of-arms and other historicizing Germanic ornaments made by the majority of Bohemian glasshouses at the time.[132] A design for a similar plate is included in a bound volume of working drawings that was donated by Ludwig Lobmeyr to the Austrian Museum for Art and Industry, founded in 1864 (Fig. 69.1). The rim decoration on the drawing is even more complex than that on the Toledo plate: the pattern-book drawing shows a rim of stylized dark green leaves alternating with floral stalks, interspersed with small flying insects.

The "Flower Series" comprised a large variety of luxury tableware, which is illustrated in *Blatt B* (Folio B) of the working drawings. There are three different forms of pitchers: one for iced juice, represented by an outline drawing in cross-section that shows a depression for crushed ice; a water pitcher with bell-shaped base and snake-shaped handle; and a smaller carafe, also with a snake handle. The album also illustrates a footed beaker with a short stem; a slightly bell-shaped, footed beaker with vertical acanthus-leaf decoration; a champagne glass with open bowl; and a glass with a mold-blown quatrefoil bowl on a drawn stem. Few of these glasses survive. A lobed goblet on a pedestal foot and a matching fingerbowl and plate are in the MAK, Vienna,[133] and another goblet is in The Corning Museum of Glass (acc. no. 2001.3.54). Both of these goblets have rose-colored transparent flashing near their gilded rims. Three other objects from this series still exist in the Lobmeyr firm's collection: a small plate with a band of interlaced leaves around the rim (15.3 cm), a water pitcher with snake handle (21.5 cm), and a footed bell-shaped beaker (13.3 cm).

Although the "Flower Series" was inspired by nature both in form and decoration, it is far removed from the burgeoning Art Nouveau style

that dominated the decorative arts elsewhere in Europe and Great Britain at the end of the nineteenth century. Since Ludwig Lobmeyr had no sympathy for this new form of artistic expression, the designs for this series remained stylized and highly controlled. Uncomfortable with the demands of a new era, in 1902 he transferred the firm's directorship to his nephew, Stefan Rath, who truly brought the venerable firm into the twentieth century by playing an instrumental role in the formation of the Wiener Werkstätte (Vienna Workshops), a cooperative of avant-garde artists working in furniture, jewelry, metal, and book arts, founded in 1903 by Josef Hoffmann and Koloman Moser, who were part of the earlier radical movement, the Vienna Secession (see No. 74).

J.A.P.

PLATE
Austria, Vienna, J. & L. Lobmeyr
Designed 1888
Colorless glass; blown, enameled, gilded
Diam.: 45 cm (17 ¾ in.)
Provenance: Knut Günther, Frankfurt-am-Main, Germany.
Purchased with Funds from the Florence Scott Libbey Bequest in Memory of her Father, Maurice A. Scott, 1983.9

163

Enamel work is rarely considered an integral part of the history of glass because the technique heavily relies on a metal substructure or framework, rather than being primarily made of glass. Similar to enamel decoration painted on glass vessels, ground polychrome glass powder is commonly mixed with an oily or glue-like medium so that it can be applied to the metal substructure with a brush. In enamel decoration on both glass and metal, the enamel is fused to its substrate by being fired in a kiln, which burns off the residual medium. This exquisite small bowl represents a labor-intensive version of decorative enameling called *plique-à-jour* or *email à jour*,[134] which was developed in France during the late fourteenth to early fifteenth centuries and was perfected in China and Japan. In Europe, interest in Asian enamelwork intensified in the last decades of the nineteenth century, following the 1854 treaty between Japan and the United States, which opened Japanese markets to Western trade. The result was an increasing influence of Far Eastern art on Western decorative arts.

Plique-à-jour (a French term that literally means "braid letting in daylight") is an enameling technique that looks like miniature stained glass. It is a technical tour de force that requires glass enamels to be suspended within a filigree framework of gold or silver without a metal backing. To create a vessel in this technique, the base and the wall are first laid out in a flat filigree framework. Next they are soldered together, then assembled and shaped on an iron form. Once the framework is complete, the small openings are filled with ground glass enamel suspended in a glue-like medium. The most challenging aspect of this process is that, until the enamels are fused in a kiln, only the surface tension of the liquid holds the enamel mass within the filigree "walls." All areas of one color are filled with the enamel in suspension before the artist moves on to work in another color. Painterly effects are created by applying shades and tones in a given color field, and the modulated colors are built up in layers by inter-

mittent firings. The entire process requires great delicacy, skill, and patience.

The small bowl featured here recalls the traditional hemispherical shape of Far Eastern tableware. It is constructed of a gold wire framework on a gold base ring, with a gold band edging the rim. The curved walls are decorated in translucent enamel with two tiers of ten anemones displaying white blossoms with blue centers. The feathery green stems emerge behind a delicate fence composed of thin pointed arches in brown enamel. The center of the base displays the mirror monogram "FT" below the date "1900" (Fig. 70.1). The monogram is the mark of André Fernand Thesmar (1843–1912), from Châlon-sur-Saône, who initially became known as a painter of flowers. In 1872, Thesmar

associated himself with the studio of the famed Parisian bronze foundry of Ferdinand Barbedienne (1810–1892), where the young artist began to explore metalwork with enamels. Thesmar first became acquainted with Chinese and Japanese enamels when he visited the collection of Asian art formed by Milanese financier Henri Cernuschi (1821–1896), who had acquired various objects during his travels and displayed them at his mansion in Paris. From 1882, Thesmar briefly collaborated with the short-lived enamel studio at the porcelain factory of Sèvres, decorating porcelain with translucent cloisonné enamels.[135]

For his work in enamels, Thesmar first applied the monogram formed by the mirrored letter "F" joined by a "T" to his enameled cop-

Fig. 70.1. View of base of TMA 2005.43.

per vessels in 1875.[136] Beginning in 1891, he marked all work executed at his own studio in the avenue du Roule, Neuilly-sur-Seine, with this monogram. He produced objects in the exacting *plique-à-jour* technique for sixteen years, from the end of 1892 until about 1908. It was during this period, in 1893, that he received the medal of the Legion of Honor for his contributions to the fine arts in France. Thesmar's largest *plique-à-jour* object, a hemispherical bowl on a matching stand, was presented to the Russian Tsar Nicholas II on the occasion of his state visit to France in 1896.[137]

The Toledo Museum's anemone bowl is one of a homogenous series: a nearly identical bowl is in the Musée d'Orsay, Paris, dating as early as 1892.[138] Thesmar displayed his work in *plique-à-jour* in the jewelry and metalwork section of the 1900 Paris Universal Exposition, where his work received much praise. Due to the date 1900 that is incorporated in fine gold wire into its base, this anemone bowl may have been made on the occasion of that important world's fair. Vessels created by the laborious *plique-à-jour* technique continued to be exceptional *objets de luxe* for many years. Jewelers throughout Europe found the technique's transparency and coloristic effects perfectly suited for spectacular jewelry designs in the Art Nouveau style (most notable among them the jeweler René Lalique) representing insect wings, blossoms, and delicate leaves.

J.A.P.

BOWL
France, Neuilly-sur-Seine
André Fernand Thesmar (French, 1843–1912)
1900
Gold, translucent enamel; *plique-à-jour* technique
H: 5 cm (2 in.); Diam. (rim): 9.1 cm (3 ⅝ in.)
Provenance: Sotheby's, Paris, 26 May 2005, lot 29.
Mr. and Mrs. George M. Jones, Jr., Fund, 2005.43

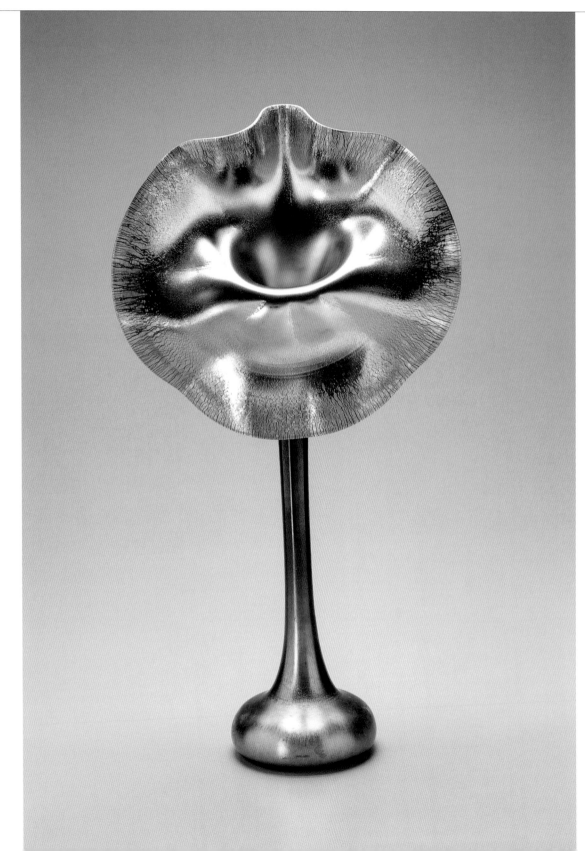

VASE
Tiffany Furnaces, Corona, Long Island,
New York
Louis Comfort Tiffany (United States,
1848–1933), designer
About 1913
Iridescent blue glass; blown
H: 50.7 cm (20 in.); W. (max.): 28.3 cm
(11 1/8 in.)
Provenance: Private collection,
Stockholm, Sweden; William Feldstein,
Beverly Hills, Calif.; Barry Friedman Ltd.,
New York, N.Y.
Gift of Helen and Harold McMaster,
1986.62

As an artist, designer, and tastemaker, Louis Comfort Tiffany altered the course of American decorative arts in many fields, not only glass. Initially he explored the role of glass within architecture. Dissatisfied with the materials available for making stained-glass windows, Tiffany began to experiment with glass in the 1870s. By 1881 he had developed and patented an opalescent glass that revolutionized that art form. Tiffany's glass was internally variegated in color, its effects modulated by light. Through experimentation with blending colors, layering glass, and molding and manipulating textures, Tiffany achieved unprecedented illusionistic effects. When he turned to another venerable art form, glass mosaic, he similarly transformed it by introducing innovative shapes and colors. The chapel installation that Tiffany exhibited at the 1893 World's Columbian Exposition in Chicago—filled with sparkling mosaic work—brought him international recognition.

That same year, Tiffany turned his attention to the production of vessel glass, and erected a glassworks in Corona, Long Island. Under the direction of an English glassmaker, Arthur J. Nash, the glassblowers developed the ideas Tiffany had already implemented in stained glass and mosaics, such as mixing different colors in the molten state and creating lustrous surfaces. As early as 1880, Tiffany had applied to patent the process of making luster or iridescent glass produced "by forming a film of a metal or its oxide, or a compound of a metal, on or in the glass either by exposing it to vapors or gases or by direct application."[139]

Tiffany's interest in iridescent glass suggested he was familiar with the English and European iridescent glass made in the 1870s. Indeed, when the Art Journal reported on glass shown at the Paris Universal Exposition in 1878, it claimed that the vogue for iridescent glass was already on the wane in England. Iridescent glass remained popular on the Continent, however, because numerous examples by European glassmakers were exhibited in Paris. Bohemian manufacturers in particular "have adopted it for

what fairly may be called objets d'art," according to the reporter. In his opinion, J. & L. Lobmeyr of Vienna (see No. 69) "carried the application of this rainbow glass beyond any other manufacturer." The Journal made a distinction between "iridescent" glass and the patinated "Bronze" glass produced by Thomas Webb & Sons (see also No. 66). As its name implies, Webb's green-based glass was "bronzed by means of metallic oxides," yet it remained translucent "with very beautiful metallic reflections."[140] With the glass he produced in the 1890s and early 1900s, Tiffany took iridescent glass to an entirely different level.

Tiffany called his entire line of vessel glass (as opposed to window or mosaic glass) "Fabrile," an Old English word meaning handwrought, and in 1894 changed it to "Favrile." The name was intended to convey that each object was hand-blown and unique. When Arthur Nash's son, Leslie H. Nash, started designing for Tiffany in 1912, he wrote that he was "not allowed to do the sort of things that sold well. I was informed that what I was doing was too commercial and that I was sacrificing Art for money."[141] Tiffany expected constant experimentation and innovation. Although the glasshouse made some functional tableware, Tiffany promoted his expensive Favrile glass as art objects to be acquired by private collectors and art museums, and almost immediately succeeded in placing a number of examples in art museum collections. As a result, his work was admired and emulated by competitors, both in the United States and abroad. An important promoter of Tiffany glass was the Parisian impresario of Art Nouveau, Siegfried Bing—it was his art gallery, "La Maison de l'art nouveau," that gave the movement its name. Commenting on the Favrile glass that Tiffany sent to his gallery in 1895, Bing marveled that "it was still possible to innovate, to utilize glass in a new way that was often opaque and matte, with a surface that was like skin to the touch, silky and delicate."[142]

The Toledo Museum's blue luster vase embodies all the remarkable qualities of Tiffany

Favrile glass.[143] Although the form is known as a "jack-in-the-pulpit" vase, it bears little resemblance to that plant. A similar one is described as a calla lily vase in a period book of Tiffany factory photographs, where it is also noted that the vase was made in two sizes.[144] Regardless of the flower that inspired the design, with its huge, brilliantly colored blossom rising from the bulb on an impossibly attenuated stem, the vase is a tour de force. The flower's edge is textured with fine lines and crackles that suggest living plant tissue, as its undulating shape maximizes the effects of light on the colorful iridescent glass.

During the second half of the nineteenth century, manufacturers working in glass as well as other materials were drawn to the novelty of making flower vases as realistic versions of the plants themselves. In the Art Nouveau period, however, glass designers such as Tiffany took a more intense, artistic view of natural forms. His vision is at the opposite end of the spectrum from the glass botanical specimens, virtuosic in their own way, that Leopold and Rudolph Blaschka fabricated for Harvard University during the same period. Although Tiffany's vases clearly represent flowers in both bud and full-blossom stages, they are rendered in an idealized, painterly manner and are obviously not intended to be used as containers. In their combinations of opalescent, clear, and iridescent glass, resplendent with delicate trailings and veinings, these unique forms imaginatively capture and reflect light.

With sinuous lines and swelling, organic shapes these floriform ornaments fulfill one of the precepts of Tiffany glassmaking as recalled by Leslie Nash, namely that forms "take on the contour natural to glass blowing."[145] Bing marveled at vessels like this and in 1898 wrote that in Tiffany's hands "there grew vegetable, fruit, and flower forms, all [of] which, while not copied from Nature in a servile manner, gave one the impression of real growth and life."[146]

A.P.

73–78 EARLY TWENTIETH CENTURY

By the turn of the twentieth century, Sweden was a modern industrialized nation when compared to many other European countries, having already shed the constraints of government regulation that had previously hampered its growth in social and economic sectors. With that shift, the venerable Swedish glass industry experienced an unprecedented period of expansion from the 1870s on, along with progress in Sweden's national textile, steel, and lumber industries. Growth was the result of investments in local infrastructure and a rapidly expanding network of roads and railroads.[1] Immigrant glassworkers, especially from Germany and Bohemia, had always been an important part of Sweden's skilled labor force. In the wake of the Arts and Crafts and Art Nouveau movements, Swedish luxury glass manufacturers — like their counterparts in England, France, and Austria — began to enlist independent artists to work with their factories. Among them was a small but remarkable group of women who had benefited from the progressive mid-nineteenth century reforms of the Swedish educational system, giving women access to higher education in academies and universities.

Anna Katarina Boberg had studied painting in Stockholm and Paris, where she met her future husband, the renowned Swedish architect Gustav Ferdinand Boberg (1860–1946). Both were accomplished artists whose work was based on the principle that domestic architecture should be a comprehensive design resulting from the coherent integration of plan, design, and craft. Anna received wide recognition for her Art Nouveau–inspired designs in porcelain, furniture, and glass in the 1890s and early 1900s at international expositions in Chicago and Paris.[2] She worked only briefly as a designer of glass in 1902, for the Reijmyre Glassworks (one of Sweden's oldest glass factories, founded in Kolmården, near Stockholm, in 1810). Reijmyre, like other Swedish companies, focused on creating glass inspired by the large French glassmakers and ateliers that dominated turn-of-the-century European art glass. Reijmyre hired Anna

Boberg and Betzy Ählström to create designs for its ambitious new line of Gallé-glas, influenced by the elaborate vessels in *marqueterie de verre* (glass inlay) patented in 1898 by the French Art Nouveau glass artist Emile Gallé (1846–1904).

Anna Boberg fulfilled her assignment in the design for this bowl with an expressive aquatic theme. The wide, globular vessel was probably intended as a planter or as a centerpiece to display blossoms floating in water.[3] The translucency gradually decreasing toward the base suggests the bottom of a pond. The glass appears to be inhabited by a shadowy beast — a sinewy eel with large, watchful eyes — swimming amid the vessel's leafy algae. All of the painterly details were applied to the blown glass form by a skilled craftsman while the glass was still hot and then worked with hand tools, most likely under the artist's supervision. The multi-colored plant sections, applied in pre-selected pieces of colored glass, are embedded between layers of transparent green and colorless glass, creating an effect of depth and relief. After the vessel was cooled, delicate engraved lines were added to enhance outlines and plant veins.

The eel bowl design was among the Reijmyre products featured in the Swedish Pavilion designed by Gustav Ferdinand Boberg for the Turin Exposition of 1902, which showcased an ambitious display of international decorative arts. Following the bowl's successful introduction at the Exposition, a limited edition was executed by Fredric Kessmeier (1859–1946), a German glassblower at Reijmyre. This bowl was part of that series and is engraved under the base "Reijmyre 1903, No. 95, Anna Boberg."

The Gallé-glas line was short-lived at Reijmyre, partly because of its cost but primarily due to Swedish patrons' waning interest in the Art Nouveau style. Nevertheless, the French decorating technique of glass overlays had long-lasting effects on Swedish glassmaking, in that it gave impetus to the development of Swedish *graal* glass a decade later.[4] The Orrefors glassworks in Småland hired from 1916 Simon Gate (1883–1945) and from 1917 Edvard Hald

(1883–1980), both painters, to experiment with new designs and in new techniques, for example *graal* developed by the masterblower Knut Bergkvist.[5] This process involved encasing a cooled blank of transparent glass in a layer of a contrasting colored glass; the form was then decorated by an engraver using cold-working techniques (cutting, etching, or engraving). The vessel was reheated, encased in another layer of colorless glass, and finally shaped with tools to the desired form. As for the eel bowl, each new design required close collaboration between the artist, the master glassblower, and the engraver. The original complex forms of these early Swedish designs soon made way for the simpler shapes of the Art Deco style.

J.A.P.

BOWL WITH AN EEL
Reijmyre Glassworks, Kolmården, Sweden
Anna Boberg (Swedish, 1864–1935), designer; Fredric Kessmeier (Swedish, 1859–1946), glassblower
1903
Colorless and translucent green and brown glass; mold-blown, applied (*marqueterie de verre*), and engraved
Diam. (max.): 22 cm (8 5/8 in.); H: 10.5 cm (4 1/8 in.)
Provenance: Carl Robert Lamm (1938), Stockholm, Sweden; Gunnar Hävermarks, Stockholm, Sweden (2002); Bukowskis Auktioner, Stockholm, Sweden (2004).
Purchased with funds from the Libbey Endowment, Gift of Edward Drummond Libbey, 2004.16

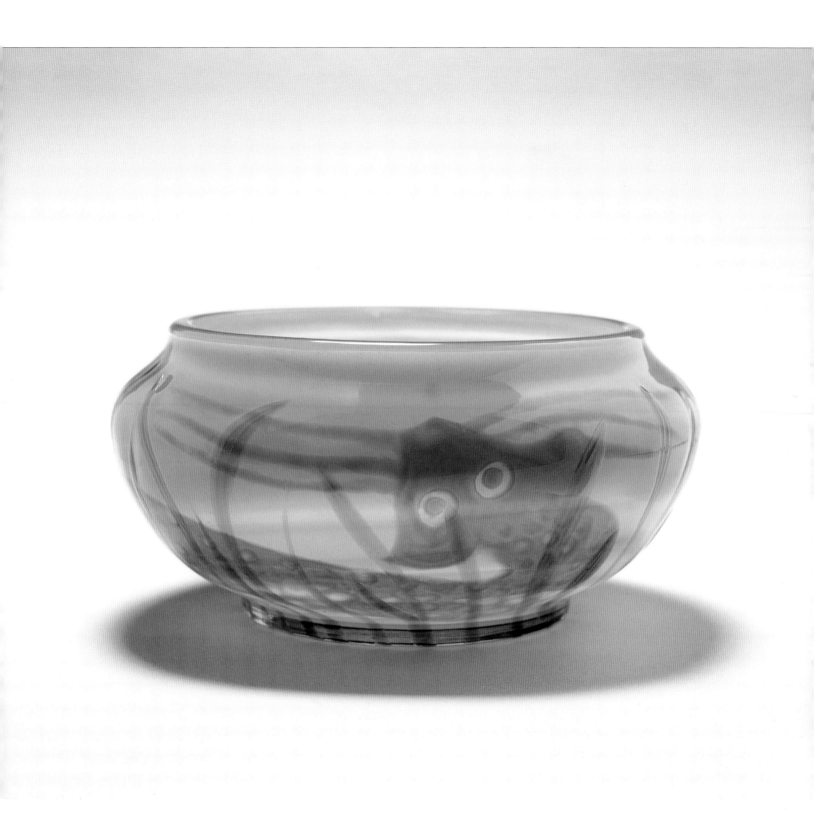

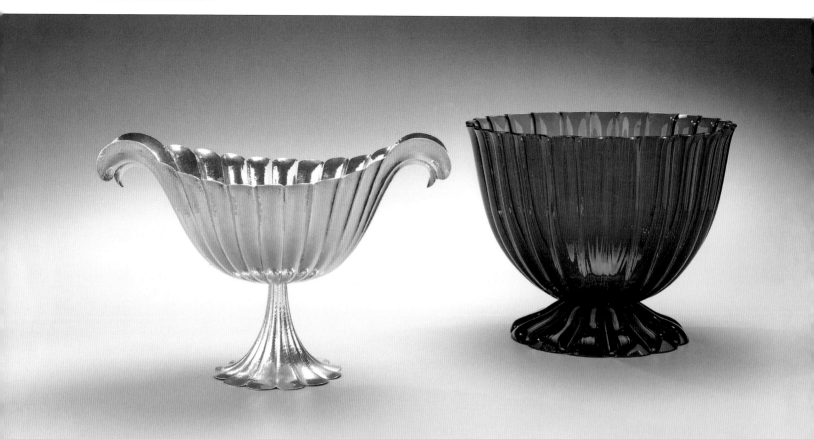

At the turn of the twentieth century, Vienna emerged as a city with a distinct artistic culture that subscribed to new forms of analytical modernism. By 1897, a group of progressive artists and architects had turned their backs on the established, historicist art scene and formed a movement called the Vienna Secession. The group's motto — "To every time its art, to every art its freedom" — reflected the group's, and the movement's, divergent attitudes. Two of the Secession's leaders — architect Josef Hoffmann (1870–1956) and painter Koloman Moser (1868–1918) — decided to expand on the movement's concepts of artistic cooperation and personal artistic vision by creating workshops that would operate under the premise of improving everyday life through good design. To that end, the Wiener Werkstätte (Vienna Workshops) were founded in June 1903 with financial backing from

Fritz Waerndorfer, a prominent young Viennese banker who also acted as the group's business manager. The working collaborative of craftsmen and artists was modeled after the Guild of Handicraft established in England by C. R. Ashbee (1863–1942) and was also initially mentored by the Scottish architect Charles Rennie Mackintosh (1868–1928).

The Wiener Werkstätte started as a small metal workshop; but it quickly expanded, and by 1905 the group had grown to a hundred employees with thirty-seven master craftsmen. Emphasis was placed on individuality as opposed to mass production, appropriateness of design in relation to the function and utility of the object, and execution with flawless craftsmanship. The program quickly grew to include designs for entire interiors and then to architecture itself, in order to achieve a total aesthetic ensemble. The

FLUTED BOWL
Wiener Werkstätte, Vienna, Austria
Josef Hoffmann (Austrian, 1870–1956), designer
Possibly Moser & Söhne, Carlsbad, Bohemia
About 1923
Transparent purple glass; mold-blown, applied
H: 21.5 cm (8 ½ in.): Diam. (rim): 26.5 cm (10 ½ in)
Provenance: Fred Silberman, New York, N.Y.
Gift of Mr. and Mrs. Lewis H. Kirshner in memory of Mr. and Mrs. Abraham Goodman, 1978.49

group's initial clientele was Vienna's reform-friendly, intellectual, and wealthy bourgeoisie, whose patriotic sentiments embraced traditional Austrian handicraft. In their enthusiasm for the new movement these Viennese patrons commissioned a broad array of complex buildings and interior decoration projects. The rapidly growing workshops, which produced designs for a wide range of domestic items from clothing to wallpaper, glassware to calling cards, soon expanded by opening showrooms in other European cities, as well as in New York. As a result of its widespread popularity and the quality of its products, the efforts of the Vienna Workshops were recognized with awards at many international exhibitions. In the end, the exquisite craftsmanship was appreciated more often by an affluent international clientele than by the average consumer that the Wiener Werkstätte set out to serve.[6]

From 1906 (when Koloman Moser retired from the business) to 1915, the Wiener Werkstätte style was dominated by rigorous geometry. This changed when Dagobert Peche (1886–1923) joined the group in 1915 and served as its artistic director from 1919 to 1923. Peche embraced the decorative and craft aspects of design and denounced the emulation of machine production, but his vision was a near antithesis to the practical, down-to-earth concerns that had previously dominated the Wiener Werkstätte. His designs were highly decorative and his style animated, asymmetrical, and organic, with a strong accent on individuality rather than a shared Wiener Werkstätte signature style.[7] Hoffmann had continued to remain at the helm of the workshops, so when Peche died prematurely in the spring of 1923, Hoffmann alone continued to provide designs for the metal workshops (Fig 74.1).[8] His models were executed in brass, alpaca (an alloy of copper, zinc, and nickel), and silver, in order to accommodate the price range of a broad consumer base, recognizing that the silver version (see color plate 74, left)[9] could only be afforded by a wealthy customer.[10] Hoffmann's designs,

true to his preference for stylistic simplicity and manufacturing integrity, were dominated by simple forms and devoid of added decoration. His more than forty designs in glass followed this same concept. Bowls, dishes, vases, covered jars, and entire table services were blown in rich jewel tones of gold and smoky topaz, olive green, purple, and blue (iris).[11] The severe classicism of Hoffmann's vessel shapes contrasts sharply with Peche's highly decorative designs and with those of his successor, Julius Zimpel.[12] But regardless of the designer, all Wiener Werkstätte forms articulate a clean geometric structure that relies on the material and the working techniques for effect.

The large fluted bowl in the Toledo Museum's collection is blown of transparent purple glass in an optic mold and applied to a pedestal foot produced in a similar fashion.[13] The pronounced ribs generate an undulating effect that is enhanced by the vessel's transparency, while the design terminates in the crisp rim of the bowl and the edge of its base, which are ground and polished. The actual maker of this glass bowl is not known, because the Wiener Werkstätte drew on the expertise of numerous specialist glass firms to execute their designs, including the Vienna retailer J. & L. Lobmeyr, the Bohemian glass manufacturers Albert and Rudolf Ritter von Kralik, Meyr's Neffe in Winterberg, and Moser & Söhne in Carlsbad. A light purple glass vessel of identical shape was executed by Moser & Söhne in 1928, a color that the firm named "Alexandrite."[14] The vessel's design relied on perfect execution in the combination of centuries-old forming techniques, a single flawless material, and a form that required little final finish-work. Such an object could be produced in large quantities and was therefore suited for sale to a broader customer base.[15] These objects are evidence that, in the 1920s, the Wiener Werkstätte stood alone in its demand for luxury and individuality in a market increasingly determined by machine technology, mass production, and homogenous design. J.A.P.

Fig. 74.1. Study for a Footed Silver Bowl. About 1920. Wiener Werkstätte, Austria, Vienna. Josef Hoffmann (Austrian, 1870–1956). Pencil on lined paper, 45.7 x 28.9 cm (18 x 11 ⅜ in.). Gift of Barry Friedman, Ltd., New York, 1986.67.

Color plate 74, left:
Footed Bowl (*Aufsatz*).
About 1920–24. Wiener Werkstätte, Vienna, Austria. Josef Hoffmann (Austrian, 1870–1956), designer. Marked JH / WW / Made in Austria / 900. Silver, raised and chased. H: 21.7 cm (8 ½ in.); W: 33 cm (13 in.). Provenance: Barry Friedman Ltd., New York, N.Y. Gift of Mr. and Mrs. Stanley K. Levison, 1986.52.

Furniture and small objects have been decorated with glass inlays nearly continuously since antiquity (see Nos. 6, 51). By the mid-nineteenth century, the powerful furnaces and annealing ovens installed by the major international glass industries facilitated the creation of large-scale works never seen before. The Cristalleries de Baccarat, near Paris, and F. & C. Osler, in Birmingham, particularly excelled in making chairs, tables, sideboards, and fountains constructed from large cast-glass components fitted onto (often silvered) metal frameworks. These were primarily showpieces intended for international world fairs, or made as special commissions.

René Lalique featured this liqueur cabinet embellished with glass plaques (Fig. 75.1) as the focal point of his firm's display at the Salon d'Automne in 1928.[16] The rectangular pearwood cabinet, resting on a separate rosewood base, is decorated near top and bottom with friezes composed of three colorless cast-glass plaques with scrolls (*rinceaux*) in relief. Lalique showed the cabinet at the Salon d'Automne with the doors open to reveal the dazzling interior, lined entirely with mirrors and fitted with two glass shelves. The interiors of the heavy doors display ten mold-cast glass plaques, repeating five designs, which are mounted in silvered metal holders. In keeping with the purpose of the cabinet, Lalique chose a Bacchic theme of fauns and pairs of cherubs frolicking among undulating, fruited grapevines. The exuberant movement captured in the dancing figures and the whirling background underscored the dizzying display of Lalique barware placed inside the cabinet and multiplied by the mirrored interior. The dynamic designs of the decorative plaques contrast with the angular proportions and smooth veneer of the cabinet's exterior surfaces. At the Salon d'Automne, Lalique chose to echo the vibrant orange-yellow glow of the pearwood in the linear treatment of the walls surrounding the cabinet, alternating cascading curtain panels with panels of vertical pearwood fitted with glass sconces.[17]

By 1929, Lalique had established a reputation as an artistic leader of glass in the Art Deco

Fig 75.1. Liqueur Cabinet.

Fig. 75.2. Serpent Vase, 1928. Lalique & Cie., Nancy, France. René Jules Lalique (French, 1860–1945), designer. Red-brown glass; mold-blown and acid-polished, H: 24.8 cm (9 ¾ in.). Purchased with Funds from the Florence Scott Libbey Bequest in Memory of her Father, Maurice A. Scott, 1976.47.

style, a term derived from a phrase in the title of the 1925 Paris world's fair, the Exposition Internationale des Arts Décoratifs et Industriels Modernes. At that seminal exhibition, Lalique presented the massive *Serpent Vase* of vibrant orange-brown glass, which caused nearly as much of a sensation as did his famous glass fountain in the Perfume Pavilion.[18] The vase still remains one of the firm's most popular designs and its rich jewel tone belies the fact that Lalique always used color with great restraint (Fig. 75.2).

The snake was a recurring theme in Lalique's glass production as it had been in his earlier jewelry designs in the Art Nouveau style. It was his work in jewelry, in fact, that led to Lalique's successful career as a glass artist and designer. Lalique had first trained as a jeweler in London and Paris, opening a studio in Paris in 1890 that soon attracted an elite clientele with esoteric tastes. In addition to using precious stones, he often incorporated glass in his jewelry designs, ranging from ethereally thin components enhanced by colorful enamels in the *plique-à-jour* technique (see No. 70) to figural pendants of cast glass simulating translucent gemstones.

Lalique experimented early on with the *cire perdue* (lost-wax) casting technique, sometimes marking the molds of these creations with his own thumbprint. His innovative work caught the attention of leading French fragrance manufacturers, who commissioned him to create a line of glass perfume bottles, which he began to produce at a rented glass factory in Combs-la-Ville, near Fontainebleau, in 1909. It was not until he bought a larger factory in 1918 that he began to manufacture high quality, mass-produced mold-blown and press-molded art glass that would appeal to a broader market. Although Lalique came to focus on glass design relatively late in life, around the age of fifty, he enthusiastically embraced the medium's full capabilities. As one of the first artists of the twentieth century to explore the architectural possibilities of glass on a large scale, he attracted numerous private and public commissions. In the same year that the liqueur cabinet was introduced at the Paris Salon,

Lalique's firm completed two other important commissions: the first for glass panels decorating the new private dining room of the noted fashion designer Jeanne Paquin in Paris, and the second for the glass insets in the dining car of the Orient Express.[19] Both commissions, though prestigious, were dwarfed a few years later by his largest dining room commission, for the glass fittings on the massive, ill-fated luxury liner *Normandie* (launched 1932, destroyed by fire 1942).
J.A.P.

LALIQUE & CIE, NANCY, FRANCE
René Jules Lalique (French, 1860–1945), designer
1928
Pearwood cabinet and rosewood base on basswood (*Tilia*) carcass; silvered metal (brass?) fittings; press-molded colorless glass insets
H: (cabinet including plinth): 177.8 cm (70 in.); W. (closed): 91.4 cm (36 in.); Depth: 38.1 cm (15 in.)
Provenance: Lady Waite (1928–1977), London, United Kingdom; L'Odeon, London.
Purchased with Funds from the Florence Scott Libbey Bequest in Memory of her Father, Maurice A. Scott 1978.46

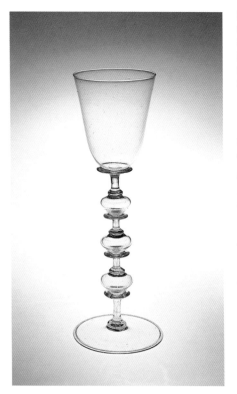

Fig. 76.1. Goblet, 1650–1700. Possibly Bonhomme Glasshouse, Liège, Southern Netherlands. Colorless glass, H: 28.8 cm (11 3/8 in.). Purchased with funds from the Libbey Endowment, Gift of Edward Drummond Libbey, 2004.88.

tion of Louis Comfort Tiffany at Corona, on New York's Long Island. Not only did he supervise the glassworks operations, but he also played a significant role in developing many of the innovative glasses for which Tiffany became famous (see No. 71).[21] By 1908 A. Douglas Nash had joined the firm, where he was initially involved in marketing Tiffany products. Later he worked with his brother Leslie in designing glassware. After Tiffany Furnaces closed in 1928, A. Douglas Nash purchased the Corona glasshouse from Tiffany and operated it as A. Douglas Nash Corporation until 1931. There, Nash continued to make lustered and complex colored glass in the Tiffany tradition, but it was his elegantly proportioned and delicately colored tableware that became the basis of his finest work for Libbey.[22]

As shown by the Libbey Glass Company's 1933 trade catalogue, *The New Era in Glass,* Nash's designs lack a unified vision, offering instead a feast of glassmaking techniques in distinctive combinations of historical and modernist elements. The tablewares were obviously intended to appeal to a wide range of consumer tastes. Many Nash-designed vessels are of sparkling, colorless crystal, some with jewel-tone accents. Only one pattern with opalescent feathering directly recalls Nash's experience with Tiffany.[23] With applied prunts and filigree decoration, Nash imitated the historicism that Whitefriars and other English glasshouses introduced around 1900. Nash's opalescent threaded, dimpled, and wave designs have roots in the English art glass that his father made in the 1880s, but they more closely resemble contemporary British interpretations of the earlier styles.[24] Some of Nash's designs include heavy knopped or tiered stems, while others feature

Renowned for its brilliant cut glass (see No. 72), the Libbey Glass Company began to explore fresh areas of the tableware market after the end of World War I in 1918, when the taste for such ware was in decline. Even though the Great Depression of 1929 to 1939 further reduced demand for luxury products, the company decided in 1931 that Libbey should again offer high-end glass. The firm hired Arthur Douglas Nash to oversee the project and invested more than $300,000 to implement his vision. In 1933 Libbey introduced the Nash line, which it promoted as ushering in a "New Era in Glass." The public was assured they would see "things that have never before been done in glass."[20]

Nash was well acquainted with the glass trade. His father, Arthur John Nash, was a practical glassmaker who rose to prominent positions in the factories of Stourbridge, England. Soon after immigrating to the United States in 1890, the senior Nash joined the glassmaking opera-

From left to right:

76A. CHALICE, STOURBRIDGE PATTERN
About 1933
Colorless and blue glass; blown, cut
H: 25 cm (9 7/8 in.)
Provenance: Edwin D. Dodd, Toledo, Ohio.
Bequest of Edwin D. Dodd, 2005.64

76B. CHALICE, VICTORIA PATTERN
About 1933
Colorless and opalescent pink glass; blown, cut
H: 23.5 cm (9 1/4 in.)
Provenance: Edwin D. Dodd, Toledo, Ohio.
Bequest of Edwin D. Dodd, 2005.69

76C. CHALICE, LIDO PATTERN
About 1933
Colorless and blue filigree glass; blown, molded foot
H: 26.5 cm (10 3/8 in.)
Provenance: Libbey Glass Company.
Gift of Owens-Illinois Glass Company, 1951.162

76D. CHALICE, DRUID PATTERN
About 1933
Colorless and red glass; blown, engraved
H: 20.6 cm (8 1/8 in.)
Provenance: Libbey Glass Company.
Gift of Owens-Illinois Glass Company, 1951.170

76E. CHALICE
1933–35
Colorless and green glass; blown, cut
H: 25.3 cm (10 in.)
Provenance: Edwin D. Dodd, Toledo, Ohio.
Bequest of Edwin D. Dodd, 2005.73

76A–E: Libbey Glass Manufacturing Company, Toledo, Ohio.
Arthur Douglas Nash (United States, 1881–1940), designer

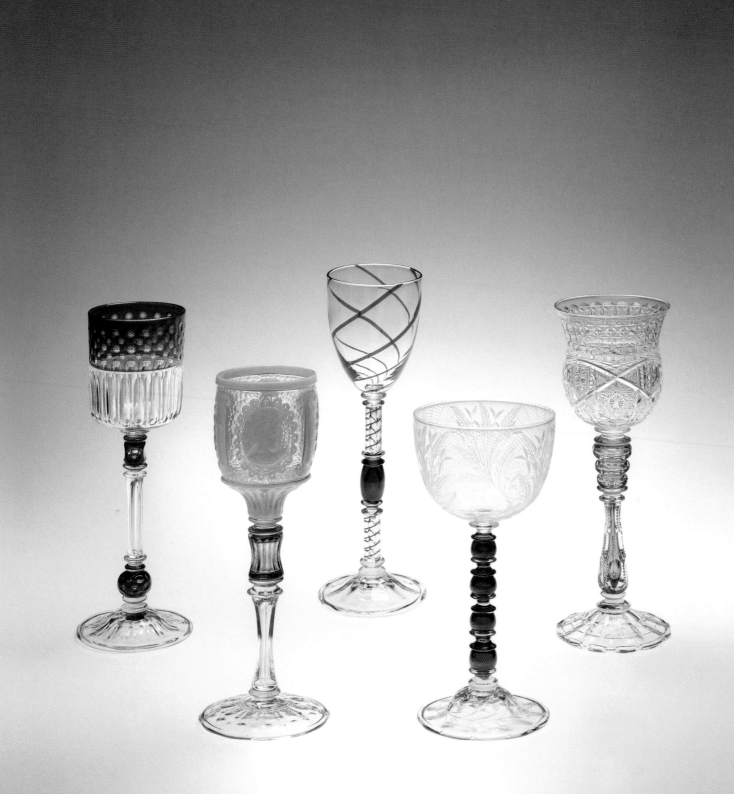

slender balusters and twisted stems. Much of the cut and engraved decoration employs traditional motifs, but many examples also have an abstract, geometric quality that reflects up-to-date patterns of the 1930s. Nash's clearest expression of the modern Art Deco style is his Cubist-inspired Syncopation pattern, patented in 1933.[25]

The five drinking vessels selected here from the Toledo Museum's collection appear in Section D of Libbey's 1933 catalogue, devoted to special-order "chalices." Commanding an astounding $200 to $2,500 per dozen — prices that equal about $3,000 to $37,000 in 2005 dollars[26] — the chalices were promoted as combining "the beauty of the past with the craftsmanship of the present."[27] These majestic goblets are characterized by tall stems of almost architectural character — "custom built," as the catalogue states in its foreword — incorporating a variety of knops, wafers, and shafts derived from historical designs. Stems rise from domed and conical feet with molded patterns and folded-under edges of the types that were common in the seventeenth and eighteenth centuries and that Nash had explored in stemware he made on Long Island. The proportions of Nash's chalices recall the avant-garde designs by Otto Prutscher for the Wiener Werkstätte, but unlike Prutscher, the designs look backward to the past rather than forward to the future. For Nash, the "beauty of the past" was found in reinterpreting the historicizing styles of the late nineteenth century, largely as practiced by English glasshouses.

As its name implies, the Lido chalice (76C) owes much of its design to traditional Venetian techniques.[28] A tight filigree pattern in the stem seems to explode around the bowl. The spiral movement of the stem is interrupted with an oval bead that provides a grip as well as visual respite.

With its tall stem composed of multiple knops and wafers, the Druid goblet (76D)[29] recalls seventeenth-century wine glasses made in Liège (see Fig. 76.1)[30] and Nuremberg. The smooth red knops on the Nash goblet energize the design and contrast with the busy, engraved surfaces of bowl and foot. Even though this chal-

ice has an overall Baroque aspect, the bowl's delicate spider-web engraving is nineteenth-century in style.[31]

The most ambitious and costly of Nash's "exquisite, custom-made chalices" was the Victoria-pattern goblet (76B).[32] Although the goblet's design refers to the nineteenth-century *néo-grecque* style and English cameo glass (see Nos. 58, 66), it also acknowledges ancient Roman prototypes, with its shell-like opalescent carved cameos of a man wearing a Roman helmet and a bejeweled woman, separated by elements suggesting Ionic columns. Placed within a Victorian scalloped border, the delicately shaded profiles shimmer against a textured background reminiscent of hand-hammered metal wares of the Arts and Crafts era.

The Stourbridge pattern goblet (76A) was intended to evoke English traditions "with a suggestion of the modern."[33] The most angular and least ornamented of the "New Era in Glass" series, it is also the most modern in style. The richly cut, green-tinted chalice (76E), on the other hand, suggests Victorian grandeur. Not illustrated in the 1933 catalogue, it may have been an experimental object or custom-designed. Its stem is similar to Nash's Rajah pattern.[34]

Elegantly conceived and exquisitely crafted, the Nash goblets represent a unique concept in American glass of the 1930s. Although conservative consumers may have appreciated the superb quality, they were not willing to pay the premium prices. The Nash line was a financial disaster for the Libbey firm and led to the sale of the glass tableware company to Owens-Illinois in 1935.
A.P.

The line of glass known as "Ruba Rombic" was the most extreme expression of the Art Deco style produced by an American glasshouse. The designer, Reuben Haley, worked for Consolidated Lamp & Glass Company of Coraopolis, a town west of Pittsburgh. Most of Haley's other designs borrowed heavily from the French glass made by René Lalique (see No. 75), but in Ruba Rombic he created something wholly original, unparalleled by anything in European glass. The silver designer Erik Magnussen (1884–1960) used a similar concept in a silver tea service for the Gorham Manufacturing Company of Providence, but it was not publicized until after Ruba Rombic's debut in January 1928.[35] Haley's three patents for the pattern, filed February 1, 1928, included one specifically for the vase featured here.[36] The title of Magnussen's silver set, "Lights and Shadows of Manhattan," indicates that his work was an interpretation of a cityscape dominated by skyscrapers. While the name Haley chose for his glass sounds like a jazz-age dance step, according to the company it meant a poem that was irregular in shape.[37]

Each of the nearly forty vessel shapes offered in Ruba Rombic featured angular planes of elongated triangles, trapezoids, and other geometric shapes. The result, achieved by mold-blowing, rivaled any Cubist sculpture. While Cubism was a phenomenon in the fine arts before the beginning of World War I in 1914, its geometric aspects formed the basis of the Art Deco style that dominated design after the war in the 1920s and continued to inform interior design and the decorative arts well into the 1930s.

When Consolidated unveiled its bold new pattern at the January 1928 glass fair in Pittsburgh, a trade journal pegged it as "an absolutely cubist creation" and said that:

some would call it the craziest thing ever brought out in glassware. The shapes, even to the tumblers, are all twisted and distorted, though at that geometrically correct. The first reaction . . . is all but shock, yet the

more pieces are studied the more they appeal and there comes a realization that with all their distorted appearance they have a balance that is perfect and are true specimens of cubist art.[38]

Consolidated launched its provocative modernist glass with much fanfare. A teaser advertisement in the December 1927 issue of the trade journal *China, Glass & Lamps* hinted at the "new creation" soon to debut with an image of small geometric shapes that were the components of the pattern.[39] A sensational seven-page advertising spread promoting "Ruba Rombic, An Epic in Modern Art," was published in the February 1928 issue of *The Gift and Art Shop*. The dramatic images even included the oddly shaped shadows cast by the various forms, as if to flaunt their irregularity. Another advertisement had a jagged outline mimicking the lines of the glass. Here, Consolidated declared that "The 'Curve of Beauty' Becomes Angular in Ruba Rombic." The company went on to explain that although the English artist William Hogarth's definition of beauty [as outlined in his *Analysis of Beauty*, 1753] had held sway for centuries, "in our architecture today we find the curve supplanted by the straight lines because the modern architect has learned how to support masonry without the aid of the old arches, trusses, [and] pilasters that once were necessary." The company expected some reluctance on the part of the consumer and confronted it directly: "when you come to think of it, there is no real reason why a vase should be spherical instead of angular, is there? Or a goblet rounded instead of cornered?" This glass was clearly for the sophisticate who preferred art to practicality, or as the company put it, it was designed for the "alert hostess."[40]

In contrast to Ruba Rombic's hard edges, its colors were described as "soft warm browns" and "lovely lavenders."[41] The Consolidated Lamp & Glass Company's trade catalogue of 1931 provided an expanded list of colors available for the pattern: honey, amethyst, French crystal, silver, green, and

topaz. Other factory documents record such poetic-sounding color names as sunshine, lilac, jade, jungle green, and smoky topaz—all typical of the cubist palette. The Toledo Museum's large vase, with its acid-finished surface, is an example of the color denoted by Consolidated as "French crystal." The colorless glass was acid-etched, but the rim and edges of the polygons were treated in advance with a resist so that they remain transparent.

Production of Ruba Rombic ceased when Consolidated shut down operations during the Great Depression, in 1932. Two other factories in the Pittsburgh area had come out with rival modern patterns, and Haley himself adapted his design for a line of pottery made by the Muncie Pottery Company of Muncie, Indiana. A.P.

VASE
Consolidated Lamp & Glass Company,
Coraopolis, Pa.
Reuben Haley (United States,
1872–1933), designer
1928–32
Colorless glass; mold-blown, acid-etched
H: 39.7 cm (15 5/8 in.); W: 22.4 cm
(8 13/16 in.)
Provenance: William H. Straus, New York,
N.Y.
Purchased with funds from the Libbey
Endowment, Gift of Edward Drummond
Libbey, 1993.60

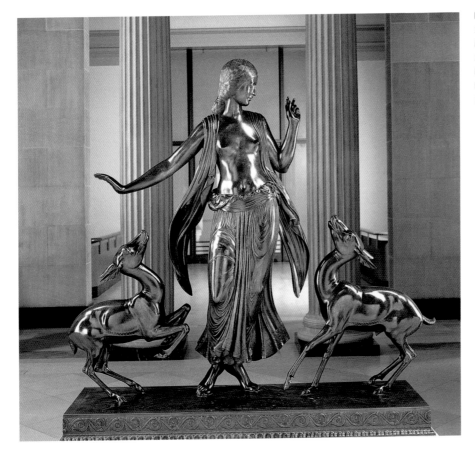

Fig. 78.1. Paul Manship (United States, 1885–1966), *Dancer and Gazelles*. Modeled 1916; this cast made about 1922. Bronze, H: 183 cm (72 in.). Purchased with funds from the Frederick B. and Kate L. Shoemaker Fund, 1923.24.

When the Gazelle Bowl was introduced in 1935, it marked a turning point in the history of Steuben Glass, the distinguished American glassworks that was founded in Corning, New York. In 1903 Thomas G. Hawkes, president of a leading glass-cutting firm in Corning, decided to build his own glassworks rather than continue to rely on other factories for blanks suitable for cutting and engraving. He convinced Frederick Carder to leave his position as a designer at Stevens and Williams, a prominent English glasshouse, and manage his new Steuben Glass Works in Corning. Under Carder's supervision, Steuben not only made blanks for Hawkes, but it also produced tableware and ornamental objects fabricated of various types of colorful art glass. In 1918, Corning Glass Works acquired Steuben Glass Works and operated it as the Steuben Division. Carder remained the

head of Steuben until he was removed in 1932 and named art director of Corning Glass Works. During the economically depressed period of the early 1930s, consumers who could still afford luxury glass were no longer interested in the products Steuben offered and Corning Glass Works considered closing down the division because it was unprofitable. However, Arthur A. Houghton, Jr. (1906–1990), a great-grandson of Corning's founder, persuaded the company to let him implement a fresh vision for the Steuben Division, and in the fall of 1933 Houghton was appointed CEO of the reorganized Steuben Glass, Inc.

Houghton charted a course for Steuben Glass that was a radical departure from the Carder years, in both material and design. The Steuben glassblowers would now use almost exclusively the remarkable, flawless, colorless

crystal that Corning's chemists had recently perfected for other applications.[42] Designs that would exploit the brilliance and clarity of this superior glass would come not from within the industry but from artists working outside the world of glass. A consistent, distinctive, and recognizable Steuben art form would emerge.[43]

Houghton hired architect John Monteith Gates to be Steuben's director of design. A young sculptor, Sidney Biehler Waugh, became the firm's principal designer. Waugh had attended the School of Architecture at the Massachusetts Institute of Technology and was studying in Paris in 1925, the year of the famous Exposition Internationale des Arts Décoratifs et Industriels Modernes. This exhibition inspired the term "Art Deco" as a designation for the distinctive style that characterized design of the 1920s

and 1930s (see Fig. 78.1).[44] In 1929 Waugh won the Prix de Rome to study at the American Academy in Rome, and three years later he returned to the United States. It was his work as an architectural sculptor for several government buildings in Washington, D.C., that caught the attention of John Gates and led to Waugh's appointment at Steuben Glass.

The Gazelle Bowl was Waugh's first major design in glass.[45] A compact and robust sculptural work, it epitomizes the modern aesthetic as Houghton envisioned it. The glass itself, with its purity and dazzling transparency, represented a technological breakthrough and "embodied the modern movement's infatuation with new materials for the decorative arts."[46] The spherical bowl rising from the separate, angular base expresses the geometric contrasts characteristic of the Art Deco style. The cut and polished planes of the base provide further geometric play and striking optical effects. Horizontal cut bands unify the composition and, on the bowl, provide a frieze-like space for the engraved decoration. The arrangement recalls Waugh's expertise in bas-relief sculpture, but there is nothing static about the design of elegant gazelles depicted in different running poses. With their overlapping legs, they seem to be moving not in a single line but as a herd. The gazelles appear sleek and muscular yet are engraved with a minimum of detail. Waugh's design complements the bowl's round shape, enhancing the clarity of the crystal and providing an ethereal quality that serves as a counterpoint to the weight and solidity of the object as a whole.

As a blown, cut, and engraved colorless glass object, the Gazelle Bowl demonstrates how Steuben Glass turned away from the innovative, often experimental aspects of earlier art glass and chose instead to look back to traditional methods of glass production and decoration. In Waugh's opinion, glassmakers of the Art Nouveau era had frequently depended "on chance effects" that could degenerate into "mere feats of technical virtuosity." He endorsed the return to "more orthodox methods of production," with "greater

attention to perfection of metal and soundness of design than to those half-fortuitous effects which, to the modern eye, often seem more bizarre than beautiful."[47]

In reviving the use of wheel-engraved decoration, Waugh was following Swedish models. At the Orrefors Glassworks in the Småland region of Sweden, Simon Gate and Edvard Hald experimented with engraving in the late 1910s and enlisted skilled Czech engravers to work at the factory and to train young artisans. Orrefors engraved glass gained international recognition as a result of the 1925 Paris Art Déco Exposition.[48] Waugh's gazelles reflect the particular influence of Vicke Lindstrand, a leading designer and engraver at Orrefors in the 1930s.[49]

The Gazelle Bowl was the first of Steuben's renowned line of art objects in glass intended for expositions, ceremonial presentations, and private collections.[50] The exhibition of Steuben glass mounted by the Toledo Museum of Art in 1936, the first in a major art museum, included a Gazelle Bowl owned by the Metropolitan Museum of Art. Shortly thereafter, William E. Levis, president of Owens-Illinois Glass Company, acquired this example and presented it to the Toledo Museum for its permanent collection.
A.P.

BOWL AND STAND

Steuben Glass, Inc., Corning, New York
Sidney Biehler Waugh (United States, 1904–1963), designer
1935
Colorless glass; blown, cut, engraved
H: 17.8 cm (7 in.); Diam. (rim): 16.5 cm (6 ½ in.)
Provenance: Steuben Glass, Inc.
Gift of William E. Levis, 1936.36

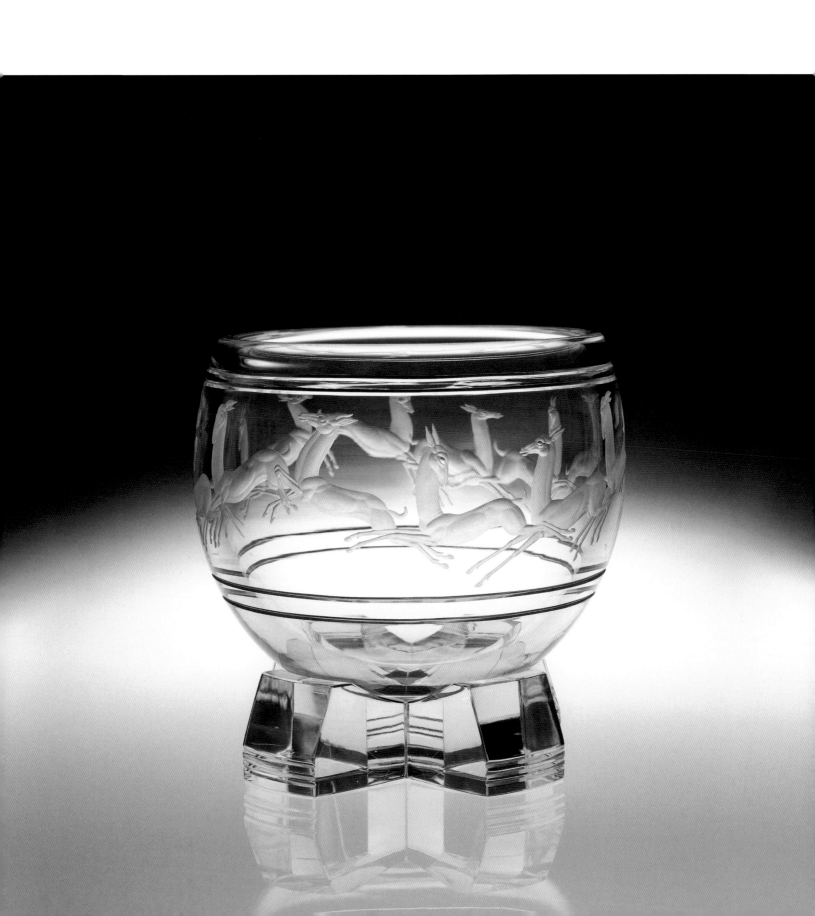

79–100 **CONTEMPORARY ARTISTS**

79 PLATTER

In the United States during the mid-twentieth century, a key new development emerged: glass-making in non-factory settings. This development — led by a group now called the proto-studio glass artists, who worked in their own private studios — prefigured a subsequent move toward further independence, the studio glass movement. In contrast to their commercial counterparts, who worked as teams in factories, the proto-studio glass artists generally worked alone and were responsible for their work from conception to sales, including designing, fabricating, and marketing.[1] They worked in small studios using the warm-glass techniques of slumping, lampworking, and small-scale lampworking and glassblowing. They were resourceful in applying limited technical information, because most glassworking at this time was confined to large factories. As a result, the newly independent glass artists borrowed some of their glass methodologies from clay-forming. One such artist was the former ceramist, jeweler, and metalworker Glen Lukens.

Glen Lukens was teaching ceramics at the University of Southern California when, in 1945, he took a leave of absence to support post-war reconstruction efforts. After serving in the Pacific theater during the war, he was assigned to work for the United States government in Haiti, where he established a pottery-making facility — the first of its kind in the country. Following his return to the United States after the war ended, he resumed work in Haiti as a technical advisor for the International Labor Organization (an agency of the United Nations), importing clay-working equipment. The warm climate made his continued work with clay possible (Fig. 79.1).[2] Around this time, Lukens discovered that he could slump glass in the same molds he used to shape ceramic vessels.

After returning to the United States in the mid-1950s, Lukens turned to glass as his primary creative medium, because it did not require the painful "hands-on" forming methods that clay demanded. Extending his clay expertise, Lukens slumped glass into clay molds and added oxides to

Fig. 79.1. *Gray Bowl,* 1940s. Glen Lukens (United States, 1887–1967). Earthenware; press-molded, glazed, Diam.: 28.6 cm (11¼ in.). Los Angeles County Museum of Art, Gift of Howard and Gwen Laurie Smits in honor of the museum's twenty-fifth anniversary, M.90.82.31. Photograph © Museum Associates/LACMA.

GLEN LUKENS
(United States, 1887–1967)
About 1955
Glass; slumped
Diam.: 49.5 cm (19 ½ in.)
Provenance: Fifty / 50 Mid-Century Decorative Arts, New York, N.Y.
Purchased with funds from the Libbey Endowment, Gift of Edward Drummond Libbey, 1992.45

impart a range of tints enlivened by splashes of intense color. He termed these objects "desert glass" because he would travel to the Mojave Desert outside Los Angeles to collect alkaline minerals for colorants. Many ceramists collected mineral colorants from natural soil deposits, but glassmakers did not. Once commercial frits were developed, Lukens's use of local materials was no longer necessary.[3] As he did with clay, Lukens strove to create forms that were "simplified to [their] essence";[4] indeed, the rough texture inherent in his clay molds imparted a tactile nuance to the glass forms that would not be seen until the revived interest in *pâte-de-verre* and cast glass later in the century (see works by Diana Hobson and Howard Ben Tré, Nos. 93 and 98).

Lukens's work in glass reveals an enduring leitmotif of American studio glass: rediscovering "lost" techniques through the exploration of related media and transferring it to the forming of

glass. Indeed, slumping, a warm-glass technique that requires only a small kiln to heat the glass until it deforms into the shape of the supporting structure, was a perfect crossover from clay.

The *Platter* in the Toledo Museum's collection[5] is unusually large for a Lukens slumped-glass work. The blue color is reminiscent of brilliant blue ancient Egyptian faience beads, which had entered modern consciousness following the discovery of Tutankhamun's tomb in 1922. Using glass from discarded leaded glass windows or from Mexican factories (a type of *malfin* glass, made by mixing frit and cullet in a clay pot in the furnace without stirring, to create a bubbled, rough-looking glass), Lukens imparted to this platter his signature aesthetic — the textured surfaces. As with all proto-studio glassmakers, Lukens can be described as an "accidental" glass artist.

M.D.L.

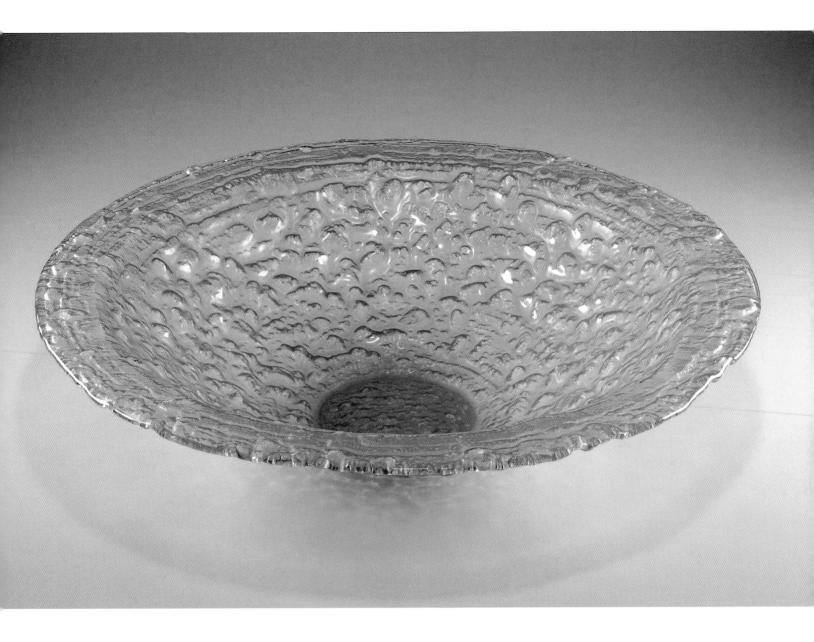

80 ACROBATS IN SPOTLIGHTS

Maurice Heaton exemplifies the multi-generational, artisan-based European tradition of glass-working. In all aspects of his *oeuvre*, he featured bright enamels and Art Deco-style decorative morphology. This can be seen in his high-profile works of art, including his 1932 project, *The Flight of Amelia Earhart across the Atlantic*, a large window for Radio City Music Hall in New York. Using a combination of unique techniques, Heaton applied vitreous glazes to glass with an airbrush and then kiln-fired them. In 1931 an article in *Architecture* illustrated several of Heaton's commissions, including large, paneled windows for Stern Brothers and L. P. Hollander & Company in New York City; glazed elevator doors for Park Avenue apartments; and several showroom windows.[6] All of these designs incorporated a classical Art Deco approach. Sadly, only photographic images of these projects survive, because Heaton's studio was destroyed by fire in 1974, and by that time many of his commercial installations had been dismantled. Heaton also employed the traditional glass decoration technique of *verre églomisé,* or gold reverse painting on glass, first used in ancient times and revived in Eastern Europe during the early and mid-nineteenth century.

The Toledo Museum's plate *Acrobats in Spotlights* reflects Heaton's trademark Art Deco sensibilities.[7] It is a unique work and one of the first enamel-on-glass objects that Heaton made.[8] This graceful design exploits the circularity of the plate to frame the balanced surface decoration of dark brown, yellow, and red figures. This plate is typical of Heaton's restrained aesthetic, in which the decoration enhances the overall form without overwhelming it.

For his plates, Heaton used the warm-glass techniques of kiln-forming (slumping) and applying powdered glass enamels. As described in an article in a 1954 issue of *Craft Horizons,* Heaton would cut and grind a flat piece of glass to the desired shape, then attach the glass to a turntable. He then made the design directly on the glass by tapping powdered enamels through graded sieves and over curved and angled templates to create overlapping shadows. He fixed the completed design with adhesive spray and then placed the object in a sheet-iron mold into which it would slump in the kiln while the enameled design was fused onto it. To accomplish this, Heaton made the molds and all his tools himself.[9]

Maurice Heaton was the son of an Arts and Crafts cloisonné enameler and the grandson of a London-based maker of stained glass, who specialized in Gothic Revival-style windows. He immigrated to the United States in 1914, just before the outbreak of World War I. Settling in New York, he attended the progressive Ethnic Culture School, followed by a year at the Stevens Institute of Technology. By 1923 Heaton began to work with his father on large architectural stained-glass commissions. His work quickly attracted a following, and in 1928 the noted textile designer Ruth Reeves asked him to create glass shades for polished-steel floor lamps. Similar commissions followed. Soon, Heaton was designing for Lightolier, and by the 1940s his work was featured at East Coast industrial design shows. The practical application of his design talents became a recurring theme, as he balanced ambitious art projects with mass-produced designs that provided steady income.

Like Glen Lukens (see No. 79), Heaton scavenged and modified equipment and forming methodologies originally developed for ceramic production. Even though he designed works for commercial manufacturers (albeit limited editions), both the means and the location of his production place his activity within the realm of American proto-studio glassmakers.
M.D.L.

MAURICE HEATON
(United States, born Switzerland, 1900–1990)
About 1947–49
Colorless glass; slumped, enameled
Diam.: 33 cm (13 in.)
Provenance: David A. Ackley, Ypsilanti, Mich.
Gift of Mr. and Mrs. Lewis H. Kirshner in memory of Mr. and Mrs. Abraham Goodman, 1986.20

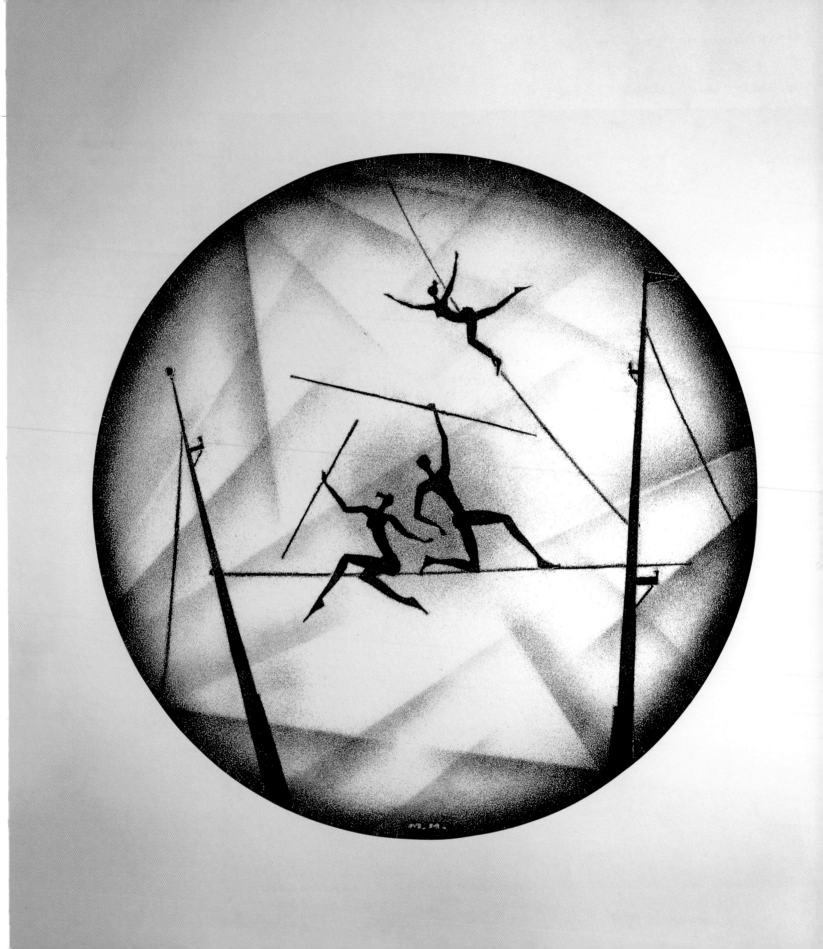

Cleveland artist Edris Eckhardt is renowned as an early leader in twentieth-century American ceramics and glass. A committed professional artist during a period that was characterized by hobbyists, she worked in "craft" media to create figural and abstract sculptures. Her finest pieces capture the best elements of both clay and glass.[18]

Ancient Splendor was one of several works Eckhardt executed while working at the University of Southern California, Los Angeles, from January to June 1962.[19] Cast of bronze and glass, this sculpture is reminiscent of clay in its texture and tonalities, and of glass in its glints of embedded light. The sculpture, which stands on three asymmetrically placed legs mounted on a wooden base, captures the aesthetic of the period through its random array of more than 150 glass inserts fused into bronze "settings." While softly rounded glass "gems" form abstract patterns and starbursts on the textured surface, this hollow-built work dances brightly on squat legs, its bejeweled splendor evoking an ancient civilization. *Ancient Splendor* (the centerpiece of Eckhardt's 1968 retrospective at The Corning Museum of Glass), and its companion, *Tree of Good and Evil* (1962), are considered Eckhardt's two most important sculptures, as they combine impressive scale with her love of texture and explorations of the inherent potential of glass.

Eckhardt (born Edythe Aline Eckhardt) began her studies at the Cleveland School of Art (later the Cleveland Institute of Art), spending Saturday mornings at the local Cowan Pottery Studio. Early artistic influences included viewing art at the Cleveland Museum of Art (especially works by local artists, including ceramist Viktor Schreckengost, born 1906) and studying with the internationally known Ukrainian cubist sculptor Alexander Archipenko (1887–1964).[20] When the Great Depression of the 1930s threatened the livelihood of Cleveland's artists, Eckhardt received support from Linda Eastman, Director of the Cleveland Public Library, who connected her with the Federal Art Project (FAP) of the Works Progress Administration (WPA). It was during this time that Eckhardt began to use piece-molds to produce limited editions of figural designs. In late 1933, Eckhardt created a series of ceramic figurines inspired by Mother Goose rhymes and other children's stories, hand-modeling and decorating each one. Her *Alice in Wonderland* series won First Prize, Ceramic Sculpture, at the Cleveland Museum of Art's May 1936 show, and was followed by series based on other fictional characters, including *Uncle Remus* and W. H. Hudson's *Green Mansions*, then popular with young readers. This interest in figural and popular themes was in tune with the regionalist art produced by contemporary painters of the day, such as Thomas Hart Benton and Saul Bellow. Eckhardt's *Alice in Wonderland* series was displayed at the 1937 Paris World's Fair, and other works at the 1939 New York World's Fair. As part of her work for the FAP, Eckhardt also made ceramic tiles for Cleveland's public housing apartments and administration buildings. All of these activities trained Eckhardt as a sculptor and honed her sensitivity to working with flat formats.

Like Glen Lukens (see No. 79), Eckhardt transferred her knowledge of clay to innovative investigations of glass. By 1953 she had rediscovered the technique of laminating gold or silver between two or more layers of glass, a technique seen in ancient glass vessels (see Fig. 6.2) and in nineteenth-century Bohemian glass. Eckhardt engraved sheets of metal with a stylus, slumped them between sheets of glass, and rolled them on a marble marver. By 1956 she was attempting to re-create Roman gold glass (see No. 14) and melting her own glass from batch in her studio. For her groundbreaking work — combining glass with other materials (notably bronze) and the invention of a tool for drawing with hot glass — she received two Guggenheim Fellowships (1956 and 1959) and a Louis Comfort Tiffany Foundation Fellowship (1959).[21] She later rediscovered the *verre églomisé* technique and learned how to cast glass in lost-wax molds (*cire perdue*), which she used to form plaques and freestanding, figurative sculptures.

As Eckhardt declared in 1985, "I'm only happy when I am working with three-dimensional forms. I work in glass from an artist's viewpoint, not a craftsman's — as I am a sculptor."[22] With this statement she separated her work from craft and positioned herself within the field of fine arts, ahead of many of her fellow glassmakers and ceramists.

M.D.L.

EDRIS ECKHARDT
(United States, 1905–1998)
1962
Transparent multi-colored glass; bronze
H: 30.5 cm (12 in.); W: 53.3 cm (21 in.)
Provenance: Dr. Paul Nelson, Cleveland,
Ohio; Attenson's Coventry Antiques &
Books, Cleveland Heights, Ohio.
Purchased with funds from the Libbey
Endowment, Gift of Edward Drummond
Libbey, 2005.22

83 TALL BOTTLE WITH APPLIED ORNAMENTATION

John Burton, a glass artist, metallurgist, poet, philosopher, and author, was born and raised in England, where he trained as a metallurgist and worked in a laboratory under the British Admiralty. Surprisingly, he began working with glass out of necessity, when he needed to repair a broken burette. His interest in glass was piqued, and before long he began to experiment with making small objects from heated glass. Today he is best known as a self-taught flame-worker, who made small utilitarian objects in his own studio and was the first flameworker to establish a university program in glass.

Burton's approach to glass emphasized the light, fragile nature of the medium. Choosing Pyrex® as his glass material, he created works that were small and intimate — often no more than ten or eleven inches tall — and he favored bottles, goblets, bells, bud vases, cruets, some jewelry, figurines, and small objects he called "touch pieces."[23] Described as "unsophisticated and spontaneous," each work emphasized the elements that revealed its handmade origins.[24] Though Burton had very little knowledge of glass chemistry, he pursued ambitious glass experiments, acquiring new skills as he worked. Two of his techniques involved adding bits of insoluble material to a work and intentionally trapping air bubbles in order to add texture that resembles ancient glass. Such inclusions represented a risk to a finished work, as each element had a different coefficient of expansion and, during the heating and cooling process, could result in shattering the finished piece.

Tall Bottle with Applied Ornamentation in the Toledo Museum illustrates Burton's connection to the aesthetic of ancient glass.[25] Here, color prunts give texture, color, and a sense of primitive glass-working methods. As Burton stated in 1958, "I am always lured back to my far greater preference for work of earlier artists in glass. I love the simple shapes of the tear bottles and other vessels made by the Greeks and Romans."[26] For Burton, a primary aesthetic goal was to produce objects that resembled ancient glass, even down to the patina of devitrification.

Maintaining a studio in Chatsworth, near Los Angeles, and later in Santa Barbara, California, Burton used simple tools: a clay brick supporting a torch that delivered oxygen and propane flame at 1800°C (3272°F) while he worked with a glass blowpipe, brass shapers, and carbon marver, forceps, and shears. Interestingly, in spite of his interest in authenticity, he did not melt his own glass batch formulation, but purchased the best he could find. His use of a glass blowpipe was also unusual, since it cannot be dipped into molten glass but rather must be used by dripping glass onto it and then forming the hot glass. After achieving the essential form, Burton would cut open the tube and shape the final form with tools. His method of blowing glass in a flame became known as "John Burton's method."

Burton, with his apprentice and colleague Margaret Youd, was the first studio flameworker to establish a university glass program, "The Art of Glass Design," at Pepperdine College (now Pepperdine University), in Malibu, near Los Angeles. The curriculum was built around his flamework techniques and was offered from 1968 until 1973.[27] Burton published a book in 1967 titled *Glass: Philosophy and Method*. Filled with practical tips and personal asides, he linked his work to an overarching humanism that linked "people and glass — in that order."[28]
M.D.L.

JOHN BURTON
(United States, born United Kingdom, 1894–1985)
1967–77
Colorless and colored glass; blown, flame-worked
H: 20.7 cm (8 5/32 in.)
Provenance: The artist.
Gift of Mrs. Elsie Burton, 1986.43

84 BLUE / RUBY SPRAY (FROM THE *CROWN* SERIES)

For American glass artists to leap from isolated studio experiments (such as those featured in Nos. 79–83), three conditions had to coalesce: focused artistic activity on the part of glass artists, access to technical knowledge, and sustained validation of the work of glass artists by galleries, museums, and universities. In 1962, a remarkable event jump-started what became the American studio glass movement: the Toledo Workshops.

The impetus behind the first two (of three) of the workshops was supplied by Harvey Littleton (then a faculty member at the University of Wisconsin), who wanted to explore hot-blown glassworking outside the factory setting.[29] Otto Wittmann (then Director of the Toledo Museum of Art) invited Littleton to use the resources of the Museum and of the city of Toledo, Ohio (recognized for its Libbey Glass factory and other glass industries) for an experimental glassblowing workshop. A garage on the Museum grounds served as the location, and the first workshop was held from 23 March through 1 April 1962. Seven students enrolled and others attended unofficially; attendees ranged from beginning ceramists to university art faculty.[30] To validate the experience, registered attendees each received three college credits from the University of Toledo.

But as the workshop began, the need for technical expertise became immediately evident: the glass batch did not melt properly and the stoneware crucible broke apart in the heat. Littleton enlisted the advice of his friend Dominick Labino, vice-president and director of research at the nearby Johns-Manville Fiber Glass plant. To help melt a malleable batch, Labino asked Johns-Manville to donate two hundred pounds of Number 475 glass marbles (used to make fiber glass). To provide a proper furnace, Labino rebuilt it with special bricks.[31] Finally, to advise on glassblowing techniques, Littleton enlisted Harvey Leafgreen, a retired local glassblower.[32]

As a follow-up to the first workshop's success, a second Toledo Workshop, funded by grants from the Danish silvermaker Georg

Jensen, Inc., and the University of Wisconsin Research Committee, was held at the Toledo Museum in June 1962. The *Glass Workshop Report* that documented the two projects articulated a vision that would guide the American studio glass movement for the next fifteen years:

> to introduce the basic material (glass), the molten metal, to the artists and craftsmen — to design and test equipment which they might construct for themselves — to investigate techniques for the artist working alone — to look with this knowledge at the glass of the past and present — to look at education possibilities within the secondary, college, and university systems.[33]

Littleton soon became an evangelist of studio glassmaking, whose mission was to promote glassblowing as a studio art activity. The studio glass movement received additional impetus when Littleton was featured in a 1966 *Life* magazine article about the changing aspects of American crafts.[34] As the sole glass artist featured in the article, Littleton's image as the leader of the new glass movement was established.[35]

Expanding the limits of glass as an art medium in the 1970s and 1980s, Littleton focused on sculptural forms, which he often described in his writings as cased and pulled lineal forms. *Blue / Ruby Spray*, one of Littleton's last hot-glass works, typifies this concept.[36] Here, like some large-scale textile works of the era, separate elements combine to form a whole. In this case, the form is a crown, with a central core surrounded by smaller pieces forming multiple arcs; even the sculptural spaces (or voids) are integral to the object's aesthetic. The Euclidean purity of *Spray* expresses both Littleton's technical background and also his interest in forming large glass works with dramatic presence. He once described this *Crown* series:

> [I]n 1978 in search of color in glass sculptures, I went to multiple cased overlays holding the forms to simple geometry. The

color mixing and relationships are very similar to the color experienced in my prints. . . . [T]he shapes are finally and fully realized after cutting and polishing and in studying their relation to one another and the space they define.[37]

Born in Corning, New York, the site of Corning Glass Works and later also of The Corning Museum of Glass, Littleton was virtually born into glassmaking. His father, Jesse Littleton, was the first physicist holding a doctoral degree to be hired by Corning to develop new commercial products.[38] Littleton first went to college to study art, but because his family wanted him to become a physicist like his father, he enrolled in 1939 as a physics student at the University of Michigan. The lure of art still beckoned, however, and two years later he transferred to Cranbrook Academy of Art in Bloomfield Hills, Michigan. While a student there, he worked as an assistant to Swedish sculptor Carl Milles (1871–1955). Milles did not encourage him artistically, however, and in 1941 Littleton returned to the University of Michigan to study industrial design.[39]

Littleton's early work as a professional artist was in clay, but he felt that he could not achieve his sculptural goals in that medium.[40] Littleton's connection with glass was kindled when he took a teaching position at the School of Art and Design of the Toledo Museum of Art, from 1949 to 1951. At that time, Littleton was still studying clay under Maija Grotell (1899–1973) at the Cranbrook Academy, where he received his master of fine arts degree in 1951. Grotell, a Bauhaus artist from Germany, taught that traditional craft-making materials could be used to create works of art. Later, Littleton would bring this concept to the American studio glass movement.

Earlier in his career, Littleton held several jobs related to glassmaking, including as inspector of blown-glass cookware and as mold-maker for Vycor® Multiform, a fused-glass product, at Corning Glass Works. The fact that he continued

to work in both clay and glass contributed to his later advances in glass.[41] When Littleton expressed a desire to travel to Europe to see first-hand the history and chemistry of glass, he was advised to visit Jean Sala (1895–1976), an expatriate Spaniard living and working in Paris, where he learned that it was possible to fit a stand-alone glassblowing facility into a private studio. His later visits to the glass factories of Murano, Italy, underscored the potential for glassworking outside a large factory setting.

With the success of the Toledo Workshops and his subsequent introduction of a glass curriculum at the University of Wisconsin, Madison, in 1964, Littleton saw his dream materialize: the ability to make and form hot glass outside a factory setting became reality. In Littleton's landmark book, *Glassblowing: A Search for Form* (1971), he made a statement that was radical for its time: that studio glass was an appropriate medium for artistic expression. The comment struck a chord in many artists, and had a broad impact among glassmakers across the United States.[42] Littleton's influential career as a glass artist ended in fall 1990, when he stopped making hot-glass sculptures and returned to intaglio glass printing, a process he had developed in the 1970s.
M.D.L.

HARVEY K. LITTLETON
(United States, born 1922)
1990
Colorless and colored barium potash glass; blown, with multiple cased overlays
Largest of the twelve parts: H: 43.1 cm (17 in.)
Provenance: Maurine Littleton Gallery, Washington, D.C.
Partial gift of Ross E. Lucke in memory of Betty S. Lucke, by exchange, and partial purchase with funds from the Libbey Endowment, Gift of Edward Drummond Libbey, 1992.41 A–L
© 1990 Harvey K. Littleton

Dominick Labino, an electrical engineer and artist, was one of the first successfully to combine technological innovation and aesthetics with studio-made glass. Trained at Pittsburgh's Allegheny Vocational High School (1928) and then at the Carnegie Institute, Labino had a life-long love of tools and problem-solving, commenting that "machines were more beautiful than art because they are doing something, and they are doing it for a purpose."[43]

Labino's fascination with technique contrasted to his friend Harvey Littleton's drive to make art, which reflected an ongoing tension within the growing American studio glass movement. Both artists had a passion for the medium, and Labino's can be clearly seen in *Emergence XII*, an early work that shows his sympathy for the material.[44] Casually formed (perhaps because he was working at what was then the extreme edge of technical capabilities), the liquid state of molten glass, inherent in all hot-glass work, is evident in the finished form. Though relatively small, this work has a presence rarely seen in early American studio glass.

During Labino's early career, the two threads of science and art manifested as early as the 1930s, when he was in charge of the Owens-Illinois Glass Co. milk-bottle plant. He set up a small laboratory to formulate new glass batches and to fabricate small glass objects. In the 1940s, Ben Alderson, Labino's predecessor at the plant, taught him how to blow hot glass. Although he enjoyed the experience, he only dabbled in glass fabrication as a hobby. For example, he made a glass paperweight as a farewell gift for a friend who retired in 1958. Two years later, he melted glass batch and fashioned primitive blowpipes on which he blew bottles.[45] Interestingly, Labino's further involvement with studio glass ultimately grew from his frustration with industrial glassmaking. As he recalled, "I had just had it in industry. I would say to myself, 'How many years will I have to stay here until I can decide to do something that I don't have to get approved by fourteen to twenty people?'"[46] So it was his work as a hob-

byist with a home studio that gave Labino the freedom and independence that would fuse his interest in the potential of glass for making art and his understanding of glass chemistry. Both interests were keys to the success of the Toledo Workshops in 1962 (see No. 84).

Labino was always intrigued by how glass objects were made. Because many surviving examples of ancient glass were not technically understood, he felt compelled to investigate. He questioned, for example, how the Egyptians fabricated core-formed glass bottles (see Nos. 1, 3) and published his findings in *The Journal of Glass Studies*.[47] His 1968 book, *Visual Art in Glass*, was one of the first books to connect the terms "art" and "glass." But unlike Littleton, Labino felt that understanding the fabrication process was critical to making "glass art." "If you want to make glass right," he observed, "it is very complicated, but many so-called artists do not want to be bothered by technology."[48] Although Labino had a successful career as a glass scientist and inventor,[49] he is perhaps best remembered by glass artists as being generous in offering his technical expertise and inventions to fellow artists. In 1964, he built the furnace used at the First World Congress of Craftsmen, sponsored by the American Crafts Council and held at Columbia University, where he demonstrated glassmaking in a small-scale studio.[50] Many of his studio inventions are now commonplace: the top burner furnace (eliminating the need for a second glory hole), the creation of insulation materials that made annealing ovens more efficient, and his triple-hinged furnace door. Each of these innovations has benefited the artists who followed him. M.D.L.

DOMINICK LABINO
(United States, 1910–1987)
1972
Colorless and colored glass; tooled, enclosing air bubble and veil forms
H: 22.9 cm (9 in.)
Provenance: The artist.
Gift of the Art Museum Aides in memory of Harold Boeschenstein, 1973.3

86 TENTH ANNIVERSARY GOBLET

Known for his "fanciful and innovative goblet designs, which often take their inspiration from Venetian glass of the Renaissance through the 1950s," Fritz Dreisbach is widely recognized as encyclopedic in his knowledge of glass history and technology.[51] Glass has been a focal point of his life, and throughout overlapping careers as an artist, craftsman, educator, and glass technician, he is noted for his enthusiasm for the medium. Dreisbach studied glass-working with Harvey Littleton at the University of Wisconsin, Madison, along with Dale Chihuly (see No. 92), earning his M.F.A. in 1967.[52] Tom Philabaum, a fellow artist and gallery owner, has commented that Dreisbach was an "ambassador and crusader for glass for years. He traveled all over America on a motorcycle with glass and pipes on his back. He spread the gospel of glass all over America."[53]

The Vase with Two Prunts (Fig. 86.1)[54] is an early work that illustrates the difficulty in attaining the skills needed to form glass. While not typical of Dreisbach's later prowess in goblet making, the simple blown form is reflective of all early American studio glass in its directness and its uncomplicated shape and content. During the early years, technological issues hampered both formal and content expressions. Only after techniques were truly mastered could content be added to the works produced. The facts that this work came into the Toledo Museum early in the studio glass period, and that it was a purchase, indicate the importance of Dreisbach and his work in the field.

Dreisbach's *Tenth Anniversary Goblet,* made in 1972,[55] is a large, ambitious vessel that strives to re-create the complex forms seen in the finest sixteenth-century Venetian glass (see No. 35). Casually crafted, due to incomplete experience with challenging techniques used in historical glassmaking, the goblet represents the best that early American studio glass artists could achieve at the time. In the next decade, many traditional skills were learned and the work moved from a focus on "how to" toward "content driven" artworks.

Dreisbach began blowing glass with Tom McGlauchlin at the University of Iowa and soon became the first director of the Glass Studio at the Toledo Museum of Art's School of Art and Design, from 1967 through 1970. Always members of the glassmaking vanguard, Dreisbach and McGlauchlin were among the handful of artists who founded the Glass Art Society in 1971, an organization that remains the heart of the American studio glass community.[56]
M.D.L.

Fig 86.1. *Vase with Two Prunts,* 1966. Fritz Dreisbach (United States, born 1941). Light green glass; free-blown, H: 26 cm (10 ¼ in.). Museum Purchase Award, Toledo Glass National, 1966.134.

FRITZ DREISBACH
(United States, born 1941)
1972
Glass; free-blown, applied and pressed decoration, engraved
H: 23.5 cm (13 ⅜ in.); Diam. (rim): 14.1 cm (5 ⅞ in.)
Provenance: The artist.
Museum Purchase Award, Toledo Glass National, 1973.4

87 **VASE FORM**

Like other pioneers of the American studio glass movement, Robert Fritz first worked in both clay and glass, but it was his exposure to the work of other artists in glass that molded his career as a glass artist. *Vase Form*[57] represents his dynamic, fluid style that — like the work of Dominick Labino (No. 85) — reflects the essence of molten glass. As journalist Helen Giambruni observed, "although his basic forms are usually simple, the total effect of Fritz's work is far more agitated than that of fellow artist and Californian Marvin Lipofsky. Sometimes he uses more elements than he can control, but at his best he makes an exciting and original use of his medium."[58]

A native of Toledo, Ohio, Fritz settled in California after military service during World War II. He attended California State University, San Jose, and worked as a ceramics technician under Professor Herbert Sanders. By 1957 he was teaching and studying chemistry at Ohio State University, and in 1960 he earned a Ph.D. with a specialty in glass.[59] During postgraduate studies, he visited glass factories on the East Coast to determine the viability of setting up a small glass studio; in the process he met fellow glassmaker and studio glass pioneer Harvey Littleton.[60]

Fritz first urged colleagues to use glass as an art medium when he spoke at the American Craft Council conference in 1961. But it was not until 1964, when he attended a summer workshop led by German glass artist Erwin Eisch, that he applied the concept to his own career. Inspired by Eisch's workshop, Fritz decided to devote his future creative efforts to glass. Indeed, Fritz credited Eisch with a long-lasting and substantial influence on his work. In the fall of that same year, Fritz returned to California and established a course in glassmaking at San Jose State University (now California State University, San Jose) that effectively founded the school's glass studies program.
M.D.L.

ROBERT C. FRITZ
(United States, 1920–1986)
1966
Light olive green glass; blown, applied prunts
H: 20 cm (7 ⅞ in.)
Provenance: The artist.
Museum Purchase Award, Toledo Glass National, 1966.135

88 BOWL (*TIERRA DEL FUEGO SERIES*)

Once glass became established as part of university studio art curricula in the mid-1960s, the term "studio glass artist" (later simply "glass artist") was applied to people who worked in the medium. By the late 1980s, glass artists began referring to themselves as "sculptors," in order to associate their work with that of other artists and to distance themselves from glassworking as a craft. At the same time, they positioned themselves as part of an art movement, implying a uniformity of theoretical attitudes, a formal vocabulary, and artistic goals adhered to by a majority of the group. In fact, however, there was and still is no uniformity of vision or theoretical discourse within the studio glass movement relating to artistic goals, technologies, or even how many artists can work together in a studio. Perhaps the most significant unifying element is the artists' raw enthusiasm for the material itself. Regardless of such non-conformities, the term "studio glass movement" has widespread recognition in the art world.

Mary Ann ("Toots") Zynsky explores the fragility of glass as she fashions works of daring color and intense power. Her works suggest both sculptural object and functional vessel, an ambiguity that beguiles with color and reassures with familiar form. Zynsky was first attracted to glass as a medium while studying painting at the Rhode Island School of Design (RISD), where she noticed a group of students in the glass studio, dressed in outlandish costumes, preparing to make a film. Zynsky recalls that she "saw them and all this hot glass swirling through the air. It was nuts."[61] Zynsky shifted her medium to glass and studied under two prominent faculty members, Buster Simpson and Dale Chihuly (see No. 92). Simpson introduced her to slumping large sheets of plate glass and taught her how to record the process on videotape, as performance art.[62] She was so intrigued by this aspect of glass that for the next six years, Zynsky focused on making "ephemeral, temporary sculptural installations" out of impermanent materials.[63]

Zynsky's early output focused on fusing, casting, and breaking sheets of glass that appear to have been arrested in a molten state.

Fig. 88.1. *Waterspout 15*, 1979 / 1994. Toots Zynsky (United States, born 1951). Glass; blown, trailed decoration, H: 33.6 cm (13 ¼ in.), Purchased with funds from the Libbey Endowment, Gift of Edward Drummond Libbey, and gift of Elliott-Brown Gallery, 1995.2. © 1994 Toots Zynsky.

She then moved on to installation pieces that featured slumped glass, iron, refractory brick (also called "firebrick"), and other materials. Even in these early works, "[h]er form [set] colors in motion, creating an almost kinetic effect. She [used] the slumping process to add a surrealist dimension, creating folds that belie the customary stiffness of glass."[64]

Zynsky's experiments with slumping and fusing glass led her to invent a new glass technique that featured fiber-optic filaments, which she first learned about at the Corning Glass Works. *Waterspout 15* (Fig. 88.1)[65] is an early, breakthrough example of this technique, which lends an elusive, shimmering, weightless quality to otherwise heavy glass. After working with colorless fiber-optics, Zynsky adopted a technique that she jokingly calls "filet de verre" (a play on the term for the traditional glass tech-

nique, *pâte-de-verre*), which involves drawing threadlike fibers from colored glass rods. She fuses these filaments, measuring ten to fourteen millimeters thick, into a variety of vessel shapes by arranging the filaments on a bed of compressed plaster, then heating them in a warm-glass kiln. Zynsky credits her teacher and fellow glass artist Albinas Elskus with originating this technique.[66] In 1982, when a friend, Mathijs Teunissen Van Manen, saw her "filet de verre" vessels at the Theo Portnoy Gallery, New York, he learned that Zynsky pulled her glass strands laboriously by hand and helped her devise a mechanism that would allow her to pull

glass filaments continuously. She used that equipment for her work through the 1990s.

Zynsky's *Bowl* (1988) from the *Tierra del Fuego* series[67] reveals a deft placement of color blocks that "spark" one another. Contrasting shades of pink and green are juxtaposed freely, recalling the shimmering flesh tones in a painting by Rubens or van Gogh. By placing slender wisps of colored glass side by side so that they make "stepped junctures" between color passages, Zynsky has emphasized the constructed aspect of her process. Her finesse as a colorist tends to exceed that of most of her contemporaries. M.D.L.

TOOTS ZYNSKY
(United States, born 1951)
1988
Glass threads
H: 16.8 cm (6 ⅝ in.); W: 27.3 cm (10 ¾ in.)
Provenance: Clara Scremini Gallery, Paris, France.
Gift of Dorothy and George Saxe, 1991.141
© 1988 Toots Zynsky

Therman Statom's colorful, painted glass assemblages can be divided into two categories: individual sculptures in a range of sizes and large installations. His early works presaged this enduring pattern of production. In 1974, Statom constructed a room-size installation of sheet-glass and blown-glass elements that relied on the sparkle and transparency of the colorless glass for its textural interest. But he was concurrently making colorful vessels that combined large, blown forms into complex vessels-within-vessels.

Statom also experimented early with found objects. In 1977, for example, he inserted a piece of sheet glass against the back of a second-hand kitchen chair, a multi-media approach that indicated his ability to adapt glass to wider trends in the art world. In the early 1980s, he discovered what became his signature form — the house. First executed in cast glass with paint or other coloring agents applied to the surface, the form was both whimsical and mystical. While retaining the directness and simplicity of a child's rendering, Statom's constructed houses have the solidity of a sculptural form. They also call forth his hallmark palette of sunny pastels. Statom later added the cone, the sphere, the ladder, the chair, the table, and the narrow box to his formal vocabulary — all of which became vehicles for painted surfaces.[68] In *Pink Ladder* (Fig. 89.1)[69] the form implies both construction work and a pathway between physical and spiritual realities.[70] Made of siliconed plate glass, this construction reflects influences from Larry Bell's glass and Plexiglas cubes and the coloration concepts seen in the work of DeWain Valentine.

Over time, Statom's expressive use of color and painting on glass became the focus of his work, growing ever more assertive and dense. Critic Matthew Kangas noted that Statom "had imbibed at the well of the action-painting school in his colorful and expressive . . . installation."[71] Using cheerful colors and casual craftsmanship, Statom incorporates surrealist elements, randomly linked, to express his irrever-

THERMAN STATOM
(United States, born 1953)
1991
Sheet glass; cut, paint, mixed media
H: 62.6 cm (24 ⅝ in.); W: 47 cm (18 ½ in.)
Provenance: Maurine Littleton Gallery, Washington, D.C.
Gift of Mr. and Mrs. William Block, 2003.66
© 1991 Therman Statom

ent view of glass as a creative medium. By painting, gluing, and often covering up the glass, he manipulates its transparent, refractive, and reflective qualities. Statom has explained that glass serves him "like a canvas... except it's got more sensibility."[72]

Statom's *August Spring* in the Toledo Museum collection is a constructed and assembled house form,[73] populated (like Statom's larger installation works) with a selection of everyday objects. The miniature objects have been rendered three-dimensionally in bright colors that seem to capture the "imaginative play fantasies of childhood."[74] The objects imply a narrative, to be supplied by the viewer, using each element as a clue to the story line. As with his installation art, Statom uses limited painting on glass (a variant of *verre églomisé*) to articulate the interior and complete the work.

Statom studied glassworking at the Pilchuck Glass School, in Stanwood, Washington, in 1971. He had initially planned to be a ceramist, but after seeing the work of Fritz Dreisbach (see No. 86), Statom shifted his focus to glass. Statom was a member of the second generation of glass talent developing in the 1970s that also included his classmate Toots Zynsky (No. 88). The Toledo Museum of Art commissioned Statom to create a "sculptural canvas of glass." Installed as the entrance of the Museum's School of Art and Design, *Hydra* includes visual references to works in the Museum's collection, evoking "memory, occupying that ambiguous area between the viewer's dreams and [his] own work."[75]
M.D.L.

Fig. 89.1. *Pink Ladder*, 1986. Therman Statom (United States, born 1953). Sheet glass, blown glass; paint, colored pencils, found objects, H 214.6 cm (84 ½ in.). Gift of Dorothy and George Saxe, 1991.103. © 1986 Therman Statom.

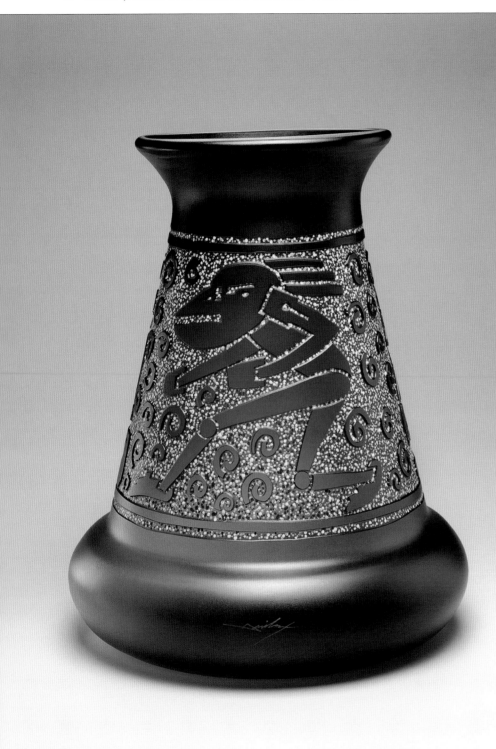

DAN DAILEY
(United States, born 1947)
1985
Colorless glass; blown, enameled, sand-
blasted, acid-polished
H: 30 cm (11 $^{13}/_{16}$ in.)
Provenance: The artist.
Purchased with funds from the Libbey
Endowment, Gift of Edward Drummond
Libbey, 1992.86
© 1985 Dan Dailey

Dan Dailey's refined figurative works record the foibles of human nature. He graduated from the Philadelphia College of Art, where he studied with ceramists William Daley and Richard Reinhardt. As instructor and student, Daley and Dailey were a natural fit, because both had an artistic sensibility that favored geometric forms. While still a student, Dailey received a grant to set up a glass studio, which at that time required building most of the equipment. This project provided Dailey with a critical exposure to glassworking, and soon he was "hooked on glass; no going back."[76]

After college, Dailey spent some time draw-ing cartoons for Zap Comics. Eventually, his graphic ability to capture the essence of a thought, emotion, or action became the back-bone of his art, and it is evident in the Toledo Museum of Art's *The Chef*[77] as well as in *Race*.[78] Over the years, Dailey adopted a forming method-ology that involves working with a team of assis-tants and multiple media. One of a series of twen-ty-four vases, *Race* was the next to last to be com-pleted. The basic shape was blown by Dailey, with the assistance of Delmar Stowasser and Bill Rupert, at Fenton Glass Factory in Williamstown, West Virginia, in the summer of 1984. The form was then masked, sandblasted, acid-polished, and enameled at the artist's studio.[79]

As in much of Dailey's work, the narrative theme in *Race* explores the human condition using humorous, punning word-play — in this case a single, cartoonish human who is running in an inexplicable contest. The light-hearted nar-

rative is balanced by the simple sobriety of the form, which literally adds weight and gravity to the content. *Race* is the highlight of this phase in Dailey's career. It is also one of the best examples of his cartoon-like drawing style and his skill at using the vessel shape as a three-dimensional surface. *Race* was first displayed in the 1987 exhibition "Dan Dailey: Simple Complexities in Drawings and Glass 1972–1984."[80] Although coveted by a number of collectors, *Race* remained in the artist's personal collection until it was acquired by the Toledo Museum in 1992.

For Dailey, glass has an appeal that is multilayered. First, the shine of glass exudes a deluxe quality that clay does not. Also, from his background in ceramics, he can transfer certain clay-working techniques to the medium of glass. For example, throwing a pot on a potter's wheel harnesses centrifugal force and gravity—the same two factors at work when forming molten glass on the end of a blowpipe. Aesthetically, Dailey was attracted to glass because of its bright surfaces and sparkle, like his other favorite medium, metal: "I suppose it's similar to the reason I like drawing in ink over drawing with a crayon; I don't find the clarity that I'm looking for in the line. I believe there is a certain quality of form that I can achieve with glass that I can't with clay."[81]

When Dailey earned his M.F.A. from the Rhode Island School of Design in 1972, he was among the first to graduate from its nascent glass program, led by Dale Chihuly (see No. 92). Intrigued with combining diverse vocabularies of form, Dailey found artistic inspiration in the Art Nouveau and Art Deco, as well as in Italian modernist furniture of the 1950s.

As one of the second generation studio glass artists, Dailey had little technical expertise to draw upon to achieve his artistic goals; this made him a student of glass technology, studying everything made of glass for clues about fabrication. In 1972 he received a Fulbright-Hayes Fellowship to work as a designer at the Venini Glass Factory in Murano, Italy. Two years later he worked as a designer and independent artist

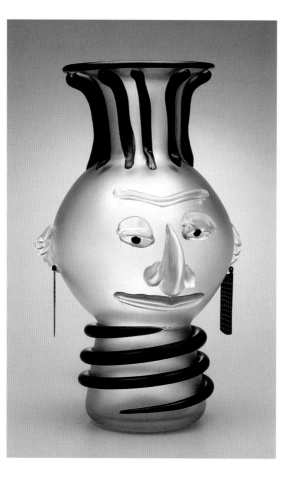

Fig. 90.1. *The Chef* (from the *Head Vase* series), 1988. Dan Dailey (United States, born 1947). Colorless glass, bronze, H: 45.7 cm (18 in.). Gift of Dorothy and George Saxe, 1991.117. © 1988 Dan Dailey.

for the Cristallérie Daum in Nancy, France, a partnership that continued for several decades. Renowned for its late-nineteenth-century art glass, Daum makes art-glass multiples based on designs by independent artists, most featuring cased and colored glass, etched with hydrofluoric acid. In time, Dailey would apply similar techniques to his own work. These Venini and Daum experiences opened Dailey's eyes to the historical heritage and respect for craftsmanship that glassblowing had within the European tradition. Dailey has described himself as an observer who notes the "oddities" of human nature.[82] For him, new concepts are just waiting to be translated into three-dimensional objects.

M.D.L.

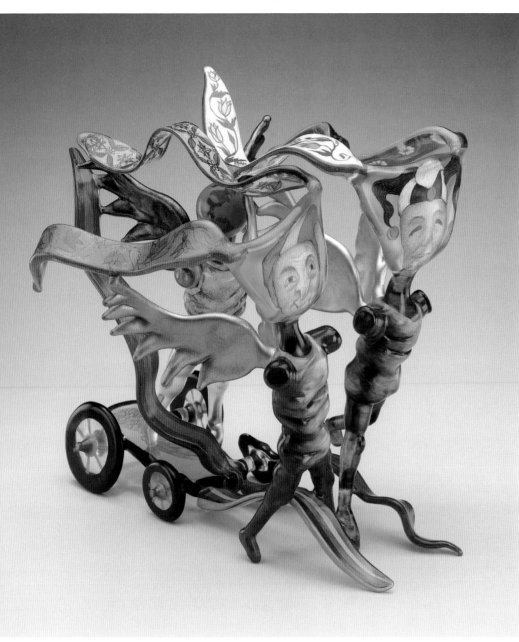

GINNY RUFFNER
(United States, born 1952)
1990
Flame-worked glass, Prismacolor® pencils,
oil paint, Krylon® fixatif
H: 33 cm (13 in.)
Provenance: Heller Gallery, New York,
N.Y.
Gift of Mr. and Mrs. William Block,
1996.7
© 1990 Ginny Ruffner

Ruffner's themes express the meaning and uses of beauty, fecundity, literature, language, and what it means to be a woman artist. This last issue is especially noteworthy, since studio glass has long been a man's domain.[84] Her *Beauty as Drama, #141–52,* exemplifies these central concerns.[85] *Glass* journalist Matthew Kangas described it as one of the finest examples of her *Beauty* series.[86] Throughout the series, Ruffner explores the power and constructs of beauty. In this work, figures representing beauty lead a third winged figure, set on top of a small open cart. An orb representing the Earth rests on top of the third figure's body. The wings signify the transcendence of art as a flight of imagination. Incorporating clear references to the famous Hellenistic Greek marble statue, *Winged Victory of Samothrace,* Ruffner's *Beauty as Drama* considers the "male-dominated proscriptions of art history."[87]

In December 1991, at the age of thirty-nine, Ruffner was severely injured in an automobile accident. After six weeks in a coma, she spent months reconnecting to her life as an artist. She later described the accident as having "rearranged" the synapses in her brain, albeit leaving it still sprightly and well-tuned.[88] During her recuperation, she did collaborative works with an artist-friend, Steve Kursh: Ruffner's blown and painted glass bubbles were set within Kursh's metal matrices. With the help of assistants, Ruffner continues to create sculptures in glass.
M.D.L.

Like the proto-studio glass artist John Burton, who chose lamp-working as his glass technique (see No. 83), Ginny Ruffner creates content-rich works that tease the eye and challenge the mind. While using traditional flame-working techniques in the early to mid-1980s, Ruffner began to add paint to flame-formed sculptural shapes to comment on autobiographical themes of love, life, and aging. Susanne Frantz, former curator of contemporary glass at The Corning Museum of Glass, described Ruffner's work as "little bombs coated in M&M wrappers. They look easy, they slide down easily, but they're very serious."[83] They are also deliciously feminist and saucy.

Many articles, books, and catalogues have been written about Dale Patrick Chihuly, whom Jennifer Hawkins Opie, former curator of ceramics and glass at London's Victoria and Albert Museum, has described as the "best known and most visceral of glass artists."[89] This world-renowned and charismatic artist makes lushly colored, blown biomorphic objects that match his high-energy personality. Chihuly has been described as having a "Warhol-esque genius for self-promotion," as a "glass leprechaun,"[90] and as a master of theatricality who provides "if nothing else, . . . pretty good theater."[91] Throughout his career, Chihuly has brought American studio glass to widespread attention, both nationally and internationally. With energy, art, and showmanship, he has established an enduring reputation through a memorable body of work. Moreover, he is one of only two American glass artists who have had solo shows at the Musée du Louvre, Paris.[92]

Two aspects of glass have been important in forming Chihuly's body of work. The first was his decision to use the blowpipe but decenter the finished product. Most blown forms have a relentless symmetry, but Chihuly creates off-centered forms instead. Second, he has a daring sense of color, which he expresses by using the innate ability of glass to refract and reflect colors.

Since 1990, the Toledo Museum of Art has collected examples of Chihuly's work that mark the progress of his entire artistic evolution.[93] *Gold Over Turquoise Blue Venetian #528* is one of more than twenty Chihuly objects in the collection.[94] Part of his *Venetian* series, begun in 1988, it reflects Chihuly's collaboration with Lino Tagliapietra, master Venetian glassblower, the artist most directly responsible for inspiring this series. Controversial at the time, the series explores Chihuly's fascination with earlier styles of art, not only Venetian-made glass but also European Art Nouveau and Art Deco glass.

Chihuly discovered glass in the early 1960s, just as glass was being invigorated in the United States as an art form at the Toledo Workshops (see Nos. 84 and 85). After studying interior design at the University of Washington, Chihuly traveled in Europe and the Middle East before completing his undergraduate degree in 1962. It was during this time that he began experimenting with glass, making tapestry-like woven wall hangings that incorporated bits of fused glass and metal.[95] In 1965, Chihuly received a scholarship to study with Harvey Littleton at the University of Wisconsin, but by 1967 he had moved on to the Rhode Island School of Design (RISD) in Providence. His early work featured neon and large-scale environmental installations, but when Chihuly met the glass artist Italo Scanga there, it sparked his love affair with Italian glass techniques.

After earning his M.F.A. in ceramics at RISD, Chihuly received a Fulbright-Hayes Fellowship to study glass in Europe. While at the Venini Glass Factory on the island of Murano, outside Venice, he created a number of designs for objects that were not, ultimately, put into production. In 1969, he met Czechoslovakian studio glass artists Jaroslava Brychtová and Stanislav Libenský (see No. 94) and Erwin Eisch in Germany. Upon his return to the United States, he set up the glass department at RISD, where he taught for the next decade. Among his students were Dan Dailey, Therman Statom, and Toots Zynsky (see Nos. 88–90).

While teaching at Haystack Mountain School of Crafts, in Maine, Chihuly realized the need to make collaborative opportunities available to glass artists. He dreamed of establishing a facility like Haystack on the West Coast, where he was born. In 1971, with the support of art patrons John H. and Anne Gould Hauberg, Chihuly started the Pilchuck Glass School on the Haubergs' tree farm near Stanwood, north of Seattle.[96] Their gift was supplemented by a grant from the Union of Independent Colleges of Art to offer a two-month summer program in glass, thanks to his collaboration with Ruth Tamura, then glass department chair at the California College of Arts and Crafts, Oakland. From its earliest days as an "Age of Aquarius" rag-tag adventure with sixteen students sleeping on the ground, Pilchuck has grown into a mainstay of the studio glass movement and continues to provide a venue for glass artists from all over the world to meet, work, and learn from one another.

An automobile accident in 1976 deprived Chihuly of the use of his left eye and his depth perception, which meant he chose to no longer blow glass. Yet because he had always worked collaboratively, his creative output continued. By being "the guy up front with the baton"[97] and working with the best gaffers, choreographing their movements and guiding their serendipities, Chihuly shifted from being one of the group to the more central role of controlling the outcome.

M.D.L.

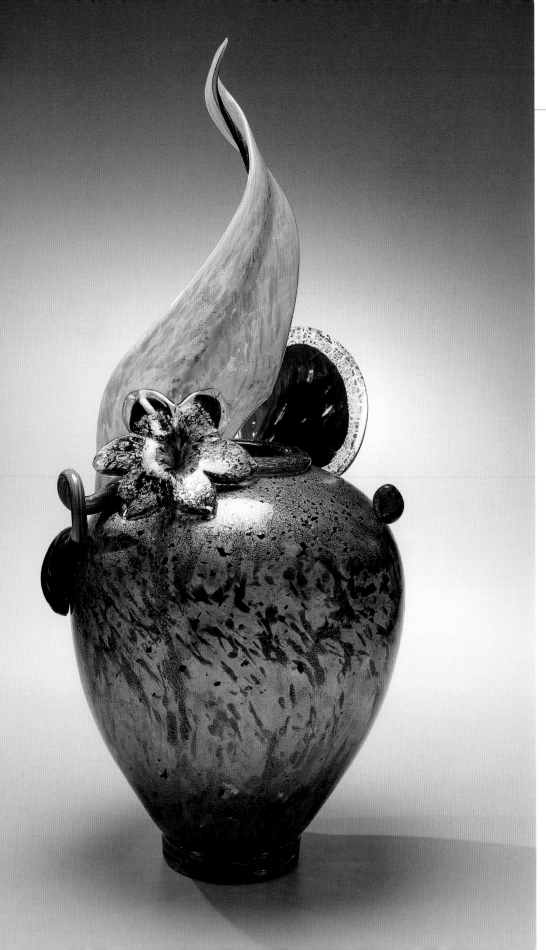

DALE CHIHULY
(United States, born 1941)
1990
Colorless and colored glass; blown, applied
and tooled decoration, gold leaf
H: 73.7 cm (29 in.)
Provenance: The artist
Gift of the Apollo Society and the artist,
1991.21
© 1990 Dale Chihuly

93 UNTITLED: BOWL

Commenting on Diana Hobson's work, the London glass collector and author Dan Klein once wrote that "[t]he best possible compliment . . . is to say that it needs no explanation."[98] Her delicate vessels are direct and subtle, presenting in neatly edited forms her apt explorations of vulnerability, beauty, and tenuousness.

Pâte-de-verre (also known as "paste glass") is a challenging technique that has its origins in ancient Egypt. It was revived in the early 1900s, notably by the glass manufactory Daum Frères, in Nancy, France.[99] While studying jewelry, silver, and glass at the Royal College of Art in London, Hobson discovered ancient Roman examples of *pâte-de-verre* in 1976, during a visit to Oxford University's Ashmolean Museum of Art and Archaeology. Her work as an enamelist naturally led to interest in *pâte-de-verre*, since both media involve fusing crushed glass with coloring agents. When she first began working with that medium in the 1970s, few contemporary artists were exploring its potential. One of the exceptions was Dan Dailey (see No. 89).

Hobson first explored the *pâte-de-verre* technique by researching documentation about Gabriel Argy-Rousseau (1885–1953), the noted French glassmaker and ceramicist who, in the early 1900s, specialized in limited production, hand-formed objects that could be made in an independent studio.[100] Hobson began to experiment with her own *pâte-de-verre* at the Camberwell School of Art.[101] After an exhaustive process of trial and error, she resorted to crushing glass in a heavy plastic bag with a hammer, experimenting with making her own molds and cleaning them with toothbrushes.

Pâte-de-verre objects are by nature small, as warm-fused glass tends to have limited structural strength. Hobson took this aspect of the medium into consideration when forming her petite vessels. *Untitled* (1987),[102] a fine example of her work that clearly reveals the density, fragility, and opacity of this type of glass. The flared bowl and slightly uneven sides, along with the delicate abstract pattern and soft colors, capture all the vulnerability of glass with none of its bluster and shine.

In 1986, Hobson presented a body of work at the Victoria and Albert Museum's Crafts Council Shop in London.[103] Her efforts were well received, and she was on her way to being considered a leader in this challenging format. Hobson has continued this experimental approach to her art and has moved from working exclusively in glass to incorporating objects in other media, including objects found in nature such as feathers and stones, and working on multi-media installations with musicians and other artists.

M.D.L.

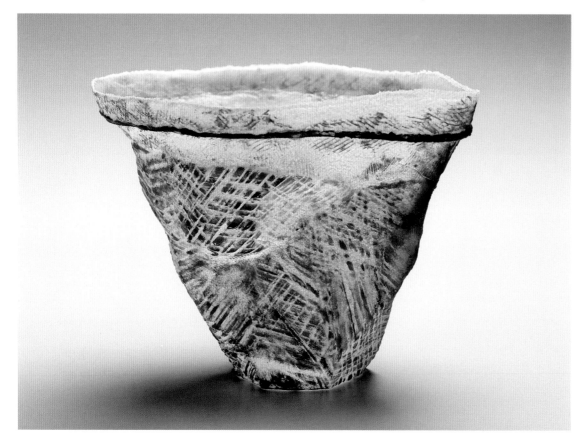

DIANA HOBSON
(United Kingdom, born 1943)
1987
Pâte-de-verre
H: 11.4 cm (4 ½ in.)
Provenance: The artist.
Gift of Carol and Don Wiiken, 2001.32
© 1987 Diana Hobson

Stanislav Libenský and Jaroslava Brychtová are considered to be among the Czech Republic's preeminent glass artists, and their devotion to sculptural glass has exerted lasting international influence. Working both singly and together, this husband-and-wife team — like American proto-studio artists Frances and Michael Higgins (see No. 80) — established a worldwide reputation. Their influence on Czech art is particularly significant: Stanislav Libenský taught three generations of Czech glass artists, and together they created monumental works in glass.

Libenský and Brychtová worked from the time of their first collaboration in 1956 through times of great upheaval in Czechoslovakia. Their early lives coincided with a brief democratic period, their young adulthoods were spent in wartime conditions under the Nazis, and their mature years were lived under Communism. Only during their final years together were they able to work in both political and artistic freedom.

The son of a blacksmith, Libenský first studied painting and glassworking at the School of Applied Arts (later the Academy of Applied Arts) in Prague. Czechoslovakia has a long tradition of glass as an art medium, so his choice was not unusual. His early work, thin-walled blown vessels, featured religious themes and images based on Renaissance art.

Brychtová was the daughter of Jaroslav Brychta, a Czech glass sculptor who received the Grand Prix in Paris in 1921 and the Grand Prix in Brussels in 1935.[104] Following the end of the war in 1945, she enrolled at the Academy of Applied Arts, where she studied cutting and engraving of glass and stone. Libenský and Brychtová met in the mid-1950s, while collaborating on a project at the Železný Brod Glassworks; they married in 1963. When the Communist party took control of Czechoslovakia after the war, Libenský and Brychtová supported a rebirth of Czech art as a form of political protest. Building on the centuries-old tradition of large-scale glass castings, glass was particularly suitable to the task. Czech glass manufactories, unlike their American counterparts, often invited artists to

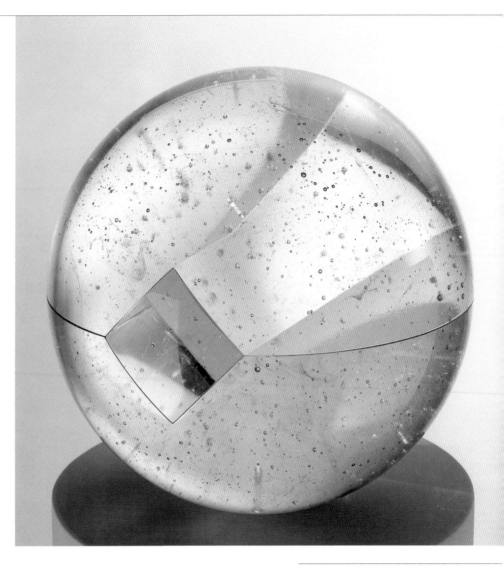

STANISLAV LIBENSKÝ
(Czech Republic, 1921–2002)
JAROSLAVA BRYCHTOVÁ
(Czech Republic,
born 1924)
1978–79
Optical glass, cast
Diam.: 38.7 cm (15 ¼ in.)
Provenance: Heller Gallery, New York, N.Y.
Gift of Dorothy and George Saxe, 1993.5
© 1979 Stanislav Libenský and Jaroslava Brychtová

work with the glass-working team, and only in a factory could large-scale works be fabricated. When they began collaborating, Brychtová urged that monumental sculptures would make the most of the factory resources. Her skill as a factory liaison became a critical part of their success as a production team. It was only when the couple established their own glass studio in the 1990s that they ceased to work closely with factories.

The Cube in Sphere in the Toledo Museum collection[105] is a technically challenging and visually beguiling sculpture. A premier example of the geometric, disciplined formal studies that Czech glass is known for, it is also a feat of technical accomplishment. Made of optical glass (an industrial material), the work could only have been fabricated in a factory setting and reflects the industrial bias of much Czech glass.

Libenský and Brychtová were influenced by many avant-garde movements of the twentieth century, including cubism, the surrealism of Romanian sculptor Constantin Brancusi (1886–1957), and the arts of Africa and Oceania. Cubism became a cornerstone of their art; it was not the formalist French cubism, however, but rather a Czech variation that treated cubism as a philosophical approach to art-making. Libenský and Brychtová "projected both the real plane and the front plane, and the cubist principle of the frontal, two-dimensional space was realized through light."[106] This approach led to their innovative use of internal space also in table-sized sculptures (see Fig. 94.1).[107]

M.D.L.

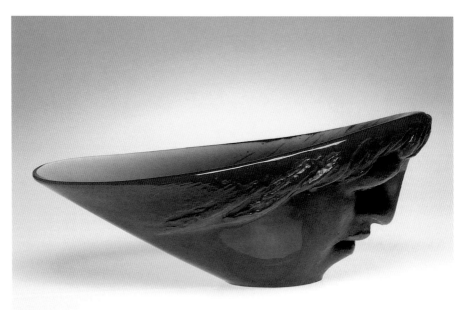

Fig. **94.1.** *Head Dish*, 1956 / 1983–84. Stanislav Libenský (Czech Republic, 1921–2002) and Jaroslava Brychtová (Czech Republic, born 1924). Saphrin glass, cast, W: 29.8 cm (11 ¾ in.). Gift of Dorothy and George Saxe, 1991.123. © 1984 Stanislav Libenský and Jaroslava Brychtová.

Ann Wolff is a sculptor, painter, and printmaker, and, although she works with glass, she prefers not to be called a "glass artist." Her mastery of many media indicates her extensive talent and informs each new medium she explores. Through her fascination with body parts (especially the human head), Wolff explores themes of women's dependence on men, women as homemakers, and the need for personal freedom. Although her themes and forms are a natural extension of personal experience, they are also allegorical. Her haunting, mystical works often involve opposites (masculinity and femininity, positive and negative, captivity and freedom) expressed through layers of questions and answers that are probed by symbolic imagery.

Wolff combined glass and wood to create *December Woman*,[108] during a sabbatical from working exclusively in glass and a foray into sculpture using clay, bronze, and other materials, from the mid-1980s to the mid-1990s. In this sculpture, Wolff's interest in printmaking and other graphic media can be seen in the intensity and painterly sensibility of her work. Here, the glass "face" is strongly drawn, with painterly and graphic rendering that seems to express the sadness of aging, as suggested by the title. The haunting eyes look out from atop a rigid, totemic torso. Painted with bold splashes of color, the figure's gender and maturity are indicated by sagging, block-like breasts. With its stoic posture and somewhat battered appearance, this sculpture reflects Wolff's ongoing investigations into the human condition.

Growing up in post-World War II Germany, Wolff first studied visual communications before becoming a designer for Sweden's Pukebergs Glassworks in 1960. Göran Wärff, a colleague she met there and later married, introduced her to glass as an art medium. She partnered with the distinguished Swedish glass manufactory Kosta Boda from 1964 to 1978 but ultimately established an independent studio in Transjö. Wolff lives and works in both Sweden and Germany, where she is a professor of design at the Hochschule für Bildende Kunst, Hamburg.[109]

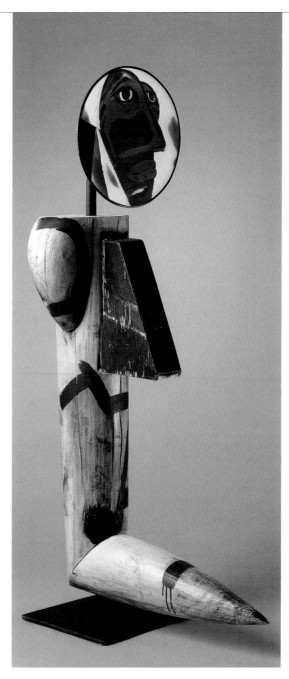

ANN WÄRFF WOLFF
(Germany, born 1937)
1988
Glass; blown, painted wood, metal
H: 121.9 cm (48 in.)
Provenance: Clara Scremini Gallery, Paris, France.
Gift of Dorothy and George Saxe, 1993.11
© 1988 Ann Wolff

While other glass artists work with figurative imagery (e.g., Dan Dailey, No. 89, and Howard Ben Tré, No. 98), Wolff's art feels uniquely personal in its characterization.
M.D.L.

Dana Zámečníková uses glass as a structural canvas for powerful painted images. Rejecting the traditional, time-consuming process of enameling on glass, she applies images directly onto the glass with oil paints. Seeing herself as an artist who is free to choose her medium, Zámečníková works in glass because she believes it is the best way to express her ideas. Like her German colleague Ann Wolff (see No. 94), she refuses to call herself a "glass artist."

Zámečníková's works usually include narrative content (often personally linked) that is "short-circuited" by her layered presentation. Her themes are often humorous, magical, or puzzling — and always interesting. For her, the challenge is to "tell the story without becoming too literal [and] without losing the mystery and magic."[110] As Zámečníková explains, "the layers of glass I use are layers of events I experience."[111] The layers, which add both actual and metaphorical depth, allow the images to interact in a given work of art, deepening its meaning and sophistication. Her narratives are drawn from the people and experiences of her life. As she explains, "I want to show how much they influence me, and how often and to what extent my daughter, my husband, all those dogs, a horse, and our beloved mouse — my family — appear in my work."[112] With figures in various stages of dematerialization, rendered alternately with scratchy outlines and dense passages of color, Zámečníková can "record mutually incongruous stories, a summary of history and contemporary time, confusion of symbols."[113]

Zámečníková's gestural painting on glass captures her enthusiasm for theater and its magical qualities. In this case, the mystery of *Theater* doubles as a metaphor for the mysteries of life itself.[114] Her interest in constructed sets, architecture, and theatrical drama is clearly evident. Zámečníková's interest in the theater stems from early studies of architecture and theater in Prague. Her first job after graduating from the Academy of Applied Arts was in stage design, and for a time she was the youngest stage designer working for the Prague National Theater.[115] She was introduced to glass in 1973 when she met glass artist Marian Karel (born 1944), whom she later married. Karel, a student of Stanislav Libenský (see No. 93) at the Academy of Applied Arts, shared the technical information she needed to work in glass.

Zámečníková first painted on cubes or spheres of glass encased within larger glass constructions. By the late 1970s, she had adopted her signature technique of painting on layers of plate glass, perhaps an extension of the Baroque-style sets she had designed for a production of Molière's *Amphytrion*.[116] Artists of the Baroque era (the seventeenth and eighteenth centuries) often used layering to enhance visual and dramatic effects. Ironically, Zámečníková's lack of formal training in glass gives her work a freshness and originality not often seen in Czech studio glass.
M.D.L.

DANA ZÁMEČNÍKOVÁ
(Czech Republic, born 1945)
1983
Sheet glass; wire, lead, oil paint
H: 45.9 cm (18 $\frac{1}{16}$ in.); W: 67.6 cm (26 $\frac{5}{8}$ in)
Provenance: Heller Gallery, New York, N.Y.
Gift of Dorothy and George Saxe, 1991.140
© 1983 Dana Zámečníková

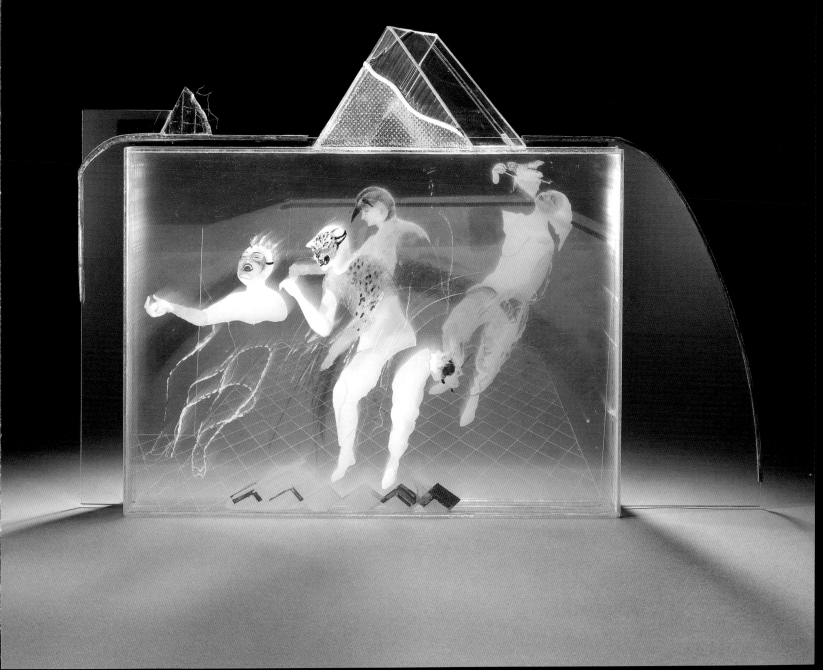

97 CASKET: RED AND WHITE PLUM BLOSSOMS

Kyohei Fujita, one of Japan's preeminent glass artists, was initially attracted to the medium of glass while still in junior high school, because with glass, as he observed, "you can see results very quickly indeed."[117] Fujita's first exposure to glass probably resulted from early contact with the work of a family relative, the 1930s pioneer studio glassmaker, Tochichi Iwata.[118] After studying metal engraving at the Tokyo School of Fine Art, Fujita first worked for the Iwata Glass Company.

On the eve of World War II, Fujita helped organize the Mahani craft circle. Like the *Mingei-kai* (short for *minshu-teki Kogei*, or "common people's craft," begun by Soetsu Yanagi (1889–1961), the Mahani circle artists believed that utilitarian objects could also be art. Fujita remained a member until 1956, when he felt the Mahani circle had become too tightly focused on traditional crafts at the expense of newer ones. Fujita opened his own glass studio in 1949, though he had not yet mastered all the technical aspects of glassblowing. By 1957, however, he had produced a body of work large enough to earn him a solo exhibition at Tokyo's Matsuzakaya department store. His early works were small, blown vessels with a variety of decorative schemes, including multi-colored glass inclusions, gold leaf encased in overlays of clear glass, and contrasting trailed-glass festoons with metallic accents. These intricate pieces were then sandblasted to impart a matte surface texture.

By the mid-1960s, Fujita was making vessel-based *ryudo,* organic forms that refer to Roman cage cups. *Ryudo* is a glass technique that involves a race against time, in which the glass is brought to the melting point, with its flow solidifying as it cools. This interest in using the liquid-to-solid progression inherent in hot glass dovetails with the longstanding Japanese passion for the random and unexpected effects of the *anima* (spirit) inherent in all things. Throughout his career, Fujita would return to this technique.

In 1977, Fujita first visited the glass factories of Murano, Italy, where designers often collaborate with Italian master glassblowers. This

Fig. 97.1. *Writing Box (Suzuri-bako),* about 1800. Japan, Tokugawa Period (1603–1868). Lacquer (*hiramakie, kirikane,* gold *fundame,* sprinkled on a black ground), inlaid gold foil, H: 22.5 cm (8 ⅞ in.). Gift of H. A. Fee, 1952.29A–D.

tradition of interactive, spontaneous collaboration gives Italian glass its distinctive character and inspired in Fujita a renewed sense of color and form. The process was a perfect match for Fujita's customary Japanese respect for serendipity in art-making.

Red and White Plum Blossoms,[119] from a series Fujita began in 1973, is based on Japanese *kazaribako,* or traditional ornamented caskets, which are similar to the lidded, hinged boxes used for reliquary or ornamental purposes (compare Fig. 97.1, a lacquer writing box decorated with a scene of a blossoming plum tree at night, beside a stream).[120] Here, Fujita merged the traditional *kazaribako* form with another form used in lacquered storage boxes and inkstone cases of the Heian Period (794–1192). To make this box series, Fujita worked with a team of glassblow-

ers, who blew hot glass into specially made iron molds that form the top and bottom halves of the box. He then applied metallic foils to the outsides of both halves and had them encased in another layer of hot glass. Fujita's decorative elements derive from the *Rinpa* (Sōtatsu-Kōrin) school, founded by Tawaraya Sōtatsu in the seventeenth century, which favored strong decorative patterns, asymmetrical compositions, simple silhouettes, and a variety of colors. After the annealing process, the two glass halves were sandblasted and hand-finished, and metal mounts were added to the rims. Interestingly, Fujita used his early training in metals to inform his glass technology, melding the two mediums to create a work that references Japan's long aesthetic traditions.

M.D.L.

98 BEARING FIGURE WITH AMPHORA

Although a number of high-profile artists in the early and mid-twentieth century used glass — Alexander Calder, Joseph Cornell, Barbara Hepworth, Wassily Kandinsky, Henry Moore, and David Smith, to name a few — works made of glass had not yet become widely recognized as high art. During the late twentieth century, however, two factors converged to give glass new recognition by the art world. One was that several well-known artists — including the conceptual and minimalist sculptor Christopher Wilmarth (see No. 99) and painter-sculptor Larry Bell (born 1939) — began to created works using glass. Conversely, the work of certain glass artists — among them Howard Ben Tré and Bert Frijns (see No. 100) — began to be featured in international art galleries. This crossover activity led to fertile dialogue between glass artists and fine arts artists.[121] In addition, collectors who were interested in sculpture, regardless of medium, spurred a trend to acquire large sculptural works in glass.

Howard Ben Tré is one of several glass artists who have been embraced by the international art world. Much of the impact of his sculpture derives from his use of cast glass. As with plate glass, the thick "white" glass he uses to make his rough-textured "green" pieces has a naturally occurring verdant tinge unless it is changed by chemical modifications.[122] Ben Tré prefers glass that remains murky and dense and has a mysterious glow, and he allows imperfections in the glass, which lend an intriguing timelessness to his work.

Typically, Ben Tré begins a sculpture by making a gestural drawing to establish the general outline and character. He then makes a full-scale mechanical drawing to help establish the scale and proportions. He transfers the drawing to full-sized patterns of rigid polystyrene and cardboard and, after refining shape and size, takes the pattern to a foundry, where it is converted to three-dimensional resin-bonded molds. At a glass factory, some twenty to fifty ladles of molten glass are poured into the thick, heavy molds. For the next six weeks, the molds

and their contents are "cured" (hardened) in annealing ovens before they can be ground, cut, sandblasted, and embellished with metal.

Bearing Figure with Amphora is one of eight works by Ben Tré in the Toledo Museum collection.[123] Feelings of power, vulnerability, and luminescence combine to give the sculpture a spiritual dimension. A large, totemic granite form embraces a smaller, anthropomorphic form of cast glass, which has a golden orb suspended inside. Playing on the reference to an amphora (an ancient Greek jar used for storing grain, oil, or wine), the work explores the internal / external aspects of the private / public self and perhaps also the sense of maternity, regeneration, fertility, and life. As with many of Ben Tré's works, the form and tone of this sculpture draw their inspiration from architecture — Greek temples, Mayan ruins, and Gothic cathedrals.[124] As art critic and scholar Arthur C. Danto observed, "with Ben Tré's later work — the posts, the columns, the abstracted figures, the basins and what I think of as pestles — he is inventing the forms of an imagined civilization."[125]

Ben Tré believes that his mature work began around 1977, when he was still an undergraduate at Portland State University. As he explained, "[g]lass as a medium allows me to explore the merging of organic and geometric qualities in form and decoration. I am particularly interested in sand casting of glass because the process gives a timeless feeling to contemporary shapes and frees me from the limitations of the blown form."[126] During a trip to Britain, he was drawn to the architectural glass at Tintern Abbey, Monmouthshire, Wales, which made him aware of the potential for monumentality in his architectural imagery, qualities that continue to influence his work.

M.D.L.

HOWARD BEN TRÉ
(United States, born 1949)
1995–97
Colorless low-expansion glass; cast; gold
leaf inclusion, patinated cast bronze,
granite casing
H: 213.4 cm (84 in.); W. (max.):
91.4 cm (36 in.)
Provenance: The artist.
Gift of Georgia and David K. Welles, 2003.57
© 1995 Howard Ben Tré

Christopher Wilmarth used light as his sculptural medium. Although he worked with other materials, glass, for him, "is only a vehicle . . . used not for its own sake but for its ability to generate an experience of light."[127] Wilmarth's early years in California, renowned for its unique and evocative light, deeply informed his art.

When he moved to New York in 1960 to study at the Cooper Union for the Advancement of Science and Art, Wilmarth spent his first few days photographing downtown Manhattan and then incorporated the imagery into his drawing, painting, and sculpture. Acutely sensitive to his environment, he took an intuitive and expressive approach to his work rather than the strong formalism of the period.[128] Glass had always fascinated Wilmarth, and in 1979, while working as a visiting artist at the University of California, Berkeley, he learned glassblowing from Marvin Lipofsky (born 1938), an instructor at the California College of Arts and Crafts (now California College of Arts). As Wilmarth worked with bent and blown glass — making wall pieces, blown-glass reliefs, and free-standing glass-and-steel sculptures — his work came to express poetic evocations of male and female, inflected with a sense of longing. While these sculptures manifested his fascination with sadness, decay, and how (or whether) the spirit survives beyond death, he used light to communicate mood. He became a master of the minimalist sensibility that valued illusionistic techniques and explored emotional qualities through distortions. After his death, Wilmarth's preoccupation with these concepts was described as a "symbolist's soul conveyed through the modernist tradition."[129]

New Ninth #2,[130] which addresses these themes through the subtle handling of glass and steel, reveals Wilmarth's tendency to manipulate planes rather than volumes. While this sculpture might at first appear pictorial and illusionary, it is actually a non-representational, three-dimensional construct that seeks to activate the space around it. Here, Wilmarth's hallmark nuanced gradations evoke poignancy and mystery. Glass, especially blown glass — which he called "frozen breath"[131] — was the perfect vehicle for the artist to explore his interest in the nineteenth-century writings of the French symbolist poet Stéphane Mallarmé. "In my attempt to make believable art," Wilmarth wrote in 1974, "I make sculptures in which the forms seem to have evolved of themselves."[132] These dark, murky works mirrored Wilmarth's own tragic sense of life. In 1987, at age forty-four, Wilmarth took his life, but his work lives on as a testament to his probing mind and his creative efforts.

M.D.L.

CHRISTOPHER WILMARTH
(United States, 1943–1987)
1981
Plate glass; steel
H: 97.2 cm (38 1/4 in.); W: 81 cm (31 7/8 in.)
Provenance: The artist
Purchased with funds from the Libbey Endowment, Gift of Edward Drummond Libbey, 1982.1
© 1981 Christopher Wilmarth

100 BOWL ON STONE

Bert Frijns lives on a farm on an island in Zeeland, in the southwest of The Netherlands. His choice of locale underscores his disengagement from the world glass art community and his refusal to follow contemporary glass trends. While many glass artists exploit the wide range of colors possible in glass, Frijns prefers the muted green tint and slight imperfections inherent in commercial sheet glass. Using transparent, colorless glass as his palette, Frijns's work reflects Holland's geography and its cool, white light.

After an early education in sculpture and design, Frijns settled on exploring pure geometry (it is almost a Dutch national trait) and, after initial experiments with small vessel forms, his sculptures became large and bold. He even experimented with sawing blocks of glass to create geometric sculptures. By the early 1990s, he returned to bowl forms, but added dents to embellish the work. Frijns's training as a sculptor is evident as he brings those sensibilities to his minimalist work, whatever the scale. He has completed a number of site-specific pieces that are large-scale installations. All of his works invite contemplation, and appear deceptively simple in concept and execution.

The Toledo Museum's *Bowl on Stone*[133] is typical of Frijns's later bowl forms but remains consistent with earlier works that express an ongoing evolution, incorporating an ever-increasing level of meaning and sophistication. One theme that informs all of his work is how light transforms ordinary glass. Described as creating "serene oases" with minimalist and muted sensibilities, Frijns was deeply influenced by modernist sculptors Henry Moore and Constantin Brancusi, and even by the environmental artist Christo (Christo Vladimirov Javacheff). Art historian Dorris Kuyken-Schneider has noted a "sacramental aspect" to Frijns's works, comparing them with ritual vessels, "modern variations of the Holy Grail and a Celtic beaker, like the one used by the Knights of the Round Table."[134]

In *Bowl on Stone,* Frijns used a kiln to deform a sheet of glass — ordinary window glass — to create the desired shape. The process involved placing the sheet of glass over a ring and heating it to between 580 and 900°C., causing it to slump into a perfect parabolic shape.[135] The "brim" of the resulting hat-like form was cut away and the edge polished, either by hand or on a polishing wheel. Using handmade tools and molds and a trial-and-error method of fabrication, Frijns initially had to discard about 90 percent of his work, until he arrived at the right method for timing during the forming process. To complete these works, Frijns adds water to enliven the work through its reflective qualities and its slowly changing level. The water is reflected onto the stone beneath, creating beguiling distortions at the points of intersection between glass and stone and underscoring the dichotomy between hard and soft, liquid and solid. With its ritual and primeval aspects, the water transforms the sculpture from a "dead" to a "living" work, the movement of the water serving as a key element.[136] As German glass scholar Helmut Ricke noted, "Frijns's work revolves around the concepts of balance and harmony," where the form rests and requires "just the smallest push to result in instability and movement."[137]

M.D.L.

BERT FRIJNS
(The Netherlands, born 1953)
1999
Sheet glass; marble
Diam. (bowl): 109.5 cm (43 1/8 in.); W: (stone): 73 cm (28 3/4 in.)
Provenance: Galerie Rob van den Doel, The Hague, The Netherlands.
Purchased with funds given by Byron and Dorothy Gerson, John D. Nichols, the Estate of Norma M. Sakel, Harold and Arlene Schnitzer in honor of George and Dorothy Saxe, Jean Sosin, and the Estate of Martha Zimmerman, 2000.38
© 1999 Bert Frijns

GLOSSARY

Note: This glossary contains extensive quotations from *Looking at Glass: A Guide to Terms, Styles, and Techniques,* by Catherine Hess and Karol Wight (© 2005 J. Paul Getty Trust) and from *Glass: A Pocket Dictionary of Terms Used to Describe Glass and Glassmaking* by David Whitehouse (© 1993 The Corning Museum of Glass). The Toledo Museum of Art thanks the authors, The Corning Museum of Glass, and The J. Paul Getty Museum for permission to integrate parts of their works in order to incorporate consistent terminology into this book.

ACID-ETCHING or **POLISHING**: The use of hydrofluoric acid (HF) to alter the surface of the glass. Acid can be used to create a matte surface, to polish glass, or to decorate it. In this process, the glass is first covered with a wax-like acid-resistant substance (known as *resist*) through which the area or pattern to be etched is incised with a sharp tool. A dilute mixture of hydrofluoric acid and potassium fluoride (KF) are then applied to the exposed areas of the glass until the desired result is achieved. An effect similar to WEATHERING can be achieved by exposing glass to fumes of hydrofluoric acid to create a matte surface. See Nos. 71, 90, and Fig. 75.2

ALKALI: A soluble salt leached from the ashes of burned plants that contain potassium or sodium carbonate and called POTASH (K_2CO_3) or soda ash (Na_2CO_3), respectively (see SODA). It is one of the essential ingredients of glass, generally accounting for about 15 to 20 percent of the BATCH. The alkali is FLUX, which reduces the melting point of SILICA (in the form of sand or, less often, FLINT), the major constituents of glass. Without the addition of flux to the batch, the temperature at which silica melts would be too high to be practical or commercially viable.

ANNEALING: The process of heat-treating and slowly cooling a completed glass object in a heated chamber known as a *lehr* (German; also spelled: *leer*), in order to allow the stresses that are built up in the glass during manufacture to dissipate without deforming the object. The *lehr* is either a chamber connected to the main glass FURNACE or a separate construction. Annealing is a critical step in glassmaking, because if a hot glass object is allowed to cool too quickly, its molecular structure will be highly strained by the time it reaches room temperature; indeed it may spontaneously break during the cooling process. Highly strained glass breaks easily if subjected to either mechanical or thermal shock. The strain is caused by different parts of the glass cooling and hardening at differential rates. To equalize the cooling process, the glass is initially heated to a uniform temperature and then allowed to cool slowly and uniformly in the *lehr*.

APPLIED DECORATION: The fusion of heated glass elements to a hot glass object during manufacture. These applied elements are either left in relief or are MARVERED until they are flush with the surface. See also TRAILING.

BATCH: The mixture of raw materials needed to make glass. The ingredients—generally SILICA (from SAND, FLINT, or quartz), an ALKALI (in the form of SODA ash or POTASH), and LIME (as calcium-containing impurities or calcined limestone)—are heated in a crucible or pot, made of fireclay. Other elements, such as CULLET and METALLIC OXIDE, can be added to the pot to form part of the batch. When the mixture is in a molten state it is called the *melt*, although the word *batch* is commonly used to denote the same thing.

BLANK: A cooled glass object, usually a vessel, which will be further formed or decorated, often using cold-working techniques such as CUTTING and ENAMELING.

BLOWING: The technique of forming an object by inflating a gob of molten glass gathered on the end of a BLOWPIPE. To pick up the GATHER, the "nose" of the blowpipe (the conical end opposite the mouthpiece) is preheated so that the glass will adhere to it, then it is dipped into the BATCH of molten glass inside the FURNACE, rotated, and withdrawn from the furnace. The GAFFER shapes the gob (using a MARVER, a BLOCK, or a pad of damp paper) and blows through the pipe, slightly inflating the gob to form an initial PARISON. Free-blown glass is shaped by manipulating the parison using gravity, centrifugal force (by twirling the pipe), and tools such as JACKS, PINCERS, or SHEARS. By contrast, MOLD-BLOWN glass is shaped by inflating the PARISON in a MOLD.

BLOCK: A chunk of wood—traditionally apple, pear, or cherry wood—hollowed out to form a concave hemisphere or oval. To preserve its shape and avoid cracking or splitting, the block is always kept in water when not in use. The block is used to help the glassblower shape a GATHER of glass into a sphere before inflation, and it is kept wet while in use to reduce charring and to create a "cushion" of steam between it and the hot glass.

BLOWPIPE, or blowing iron: The iron or steel tube, usually about 150 cm (60 in.) long, used for inflating glass. Blowpipes have a mouthpiece on one end, and the other end flares out to form a conical shape (the "nose") onto which hot glass is gathered.

BRILLIANT CUTTING: The process of decorating a glass object with deeply cut, elaborate patterns that frequently cover the vessel's entire surface and are highly polished. Brilliant-cut, also called rich-cut, glass vessels were especially popular in the United States from about 1880 to 1915. See also CUTTING and No. 72.

BUBBLE: See PARISON.

CALIPERS: An instrument with two adjustable arms that serve to measure diameter or thickness. A glassworker uses calipers to copy a given form, in order to create identical or matching pieces in a set or series, such as a table service of glassware.

CAMEO GLASS: A type of glass made of two or more layers of glass of different colors. During manufacture, the primary layer, which serves as a background color for the design, is covered with one or more layers of contrasting color, usually by ENCASING. The outer layers are carved, CUT, ENGRAVED, sandblasted (see ABRASION), or ACID-ETCHED to produce a design in relief. The glass used to make the over-layers is generally softer to facilitate the creation of the relief design. The first cameo glass objects (vessels, gems, plaques, and INLAYS) were made by the ancient Romans. Most historic examples of cameo glass vessels consist of only two layers of glass, usually white over blue, but some were produced with as many as seven layers. See Nos. 8, 66.

CANE: A thin glass rod (usually monochrome) or a composite rod, consisting of groups of single glass rods of different colors bundled together and FUSED to form a polychrome design that is visible when seen in cross-section. Cut segments of cane are used in the manufacture of MOSAIC GLASS and MILLEFIORI. Small canes of glass, with decorative finials, were used in antiquity as perfume dippers and for stirring. See Nos. 5–7, 51, 64, 88. See also FLAMEWORKING.

CASING: The process of applying one layer of glass onto the inner surface of a preformed cup that is made of glass of a different color. Also known as inside casting or cup-overlay. The two glass components adhere to one another and are then inflated together. Sometimes the outer layer is CUT or ACID-ETCHED to create CAMEO GLASS. See No. 57.

CASTING: A general term that refers to various techniques for forming glass vessels or objects in a mold (see also LOST-WAX CASTING and MOLDING). See Nos. 2, 4, 75, 98.

COMBING: A technique for decorating a glass vessel with a zigzag, wavy, festoon, or feather pattern of two or more colors. Combing is achieved by applying thin TRAILS of glass of a contrasting color to the glass body. The trails are dragged at right angle to the glass surface using a hooked or pointed tool to achieve the desired pattern. Combing is done either before or after MARVERING the trail into the body. See Nos. 1, 3, 23.

CORE: A form made of clay and vegetable material that is covered with a layer of calcite (calcium carbonate, $CaCO_3$). The core is built up over the end of a rod and defines the shape of the interior of a small vessel that is formed over it. It is thought that, in pre-Roman times, the core was made of animal dung mixed with clay; the rod may have been made of wood or metal.

CORE FORMING: The process of making a small glass vessel by TRAILING or gathering hot glass around a core supported by a rod (sometimes also called "rod forming"). After forming, the object—with the rod still attached—is ANNEALED. After annealing, the rod is pulled out and the core is removed by scraping it from the interior of the finished vessel. See Nos. 1, 3.

CRACKING OFF: The process of detaching a glass object from the BLOWPIPE or PONTIL by weakening its join to the rod, either by dripping water on it (to create thermal shock) or by scoring it with a metal file (to create a tiny crack) and then gently tapping the object, the blowpipe, or the pontil, to break it free.

CRISTALLO (Italian, "crystal"): A term first used in Venice in the fourteenth century to describe glass that resembles colorless rock crystal, a variety of quartz prized for its clarity. The creation of *cristallo*—essentially by adding a DECOLORIZING agent—was arguably the greatest achievement of Venetian glassmakers and that upon which the city's great export trade in glass came to be based. Although clear glass had been created by various cultures in antiquity (see Nos. 2, 4), its mass production was exclusive to Venice in the fifteenth century. In the sixteenth century, emigrant Venetians transmitted the process to other centers in Europe, such as Bohemia, Austria, Spain, The Netherlands, France, and England.

See also *FAÇON DE VENISE* and Nos. 28, 30, 34, 37.

CRIZZLING: A chemical instability in glass caused by an imbalance in the ingredients of the BATCH, particularly an excess of ALKALI or a deficiency of stabilizer (usually LIME). This instability causes the glass to react to moisture in the atmosphere and thus to deteriorate. The process produces a network of fine cracks and surface dampness as the alkaline moisture is drawn to the surface. The process is increasingly destructive unless the glass is placed in a stable and controlled environment. Although crizzling can be slowed or perhaps even halted in this manner, it cannot be reversed. Glass suffering from crizzling is also known as weeping, sweating, sick, or diseased. See Nos. 47, 48B.

CRYSTAL: A term used to describe clear, colorless glass of superior quality that has a high refractive index (a measure of the amount that glass changes the direction, or bend, of light waves that strike its surface), which consequently makes it particularly brilliant, or sparkling. LEAD GLASS has a higher refractive index (bends the light waves more) than SODA-LIME GLASS and, when decorated by cutting, gives a more brilliant effect. Today the word "crystal" is often used to describe any fine glass object. See also LEAD GLASS.

CULLET: Fragments of raw or broken glass, often added to a new BATCH to act as FLUX, reducing the time or temperature required to melt the components. "Cullet" also refers to scrap glass intended for recycling.

CUTTING: The process of removing glass from a vessel to shape or decorate it by grinding it with a rotating wheel made of stone, wood, or metal (frequently copper) attached to a lathe, with the action of an ABRASIVE suspended in liquid (such as vegetable oil). The earliest known cut-glass vessel, which dates to about 720 B.C.E., was found in the ancient city of Nimrud in Assyria (modern Iraq), but glass-cutting was not used extensively before the Roman period. See also BRILLIANT CUTTING, ENGRAVING, FACETING, and LATHE cutting.

DECOLORIZER: An agent added to the BATCH to counteract the effects of impurities that occur naturally in the raw materials used to make glass, and which accumulate as those materials are handled. The impurity most responsible for discoloring glass is iron (Fe), which imparts a greenish-blue tint. Iron compounds mainly absorb light at the red end of the spectrum as it penetrates the glass, causing the glass to appear green. To make the glass appear more uniformly colorless, glassmakers can add various compounds—such as manganese dioxide (MnO_2) or cerium oxide (CeO_2)—to absorb light on the opposite, or blue, end of the spectrum. Indeed, from the time of the Roman scholar Pliny the Elder (23–79 C.E.) until the present, manganese has been the principal decolorizer of glass.

DEVITRIFICATION: The change that occurs in glass from its normal, non-crystalline state to a crystalline one. This process may occur as a defect, from improper cooling or ANNEALING of the hot glass (usually when it is cooled too slowly), or from accidentally heating the glass to an excessively high temperature.

DICHROIC GLASS: A type of glass whose physical proper-ties enable it to appear one color in reflected light and another color when light is transmitted through it. These properties are sometimes due to the presence of minute quantities of colloidal gold, silver, or manganese suspended in the BATCH used to make the object. See No. 36.

ENAMEL: A substance composed of finely powdered glass that has been colored with a METALLIC OXIDE and either sprinkled with a sieve onto the glass that has been coated with a binding medium, or mixed with an oil medium and applied with a brush. Once the enamel decoration is applied, the glass object is either placed in a low-temperature MUFFLE KILN for FIRING (about 500°-700°C, or 930°-1300°F). During the Renaissance, enamel-decorated objects were reintroduced to the mouth of the FURNACE at the end of a BLOWPIPE or PONTIL. During this firing, the binding medium burns away and the enamel fuses to the surface of the glass. Several firings are sometimes required to fuse different enamel colors to a highly decorated object. See Nos. 39, 31, 41, 46, 50, 58, 69, 80.

ENCASING: Covering a vessel or object, such as a paper-weight, with a layer of colorless glass. See also CASING.

ENGRAVING: CUTTING into the surface of a glass object either by holding it against a rotating copper wheel fed with an abrasive or by scratching it with a stylus with either a diamond point or some other hard substance. Copper-wheel engraving is used to create ornamentation that lies either above the surface of the glass by removing areas of the background, called relief cutting (*Hochschnitt*), or decoration that lies beneath the surface of the glass by cutting into the object, called *intaglio* (*Tiefschnitt*). Venetian engravers introduced diamond-point engraving in the sixteenth century and glass engravers in the Netherlands carried it to some of its greatest artistic heights during the seventeenth century. See Nos. 15, 34, 40, 43, 45–47, 52, 56–58, and 78, and Fig. 73.1.

FACETING: Cutting and polishing an object with a rotating wheel to give the surface a pattern of planes or facets. See also CUTTING. See Nos. 16, 18, 49.

FAÇON DE VENISE (French, "Venetian style"): Glass made in imitation of Venetian products, at centers other than Venice itself. Given the prestige, durability, and high importation costs of Venetian glass, glassmaking centers throughout Europe—especially in France, England, Germany, Bohemia, the Netherlands, Spain, and England—produced their own versions of *façon de Venise* glass in the sixteenth and seventeenth centuries. This highly imitative non-Venetian glass can be difficult to distinguish from original Venetian examples. See Nos. 37, 38.

FILIGREE GLASS (Italian, *vetro a filigrana*): Any blown glass made with colorless, white, and sometimes colored canes. The filigree technique originated in the glass factories of Murano in the sixteenth century and spread rapidly to other parts of Europe, where *FAÇON DE VENISE* glass was produced. Filigree glass was made at Murano until the eighteenth century and was revived in the twentieth century. There are three main types of filigree glass: *vetro a fili* ("glass with threads"); *vetro a reticello*, or *redexello* ("glass with a small net pattern"); and *vetro a retorti*, or *retortoli* ("glass with twists"). *Vetro a fili* displays CANES that form a pattern of parallel lines. *Vetro a reticello* is made by arranging canes in a criss-cross pattern to form a web or lattice. Sometimes an air trap is produced between each of the net interstices to enhance the glittering, brilliant, or sparkling, quality of the glass (see also PARISON). *Vetro a retorti* is made of canes that have been twisted to form spiral patterns. Most often, filigree glass is made from only clear and white glass canes. The white canes are made of *LATTIMO*, or milk, glass, produced by the addition of tin oxide (SnO_2) to the BATCH. Indeed, the old term for this glass was *latticinio* or *latticino*. The combination of white and clear canes heightens the lacy appearance of the glass and may actually relate to the concurrent and important production of Venetian lace. Similar filigree canes were made in antiquity, but the vessels in which they were used were cast rather than BLOWN (see ribbon glass under MOSAIC GLASS). See Nos. 34, 35, 41.

FLAMEWORK: The formation of objects from glass rods and tubes by heating them in a flame (referred to as *at-the-flame*). Until the nineteenth century, the flame source was an oil or paraffin lamp with a foot-powered bellows to get a flame hot enough to soften the glass for manipulation (hence the alternative name "lampwork"); since the nineteenth century, gas-fueled torches have been used. See No. 91.

FLINT GLASS: A term used to describe glass made in England during the seventeenth century in which powdered flint (impure quartz) was used in lieu of sand as the source of SILICA: see No. 48. The term is often mistakenly used to identify English- and American-made LEAD GLASS.

FLUX: An ALKALINE substance that lowers the melting point of materials in a mixture, thereby facilitating their fusion. For example, a flux is added to the BATCH in order to melt the SILICA, which normally requires very high and, therefore, hard-to-reach temperatures required to FUSE it. Fluxes are also added to ENAMELS in order to lower their fusion point to below the softening point of the glass body to which they are applied, so that they will adhere to the glass before the glass gets so hot that it loses its shape. POTASH and SODA are fluxes. See also CULLET.

FURNACE: An enclosed structure used to produce and apply heat in the production of glass. In glassmaking, furnaces are used to melt the BATCH, to keep pots of glass in a molten state, and to reheat partly formed objects at the GLORY HOLE. See also KILN.

FUSING: The use of heat to bond two or more pieces of glass in a KILN or FURNACE, or heating enameled vessels in a KILN until the ENAMEL bonds with the surface of the object. See also *PÂTE-DE-VERRE*.

GAFFER: The master craftsperson in charge of a team of hot-glass workers (also called a chair or a shop). A glass object fashioned in a glasshouse is not so much the product of an individual as that of a team, and the gaffer directs this action. The term is believed to be a corruption of the word grandfather.

GATHER: A gob or mass of molten glass collected on the end of a tool such as a BLOWPIPE, PONTIL, or gathering iron. When used as a verb, the term also refers to the action of collecting the glass by rotating the iron while dipping its tip ("nose") into the molten glass.

GILDING: The technique of decorating an object by applying gold leaf, gold paint, or gold dust to its surface. In glassmaking, the gold can be fused to the glass by FIRING. Gilding may be applied to an object with glue or resin, can be amalgamated with mercury, or, in the case of gold leaf, can be picked up by the hot glass directly from the MARVER before the object is blown. See Nos. 34, 38.

GLASS: A hard, brittle, usually transparent or translucent material made by combining and fusing some form of SILICA (sand, quartz, or flint) with an ALKALI FLUX (SODA or POTASH) to lower the melting point of the silica and using a stabilizing agent such as LIME or lead oxide (PbO) to render the resulting glass insoluble. Technically, glass is neither a solid nor a liquid. It is referred to as an *amorphous solid* (lacking the crystalline form typical of solids) or a *rigid liquid* (since it retains many of the qualities of a liquid, such as flow). The rare examples of glass produced in nature include obsidian, pumice, and fulgarites. Glass was first intentionally produced around 2500 B.C.E. in Mesopotamia (modern Iraq), to create small objects, such as beads.

GLORY HOLE: A hole in the side of a glass FURNACE, used to reheat glass that is being fashioned or decorated. The glory hole is also used to fire-polish cast glass to smooth a rim or remove imperfections remaining from the mold.

IRIDESCENCE: A rainbow-like visual effect that changes according to the angle from which an object is viewed or the angle of the source of light. Ancient glass often appears iridescent; this is not an intentional effect but, rather, the result of WEATHERING (see especially No. 19B). On certain glasses made in the nineteenth and twentieth centuries, iridescence was deliberately achieved by introducing metallic substances into the BATCH or by spraying the glass surface with stannous chloride ($SnCl_2$) or lead chloride ($PbCl_2$) while the vessel was being constructed, then reheating it in a reducing atmosphere (one deficient in oxygen). Iridescence was especially popular with Art Nouveau glass artists and is most often associated with the work of Louis Comfort Tiffany (see No. 71). See also CRIZZLING.

JACKS: A tong-like tool having two metal arms joined by a spring, used to form stems, feet, and the mouths of open vessels, and to adjust a vessel's shape.

KICK: The concavity on the underside of a vessel formed by pushing the PONTIL into the still-soft base. A kick is commonly seen in the bottoms of modern bottled products, such as wine bottles.

KILN: An oven used to form a glass object by SLUMPING, to decorate an object by FUSING ENAMEL to its surface, and for ANNEALING a completed object. See also FURNACE.

KNOP: A usually spherical or flattened spherical part of the stem of a drinking glass. A knop can be either hollow or solid, used singly or in groups, and can be placed either contiguously or with intermediate spacing. "Knop" also refers to the finial, or ornamental knob, at the center of a lid.

LATHE: A machine used to polish, cut, or modify the profile of a BLANK. The blank is mounted in the lathe and rotated at a high speed while a cutting tool or a stationary wheel, fed with a liquid abrasive, is held against the surface of the blank.

LATTIMO (Italian, "milk"): also called *Milchglass*, from *Milch* (German, "milk"). Opaque white glass made by adding bone ash, tin oxide (SnO_2), zinc (Zn), or other materials to the BATCH. *Lattimo* glass was used to create whole vessels in emulation of Chinese porcelain, as well as to form CANES that were embedded into clear glass to create FILIGREE patterns. Transparent white glass is called *latesin* or *lactesin*.

LEAD GLASS: A type of glass that contains a high percentage of lead oxide (PbO_2, at least 20 percent of the BATCH). Lead glass was first produced in the late seventeenth century (see No. 48). Lead glass is relatively soft and easier to cut, and its high refractive index gives it a brilliance that can be exploited by decorating the surface with polished wheel-cut facets. See also CRYSTAL, FLINT GLASS, and LEAD GLASS.

LEHR, leer: See ANNEALING.

LIME: A type of calcined limestone which, when added in small quantities to the BATCH, gives it stability. In antiquity, lime was unintentionally, although fortuitously, introduced as an impurity in the raw materials that comprised the batch. It was not until the seventeenth century that the beneficial effects of lime were understood.

LOST-WAX CASTING: A molding process adapted from metalworking. The object to be fashioned in glass is made first in wax. The wax model is completely covered ("invested") with clay or plaster, then heated. The wax melts and is released from the covering material through holes and channels ("gates" and "sprues"), also made of wax, which had been attached to the wax model before covering and heating it. After all wax has been released, the clay or plaster is allowed to dry and become rigid. This rigid form then serves as the mold into which hot, powdered, or chipped glass is introduced through the gates or by way of an opening in the top. If powdered or chipped glass is used, the mold is heated to fuse the contents. After ANNEALING, the mold is removed from the object, which is then finished by CUTTING, FIRE-POLISHING (see GLORY HOLE), or ACID-ETCHING.

LUSTER: A shiny, metallic effect created by painting the surface of a glass object with METALLIC OXIDES that have been dissolved in acid and mixed with an oily medium. Firing in a reducing atmosphere at temperature of about 600°C (about 1100°F) causes the metal to be deposited on the surface of the object in a thin film that, after cleaning, has a distinctive shiny surface. See Nos. 25, 26.

MARVER: A smooth, flat surface over which softened glass is rolled or pressed while attached to the BLOWPIPE or PONTIL. Marvering is used to form and smooth the PARISON and to pick up and consolidate applied decoration to the glass surface. "Marver" derives from the word *marble*, since these surfaces were initially made of polished stone. Polished metal such as cast steel or iron is now commonly used.

MERESE: A flattened, collar-like KNOP placed between the bowl and the stem, on the stem, or between the stem and the foot of a wine glass.

METALLIC OXIDE: A compound in which a metal is chemically combined with oxygen. In glassmaking, certain metallic oxides—such as the oxides of copper, antimony,

iron, manganese, tin, cobalt, and silver—are used as coloring agents for the glass body and the ENAMEL pigments, or to create a LUSTER effect in the glass surface. The resultant color depends primarily on the oxide used but can also be affected by the composition of the glass itself and by the presence or absence of oxygen in the FURNACE.

MILLEFIORI (Italian, "thousand flowers"): See CANE and MOSAIC GLASS.

MOLD: A receptacle used for shaping and / or decorating hot (molten) glass. Some molds impart a pattern to the PARISON when it is inflated inside the mold. After the parison is withdrawn from the mold, it can be further inflated and tooled to the desired shape and size (see Nos. 24, 27D). Various types of molds are used to give a glass object its final form, with or without decoration, such as:

- Dip mold: A cylindrical, one-piece mold that is open at the top so that the gather can be dipped into it, inflated, then removed. See Nos. 9, 10, 13, 19.
- Former mold: See SLUMPING.
- Optic mold: An open mold with a patterned interior into which a parison is inserted, then removed, and further inflated to decorate the surface. See No. 24.
- Piece mold: A mold made of two or more parts. See Nos. 28, 37, 53, 60, 65, 74, 75, 97.
- Pillar mold(ed): A term used by nineteenth-century British and American glassmakers to describe vessels having MOLD-BLOWN, vertical ribs on the exterior but no corresponding indentations on the interior; see No. 61. This effect was created by partly inflating a gather, allowing it to cool sufficiently to become somewhat rigid, then gathering an outer layer of glass around it. The parison was then further inflated in a ribbed dip mold, which shaped the soft outer layer without affecting the hardened inner layer. The term is frequently, but incorrectly, applied to ancient Roman bowls with exterior ribbing (see No. 5), which were made by a different process.
- Press mold: See PRESSING and Nos. 59, 63.

MOLD BLOWING: Inflating a PARISON in a MOLD. When inflated, the glass is forced against the inner surface of the mold and takes the shape of both the mold and any relief or incised decoration that it bears. See also BLOWING and MOLD.

MOSAIC GLASS: A type of vessel or object made from pre-formed monochrome or polychrome elements (often cut from CANES) that are placed in a mold and heated until they fuse. Ancient Hellenistic and Roman glassmakers first fused their elements into a disk before sagging them over a FORMER MOLD of the desired shape (see MOLD). See Nos. 5, 6. See also MILLEFIORI.

OPTICAL GLASS: Glass of extreme purity and with well-defined optical properties, originally developed for making lenses and prisms. See Nos. 78, 94.

OVERLAY: See CASING.

PARISON: The partly inflated bubble created by a GATHER on the end of a BLOWPIPE. The term derives from the French *paraison*, meaning the initial appearance of a thing (from the verb, *paraître*, "to appear").

PÂTE-DE-VERRE (French, "glass paste"): A material produced by grinding glass into a fine powder and adding

three key ingredients: a binder to create a paste, a FLUX-ING medium to facilitate melting, and a coloring agent such as powdered glass or METALLIC OXIDES. The paste is brushed or pressed into a MOLD, dried, then FUSED by heating. After ANNEALING, the object is removed from the mold and finished. When first taken from the mold, *pâte-de-verre* has a matte surface that can be left as is, polished smooth, or carved to refine the form. See No. 93.

POLISHING: The process of smoothing the surface of a cooled object by holding it against a rotating wheel fed with a fine abrasive.

PONTIL, or *punty*: A solid metal rod to which a hot object or vessel is transferred from the BLOWPIPE for further working. When the pontil is attached to the base of a vessel by means of a wad of hot glass, it can hold the vessel while the glassmaker works on it.

PONTIL MARK: The irregular round or ring-shaped scar of roughened glass left on the base of an object when the PONTIL is removed. The absence of a pontil mark on a blown glass object indicates either that the mark was ground off or that the final shaping of the object was achieved without the use of a pontil.

POTASH: The compound potassium carbonate (K_2CO_3), used as an alternative to SODA (sodium carbonate Na_2CO_3), as a source of ALKALI in the manufacture of glass. Potash functions as a FLUX to reduce the temperature at which the SILICA melts in the BATCH. Potash glass is slightly more dense than soda glass; it passes from the molten state to the rigid state more quickly and is therefore more difficult to manipulate into elaborate forms than is soda glass. Potash glass, however, is harder and more brilliant and lends itself more readily to such decorative techniques as facet-CUTTING and copper-wheel engraving.

PRESSING: The glassmaking process that involves placing a blob of hot glass in a metal mold and pressing it with a metal plunger, or follower, to form the interior shape of a glass vessel. In the resultant piece, called mold-pressed glass, the interior form does not correspond to the exterior. The interior of MOLD-BLOWN glass, by contrast, closely corresponds to its outer form. The process of pressing glass was first mechanized in the United States between 1820 and 1830 and is used in industrial glassmaking. See Nos. 59, 63.

PRUNT: A blob of glass applied to a glass object, either as decoration or to provide the user a better grasp on a vessel. Glassware with prunts would have been useful for vessels without handles, especially during the Middle Ages and the early Renaissance, when forks were not widely used and diners would instead pick up food with their hands. Prunts could also be embellished, by impressing them with stamps while the glass was still hot. See No. 32.

RIGAREE: A raised band of pattern of bands, usually made by crimping applied TRAILS.

SAND: The form of SILICA most readily available (from the seashore, riverbeds, or other deposits) and therefore most commonly used for making glass. In most present-day glassmaking, sand must have a low iron content. Before being used in a BATCH, sand is washed, heated (to remove carbonaceous matter such as earth or coal), and

put through a series of sieves, to obtain uniformly small grains. The Roman naturalist Pliny the Elder (23–79 C.E.) noted preferred sources of sand around the Mediterranean Sea, citing the mouth of the Belus River in Phoenicia (modern Lebanon) and of the Liternus River in Campania (modern south Italy).

SCHWARZLOT (German, "black lead"): A transparent, sepia-colored ENAMEL, named for the appearance of black lead, that was first used in the Middle Ages for painting lines and shadows on stained glass. *Schwarzlot* was also later applied to glass vessels, either by itself or in combination with other enamels or gold. It was often employed by *Hausmalern*, independent glass and ceramic painters, during the seventeenth and eighteenth centuries. See Fig. 44.1.

SHEARS: A heavy, scissors-like tool used to trim away hot glass while the vessel is attached to the BLOWPIPE or PONTIL.

SHEET GLASS, or plate glass: A type of flat glass made by casting molten glass in large panes on iron tables. See Nos. 89, 96.

SILICA: The compound silicon dioxide (SiO_2), used in its mineral form, is one of the essential ingredients of glass. Silica is the principal component of almost all rocks, and the most common form of silica used in glassmaking has always been SAND, which is mostly comprised of the silica mineral, quartz. Silica is an extremely hard and strong mineral and normally only melts at around 1700°C (3100°F). Since this temperature is too high to make glass production economically feasible, a FLUX must be added to the silica, to aid in its fusion.

SLUMPING: The process of sagging WARM GLASS over or into a "former" MOLD with the same shape as the desired object, usually a vessel. See Nos. 6, 79, 88, 100.

SODA: Sodium carbonate (Na_2CO_3), frequently used as the ALKALI ingredient of glass. It serves as a FLUX to reduce the fusion point of the SILICA when the BATCH is melted. Soda is present in natron, a naturally occurring mineral used by ancient Roman glassmakers, composed of different sodium salts (sodium sesquicarbonate, $Na_3HCO_3CO_3 \cdot 2H_2O$) originally found in the Wadi Al-Natrun, about 100 km (62 miles) southwest of Alexandria, Egypt. There, natron occurs in deposits formed by the evaporation of river water and in the ashes of certain plants that grow on the seashore or in saline soils.

SODA-LIME GLASS: The most common form of glass. The BATCH for soda-lime glass contains three major components in varying proportions: SILICA (60–75 percent), SODA (12–18 percent), and LIME (5–12 percent). Soda-lime glass objects are relatively light and, upon heating, remain workable over a wide range of temperatures. For this reason, soda-lime glass lends itself to elaborate manipulative techniques.

SODA-POTASH GLASS: A colorless glass containing chalk, a soft rock consisting of calcium carbonate ($CaCO_2$), as an alternative to LIME in stabilizing the BATCH. Developed in Bohemia in the late seventeenth century, soda-potash, or chalk, glass could be used to make thick-walled vessels that were strong enough to withstand extensive finish-work and elaborate decoration. See Nos. 46, 47.

STAINING: The process of coloring a glass surface by applying a silver salt (sulfide or chloride) then FIRING the glass at a relatively low temperature. The silver imparts a yellow, brownish yellow, or ruby-colored stain that may then be painted, ENGRAVED, or ACID-ETCHED.

STRIKING: The act of reheating glass after it has cooled. Striking is undertaken to develop a particular color or to activate an opacifying agent that takes effect only within a limited range of temperatures. See Nos. 45, 67.

TRAIL/TRAILING: A strand of glass drawn from a GATHER and applied to an object; thin strands are also called threads; thick strands are sometimes called coils. See Nos. 17, 20.

TWIST: A type of decoration in the stems of eighteenth-century and later drinking glasses, made by twisting a glass rod embedded with threads of white or colored glass, columns of air (air twists), or a combination of all three.

WARM GLASS: A type of glass made by shaping, fusing, SAGGING, or SLUMPING a glass object by laying it over or onto a MOLD and heating it in a KILN at a relatively low temperature, between 650–925°C (1200–1700°F). The term has been adopted because most furnace work ("hot glass"), including blowing and casting, takes place between 925–1260°C (1700–2300°F). See Nos. 2, 5, 6, 79, 100.

WEATHERING: A chemical reaction on the surface of glass caused by environmental factors. Weathering often involves the leaching of ALKALI from the glass by the action of water on the glass object, leaving behind siliceous weathering products that are often layered and flake off easily. The weathered layer often has an IRIDESCENT appearance. See also CRIZZLING.

NOTES

1–19
ANCIENT MEDITERRANEAN

1 Forbes 1955, 3–5.
2 TMA 1951.405, published: Riefstahl 1961, 27; *Art in Glass* 1969, 16; *Egypt's Golden Age* 1982, 164, cat. 177; Grose 1989, 59–60, cat. 5; *Toledo Treasures* 1995, 36; *Mistress of the House* 1996, 83, cat. 23.
3 TMA 1966.114, published: Grose 1989, 62, cat. 10.
4 TMA 1948.16, published: Grose 1989, 61–62, cat. 9.
5 Henein and Gout 1974; Goldstein 1979, 24–29; Grose 1989, 31, 45–57; Nicholson et al. 1998; Giberson 1997; Von Saldern 2004, 7–14, 30–47.
6 TMA 1979.74, published: "Recent Important Acquisitions," *JGS*, vol. 22 (1980): 88, fig. 1; Grose 1984, 18; Grose 1986, 67, fig. 2; Grose 1989, 87, cat. 34, color pl. p. 70. On Achaemenid tableware that imitated rock crystal, see also Oliver 1970; Pfrommer 1987; Vickers 1996.
7 Grose 1989, 80–81.
8 Oliver 1970, 10.
9 See the essays in Oppenheim et al. 1970.
10 TMA 1923.195, published: *Art in Glass* 1969, 18; Grose 1989, 58, cat. 1.
11 Von Saldern 1959, 23–25, figs. 1–2; Von Saldern 2004, 58–59, pl. 10.53.
12 Schmidt 1957, pl. 70c; Triantafyllidis 2001, 13–15; Von Saldern 2004, 106–115.
13 For Olympia and other references, see Oliver 1970, 9; note 3.
14 Fukai 1977; Grose 1989, 81.
15 These seven vessels also illustrate the importance of core-formed vessels in the Toledo Museum's collection, which is the largest and most comprehensive collection of core-formed vessels, after the important group assembled by the British Museum. Within the Toledo holdings, one can study the considerable variety of forms that glassmakers produced at the end of the first millennium B.C.E.
16 Grose 1989, 109–129; Von Saldern 2004, 67–82.
17 TMA 1923.342, published: Grose 1989, 133, cat. 64.
18 TMA 1923.153, published: Grose 1989, cat. 95.
19 TMA 1923.161, published: Grose 1989, cat. 104.
20 TMA 1923.157, published: Grose 1989, cat. 122.
21 TMA 1923.152, published: Grose 1989, 161–162, cat. 147.
22 TMA 1985.66, published: Grose 1989, 164–165, cat. 154; Von Saldern 2004, 77, pl. 12.70. The turquoise trails are heavily weathered and covered with a white enamel-like crust.
23 TMA 1923.106, published: Grose 1989, 165, cat. 156; Von Saldern 2004, 77, pl. 12.68.
24 Grose 1989, 110 and note 9 (Mediterranean Group I); Triantafyllidis 1998; Von Saldern 2004, 71–76.
25 Grose 1989, 115–117 (Mediterranean Group II); Von Saldern 2004, 76–79.
26 Grose 1989, 122–125 (Mediterranean Group III); Von Saldern 2004, 79–82.
27 TMA 1980.1000, published: "Recent Important Acquisitions," *JGS* 23 (1981): 91, fig. 4; Harden 1980, 22–24, figs. 8–10; Grose 1984, 20; Grose 1986, 68–69, fig. 3; Grose 1989, 198, cat. 183.
28 See Stern and Schlick-Nolte 1994, 102–104, 258–261, cat. 68, for discussion around a slightly smaller footed bowl in the Ernesto Wolf collection, said to have been part of the same tomb group as the Toledo *krater*.
29 Harden 1968.
30 Von Saldern 1975; Grose 1989, 186ff., fig. 93.
31 Grose 1989, 187–188, figs. 92, 96 (see note 9 for earlier references); Von Saldern 2004, 117, 148, pl. 22.131.
32 Platz-Horster 1976, 16–20.

33 TMA 1970.428, published: Grose 1989, 179–280, cat. 292.
34 Grose 1989, 189–197.
35 Grose 1977; Grose 1989, 241ff.; Von Saldern 2004, 161–168.
36 Stern and Schlick-Nolte 1994, 54–64.
37 TMA 1923.1393, published: *Art in Glass* 1969, 20; Grose 1989, cat. 510.
38 TMA 1968.87, published: *Art in Glass* 1969, 12; Grose 1989, 289, cat. 339.
39 Grose 1989; see 17–23 about the sources.
40 TMA 1967.9, published: Sangiorgi 1914, no. 302, pl. 39; *Art in Glass* 1969, 20; Grose 1989, 338–339, cat. 605.
41 TMA 1923.1478, published: Grose 1989, 339–340, cat. 609. See also Von Saldern 2004, 168–169.
42 TMA 1923.1475, published: Grose 1989, 341, cat. 616.
43 See *Cameo Glass* 1982, 13–15; *Glass of the Caesars* 1987, 53–84; *The Portland Vase* (*JGS*, vol. 32 [1990]); Whitehouse 1991, 19; Von Saldern 2004, 202–217.
44 Sturgis 1894, 555–558, illustrates eighteen of Coleman's fragments, and Richter 1914, 72, note 1, states that all of Curtis's cameo glass once belonged to Coleman. For Coleman, see Grose 1989, 21–23.
45 TMA 1923.1641, published: Sturgis 1894, 557, fig. 17. The inner vessel surface, small as it is, shows the traces left when a cast glass object was turned on a lathe to remove imperfections and to polish it.
46 For example, the group of re-used Second Style and new Fourth Style still lifes of theatrical masks in the *triclinium* of the House of Ma. Castricius (Pompeii VII 16, 17), published: Ling 1991, 206, figs. 226, 227.
47 TMA 1961.9, published: *Silver for the Gods* 1977, 116–118, cat. 76; Stern 1995, 85, fig. 57; *Antioch* 2000, 186–187, cat. 69.
48 Berlin, Antikensammlung, Inv. Nr. 3779,13: Pirzio Biroli Stefanelli 1991, 169–171, 272, cat. 93.
49 *Trésor de Saint-Denis* 1991, 83–87, cat. 11. On this so-called Cup of the Ptolemies, some of the masks are as deeply undercut as Toledo's cameo glass fragment.
50 Introduction of the *onkos* is attributed to the Athenian dramatist Aeschylus (about 525–456 B.C.E.), along with elaborate robes and larger, more dignified masks: Bieber 1961, 22.
51 Bieber 1961, 232–235; Griffin 1984, 208–220. Bieber 1961, 234, fig. 779, illustrates a mid-first-century C.E. clay lamp with a disc relief of a king and queen, probably Atreus and Merope, wearing diadems on their tall *onkoi*.
52 TMA 1981.93, published: Stern 1995, 199–200, cat. 137.
53 TMA 1983.17, unpublished.
54 Von Saldern 2004, 267–68, pl. 38.227; Stern 1995, 88, fig. 59. There is also a small group of shell-shaped perfume bottles, which relates stylistically to this early group of serving dishes; they were used not for food but for personal adornment. Unlike the serving dishes, however, these bottles consist of two shell halves that close to form the body of the container.
55 Whitehouse 2001, 74–76, no. 548, for the head flask; 121–122, no. 623, for a ribbed variety; and 182, no. 724, for the simple pitcher.
56 Harden 1935; Stern 1995, 199; Whitehouse 2001, 13, 23–24, nos. 487 and 488.
57 On the excavation of six Roman glasshouses in the Hambach forest, near the road that connected Cologne with the Atlantic seaports, see: Seibel 1998; Follmann-Schulz 2001; Wedepohl et al. 2001.
58 Monkey: Fremersdorf 1961, 78–79, pls. 177–179; *Glass of the Caesars* 1987, 173, cat. 94; Wolff 2003, 72, fig. 88. Slippers: Fremersdorf 1984, 115, no. 261; *Glass of the Caesars* 1987, 137–138, cat. 66; Wolff 2003, 70–79.

59 TMA 1967.6, published: Sangiorgi 1914, no. 103, pl. 19; Harris 1927, 291, Harden 1935, 174, Group G1iic; *Art in Glass* 1969, 24; Grose 1978, 79, fig. 15; Stern 1995, 51, pl. 1; 97–98, cat. 1; Von Saldern 2004, 248–149, pl. 37.221; Cosyns 2005, 180–182.
60 The phrase is similar to one that occurs in the text of the New Testament (Matthew 26:50), which led one scholar and a host of delighted journalists to propose that glasses carrying this phrase were used by Jesus and the Disciples at the Last Supper: Harris 1927, 289ff. However, Cosyns 2005, 181–182 and note 12, notes that the verse is uttered by Jesus after Judas betrays him with a kiss in the Garden of Gethsemane and actually means "Friend, do what you have come for," and thus has no connection with the inscription on these mold-blown cups.
61 Price 1991, 69, pl. XVIIb; Stern 1995, 98; Cosyns 2005.
62 Harden 1935; *Glass of the Caesars* 1987, cat. 88; Price 1991; Grossmann 2002, 24–25; Stern 1995, 69–74.
63 TMA 1977.14, published: "Recent Important Acquisitions," *JGS* 20 (1978): 120; Grose 1984, 32; *Clearly Inspired* 1999, 35. The dealer also reported that Toledo's jar was found with pottery and a barrel-shaped blue glass cup with opaque white trails at rim and base and a double white coil for a handle (Kurt T. Luckner, TMA 1977.14 documentary file, memorandum dated 29 June 1977). The ashes and calcined bones found in the jar have been removed.
64 Isings 1957, 81–83; jar Form 63; Lid Form 66b. See also Whitehouse 1997, 171–175, nos. 300–307.
65 Dr. Dela von Boeselager generously contacted the museum of Krefeld to check this: Among all of the tombs in the cemetery (which is on sandy soil, with no rock to cut tomb chambers as in the Cologne area), published and unpublished, only one was found in a stone container, and it held no glass but three lamps. For Gelduba, see von Elbe 1975, 230–233; Pirling 1966–2003; Reichmann 2002.
66 Wolff 2003, 128–129, describes a few of the dozen glass urns on view in the galleries of the Römisch-Germanisches Museum, Cologne. Dela von Boeselager notes that a similar urn, H 28 cm, was recently found in nearby Mönchengladbach-Wickrathberg, now in the Rheinisches Landesmuseum, Bonn: Volsek 2004, 102–103, Abb. 77.
67 Stern 1995, 23–25, 36–44; Jackson et al. 1998; Foy et al. 1998; Dussart et al. 2004, 80–82.
68 Seibel 1998; Follmann-Schulz 2001; Wedepohl et al. 2001; Von Saldern 2004, 590–600.
69 Stern 1999, 442–443.
70 Wedepohl et al. 2001, 59–60.
71 TMA 1979.54, published: TMA *Museum News* 21.4 (1979) 11; *Antioch* 2000, 82–84, cat. 82.
72 Such as the round-mouthed ewer found in the dining room of the House of Menander at Daphne, a suburb of Antioch, now in Dumbarton Oaks, inv. No. 40.24, published: *Antioch* 2000, 188, cat. 71, or the five ewers in the Sevso Treasure: Pirzio Biroli Stefanelli 1991, 309–311, cat. nos. 202–204, 207–208; Mango 1994.
73 Northampton, Mass., Smith College Museum of Art, 1948:4. This ewer was blown into a dip mold patterned with narrow ribs, and the glassblower twisted and slightly expanded the body during manufacture.
74 See the fifth-century C.E. illumination of the Feast of Dido and Aeneas, in the *Vergilius Romanus*, Vatican Library, cod. lat 3867, vol. 100v: Weitzmann 1977, 56–57.
75 See Barag 1985; Barag 2005.
76 TMA 1979.53, published: "Recent Important Acquisitions," *JGS* 22 (1980): 89; Stern 1995, 208, 230–232, cat. 148.

77 TMA 1923.457, published: Richter 1914, 77, fig. 6; Stern 1995, 219–220, cat. 139, color pl. 21; TMA *Guide* 2005, 10.

78 TMA 1967.8, published: Sangiorgi 1914, no. 107, pl. XXII; *Art in Glass* 1969, 24; Grose 1978, 82, fig. 19; Stern 1995, 216–219, cat. 138; Von Saldern 2004, 294, pl. 41.247. Note: The surface is covered with a thick exterior layer of silver iridescence. This flask is also interesting because its broken glass handle, applied to the rim, was not attached to hair or neck; intact examples (such as Yale 1953.28.14) show that the end was pulled down using a tool to pinch the glass into a small disc at the tip, a process that chilled the surface so that it failed to fuse with the wall of the vessel. This has been identified as a distinctive practice, giving its name to the Workshop of the Floating Handles: Stern 1995, 86–91.

79 Kleiner 1992, 75–78; *I Claudia* 1996, 38, 53, cat. 1; 56–57, cat. 5; 184.

80 Matheson 1980, 59–60; Stern 1995, 217–218; Grossmann 2002, 30–31.

81 See Scatozza Höricht 1986, no. 103, who notes that the head flasks from Pompeii and Herculaneum were made in different molds.

82 Stern 1995, 204–206, 220.

83 See Stern 1995, 209–210, fig. 90, for a cup from Kep on the Taman peninsula, Ukraine.

84 TMA 1967.12, published: "Recent Important Acquisitions," *JGS* 11 (1969): 111, no. 14; Riefstahl 1967, 433, fig. 13; *Art in Glass* 1969, 29; Grose 1978, 86, fig. 26; Grose 1984, 35; *Age of Spirituality* 1977 (1979), 559–560, cat. 503 (Margaret E. Frazer).

85 Although the original wall mosaic is lost, its appearance survives in many replicas in Roman and Italian churches and private grave monuments. See Frazer 1977, 556; Caron 1997, 34, 38, fig. 53. See also Dorigo 1971, 215, color pl. 25 (*traditio legis* mosaic apse in Sta. Costanza, Rome).

86 The feast of Sts. Peter and Paul is celebrated on June 29, believed to be the day when both were martyred.

87 A gold glass now in the Vatican was probably made in the same workshop in the city of Rome; it survives in fragmentary condition but includes additional detail—the river is labeled as the Jordan and lambs gambol in the landscape, published: Morey 1959, 19, no. 78l; Diam. 7.7 cm.

88 For example, TMA 1923.1880, an unpublished medallion of a bearded man, the incised gold-leaf portrait protected by a layer of medium blue glass sandwiched against the gold by the second layer of transparent glass. General literature: Morey 1959; *Masterpieces of Glass* 1968, 67–70, nos. 88–93; *Glass of the Caesars* 1987, 276–286, nos. 152–161; Whitehouse 2001, 239–252, nos. 828–845.

89 Whitehouse 2001, 240, observes that the presence of air bubbles trapped between the gold and the upper layer of glass proves that the gold leaf was attached to the *upper* surface of the *lower* layer of glass and not to the underside of the vessel. The presence of bubbles above the red enamel of Fig. 14.1 confirms this sequence.

90 TMA 1967.11, published: "Recent Important Acquisitions," *JGS* 11 (1969): 111, no. 13; *Art in Glass* 1969, 27; Noll 1973, fig. 1; *Age of Spirituality* 1977, 104, cat. 95 (Stephen R. Zwirn); Grose 1978, 86, fig. 27.

91 Inv. No. XI 1734, acquired 1954; published: Noll 1973, 33, fig. 2.

92 The Corning Museum of Glass, inv. no. 54.1.83, owns a related gold-glass fragment with a victorious horse and rider, with the Greek inscription, "*Aouoite pie zeses*" ("Avitus, drink and may you live [for many years]"), published: Whitehouse 2001, 247, no. 839.

93 For the use of glass fragments to decorate graves, see Haevernick 1962; Whitehouse 2001, 240; Von Saldern 2004, 463–474. See Hill and Nenna 2001 regarding the use of more than seventy glass vessels (none of them gold-glass, removed and transported to the Metropolitan Museum of Art, New York, after excavation between 1907 and 1909) to decorate the interior of a fourth- or fifth-century tomb at Al-Bagawat, the Early Christian necropolis of Hibis, in the Kharga Oasis, Egypt.

94 With the widespread adoption of Christianity in the fourth century, funeral feasts in honor of saints took on some of the trappings of pagan festivals, and Early Christian writers sought to ban them. For example, the Council of Laodicea in 363 specifically forbade clergy and laypeople to set up tables at such events or to take food home afterward. St. Paulinus of Nola (353–431), who cared for churches at the grave of St. Felix near Nola, wrote passionately against excess eating and drinking as well as other forms of immoral behavior by the crowds of illiterate people who flocked to visit.

95 A similar woman appears on a contemporary engraved glass dish with the hero Bellerophon and Pegasus. Like the two women on the Toledo beaker, she sits on a rock and wears only a mantle draped around her bent right leg, but she is identified as the nymph of spring by her reed crown and because her left hand rests on a jar from which flows water. London, The British Museum, GR 1967.11–22.1, published: *Glass of the Caesars* 1987, 218–219, cat. 121.

96 TMA 1930.6, published: Weerth 1881, 57ff., pl. 3 (wine storage tower and a young woman being taught by Venus how to drink wine); Kisa 1908, vol. 2, 559, fig. 248, 663–665; Eisen and Kouchakji 1927, 2:393–394, fig. 167, 399–400, pls. 99–100 (Hera and Hebe and the temples and palaces of the Palatine Hill, Rome); Fremersdorf 1967, 31, 175–176, pls. 236–239; Haberey 1965, 5–6, no. C.2, Abb. 16–17 (Wedding at Cana); *Art in Glass* 1969, 28; Painter 1971, 44–47, pl. 18a; Grose 1978, 85, fig. 25; Grose 1984, 35 (Venus and Cupid); Polzer 1986, 73, pl. 7B, C (Isis); *Toledo Treasures* 1995, 50 (theater); Caron 1997, 32, cat. 7, comparanda no. 6 (banquet scene); Saguì 1997, 343, 345, 346, no. 2, fig. 7a–c (connects TMA beaker with a cup engraved with winged figures in a marine landscape that was found in the House of John and Paul, Rome); De Tommaso 1998, 113 (funerary; connects TMA beaker with MNR Inv. 388159, see note 99 below; Paolucci 2002, 71, Fig. 98; Von Saldern 2004, 421, pl. 55.342 (Venus and Amor). Dr. Dela von Boeselager generously verified some references and also discussed the iconography with Henner von Hesberg, who suggests that the young man could be Hypnos/Somnus and the women could be Ariadne and a nymph (see *LIMC*, vol. 3 [1986]: 1050ff.).

97 Dr. Stern's notes are preserved in the documentary file for TMA 1930.6. British Museum GR 1886.5–12.3 is a bowl with dancing satyrs and maenads, interspersed with buildings, plants, musical instruments, and snakes. The closest parallel, British Museum GR 1886.5–12.2, is a flask engraved with three scenes: 1) between two palm trees, a standing woman displaying a fish on a line; 2) two winged figures and three fish next to a large cauldron; and 3) a (bearded) man holding behind him a *thyrsos* (?) and pouring wine from a *rhyton* into the cup of a clothed woman (the deceased?) reclining on a rock in front of a standing woman with widespread arms (a mourner?). The *thyrsos*(?) is drawn quite differently from the two palms. The two vessels were purchased together in Amiens, northern France; they have been published,

respectively: Harden 1978, no. 19, pl. 4, and no. 18, pl. 3; *Glass of the Caesars* 1987, nos. 129 and 132.

98 Museo Nazionale Romano, inv. 388159. Diam. (reconst.): 14.4 cm; published: De Tommaso 1998, 113–114, 115 fig. 3 (drawing). Paolucci 2002, 65–77.

99 Gasdìa 1937; Nash 1961–62, 1:357–361, fig. 436; Dorigo 1971, 59–63, color pl. 4; Ling 1991, 193–194, fig. 212; Richardson 1992, 128, 129. fig. 32. Classicists dispute the identities, but the most widely accepted are Ceres, Proserpina, and Bacchus. The partly nude, bejeweled goddess may instead be Venus, who in Etruscan and Roman imperial temple pediments and wall paintings is sometimes represented reclining with or opposite Bacchus / Liber. See, for example, the pediment from the Sant' Abbondio temple, in Swetnam-Burland 2000, 61, fig. 7.3.

100 See, for example, the children wearing wings in the Room of the Mysteries, Villa of the Mysteries, Pompeii.

101 "At Eleusis it [the red mullet] is held in honour by the initiated, and of this honour two accounts are given. Some say, it is because it gives birth three times in a year; others, because it eats the Sea-Hare, which is deadly to man."—Aelian: *On Animals* 9.51.

102 "Recent Important Acquisitions," *JGS* 24 (1982): 89.

103 Whitehouse 1997, 213–219.

104 Harden 1936, 160–161.

105 Weinberg and Goldstein 1988, 87–94.

105A Whitehouse 2005, 50–51, no. 60.

106 Whitehouse 1997, 257–258, no. 440; 259, no. 443; Carboni 2001, 31–35, nos. 8 and 9.

107 Weinberg and Goldstein 1988, 82–83, nos. 360–363, note 174.

108 TMA 1923.1211, published: Richter 1914, fig. 17; Grose 1978, 82, fig. 28.

109 "Recent Important Acquisitions," *JGS* 24 (1982): 89.

110 Fukai 1977, 39, fig. 30, 169–176; Laing 1991, 109–121, figs. 25, 26; Carboni 2001, 31, no. 8.

111 TMA 1923.1359, published: Goodenough 1953, 1:170; vol. 3, figs. 408–413; *Art in Glass* 1969, 32; Barag 1970, 49, 56 (B II 1), 60, fig. 16; Stern 1995, 255–256, cat. 171.

112 Barag 1970, 51–54; Raby 1999, 113–183; Woods 2004.

113 Barag 1970.

114 Ibid., 54–62, suggests a Jewish pilgrim would fill the jar with oil from lamps burning at sacred places, such as the seven synagogues on Mt. Zion. See also *Age of Spirituality* 1977, 386–388, cat. 354–356 (Bezalel Narkiss); Grossmann 2002, 22–23.

115 Stern, 1995, 248, citing Barag 1970, 37–38. Donald Harden notes an otherwise unpublished hexagonal copper (or bronze) object in the Rockefeller Museum, Jerusalem, that was probably a mold for the body and vase of a vessel like this one. See *Glass of the Caesars* 1987, 152.

116 TMA 1948.14, published: *Art in Glass* 1969, 32; Harden 1971, pl. V, no. b; Engle 1978, 84; Grose 1978, 90, fig. 33; Vose 1984, 52, color ill.; Stern 1995, 266–267, cat. 190.

117 Matheson 1980, 132–135, nos. 353–358. Most of the jugs come from Syria and Palestine, but some seem to have been carried home by pilgrims from as far away as Egypt.

20–27
ISLAMIC WORLD

1 The Umayyads were the first dynastic (651–750 C.E.) power in the Islamic world. They made Damascus their capital, in recognition of Syria's central role in an empire that encompassed Spain in the west to Central Asia in the east. For a historical survey of the dynasty, see Hawting 1986.

2 Grabar 1987; Ettinghausen et al. 2001, 10–130.

3 TMA 1923.2044, published: "Ancient and Near Eastern Glass," TMA *Museum News* 4.2 (1961): 40 (top center); Toledo 1969, 21; Harden 1971, 93, 115, pl. 9d; Kondoleon 2000, 195, cat. 84.
4 Carboni 2001, 25; Bussagli-Chiappori 1991, 65, illus.
5 For a few examples of *vasa diatreta*, or cage cups, see Harden et al. 1987, 238–249.
6 Carboni 2001, 25.
7 TMA 1923.2028, unpublished.
8 Damascus 1964, fig. 48.
9 TMA 1923.2015, published: Lamm 1929–30, pl. 15:4; TMA *Museum News* 4.2 (1961): 43 (top); Toledo 1969, 37 (top); Carboni and Whitehouse 2001, 115–116, cat. 334.
10 See especially Erdmann 1952 and Morton 1985, nos. 551–553.
11 TMA 1923.2055, published: Bornstein and Soucek 1981, 34, no. 12; Carboni and Whitehouse 2001, 118–120, cat. 36.
12 See, for example, Masson and Pugachenkova 1982.
13 For a general study on Persian and Central Asian rhyta, see Melikian-Chirvani 1982.
14 See, among others, Pugachenkova and Rempel 1965, pl. 213; Harper et al. 1978, no. 86; *Seven Millennia of Persian Pottery* 1980, figs. 160–164.
15 Carboni and Whitehouse 2001, 116–118, cat. 35; Carboni 2002.
16 TMA 1983.79, published: *JGS* 26 (1984): 137, no. 3; Carboni and Whitehouse 2001, 179–180, cat. 85.
17 A discussion on "molar" flasks is in Carboni 2001, 98–100, cat. 27.
18 For relief-cut glass, see Harper (Oliver) 1961 and Carboni and Whitehouse 2001, 155–161; for carved rock crystal, see Lamm 1929–30, 179–240, pls. 64–88.
19 Clairmont 1977, 97–98, no. 323, pl. XX and Contadini 1998, 16–38.
20 Lamm 1929–30, pls. 71:1–2, 74:1–2, 75:1–6; the three flasks with similar shape, in the Freer Gallery of Art, Washington, D.C., the Victoria and Albert Museum, London, and the Keir Collection, Richmond, England, are illustrated respectively in Lamm 1929–30, pls. 71:1 and 75:2 and in Contadini 1998, fig. 24.
21 In addition to Lamm 1929–30, 205, pl. 71:1, see von Saldern 1955, pl. 7. The same motif is found also on the bottom of the so-called Corning cup (von Saldern 1955; inv. 53.1.109); flanked by two affronted birds, the pattern also provides a good parallel in glass for the Toledo bottle.
22 For the technique, see especially Gudenrath 2001, 66, figs. 82–84 and Carboni 2001, 291.
23 TMA 1923.2203, published: Lamm 1929–30, I, 102, fig. 4; II, pl. 32:4.
24 Allan 1995; Henderson 1995, Carboni 2001, 291–303.
25 TMA 1923.2359, published: Lamm 1929–30, pl. 332:8; Carboni and Whitehouse 2001, 142–143, cat. 58.
26 TMA 1969.367, published: *JGS* 13 (1971): 140, no. 33; Atil et al. 1981, 138, cat. 55.
27 For the shape and its development in glass, see Carboni 2001, 150–151, cat. 37 a, b.
28 An example attributed to the early twelfth century is in Atil et al. 1985, 83–87, cat. 100 .
29 See Hasson 1979, 20, no. 35, and Jenkins[-Madina] 1986, 20, no. 19, for two examples in the L. A. Mayer Memorial, Jerusalem, and in The Metropolitan Museum of Art, New York.
30 TMA 1962.27, published: Toledo 1969, 37 (bottom); Carboni and Whitehouse 2001, 92, cat. 18.
31 TMA 1971.162, unpublished.
32 Carboni and Whitehouse 2001, 168, cat. 74.

33 Linear drawings exemplifying the two types are in Carboni 2001, 241, cat. 68.
34 Carboni 2001, 259, n. 59.
35 Rare types with well-wishing inscriptions are found in Carboni and Whitehouse 2001, 93–94, cat. 19–20.
36 Carboni and Whitehouse 2001, 92, cat. 18.
37 Bahrami 1988, 83, pl. 8 (right).
38 Kröger 1995, 179–180, 182–183; Carboni 2001, 165–167, cat. 38 a-c.
39 TMA 1933.320, published: TMA *Museum News* 73 (1935): 3–5, cover plate; Toledo 1969, 41 (top) Atil et al. 1981, 121, 124 note 50.
40 Hautecoeur and Wiet 1932, pls. 119–120; Meinecke 1992, 214, pt. 2, no. 22.
41 For a short biography, see Mayer 1933, 202.
42 Carboni 2001, 362–365, cat. 100.
43 Surveys of Islamic enameled and gilded glass are in Lamm 1929–30, 291–433, pls. 109–205; Ward 1998; Ribeiro and Hallett 1999; Carboni 2001, 323–369; Carboni and Whitehouse 2001, 226–273; Carboni 2003.
44 Hardie 1998; Carboni and Whitehouse 2001, 8–13.
45 TMA 1944.33, published: Lamm 1929–30, pl. 180:9; Porter 1987, 238, fig.; Carboni and Whitehouse 2001, 266–268, cat. 132.
46 Porter 1987; Carboni 1995.
47 Rückert 1963; Rogers 1983; Carboni 1989; Carboni 2001, 376–379.
48 Chardin 1927, p. 275; see also Charleston 1974 and Carboni 2001, 372–375.
49 Digby 1973; Markel 1991; Carboni 2001, 380–396.
50 TMA 1983.61, published: Carboni and Whitehouse 2001, 288–289, cat. 142.
51 Carboni and Whitehouse 2001, 288–289, cat. 142.
52 TMA 2005.47, unpublished.
53 TMA 1983.96, unpublished.
54 TMA 1953.108, published: "Ancient and Near Eastern Glass," TMA *Museum News* 4.2 (1961): 46 (right); Toledo 1969, 41 (bottom).
55 *Chihuly* 1988, 20, illus., in a composition entitled "Lapis Stemmed Form with Orange Persians."
56 Bayramoğlu 1976, 81, figs. 96–100.

28–36
EUROPEAN RENAISSANCE

1 The term "*cristallo*" appears for the first time in a Florentine manuscript in 1453. For the alchemical relationship of *cristallo* and rock crystal, see Zecchin 1987–89, vol. 1, 229.
2 TMA 1955.18A, unpublished.
3 TMA 1958.17, published: Hutton 1963, 4, 5; *Art in Glass* 1969, 46.
4 Theuerkauff-Liederwald, 1994, 101.
5 TMA 1932.1, published: Hutton 1963, 4, 5; *Art in Glass* 1969, 47; Lanmon 1993, 10, 11, 12, no. 4, fig. 1.4; *Le dressoir du Prince* 1995, 88, 90, cat. 46.
6 Another, shallower dish that was not mold-blown, now cracked, with a silver-gilt metal mount around the rim, is in the Victoria and Albert Museum, London. More elaborate examples are two large tazzas on composite pedestal bases, bearing the coat-of-arms on the foot, in the Musée National de la Renaissance, Ecouen, France, and in The Metropolitan Museum of Art, New York, published: *Beyond Venice* 2004, 144–145, figs. 3 and 4.
7 Guiffrey 1894, 215.
8 Gaynor 1991, 73.
9 Rochebrune 2004, 146.

10 Lanmon 1993, 11.
11 *Le dressoir du Prince* 1995, 88.
12 See Zecchin 1986, 129.
13 TMA 1940.119, published extensively, including: *Italian Art* 1930, no. 935 G; *Italian Art* 1931, vol. 1, no. 1076, vol. 2, pl. 351; Buckley 1930, 22, pl. 4 C; Godwin 1952, 1140–1142; Davis 1958, 1098; Wixom 1962, 26; Hutton 1963, 3–4; Rogers 1967, 480, pl. 16; Labino 1968, 49, fig. 31; *Art in Glass*, 42; Rothenberg 1976, 72; Gasparetto 1979, 215; *Glass Collections* 1982, 167.
14 Zecchin 1987–89, vol. 3, 116–130. In the past, the famed Venetian maestro Angelo Barovier has been credited with the enameled decoration of such goblets, a claim that cannot be substantiated. The blue glass goblet was fired in typical Venetian Renaissance fashion. Although the original foot is lost, it can be assumed to have had a double pontil mark, attesting to the vessel's second firing in the glory hole to fuse the gold and the enamels to the glass surface. A faint relief pattern is noticeable to the touch on the interior wall of the bowl, where the heated enamel softened the vessel wall, a feature typical of Venetian enameled glass from the fifteenth and sixteenth centuries.
15 Mallett and Dreier 1998, 32.
16 Schmidt 1911, 257, dates the goblet to 1475. The bucket-shaped bowl resting on a partly restored glass foot is enameled with a scene from a popular Italian tale as told in rhymes by Bonamente Aliprando in the *Cronica Mantovana*, 1414. The scene depicts the revenge of the sorcerer Virgil on the Roman princess Febilla who humiliated him. It is inscribed VERBLIO ("Vergilio") above a tower and VENITE ("come all") above the female figure standing frontally on a pedestal.
17 Several Petrarca editions were printed in Venice in the late fifteenth and early sixteenth century: Dominicus de Siliprandis for Gaspar de Siliprandis, 1477; Petrus de Plasiis Cremonensis, 1490, and Bernardino Stagnino, 1513.
18 *Hypnerotomachia* 1592.
19 Pope-Hennessy and Christiansen 1980, 11–12.
20 Horses are prominently featured in the *Procession of the Magi*, commissioned from Benozzo Gozzoli by the Medici family. However, it was the Gonzagas of Mantua who had a particular passion for breeding horses, the best of which were Arabs. In the 1490s, Francesco Gonzaga, marquis of Mantua, had an amicable relationship with Mehmet II's successor, the Ottoman emperor Bayezit II, who was at the time the best source for Arab horses.
21 For the two Cafaggiolo dishes from 1514 in the Victoria and Albert Museum, London, and in the Fitzwilliam Museum, Cambridge, see Poole 1995, no. 88.
22 The other vessel, formerly in the Parpart and Rothschild collections and now of unknown location, was decorated by a different hand: the figures are comparatively large, there is hardly evidence of a landscape, and the painted gold scrolls or dots that commonly fill the background on similar pieces are missing. See Christie's, London, 14 December 2000, lot 25.
23 Syson and Thornton 2001, 139.
24 See the "Triumph of Fame" in a frontal orientation on a birth tray (*descho da parto*, used to serve food to the new mother), commemorating the birth in 1449 of Lorenzo de Medici (later called "the Magnificent"). This plate, painted after a design by Domenico Veneziano, was commissioned by the infant's father, Piero de Medici. Piero favored such allegorical subjects and had already commissioned several plates from Matteo de' Pasti in 1441. He ordered several more from Pesellino in 1444 for his own wedding, See Pope-Hennessy and Christiansen 1980, 11–12, no. 9.

25 Mallett and Dreier, 1998, 32.
26 Zecchin 1987–89, vol. 3, 125.
27 Zuffa 1954, 3–4, figs. 4–7.
28 TMA 1948.225, published: Hutton 1963, 5; *Art in Glass* 1969, 47; Rothenberg 1976, 33; Charleston 1978, no. 18; Dreier 1989, 49.
29 Two Venetian doges, Francesco Foscarini in 1442 and Pasquale Malipiero in 1461, are the first recorded recipients of Chinese porcelains. A Sung Dynasty porcelain vessel is recorded in the Treasury of Saint Mark.
30 A Venetian document of 1564 mentions *latticino* or *latticinio*, also referring to milk glass rather than filigree glass with white threads, as it has been often erroneously called in the literature. See Zecchin 1968, 110–113.
31 An order for forty-two enameled *lattimo* goblets or "*Goti di lattimo cum figure*" from Rado da Zuppa in 1511 and made by Giovanni di Giorgio Ballarin in Murano sold for one ducat each. See Clarke 1974, 23–24, citing Levi 1895, 28.
32 TMA 1969.287, published: *Art in Glass* 1969, 48; Clarke 1974, 28, 41–43, 53; Wood 1984, 70, 71; Battie and Cottle 1991, 62.
33 Hind 1948, vol. 7, pl. 733.
34 Fortini Brown 1997, 266, fig. 294.
35 TMA 1953.122, published: Hutton 1963, 9; Rogers 1967, 480, fig. 2; *Art in Glass* 1969, 49.
36 Henkes 1994, 90.
37 Rademacher 1933, pl. 44c.
38 A similar pole glass, but with fewer and larger prunts, is in the Landesmuseum Oldenburg. See Baumgartner and Krueger 1988, 397–398.
39 TMA 1948.222, published: Haynes 1948, 39, 40, fig. XIV; Barrelet 1953, 160; Hutton 1963, 21; *Art in Glass* 1969, 50; Gaynor 1991, 48, figs. 5, 5a, 5b.
40 Gaynor 1991.
41 Rochebrune 2004, 150.
42 TMA 1982.98, published: Read 1926, 189–190, pl. 5; Buckley 1932, 159–160, pl. IA; "Important Recent Accessions," *JGS* 25 (1983): 257; Wood 1984, 80; *Toledo Treasures* 1995, 78.
43 Buckley 1932, pl. I B.
44 Ibid., pls. II B and C.
45 Ibid., pl. II D.
46 *Treasures* 1992, 43, no. 33.
47 Heikamp 1986, 319, no. 86.
48 Buckley 1932, 159.
49 Zecchin 1987–89, 109.
50 Syson and Thornton 2001, 183.
51 Ibid., 145.
52 Levey 1983, 7.
53 Hetteš 1960, 23.
54 Hess and Husband 1997, 8.
55 Zecchin 1987–89, vol. 2, 184.
56 Bortolotto 1988, 44–45.
57 Brown and Lorenzoni 1982, 213.
58 TMA 1913.415, published: Rhoades 1958, 97; Hutton 1963, 7; *Art in Glass* 1969, 49.
59 TMA 1913.420, published: Hutton 1963, 4, 6; Rogers 1967, 479, fig. 1; Labino 1968, 51, fig. 34; Lanmon 1993, 168, 169, 171, no. 5, fig. 61.2.
60 TMA 1960.36, published: "Recent Important Acquisitions," *JGS* 4 (1962): 144; Hutton 1963, 4, 6; Rogers 1967, 479, fig. 1; Labino 1968, 51, fig. 35; *Art in Glass* 1969, 52; Polak 1975, frontispiece; Morley-Fletcher 1994, 109; Dreier 1989, 67; *Clearly Inspired* 1999, 23.
61 Rosenberg 1922–28, no. 3736.
62 Rosenberg 1922–28, no. 4130.
63 Von Saldern 1980, no. 198.
64 Jackson 1911, vol. 2, 575. Casting bottles may also have

been used for sprinkling aromatic substances onto textiles such as clothing or bed linens; see *Burghley House* 1998, 109, no. 22.
65 *Burghley House* 1998, 109, cat. 22.
66 Boynton 1971, 37. I am grateful to Ellenor Alcorn for insightful comments and for this and many more bibliographical sources related to this bottle.
67 Collins 1955, 108–110.
68 Ibid., 305–306 and passim.
69 An example with a carved, spirally fluted agate body and silver-gilt mounts, thought to date about 1535–40, is at Burghley House, Stamford. It was listed among the Duchess of Devonshire's jewels in 1690.
70 Starkey 1998, 88, no. 3238.
71 Hayward 2004, 113, no. 1121.
72 Starkey 1998, 244, no. 10949; 428, no. 17393.
73 TMA 2005.286A–B, unpublished except Christie's, New York, 25 October 1988, lot 420.
74 Glanville 1990, 354.
75 Newman 1987, 65.
76 *Glass of the Caesars* 1987, 245–249, no. 139.
77 Rochebrune 2004, 154–155.
78 Inv. No. OA 457-1412, gift of Charles Sauvageot, 1856.
79 Hess and Husband 1997, 170–173.

37–51
EUROPEAN BAROQUE AND ROCOCO

1 Palumbo-Fossati 1984, 123–124.
2 A cargo ship, which probably sank in 1583 on its voyage to customers in the eastern Adriatic Sea, off the coast of Croatia near Gnaliç, illustrates these types of wares. See Gasparetto 1973, 79–84.
3 Egg 1962, 43–44.
4 Syson and Thornton 2001, 190.
5 Ibid., 183–184.
6 Ibid., 199. Unfortunately, none of these seem to have survived.
7 TMA 1913.425 (No. 37A), unpublished. TMA 1913.427 (No. 37B), published: Hutton 1963, 4, 6; Labino 1968, 53, fig. 36; *Art in Glass* 1969, 53. TMA 1913.428 (No. 37C), published: Hutton 1963, 4, 6; *Art in Glass* 1969, 53.
8 Mentasti 1982, 112–114, 136, ills. 99, 100.
9 Heikamp 1986, ill. 43.
10 TMA 1994.5 (No. 38A), published: TMA *Annual Report 1993/94*, 28. TMA 1953.110B (No. 38B), unpublished. TMA 1913.434 (No. 38C), published: Hutton 1963, 4, 8.
11 Denissen 1985, 9–19.
12 Hudig 1923, 54.
13 Ibid., 56–57.
14 Van Royen 1991, 105–119.
15 TMA 2004.90, unpublished.
16 Theuerkauff-Liederwald 1994, 29.
17 TMA 1913.423, published: Hutton 1963, 4, 8; *Art in Glass* 1969, 50; *Clearly Inspired* 1999, 24.
18 Browne 1646, chap. 18, 1.
19 David 1995, 23.
20 Gaba-van Dongen 2004, 202.
21 David 1995, 8.
22 TMA 1955.15, unpublished.
23 Baart 1998, 31, n. 22.
24 TMA 1966.116, published: "Recent Important Acquisitions," *JGS* 9 (1967): 138; *Art in Glass* 1969, 59.
25 A glass flute formerly in the Horridge Collection, Shropshire, is diamond-point engraved with the arms of both Charles II and his brother and successor James II. See *Horridge Collection* 1959, 40, lot 220.

26 In 1608, the Dutch East India Company (VOC) selected gifts of glass made in Amsterdam for the Japanese emperor (Hudig 1923, 34–35, n. 121).
27 Ritsema van Eck and Zijlstra-Zween 1993, 2:176, no. 183, note.
28 See a copy of this print in the National Portrait Gallery, London, inv. no. NPG D18501.
29 A rare English example are two heraldic glass plaques that were supposedly engraved with a diamond ring by Anne St. John, Lady Rochester, about 1643. See Harvard 1994, 50–51.
30 Willmott 2004, 295.
31 Ibid., 297.
32 Mees 1997, 13.
33 Lassels 1670, 423.
34 TMA 1955.25, published: TMA *European Paintings* 1976, 75, pl. 125; TMA *Guide* 2005, 24.
35 See Charleston 1966, 159–160. One of the earliest known objects is a pair of beakers probably made for the wedding of Michael Behaim and Katarina Lochner in 1495. One of these is now in The Corning Museum of Glass, the other is in the Hockemeyer Collection, Bremen, Germany. See Mallet and Dreier 1998, 166–167 (fig.), 274–275.
36 Hejdová 1995, 34.
37 Klannte 1938, 598.
38 TMA 1950.12, published: *Art in Glass* 1969, 50; Battie and Cottle 1991, 77.
39 Bartsch vol. 12, 22, no. 4.
40 Berndt 1933–34, 40–48.
41 Hess and Husband 1997, 199–201, no. 54.
42 Hejdová 1995, 34.
43 Simonsfeld 1887, vol. 2, 197, 198.
44 Hejdová 1995, 1, 3.
45 TMA 1953.119, published: *Art in Glass* 1969, 51.
46 Strasser 2002, 92, no. 43.
47 TMA 1950.233, published: TMA *European Paintings* 1976, 37, pl. 124.
48 Hudig 1923, 55. Theuerkauff-Liederwald 1994, 123, quotes the numbers of *roemers* ordered from Amsterdam.
49 TMA 1953.89, published: Hutton 1963, 19; Rogers 1967, 480, fig. 3; *Art in Glass* 1969, 54; Smit 1984, 109.
50 Gaba-Van Dongen 2003, fig. 12.
51 Strasser 2002, 67–68, no. 27.
52 Croiset van Uchelen 1976, 320.
53 TMA 1987.206, unpublished. For the print, see Bartsch vol. 4, 338, no. 29; Holstein 1980, vol. 23, 85, no. 112.
54 Ritsema van Eck and Zijlstra-Zween 1995, 106, no. 87.
55 *Ritman Collection* 1995, 64, lot 75.
56 A glass panel depicting the Crucifixion and signed with his initials is in the Victoria and Albert Museum, London.
57 TMA 1913.455, published: Bosch 1984, 60–61, no. 31. The beaker probably dates to late 1663 or 1664, when Schaper visited Regensburg. He subsequently executed a number of Elector portraits for De Gravels, probably intended as gifts. The back is decorated with a river scene after a print by the Parisian engraver Gabriel Perelle (1603–1677).
58 TMA 1950.35, published: *Art in Glass* 1969, 60; Bosch 1984, 82–83, no. 42. See De Vesme and Massar, 1971, no. 171.
59 TMA 1950.38, published: Bosch 1984, 118–119, no. 72.
60 Henkel 1930, 115ff.
61 TMA 1950.37, published: Bosch 1984, 441, no. 354; Dolez 1988, 63; Chambers 19889, 35.
62 The Toledo Museum of Art owns a tall covered beaker attributed to Abraham Helmhack, painted in *Schwarzlot* decoration with an Old Testament scene, probably show-

ing Esther swooning in front of Ahasuerus, and bearing the arms of the Schiller family of Nuremberg (TMA 1913.454).

63 A jug of similar shape with floral decoration, formerly in the collection of Rudolf von Strasser, is in the Kunsthistorisches Museum, Vienna. See Strasser 2002, 426, no. 266, here attributed to a Bohemian workshop.

64 TMA 1913.444, published: Hutton 1963, cover, 22; *Art in Glass* 1969, 64; Kerssenbrock-Krosigk 2001, 102 and 207, no. 206. For the silver mark, see Seling 1980 / 1994, nos. 1809ff.

65 Brill et al. 1980, 22, 27–29.

66 Formerly in the Ernesto Wolf Collection, now Landesmuseum Stuttgart (Klesse and Mayr 1987, no. 194); Castle Favorite (Sillib 1914, 96); Museum of Applied Arts, Frankfurt (Ohm 1973, no. 452); The Corning Museum of Glass (acc. no. 79.3.296; Strauss 1955, no. 271). A slightly later glass with a roundel depicts Amor offering two hearts at the altar of Love, formerly in the Helfried Krug Collection (Klesse 1973, vol. 1, 321, 320, no. 374).

67 TMA 1950.15, unpublished. The engraved lid (TMA 1950.15B) that accompanied the goblet when it was acquired by the Museum has been removed because it is not original to the vessel. The goblet would originally have been topped by a cover that matched the construction of the finial stem and the engraved decoration of the bowl.

68 Sillib 1914, 96.

69 Klesse and Mayr 1987, no. 194.

70 Strasser 2002, 440, no. 279 cites a beaker dated 1722 with the arms of a shoemaker's guild as the earliest known glass with applied, reverse-decorated medallions.

71 Fleming 1965, 65–81; Le Corbeiller 1961, 209–223.

72 TMA 1950.43, published: Hutton 1963, cover; *Art in Glass* 1969, 67.

73 Strasser 2002, 309.

74 Private collection, London. See Strasser 2002, 308, fig. 37a. The beaker was recently acquired by the Museum of Applied Arts, Berlin, published: "Recent Important Acquisition," *JGS* 47 (2005): 221, no. 12.

75 Schmidt 1914, 70.

76 Pazaurek 1927, 48.

77 See also No. 48B, an English posset pot.

78 Klesse and Mayr 1987, no. 128.

79 Hörning 1979, no. 93.

80 Francis 2000, 47.

81 Berg 1999, 80.

82 Charleston 1984, 108.

83 The German alchemist Johann Glauber published *Teutschlandes Wohlfahrt / Viedter Theil* ("New philosophical furnaces" in Amsterdam in 1646. The new furnace had vents for temperature control, which allowed the batch to be refined first at high temperature, and then the heat was reduced to a lower working temperature. The important treatise *L'arte vetraria* by the Florentine priest Antonio Neri of 1612 included a difficult recipe for lead glass and was translated into English by Christopher Merrett in 1662. It was subsequently published in Amsterdam in 1669. A slightly earlier letter, dated 30 August 1660 from Samuel Hartlib to John Evelyn, a friend of Charles II, explains a new way of making glass for chemical apparatus. Archives of the Rakow Library, The Corning Museum of Glass.

84 Ravenscroft's new glass, a lead-potash formula, contained as much as thirty percent lead oxide.

85 In 1665, three glassmakers worked on the development of

a lead glass formula in Nijmegen, in eastern Holland: John Barrowmont da Costa; Dr. Jean Guillaume Reinier, who made lead glass in Sweden by 1675; and John Odacio Formica, who obtained a fourteen-year patent in Ireland in 1675. See Francis 2000, 47 and note 3.

86 The practice of impressing a seal on the glass lasted from 1676 to about 1684 and is thought to have been copied from contemporary glass bottle production, except that for bottles the seal customarily signifies the owner. See Brain 2000, 3.

87 TMA 1960.3, published: *Connoisseur*, vol. 145.583 (February 1960): 53, fig. 2; Hutton 1963, 16, 17; *Art in Glass* 1969, 61; Rogers 1967, 482, fig. 9; Charleston 1968, 167, fig. G (b) 1; Morley-Fletcher 1984, 107; Palmer 1993, 4, fig. 15. A nearly identical posset pot, bought by Howard Phillips at Sotheby's, London, 3 April 1967, lot 118, is now in the Pilkington Museum of Glass, St. Helens, Lancashire.

88 Often, posset was made using a dry wine, like sherry, and fortified with cream, eggs, sugar, and sometimes butter. For several posset recipes dating to the early 1700s, see Katherine Harbury, *Colonial Virginia's Cooking Dynasty* (Columbia, S.C.: University of South Carolina Press, 2004).

89 TMA 1948.223, published: Hutton 1963, 16, 18; *Art in Glass* 1969, 62.

90 TMA 1950.276, published: Hutton 1963, 16, 17; *Art in Glass* 1969, 62.

91 TMA 1968.73, published: Mulliner 1923, fig. 172; *Art in Glass* 1969, 73; Charleston 1984, pl. 44 a; Young 1983, 285–286.

92 Although English goldsmiths made silver mounts for exotic and precious materials in the sixteenth and seventeenth centuries, the taste in England had waned by the early eighteenth century. In France, the *marchands-merciers* kept the flame alive, ordering silver-gilt and later gilt-bronze mounts for imported Japanese and Chinese lacquerware and porcelain. See *Chinese Porcelain* 1980, 13, 17–18.

93 See Sargentson 1996, esp. 50–52, 68–70.

94 [Royal] Society of Arts Guard Books, 2 (32), 24 April 1760, cited in Berg 1999, 79.

95 See the extensive study of Betts's probate inventory in Werner 1985, 1–14.

96 Ibid., 6.

97 Ibid., Appendix 2.

98 Liquor barrel, England, probably London, probably Thomas Betts, 1760–65. The Corning Museum of Glass, inv. no. 85.2.5. See McConnell 2004, 189, pl. 263, right.

99 He owned several pieces of "japanned" furniture (decorated in the style of Chinese lacquer), and his mahogany dining room furniture was set with silver: Werner 1985, 10.

100 Cottle 1986, 325.

101 Cottle 1989, 397.

102 Cottle 1986, 321.

103 Cottle 1989, 397.

104 An Italian landscape with classical ruins and a shepherd is in the Victoria and Albert Museum (Cottle 1989, 397, fig. 9), and a pencil drawing of a rural landscape with a traveler checking the load on his donkey in the Rakow Library of The Corning Museum of Glass (*Annual Report 1997*, 23).

105 Bewick 1845, 39.

106 Thomas Beilby left to pursue the career of a drawing teacher, but he continued to serve as an agent for his family's firm for several more years.

107 Rush 1973, 119.

108 TMA 1953.13B, unpublished.

109 Charleston 1989, 20.

110 TMA 1954.16, published: Hutton 1963, 16, 18; *Decorated Glasses* 1980, no. 16; Cottle 1989, 397.

111 The Toledo Museum also owns a rare decanter enameled with the arms of George III, which is also unsigned. TMA 1963.16, published: Cottle 1989, 394, fig. 3.

112 TMA 1963.15, published: *Art in Glass* 1969, 74.

113 TMA 2004.67, published: TMA *ArtMatters* (Spring 2005) cover, 1; "Recent Important Acquisitions," *JGS* 47 (2005): 222–223, no. 14.

114 This ambitious commission from French Emperor Napoleon was executed in Milan over the period from 1809 to 1814, and after the defeat of Napoleon, subsequently purchased by Emperor Francis II and installed in the Minorite Church, Vienna.

115 Hanisee Gabriel 2000, 32, fig. 4.

116 Effenberger 2004, 209.

117 Ibid., 212.

118 Alfieri 2000, 269.

52–72
AMERICAN AND EUROPEAN NINETEENTH CENTURY

1 For a complete study of Amelung's venture, as well as discussion and illustration of this goblet, see Lanmon et al. 1990, 66–67.

2 *MJ and BA*, 11 February 1785; 14 March 1788.

3 *MJ and BA*, 22 May 1789. For information about imported glass at this time, see Lanmon 1969.

4 Amelung's *Remarks on Manufactures*, containing his additional notes in 1790, are reproduced in Lanmon et al. 1990, app. II, 133–140.

5 Charleston *Gazette*, 25 April 1789.

6 Ibid.

7 TMA 1961.2, published: Wilson 1994, 70, no. 6, color pl. p. 74.

8 *MJ and BA*, 22 May 1789; *Daily Advertiser* 1 January 1791.

9 See von Rohr 1991.

10 "Figured" pocket bottles are mentioned in an 1817 advertisement of John Mather, a Connecticut glassmaker. The advertisement is reproduced in McKearin and Wilson 1978, 409, fig. 115.

11 As quoted in Rorabaugh 1979, 150, 151.

12 Americans consumed more alcoholic beverages in the 1820s than at any time before or since. It has been estimated that the alcohol consumption in 1830 was 5.2 gallons (about 19.68 liters) per person, but the number rises to 9.2 gallons (34.8 liters) if the calculation is based only on the population older than fifteen years of age. Rorabaugh 1979, 187, 232–233. TMA 1954.12, published: TMA, *American Paintings* 1979, 71–72.

13 The Dyott advertisement is reproduced in McKearin 1970, 37. Because Dyott found that "intemperance, swearing and quarrelling, were the destructive obstacles to continued and persevered labor," he reorganized his factory in the early 1830s on a "system of moral and mental labor" that was strictly temperate. Nonetheless, Dyott continued to do a huge business in bottles for alcoholic beverages. See Dyott 1833.

14 See McKearin and Wilson 1978, 413, 415.

15 For ancient examples, see *Glass of the Caesars* 1987, 160, 163, 172–175; Stern 1995.

16 Full-size molds were used for stems and other parts of Venetian and *façon de Venise* vessels. French glassmaker Bernard Perrot used full-size molds in the late seventeenth

and early eighteenth centuries for such forms as perfume bottles, including examples in the shape of human heads. See Bénard and Dragesco 1989; and *Beyond Venice* 2004, 162–163, 188–189, no. 14.

17 McKearin and Wilson 1978, 409.

18 TMA 1917.409, published: Wilson 1994, 115, no. 50.

19 McKearin and Wilson 1978, 414, 436.

20 TMA 1917.387, published: Wilson 1994, 111, no. 38; color pl. p. 78.

21 TMA 1917.366, published: Wilson 1994, 113, no. 43.

22 TMA 1917.38, published: Wilson 1994, 117, no. 54; color pl. p. 79. See also Cheek 1997.

23 Barber 1900.

24 TMA 1959.53, published: Wilson 1994, 198, no. 190; Palmer 2005, 61.

25 "Bohemia has long manufactured glass to a great extent, and about forty years ago an artist of that country conceived the beautiful device of incrusting small figures, medals, &c. made of fine clay, in a solid glass covering. The Bohemian did not succeed perfectly, but some French manufacturers caught the idea, and completed several very fine medallions." This report, which originated in the *New York Times*, failed to mention the cameo-incrusted glass introduced by Bakewell, Page & Bakewell two years earlier, even though the firm's accomplishment had received considerable public attention in 1825. See *Supplement to the Connecticut Courant* (5 February 1827), 277.

26 Examples of both Clinton versions are illustrated and discussed in Palmer 2005, 142–145.

27 This was a statement made by the artist James Reid Lambdin. See Palmer 2005, 57–59.

28 See, for example, an advertisement in the *Boston Commercial Gazette* (13 April 1818), reproduced in Wilson 1972, 234.

29 "Boston Glass Manufactory" in *Pittsburgh Gazette* (30 November 1819). In the 1820 census of manufactures, however, the company reported that eight men were always employed and at times there were one hundred. *Documents Relative to the Manufactures in the United States, House Document 308,* (1832) 1:324–325. John W. Webster to Parker Cleaveland, 21 December 1835, quoted in *Antiques* 1939, 11.

30 Thomas Leighton to John Ford, 1 April 1828, quoted in Spillman 1992, 4.

31 Letter of Thomas Leighton, 1 November 1829, quoted in *Glass Club Bulletin* 1968, 11.

32 Webster to Cleaveland, 1835, quoted in *Antiques* 1939, 11.

33 TMA 1953.75, published: Wilson 1994, 185, no. 156; color pl. p. 153. TMA 1992.35, published Wilson 1994, 203, no. 201A.

34 McFarlan 1992.

35 Illustrated in Wilson 1972, 247, fig. 207a; now in the collection of The Corning Museum of Glass.

36 Parke-Bernet 1961, lot 153.

37 Collection of Lura Woodside Watkins, illustrated in McKearin and McKearin 1941, pl. 55, no. 2.

38 In the collection of the Chrysler Museum, Norfolk, Va. Illustrated on the cover of *The Glass Club Bulletin*, no. 160 (Winter 1989 / 90).

39 Warren 1981, 99, fig. 55.

40 Wilson 1972, 214–217.

41 One urn is in the collection of the Los Angeles County Museum of Art. Two were sold in New York in 1961. Parke-Bernet 1961, lots 148, 149. *New England Glass* 1963, 38, 62, cat. 12.

42 See, for example, Palmer 1993, 215, no. 176.

43 Thomas Leighton to John Ford, 1 April 1838 and 28 November 1839, in Spillman 1992, 6–8.

44 TMA 2004.3 A, B, published: Mallett 2004, 110; *JGS* 47 (2005): 226, no. 24. See also Higgott 2003, 46–48.

45 A drinking glass with decoration *en suite* is still owned by the Oppitz family.

46 Until 2003, this goblet was owned by Leslie Oppitz, of Keymer, Hassocks, West Sussex, England, who is a direct descendant of Paul Oppitz. His sister, Muriel Oppitz, the great granddaughter of the artist, remembers her grandfather describing the piece as being in Paul Oppitz's possession.

47 Letter by the artist, now in the The Spode Museum Trust (inv. no. SMT 2003.1.1); Higgott 2003, 47; Higgott 2006; Smith 2006.

48 TMA 1913.526 and TMA 1913.527, both unpublished, are modest footed tumblers, stained red and wheel-engraved with landscapes; TMA 191`3.526 also is engraved with a view of Schloss Rheinstein.

49 Vaupel wrote memoirs of his life in 1860 and 1861; after that date, until his death in 1903, he maintained a diary. The primary sources of information for this essay are Vaupel 1995–96 and Maycock 1995–96.

50 Catalogue of the Massachusetts Charitable Mechanics' Association, 1850, quoted in Watkins 1943, 182.

51 As quoted in *Hunt's Merchants' Magazine* 1852. The journalist was Alexander Cummings of the Philadelphia *Bulletin*.

52 A cased pitcher in The Corning Museum of Glass has a similar hunting scene and was engraved by Henry B. Leighton, whom Vaupel trained between 1853 and 1858.

53 TMA 1974.52, published: Wilson 1994, 546, no. 904, color pl. p. 571.

54 The flask, engraved with two deer on one side and a view of the Schildhorst glassworks on the other, is illustrated in *Acorn* 1995–96, 40–41, figs. 4–5.

55 "Testament of Louis Frederic Vaupel of Cambridge, Mass.," app. to Vaupel 1995–96, 89.

56 Wallis 1868, 101–102.

57 TMA 1925.50, published: Wilson 1994, 600, no. 960; 574 color pl.

58 See Revi 1967, 81–86.

59 Examples are illustrated in a trade catalogue of J. B. Graesser, *Glasfabrikbesitzer Zwickau Sachsen,* which dates to the 1880s.

60 For example, an 1869 photograph shows Longfellow with white hair and beard as on the glass tray. See Calhoun 2004, pl. 22.

61 I am grateful to Anita Israel, Archives Specialist, Longfellow National Historic Site, for identifying this photograph as the source of the painted portrait.

62 TMA 1986.65, published: *Toledo Treasures* 1995, 126–127.

63 For an illustration of the Longfellow Jug, see Mudge et al. 1985, 46–47.

64 I am grateful to Anita Israel for searching the poet's records for references to the Libbeys.

65 TMA 1968.24, published: Wilson 1994, 343, no. 433.

66 Glebow and Hassel 1993, 52, fig. 5; also illustrated on cover. A similar but larger ceremonial goblet is in a private collection.

67 TMA 1968.40, published: Wilson 1994, 423, no. 637; color pl. p. 255.

68 Jones 1826, 70.

69 For Irish examples, see Warren 1981, 202–205. Portuguese glasshouses also produced mold-blown ware in the 1820s: see Palmer 1993, 142–143, no. 99.

70 See Westropp 1928, 542–543.

71 Pellatt 1849, 96.

72 Ibid.

73 TMA 1953.14, published: Wilson 1994, 213, no. 225.

74 A sugar bowl, pitcher, vase, and tumbler in the Winterthur Museum, for example, were all made in the same mold. See Palmer 1993, 103, 163, 204, 283, nos. 53, 121, 163, 258.

75 TMA 1917.247, published: Wilson 1994, 222, no. 248, color pl. p. 158.

76 Wilson 1993, 810–811.

77 TMA 1959.61, published: Wilson 1994, 238, no. 294; color pl. p. 160.

78 Wilson 1994, 170.

79 Pellatt 1849, 106.

80 Grose 1989, 244–247, 263–267.

81 Pellatt 1849, 104–105.

82 TMA 1987.40, published: Wilson 1994, 195, no. 183; color pl. p. 156.

83 The pillar-molded butter basins, dishes, and other table forms illustrated in an 1838 price list of British glassmaker Apsley Pellatt relate more to the pillar cutting popular in that period than to the pillar-molded glass of mid-century. A full version of this price list is in the Winterthur Museum Library. An abridged version is in Wakefield 1982, 36, fig. 22.

84 Although the pillar molasses cans in the M'Kee and Brothers catalogues of 1859 / 60 and 1864 appear to be blown, they are described in the price list as pressed. See Innes and Spillman 1981, 9, 26, 45, 71. See also Bakewell, Pears & Co. 1868, reprinted in Palmer 2005. Pillar-molded objects, especially vases, seem to have been made well into the twentieth century.

85 McKearin and McKearin 1941, 27, identifies three basic types of lily pads, based on the arrangement and termination of the peaks.

86 An American silver jug made in 1857 is illustrated in *Nineteenth-Century America* 1970, no. 143. For examples of Parian porcelain pitchers in pond lily and lily pad patterns made in Bennington, Vt., in the 1850s, see Barret, 1958, 49, pl. 64; pp. 62–63, pls. 80–81. An earthenware jug with water lilies by Cork and Edge of Burslem, Staffordshire, was exhibited at the Great Exhibition of 1851 held in the Crystal Palace in London. At that same exhibition, the Messrs. Richardson of Stourbridge showed a goblet engraved with water lilies. See *Art Journal Catalogue* 1851, 41, 139. The same firm also produced jugs with water lilies painted in enamels; see Wakefield 1982, 72, fig. 67.

87 Thorpe 1929, pl. 28, and *Spanish Glass* 1974, pl. 26, cat. 51.

88 Berntsen 1962, pls. 6, 8. For an illustration of the bucket, see Palmer 1989, 24, fig. 25.

89 TMA 1959.86, published: Wilson 1994, 143, no. 126, color pl. p. 83.

90 TMA 1995.75, published: Wilson 1994, 145, no. 131; color pl. p. 84.

91 *Redford Glass* 1979, 14.

92 TMA 1959.73, published: Wilson 1994, 144, no. 128; color pl. p. 84.

93 Palmer 2005, 65–68; Royall 1829, 2:125.

94 TMA 1962.12, published: Wilson 1994, 370, no. 497.

95 TMA 1968.57, published: Wilson 1994, 348, no. 441; color pl. p. 251.

96 TMA 1968.34, published: Wilson 1994, 364, no. 485, color pl. p. 252. See *Gothic Revival Style* 1976, 66, no. 128. This casket has a stepped lid; other examples have domed lids. A colorless casket with domed cover was acquired by the

Technischen Museum in Vienna in 1837. See Spillman 1998, 6, fig. 2.

97 TMA 1968.53, published: Wilson 1994, 400, no. 578.

98 The Portland example was made in the 1860s; collection of the Maine State Museum, Augusta, Maine.

99 TMA 1954.12, published: Wilson 1994, 603, no. 966; color pl. p. 574.

100 Nash 2001, 55.

101 A plain colorless bellows bottle with applied Prince of Wales feathers is illustrated in McConnell 2004, 469, pl. 656.

102 Vincent 1975, 77, fig. 81

103 Giovanni Maggi's print showing a bellows bottle is illustrated in Theuerkauff-Liederwald 1994, 467, fig. 93.

104 Information from the 1900 New Bedford census. See Wilson 2005, 157. Boston passenger records indicate that Liddell arrived from Glasgow on October 14, 1884, not in February as Wilson states.

105 TMA 1948.49, published: Wilson 1994, 147, no. 139, color pl. p. 87.

106 Weeks 1883, 1.

107 *Crockery and Glass Journal* vol. 4, no. 8 (24 August 1876): 25.

108 *Glass of the Caesars* 1987, 137, no. 66.

109 TMA 1968.8, published: Wilson 1994, 617, no. 997; 579, color pl.

110 The advertisement is reproduced in Fauster 1979, 226, fig. 1. A collection of Maize glass is illustrated on the same page.

111 *Gazetteer* 1861, 1384.

112 Clarke 1891, 66–73.

113 See Barret 1958, 163, pls. 236, 237.

114 The three new glass types were La Tosca, Alaskan, and Aquaria glass. See Wilson 1994, 589.

115 The original Portland Vase, believed to have been made in Rome around 5–25 C.E., is named for the Duke of Portland, to whom it belonged at the end of the eighteenth century. It was replicated by Josiah Wedgwood in his "jasperware" pottery in 1790. The first attempt to copy the vase in glass was made by Edward Thomason and a Mr. Biddle at the Birmingham Heath Glassworks in 1818, but they failed to complete the white casing. The ancient original is in the collection of the British Museum, inv. no. 1945.9-27.1.

116 George Woodall started at J. & J. Northwood in 1861.

117 TMA 1970.442 and 1970.443, published: "Recent Important Acquisitions," *JGS*, vol. 14 (1970): 162 ill.; Perry 2000, 76, 142. See also Whitehouse 1994.

118 Whitehouse 1994, 10.

119 Perry 2000, 142.

120 A related plaque by George Woodall from 1886 entitled "The Dancers" depicts two nearly identical figures engraved in opaque white glass on brownish-red ground and sold for £63 (Perry 2000, 131). A covered jar depicting the same two girls (No. W2677) in white on a dark brown ground, made about 1892–93, retailed for the same amount (Perry 2000, 40, ill.). A single *Dancing Girl* vase signed "G. Woodall" and "G.C.," now in The Corning Museum of Glass (Whitehouse 1994, 54, figs. 50 and 62, no. 50), sold originally for £30 (Perry 2000, 140). The dancing figures also appear in Daniel Pearce's sketchbook, today in the Broadfield House Glass Museum, Kingswinford, England.

121 See *Burke's Landed Gentry* (London: Burke's Peerage Ltd., 1952), 582.

122 Colné 1880, 3:361, 367.

123 TMA 1958.63, published: Wilson 1994, 604, no. 968, color pl. p. 577.

124 See, for example, Auth 1976, 94, no. 100.

125 For a French example, see Klesse and Reineking-Von Bock 1973.

126 Advertisement of 30 August 1917, reproduced in Fauster 1979, 181.

127 A photograph of the Richardson glass shown in 1878, including Locke's Portland Vase, is reproduced in Hajdamach 1991, 114, pl. 86. Locke's vase is now in the collection of The Corning Museum of Glass, acc. no. 92.2.7. For more information about Locke, see Silverman 1936, 272–275; *Cameo Glass* 1982, 111, no. 47, color pl. p. 65; Kenneth Painter and David Whitehouse, "The History of the Portland Vase, III. The Vase in England, 1800–1989," *JGS*, vol. 32 (1990): 74, figs. 43–44.

128 TMA 1972.22, published: Wilson 1994, 615, no. 994, color pl. p. 578.

129 Shaw 1973, 28, fig. 32.

130 Rath 1998, 36.

131 TMA 1983.9, published: *Toledo Treasures* 1995, 130.

132 Neuwirth 1999, 404.

133 Neuwirth 1999, 26, no. 36.

134 TMA 2005.43, published: Sotheby's, Paris, 26 May 2005, lot 29. See also Plival de Guillebon 1994 and Mouray 1912.

135 Plival de Guillebon 1994, 47–49.

136 Plival de Guillebon 1994, 50.

137 The Russian jewelry firms of Carl Fabergé and Pavel Ovchinnikov in Moscow were expertly executing complex objects and exquisite jewelry in the *plique-à-jour* technique by the turn of the nineteenth century. A third center for the production of this type of enamel work was Norway, where goldsmith Thorolf Poytz (1858–1938) and the firm of J. Tostrup in Christiania (Oslo) made traditional vessel types, as well as delicate serving trays, in the Art Nouveau style (see a cornflower bowl on stand and a footed tray inspired by the foxglove blossom [*Digitalis purpurea*] in the Württembergisches Landesmuseum, Stuttgart, acc. nos. G 4155 and G 4066).

138 For this anemone bowl (acc. no. OAO204), see Plival de Guillebon 1994, ill., 50, no. 8. A bowl with poppies, dated 1903, is in the Walters Art Museum, Baltimore (acc. no. 44.573).

139 Quoted in Frelinghuysen 1988, 57. The patent was granted to Tiffany early in 1881.

140 See *Art Journal* (1879): 84–85.

141 Quoted in Eidelberg and McClelland 2001, 48.

142 Quoted in Koch 1966, 120–121.

143 TMA 1986.62, published: "Recent Important Accessions," *JGS*, vol. 29 (1987): 126; Wilson 1994, 626, no. 1016, color pl. p. 581. The vase is engraved "8092H / L. C. Tiffany / Favrile" near the edge of the base; the suffix "H" indicates a date in 1913.

144 Eidelberg and McClelland 2001, 188. The "Favrile Glass Jack-in-the-Pulpit Stem Vase" that was in Tiffany's own collection is modeled after Iranian bottles of the eighteenth and nineteenth centuries and bears no resemblance to No. 71. See Parke Bernet 1946, 8–9, lot 48. Reference courtesy of Alice Cooney Frelinghuysen.

145 Eidelberg and McClelland 2001, 48.

146 Quoted in Frelinghuysen 1988, 57.

147 Podos 1991 and 1992 and Smith 1992.

148 Smith 1991, 9, 22.

149 The Phillips table of 1862 and the Baccarat "temple" are illustrated in Spillman 1986, 18, 34.

150 For an illustration and discussion of the display see Fauster 1977.

151 One contemporary account says the bowl was valued at $2,700; another claims it was $2,500. Similarly, the table was valued from $2,200 to $2,500. These apparently represent the costs to the company. Those variables aside, $2,000 in early-twentieth-century dollars would roughly equal

$40,000 in today's currency. See the American Institute for Economic Research, online Cost of Living Calculator, which gives value equivalents of U.S. dollars from 1913 to 2005: http://www.aier.org/cgi-aier/colcalculator.cgi.

152 Wilson 1994, 635–643.

153 Barber 1900, 95.

154 TMA 1951.1, published: Wilson 1994, 671, no. 1076, color pl. p. 762.

155 TMA 1946.27 A, C–Y, published: Wilson 1994, 668, no. 1071, color pl. p. 761. See "Fine Cut Glass Exhibit," *China, Glass and Lamps* vol. 24, no. 11 (6 April 1904): 14; and Fauster 1977.

73–78
EARLY TWENTIETH CENTURY

1 The Kosta Glassworks, Sweden's first commercial glasshouse, had been founded in 1742 and became the starting point for numerous new workshops. Between 1863 and 1903 glass production saw an annual growth of 4.8 percent. See Isacson 1996, 26–27.

2 Boberg's wooden screen with a pond scene imitating a Gobelins tapestry received favorable reviews at the 1893 Columbian Exposition in Chicago (Rappe 1894, 299), as did her decoration of a large representational vase painted for the Rörstrand porcelain factory and exhibited in Paris, 1900.

3 TMA 2004.16, published: *Svensk Jugend*, exhib. cat., Nordiska Museet (Stockholm, 1964), cat. 101; Ingrid Rosen, *Fem tidiga glaskonstnarrinnor* (Stockholm: Carlssons, 1993), 34; *Modern Art Sale*, Bukowkis, Stockholm, 29 April 2004, lot 1125; *JGS* 47 (2005): 233, no. 42.

4 The name *graal* (from the medieval Latin word for "platter" or "bowl") for this new type of glass-working technique was supposedly inspired by a tale by Swedish author Gustaf Froding (1860–1911), "Den heliga Graal" ("The Holy Grail").

5 TMA 2004.83, published: *Orrefors 100 år [One Hundred Years of Orrefors]*, exhib. cat., National Museum of Sweden (Stockholm, 1998), cat. 70; *Modern Art Sale*, Bukowskis Auktioner, Stockholm, 5 November 2004, lot 955.

6 The Wiener Werkstätte as a group was not represented at the Louisiana Purchase Exposition and World's Fair, St. Louis, in 1904, where the Libbey Glass Co. proudly exhibited its famous cut glass punchbowl (see Fig. 72.1), because the Austrian Ministry of Culture did not concur with the program of the Secession. However, Hoffmann and Moser designed the display of the Vienna School of Applied Arts for that fair, where their respective students presented work in the craft aesthetic of the Wiener Werkstätte. See Noever 2003, 77.

7 Josef Hoffmann heralded Peche after his death as "the greatest decorative genius that Austria has harbored since the Baroque period."

8 TMA 1986.67, unpublished. This drawing is marked in pencil "Vorder Aussicht" [frontal view]; "24 Teile [parts] / 12," and "01Z2790 / Ss 46 / 01Z2803 / 3060." See Vienna 1985, 353, no. 13 / 1 / 55.

9 TMA 1986.52. published: Vienna 1985, no. 13 / 1 / 55, repr. p. 353; *Silver*, vol. 21, no. 4 (July–August 1988): repr. p. 41. This vessel is marked JH [Josef Hoffmann] / WW [Wiener Werkstätte] / MADE IN AUSTRIA / 900 / Vienna silver mark.

10 Vienna 1967, 13ff.

11 Noever 2003, 340 ill. For variations of the form in olive-green and purple glass, see Bröhan 1992, 170, no. 65 and 171, no. 66.

12 Julius Zimpel (born 1896) was a nephew of Gustav Klimt and upon Peche's death was immediately appointed as his successor, but Zimpel also died prematurely, two years later, in 1925. See Bröhan 1992, 95.

13 TMA 1978.49, unpublished.

14 *Art Deco* 1980, lot 260A.

15 Hoffmann designed tableware in similar form for the Bernatzik House in Vienna, first created in 1912 and redesigned for the next generation in 1932. See *Josef Hoffmann* 1977, 22–23.

16 TMA 1978.46, published: Valotaire 1929, 91; "Recent Important Accessions," *JGS*, vol. 21 (1979): 126; Marcilhac 1989, 114; Ostergard 1991, 106; TMA , *Guide* 2005, 47.

17 Despite its remarkable exposure at the *Salon d'Automne*, the cabinet did not find a buyer in France but in England. Shortly after its exposure at the Breve Gallery in London, the cabinet was purchased by Lady Waite, heiress to the Austin automobile fortune.

18 TMA 1976.47, published: "Recent Important Accessions," *JGS*, vol. 19 (1977): 176.

19 Ostergard 1991, 106.

20 "Foreword," *New Era in Glass* 1933. A photographic facsimile of the Libbey-Nash catalogue is printed in Fauster 1979, 315–359.

21 Eidelberg and McClelland 2001, 98; *Alliance of Art and Industry* 2002, 156, 161, 207.

22 See, for example, Nash's Blue Grotto and Smoke stemware, in Revi 1981, 105, 106, figs. 184–185.

23 See item K-535, Table Center Service, *New Era in Glass* 1933, reproduced in Fauster 1979, 343.

24 See Jackson 1996, 106–107, pls. 38–42. Related Whitefriars examples are discussed in Dodsworth 1987, 84, no. 255; and Jackson 1996, 70, figs. 171–172, and 116, pl. 85.

25 *New Era in Glass* 1933, 9-C, reproduced in Fauster 1979, 335. The patent design is illustrated in Revi, 1981, 96.

26 Currency equivalent based on American Institute for Economic Research, online cost-of-living calculator. See: http://www.aier.org/cgi-aier/colcalculator.cgi.

27 *New Era in Glass* 1933, 1-D, reproduced in Fauster 1979, 336.

28 TMA 1951.162, published: Fauster 1979, 207, no. 18. See also *New Era in Glass* 1933, 5-D, reproduced in Fauster 1979, 338.

29 TMA 1951.170, unpublished. See *New Era in Glass* 1933, 7-D, reproduced in Fauster 1979, 339.

30 TMA 2004.88, published: *Verreries de la Renaissance au XIXe Siècle* (Paris: Bailly-Pommery & Voutier, 10 December 2004), lot 114. For a Nuremberg example, see the pokal of 1660–80 in *Glass Drinking Vessels* 1955, 77–78, no. 196.

31 See a goblet engraved in the 1860s by Jean-Baptiste Wilmotte at Val Saint-Lambert, in Wilmotte 1997, 50. It is interesting to contrast Nash's approach from 1933 with a cocktail set produced in 1935 by Stuart and Sons of Stourbridge that is decorated with a modernist interpretation of the spider subject. See Dodsworth 1987, title page and 58, no. 61.

32 TMA 2005.69, unpublished. See Fauster 1979, 210, no. 169, figs. 54, 56. See also *New Era in Glass* 1933, 1-D, reproduced in Fauster 1979, 336.

33 TMA 2005.64, unpublished. See *New Era in Glass* 1933, 10-D, reproduced in Fauster 1979, 341.

34 TMA 2005.73, unpublished. See *New Era in Glass* 1933, 10-D, reproduced in Fauster 1979, 340.

35 For an illustration of the Magnussen service, see Duncan 1986, 80. Duncan suggests the silver influenced Haley, but both designs were completed in 1927 and the silver service was not publicized until after Ruba Rombic was released. See Wilson 1989, 57.

36 TMA 1993.60, published: "Recent Important Acquisitions," *JGS*, vol. 37 (1995): 119; *Craft in the Machine Age* 1995, 96, 162 color pl.

37 The company explained in its 1928 broadside that the name was from "Rubaiy (meaning epic or poem)" and "Rombic (meaning irregular in shape)." The Arabic word *rubaiy* actually means "composed of four elements." The company probably got the idea from *The Rubaiyat* of Omar Khayyam without understanding that the famous poem was so named because it was composed of four-lined verses or quatrains. By changing the spelling of "rhombic," which refers to the form of an oblique equilateral parallelogram, the company gave the public a name it could easily remember—and spell correctly.

38 Quoted in Wilson 1989, 40.

39 *China, Glass & Lamps* (26 December 1927); the advertisement is reproduced in Wilson 1989, 41.

40 The 1928 advertisement is illustrated in Weatherman 1974, 48.

41 Ibid.

42 The new glass was known as "10M." See Albrecht 2004, 173.

43 Plant 1972, 2–6.

44 TMA 1923.24, published: *International Studio* (July 1923): 353 repr.; TMA *Museum News* 51 (May 1928): repr. cover; Harry Rand, *Paul Manship* (Washington, D.C.: National Museum of American Art, Smithsonian Institution, 1989), 47–48, figs. 29, 34; *Toledo Treasures* 1995, 158.

45 TMA 1936.36, published: Labino 1968, 104, fig. 90; *Art in Glass* 1969, 134; *Masterpieces of American Glass* 1990, 59, fig. 92.

46 Albrecht 2004, 173.

47 Waugh 1947, "Introduction," 5–6.

48 Steenberg 1950, chapters 6, 7.

49 Albrecht 2004, 173.

50 Plant 1972, 4, 26–27.

79–100
CONTEMPORARY ARTISTS

1 For the complete history of this aspect of glass art, see Lynn 2004, 47–67.

2 LACMA M.90.82.31, unpublished. See Peterson 1968 and Levin 1976.

3 See Kenny 1963. Ceramists during this period typically used native materials for glazes and to formulate clay bodies. Potter Laura Andreson also used local clay for her work.

4 *Glen Lukens* 1982, n. p. [15].

5 TMA 1992.45, unpublished.

6 Clute 1931, 11–16.

7 TMA 1986.20, unpublished.

8 Letter dated 25 February 1986, in Toledo Museum of Art registrar's file from Roger M. Berkowitz, then Deputy Director and Chief Curator, quoting a conversation with Maurice Heaton.

9 See Bitterman 1954.

10 See Johnson 2003.

11 As quoted by Susanne K. Frantz, "Foreword," in Johnson and Piña 1997, 5.

12 TMA 1991.88, published: *Fused Glass* 1985, 3; *Made in America* 1995, 175.

13 See Johnson 2003, 55.

14 Biographical information obtained from the Higgins Studio web site, www.higginsglass.com/history.php; and from Frances Higgins Oral History, Smithsonian Institution web site: http://www.aaa.si.edu/oralhist/higgin03.htm. Both resources accessed 27 August 2005.

15 Hollister 1985, 235–236.

16 Johnson 1999.

17 See Hollister 1985, 234–235. The Higginses' largest commission was the window for the front of the First National Bank of Appleton, Wisconsin. The window, which meas-

ured twenty-eight feet high and eighty feet wide, was lost in the early 1980s, when the bank was remodeled.

18 Eckhardt changed her name from Edythe Aline Eckhardt to Edris Eckhardt to avoid being categorized as a "woman" artist. See Bassett 2000 for references to her work at Cowan Pottery Studio and the WPA.

19 TMA 2005.22, published: Hollister 1985, 240, no. 21; Dancyger 1990, 149–150, no. 264.

20 Levin 1988, 155; Bassett 2000.

21 See Lynn 2004, 36 and passim; Clark 1987, 263; Hollister 1985, 234–235; Untracht 1962, 36.

22 Hollister 1985, 236.

23 Quoted in Uchida 1960.

24 Ibid. See also Burton 1979.

25 TMA 1986.43, unpublished.

26 Quoted in *Craft Horizons* 1958.

27 In an interesting sidelight to Burton's career, Suellen Fowler, one of his students at Pepperdine, passed on Burton's formula for making borosilicate color to Paul Trautman, who in turn founded Northstar Glassworks, which became the world's largest manufacturer of colored borosilicate. See Hollister 1993.

28 Burton 1967.

29 For an additional description of the Toledo Workshops, see *Alliance of Art and Industry* 2002, 19–20.

30 The attendees at the first workshop were ceramist Clayton Bailey, Edith Franklin, Karl Martz, Tom McGlauchlin, William Pitney, Dora Reynolds, and ceramist John Stephenson. The second workshop was attended by Erik Erikson, Robert Florian, Rosemary Gulassa, Sister Jeannine, O.P. (Siena Heights College, Toledo), John Karrasch, ceramist Howard Kottler, Elaine Lukasik, Octavio Medelin, Diane Powell, June Wilson, and Stanley Zielinski. Clayton Bailey also returned.

31 See Littleton 1988, 26; and Byrd 1982.

32 Seeing Leafgreen demonstrate the magic of off-hand blowing was still vivid to Edith Franklin thirty years later, when she recalled that "[t]he first day Harvey Leafgreen came, no one knew what he was there for. He took off his coat, got a blowpipe and some of the melted glass marbles from the furnace, and blew a bubble by putting his thumb over the blowpipe hole. I remember it was like magic that there was this bubble on the other end." See Franklin 1993.

33 *Glass Workshop Report* 1962, 2.

34 Similar changes were occurring in all crafts. By the late 1950s and early 1960s clay, for example, emerged from the cocoon of the crafts world, through the agency of Peter Voulkos and others, to gain recognition from the high art world. See Lynn 2004.

35 *Life* 1966. Also included in the article were Lenore Tawney, Paul Evans, Paolo Solari, Wendell Castle, Otto and Peggy Holbein, Francesca Tyrnauer, Bill Sax, Dorian Zachai, Alice Parrot and Peter Voulkos. Voulkos was also featured in the editor's note and described as a "sculptor." This indicates the distance, at that time, between clay and glass in terms of acceptance as art mediums.

36 TMA 1992.41 A–L, published: *Contemporary Glass* 1992, 12; TMA *Annual Report* 1992/93, 17.

37 *Americans in Glass* 1984, 86.

38 Dr. Littleton was particularly interested in annealing and is credited with discovering the temperature at which glass melts, known as the Littleton Point. This discovery, in turn, led to Corning Inc.'s development of the Pyrex® line of oven-proof glass cookware.

39 Some of the information included here is drawn from *Littleton* 1984.

40 Conversation with the author, May 1995. Littleton's con-

clusion seems odd, because it was around this time that Peter Voulkos, James Leedy, and others were about to make clay sculptures that would redefine the clay world and its artistic reach.

41 It is interesting to note that glass is considered a subset of ceramics and is treated as such in many museum collections, including the Victoria and Albert Museum, London, which is widely recognized as the leading decorative arts museum in the English-speaking world.

42 See Hunter-Stiebel 1982.

43 See Byrd 1982, 9.

44 TMA 1973.3, published: *American Glass Now* 1972, 34, cat. 51; Labino 1974, back cover; Hollister 1987, 8.

45 Byrd 1982, 2–8.

46 Ibid.

47 Labino 1966; Bonham 1967, 14. Labino gave three of his experimental core-formed vessels to the Toledo Museum: acc. nos. 1966.122–124, published: Grose 1989, 392, nos. 705–707.

48 Wilde 1981, 8.

49 Labino worked as a scientist and inventor for nearly fifty years (1939 to 1982) and received sixty patents for work on formulas for high-quality, stable glass; glass composition; furnace design; and various devices for glass-forming. His chief scientific accomplishment was the invention of silica fiber for use in jet aircraft, which led to his designing a machine to form glass into pipe insulation. His glass fibers were used for insulation in the National Aeronautical and Space Administration's Apollo series space capsules. See Lynn 2004, 71.

50 The Congress was held in New York City, to coincide with the New York World's Fair. Originally conceived by the American Craft Council as an event to bring artists together from across the United States, it was ultimately expanded to invite international participants. The Council, under the leadership of Aileen Osborn Webb, resulted in transforming the status of crafts from rural hobbies to an integral part of the national art scene. See Lynn 2004, 71.

51 As quoted in Frantz 1993. See also Kangas 1997.

52 Tina Oldknow notes that Chihuly first blew glass with Fritz Dreisbach. See Oldknow 1996, 39.

53 See Regan 2002.

54 TMA 1966.134, published: *Toledo Glass National* 1966, unp., repr.; Labino 1968, 128, fig. 110.

55 TMA 1973.4, published: *American Glass Now* 1972, 21, cat. 19l

56 Information accessed from list of instructors on Web site of Eugene [Oregon] Glass School: http://www.eugeneglassschool.org/f_dreisbach.cfm, accessed 29 August 2005.

57 TMA 1966.135, published: *Toledo Glass National* 1966, unp., repr.; Labino 1968, 128, fig. 111.

58 Giambruni 1966, 55.

59 Lipofsky 1986, 87.

60 *GAS J* 1978.

61 Blume 1994.

62 Jaulin 1987, 8–11.

63 See Zynsky biosketch on the Rhode Island School of Design Web site: http://www.risd.edu/about_profiles.cfm?type=alumni&profile=alumni_profile_54.cfm, accessed 3 December 2005.

64 Klein 1989, 3.

65 TMA 1995.2, unpublished.

66 Waggoner 1989. The notion of working with glass filaments is not new, as evidenced by several dresses spun, woven, and sewn in 1893 by the Libbey Glass Co. One example is now in the Toledo Museum of Art collection

(see Fauster 1979, 52–53; 288, fig. 4).

67 TMA 1991.141, published: "Toot Zinsky" [sic], *Glassworks*, vol. 1 (1989): 21; *Contemporary Crafts* 1993, 89, no. 114, pl. 61; Oldknow 1996, 199.

68 An interesting story is recounted by Karen Chambers in her unedited manuscript for an article later published in the April 1994 issue of *Neues Glas*. Statom grew up next door to artist Kenneth Noland and his family, and their daughter Cady was one of Statom's best friends. Noland served as a role model for Statom by proving that one could make a living as an artist. Cady Noland also went on to become an artist and she, like Statom, came to incorporate everyday fabricated objects in her work. Lynn 1997, 147.

69 TMA 1991.103, published: *Contemporary Crafts* 1993, 207, no. 102, pl. 51.

70 Fleming 1993.

71 As quoted in Chambers 1994a, 2.

72 *Glassworks* 2 (1990): 50.

73 TMA 2003.66, published: *Contemporary Directions* 2002, 77, pl. 61.

74 Porges 1993, 39.

75 See *Art to Art* 1996 and TMA *Statom's Hydra* 2002. Begun in 1995, the final version of *Hydra* was installed in 2002.

76 Letter to the author, 18 June 1995.

77 TMA 1991.117, published: *Art Scene* (May 1988): 11; *Contemporary Crafts* 1993, 194, no. 20, pl. 12.

78 TMA 1992.86, published: *Dan Dailey* 1987, 61, repr. 47.

79 TMA 1992.86, documentary file notes assembled by Davira S. Taragin, January 1993.

80 Organized by the Rosenwald-Wolf Gallery, Philadelphia College of the Arts, and shown at the Smithsonian Institution's Renwick Gallery.

81 Letter to the author, 18 June 1995.

82 See *Americans in Glass* 1984, 46.

83 Quoted in Bock 1995.

84 Letter to the author, 6 June 1995.

85 TMA 1996.7, published: *Contemporary Directions* 2002, 76, repr. 56.

86 Kangas 1991, 28. Ruffner created the series for a solo exhibition, *Ginny Ruffner: Curious Phenomena and Outrageous Observations*, which opened at the Heller Gallery, New York, in November 1990.

87 Miller 1995, 24.

88 See Lynn 1997, 121.

89 Opie 2004, 24.

90 Sullivan 1995, 52.

91 Krakauer 1992, 94.

92 Glass artist Richard Meitner and artist Mark Tobey were the other American artists to have solo shows at the Louvre. Their exhibitions were at the main gallery of the Louvre, while Chihuly's was at the Musée des Arts Décoratifs, one of the related museums within the Louvre complex.

93 Notes from Toledo Museum documentary file, 1995, by Davira S. Taragin.

94 TMA 1991.21, published: TMA *Annual Report*, July 1, 1990–June 30, 1991 (1991), repr. cover.

95 See Dale Chihuly web site, http://www.chihuly.com/essays/oldknow_2003.html

96 See Pilchuck web site, http://www.pilchuck.com/archive/2001/spring_news_2001.pdf and Herman 1992.

97 Krakauer 1992, 93.

98 Klein 1987, 16.

99 *Daum* 1978; Daum 1984.

100 Daum 1984, 129–141. See also Argy-Rousseau biosketch at: http://www.cartage.org.lb/en/themes/

Biographies/MainBiographies/A/Argy/Argy.htm

101 Theophilus 1991.

102 TMA 2001.32, unpublished.

103 Hobson 1983.

104 See Frantz 1994 and Klein 2001, 116–121.

105 TMA 1993.5, published: *Contemporary Crafts* 1993, 198, no. 46, pl. 25.

106 See *Libenský and Brychtová* 1996, 4–5.

107 TMA 1991.123, published: *Contemporary Crafts* 1993, 198, no. 45, pl. 24.

108 TMA 1993.11, published: *Contemporary Crafts* 1993, 209, no. 120, pl. 58.

109 In 1968, Wolff was awarded the prestigious Lunning Prize for Scandinavian design and was the first winner of the Coburg (Germany) Glass prize in 1977. In 1997, she received the Corning Museum of Glass's Rakow Commission for her work, *The Silent*.

110 Chambers 1985, 21.

111 Zámečníková 1992, 79.

112 Zámečníková 1999, 60.

113 Zámečníková 1993.

114 TMA 1991.140, published: *GAS J* (1986): 123; *Contemporary Crafts* 1993, 87, no. 122, pl. 59.

115 Chambers 1985, 20.

116 Suda 1991, 35.

117 Atushi 1995, 242.

118 Atushi 1991, 20.

119 TMA 1991.56, published: *Glass Japan*, exhib. cat., Heller Gallery (New York, 1991), no. 3. The first of five works in the series, made in 1989, was exhibited in *Fujita / Littleton*, exhib. cat., Glasmuseum (Ebeltoft, Denmark, 1989), 19.

120 TMA 1952.29 A–D, unpublished.

121 See Turrell 1983–84; Wortz 1986; and Goodman 1986.

122 Letter to the author from Gay Ben Tré, the artist's wife, dated 4 May 1995.

123 TMA 2003.57, published: TMA *Welles Sculpture Garden* 2001, no. 2; *Sculpture* 22.8 (October 2003): 51.

124 Ben Tré 1992, 61–62.

125 Danto 1998, 53.

126 *Americans in Glass* 1978, 57.

127 Poirier 1985, 70.

128 D'Harnoncourt 1978, 8.

129 *Christopher Wilmarth* 2001. Wilmarth's work was featured in solo exhibitions at the Wadsworth Atheneum (1974), the Seattle Art Museum (1979), a posthumous retrospective at the Museum of Modern Art (1989), and Harvard University's Fogg Art Museum (2003), which featured the drawings for his sculptures.

130 TMA 1982.1, unpublished.

131 As quoted in Rosenstock 1989, 16.

132 From a statement written by Wilmarth in 1974, published in D'Harnoncourt 1978.

133 TMA 2000.38, published: TMA *Annual Report 2000–01*, 28.

134 Te Duits 1992.

135 Van Kester 2001.

136 Klein 2001, 72–73. In an art museum setting, the water is omitted because its presence will slowly cause the glass to deteriorate and can be a hazard to nearby works of art.

137 Ricke 1998, 54.

BIBLIOGRAPHY

PERIODICAL ABBREVIATIONS

AJA *The American Journal of Archaeology*
AnnAIHV *Annales du Congrès de l'Association internationale pour l'histoire du verre*
Bulletin *Bulletin des Journées Internationales du Verre*
GAS J *Glass Art Society Journal*
GBA *Gazette des Beaux-Arts*
JGS *Journal of Glass Studies*
JRA *Journal of Roman Archaeology*
JRS *Journal of Roman Studies*
MMA Bulletin *The Metropolitan Museum of Art Bulletin*
MMA J *The Metropolitan Museum of Art Journal*
TMA Museum News Toledo Museum of Art *Museum News*. No. 1 (1907)–no. 159 (1955); New Series, vol. 1 (1957)–vol. 24 (1982). Discontinued.

Age of Spirituality **1977** *Age of Spirituality: Late Antique and Early Christian Art*, Ed. Kurt Weitzmann. Exhib. cat. New York: The Metropolitan Museum of Art, 1977 (1979).
Albrecht 2004 Albrecht, Donald. "Glass and Glamour: Steuben's Modern Moment, 1930–1960." *Antiques* 165.1 (Jan 2004): 173.
Alfieri 2000 Alfieri, Massimo. "Appendix: New Notes on Giacomo Raffaelli and Michelangelo Barbieri." In Hanisee Gabriel 2000, 263–279.
Allan 1995 Allan, James W., ed. "Investigation into Marvered Glass: 1." In *Islamic Art in the Ashmolean Museum*. Ed. James W. Allan. Oxford Studies in Islamic Art 10. Oxford: Oxford University Press, 1995: 1–30.
Alliance of Art and Industry **2002** *The Alliance of Art and Industry: Toledo Designs for a Modern America*. Ed. Davira S. Taragin. Exhib. cat. Toledo, Ohio: Toledo Museum of Art, 2002.
American Glass Now **1972** *American Glass Now*. Exhib. cat., Toledo Museum of Art and Museum of Contemporary Crafts of the American Crafts Council. Toledo, Ohio: Toledo Museum of Art, 1972.
Americans in Glass **1978** *Americans in Glass*. Exhib. cat. Wausau, Wisc.: The Leigh Yawkey Woodson Art Museum, 1978.
Americans in Glass **1984** *Americans in Glass*. Exhib. cat. Wausau, Wisc.: The Leigh Yawkey Woodson Art Museum, 1984.
Antioch **2000** *Antioch: The Lost Ancient City*. Ed. Christine Kondoleon. Exhib. cat. Princeton, N.J.: Princeton University Press in association with the Worcester (Mass.) Art Museum, 2000.
Antiques **1939** "The Editor's Attic: Cambridge Glass," *The Magazine Antiques* 35.1 (January 1939): 11.
Art in Glass **1969** Hutton, William. *Art in Glass: A Guide to the Glass Collections*. Toledo, Ohio: The Toledo Museum of Art, 1969.
Art Journal **1879** "Glass Ornamentation." *The Art Journal for 1879*. New York: D. Appleton & Co., 5 (1879): 84–85.
Art Journal Catalogue **1851** *The Art Journal Illustrated Catalogue, The Industry of All Nations 1851*. London: George Virtue, 1851.
Art Journal Catalogue **1862** *The Art Journal Illustrated International Catalogue of the International Exhibition*. London: George Virtue, 1862.
Art to Art **1996** *Art to Art: Albert Paley, Jim Dine, Therman Statom Respond to Toledo's Treasures*. Ed. Davira S. Taragin. Exhib. cat. Toledo, Ohio: Toledo Museum of Art, 1996.
Atıl et al. 1985 Atıl, Esin, W. T. Chase, and Paul Jett. *Islamic Metalwork in the Freer Gallery of Art*. Washington, D.C.: Smithsonian Institution, 1985.
Atushi 1991 Atushi, Takeda. "Glass and Sensitivity—Following a Trail of Forty Years." In *Kyohei Fujita*. Toyko: Asahi Shimbun, 1991: 20.

Atushi 1995 Atushi, Takeda. "Interview." In *Expanded Glass: Traditional and Contemporary*. Yokohama, Japan: Yokohama Museum of Art, 1995.
Aus'm Weerth 1881 Aus'm Weerth, E. "Zur Erinnerung an die Carl Disch'sche Sammlung römischer Gläser." *Bonner Jahrbucher* 71 (1881): 119–133.
Auth 1976 Auth, Susan H. *Ancient Glass at the Newark Museum*. Newark, N.J.: The Newark Museum, 1976.
Baart 1998 Baart, Jan M. "De Amsterdamse glashuizen en hun productie." In Hubert Vreeken, ed., *Glas in het Amsterdams Historisch Museum en Museum Willet-Holyhuysen*. Amsterdam: Amsterdams Historisch Museum, and Zwolle: Waanders Uitgevers, 1998.
Bahrami 1988 Bahrami, Mehdi. *Gurgan Faiences*. 1949. Reprint, Costa Mesa, Calif.: Mazda Publishers, 1988.
Bakewell, Pears & Co. 1868 Bakewell, Pears & Co. *Prices of Glass Ware Manufactured and Sold by Bakewell, Pears & Co.* 1868. Reprint with foreword by Thomas C. Pears IV; introduction by Arlene Palmer. In Palmer 2005.
Barag 1985 Barag, Dan P. "Recent Important Epigraphic Discoveries Related to the History of Glassmaking in the Roman Period," *AnnAIHV* 10 (1985 [1987]): 109–116.
Barag 1970 Barag, Dan P. "Glass Pilgrim Vessels from Jerusalem, Pt. 1," *JGS* 12 (1970): 35–63.
Barag 2005 Barag, Dan. "Alexandrian and Judaean Glass in the Price Edict of Diocletian." *JGS* 47 (2005): 184–186.
Barber 1900 Barber, Edwin AtLee. *American Glassware Old and New*. Philadelphia, Pa.: David McKay Co., 1900.
Barrelet 1953 Barrelet, James. *La Verrerie en France*. Paris: Larousse, 1953.
Barret 1958 Barret, Richard Carter. *Bennington Pottery and Porcelain*. New York: Bonanza Books, 1958.
Bartsch Strauss, Walter L. (ed.). *The Illustrated Bartsch*. New York: Abaris Books, 1978–95.
Bassett 2000 Mark Bassett, "Edris Eckhardt – Art for Education, the Ceramics Sculpture of Cleveland's WPA Project," lecture at "Women Leaders in the Art Pottery Industry: Ohio and Beyond," March 19 2000 at the Art Libraries Society of North America 28th Annual Conference, Pittsburgh, Pennsylvania.
Battie and Cottle 1991 Battie, David, and Simon Cottle, eds. *Sotheby's Concise Encyclopedia of Glass*. Boston, Mass., and London: Little, Brown, 1991.
Baumgartner and Krueger 1988 Baumgartner, Erwin, and Ingeborg Krueger, *Phönix aus Sand und Asche: Glas des Mittelalters*, Munich: Klinkhardt & Biermann, 1988.
Bayramoğlu 1976 Bayramoğlu, Fuat. *Turkish Glass Art and Beykoz-Ware* 57. Istanbul: Publications of the RCD Cultural Institute, 1976.
Ben Tré 1992 Ben Tré, Howard. "Mayan Architectural Influences in the Sculpture." *GAS J* (1992): 61–62.
Berg 1999 Berg, Maxine. "New Commodities, Luxuries and their Consumers in Eighteenth-Century England." In *Consumers and Luxury. Consumer Culture in Europe 1650–1850*. Ed. Maxine Berg and Helen Clifford. Manchester: Manchester University Press, 1999. 63–85.
Berndt 1933–34 Berndt, W. "Religiöse Darstellungen auf alten Hohlgläsern." *Die christliche Kunst* 30 (1933–34): 40–48.
Berntsen 1962 Berntsen, Arnstein. *Ein samling norsk glass*. Oslo, Norway: Gyldendal Norsk Forlag, 1962.
Bewick 1845 Bewick, Thomas. *A Memoir of Thomas Bewick Written by Himself*, 1845. Reprint, with introduction by Ian Bain. London: Oxford University Press, 1975.
Beyond Venice **2004** *Beyond Venice: Glass in Venetian Style 1500–1450*. Ed. Jutta Page. Exhib. cat. Corning, N.Y.: The Corning Museum of Glass, 2004.
Bieber 1961 Bieber, Margarete. *The History of the Greek and Roman Theater*. Princeton, N.J.: Princeton University Press, 1961.

Bitterman 1954 Bittermann, Eleanor. "Heaton's Wizardry with Glass." *Craft Horizons* 14, no. 3 (May / June 1954): 10–14.
Blume 1994 Blume, Mary. "Breaking Point: Free-Form Adventures with Glass." *The International Herald Tribune*, 3–4 December 1994.
Bock 1995 Bock, Paula. "Mind Over Matter: The Amazing Brain of Ginny Ruffner." *The Seattle Times*, 16 July 1995.
Bonham 1967 Bonham, Roger D. "Dominick Labino." *Ceramics Monthly* 15.9 (November 1967): 14ff.
Bornstein and Soucek 1981 *The Meeting of Two Worlds: the Crusades and the Mediterranean Context*. Ed. Christine V. Bornstein and Priscilla Soucek. Exhib. cat. Ann Arbor, Mich.: University of Michigan Museum of Art, 1981.
Bortolotto 1988 Bortolotto, Angelica Alverà. *Maiolica a Venezia nel Rinascimento*. Bergamo, Italy: Bolis Edizione, 1988.
Boynton 1971 Boynton, Lindsay, ed. *The Hardwick Hall Inventories of 1601*. London: The Furniture History Society, 1971.
Brain 2000 Brain, Colin. "English Stemmed Drinking Glasses 1642–1702." Data Sheet 28. Finds Research Group 700–1700. Offprint: the author, 2000. Pp. 1–6.
Brown and Lorenzoni Brown, Clifford M., and Anna Maria Lorenzoni, *Isabella d'Este*. Geneva: Librairie Droz, 1982.
Browne 1646 Browne, Thomas. *Pseudodoxia epidemica*, 1st ed. London, 1646.
Buckley 1930 Buckley, Wilfred. "The Italian Exhibition." *Burlington Magazine* 56 (January 1930): 22.
Buckley 1932 Buckley, Wilfred. "Six Diamond-Engraved Glasses." *Burlington Magazine* 61 (October 1932): 159–160.
Burghley House **1998** *Four Centuries of Decorative Arts from Burghley House*. Ed. Oliver Impey. Exhib. cat. Alexandria, Va.: Art Services International, 1998.
Burton 1967 Burton, John. "Author's Note." *Glass: Philosophy and Method—Hand-blown, Sculptured, Colored*. Philadelphia, Pa.: Chilton Book Company, 1967.
Burton 1979 Burton, John. "The Delight of Creating in Glass." *Studio Glass* 10 (Nov / Dec 1979): 20–22.
Bussagli and Chiappori 1991 Bussagli, Mario, and Maria Grazia Chiappori. *Arte del vetro*. Rome: Editalia, 1991.
Byrd 1982 Byrd, Joan Falconer. "A Conversation with Dominick Labino." In *Dominick Labino: Glass Retrospective*. Exhib. cat. Cullowhee, N.C.: Western Carolina University, 1982, 2–8.
Calhoun 2004 Calhoun, Charles C. *Longfellow: A Rediscovered Life*. Boston: Beacon Press, 2004.
Cameo Glass **1982** *Cameo Glass: Masterpieces from 2000 Years of Glassmaking*. Ed. Sidney M. Goldstein, Leonard S. Rakow, and Juliette K. Rakow. Exhib. cat. Corning, N.Y.: The Corning Museum of Glass, 1982.
Carboni 1986 Carboni, Stefano. "Oggetti decorati a smalto di influsso islamico nella vetraria muranese: tecnica e forma." In *Venezia e l'Oriente Vicino—Arte Veneziana e Arte Islamica*. Ed. Ernst J. Grube et al. Atti del Primo Simposio Internazionale sull'Arte Veneziana e l'Arte Islamica. Venezia, 9–12 dicembre 1986. Venice: L'Altra Riva, 1989, 147–166.
Carboni 1995 Carboni, Stefano. *The Five-Petaled Rosette: Mamluk Art for the Sultans of Yemen*. Typewritten manuscript of text panels and labels of an exhibition held at The Metropolitan Museum of Art, New York, 1995.
Carboni 2001 Carboni, Stefano. *Glass from Islamic Lands. The al-Sabah Collection, Kuwait National Museum*. New York: Thames & Hudson, 2001.
Carboni 2002 Carboni, Stefano. "An Anthropomorphic Glass Rhyton." In *Cairo to Kabul. Afghan and Islamic Studies presented to Ralph Pinder-Wilson*. Ed. Warwick Ball and Leonard Harrow. London: Melisende, 2002, 58–61.
Carboni 2003 Carboni, Stefano, with a contribution by Julian Henderson. *Mamluk Enamelled and Gilded Glass in the Museum of Islamic Art, Qatar* [includes translation in Arabic].

London: Islamic Art Society, 2003.

Caron 1997 Caron, Beaudoin. "Roman Figure-Engraved Glass in The Metropolitan Museum of Art." *MMA J* 32 (1997): 19–50.

Chambers 1985 Chambers, Karen S. "Dana Zámecnikova: Artist and Magician." *New Work* (Summer / Fall 1985): 21.

Chambers 1989 Chambers, Karen S. "Glass Animals," *New Work* 36 (Winter 1989).

Chambers 1994a Chambers, Karen S. "Thermon Statom: On the Brink." Unpublished manuscript, 1994.

Chambers 1994b Chambers, Karen S. "Thermon Statom: On the Brink." *Neues Glas* (April 1994): 9–19.

Chardin 1927 Chardin, Sir John. *Sir John Chardin's Travels in Persia*. London: Argonaut Press, 1927.

Charleston Gazette **1789** "Extract of a letter from a gentleman in Alexandria, to his friend in George-Town, Maryland, dated March 28, 1789." (Charleston) *City Gazette, or the Daily Advertiser* (25 April 1789).

Charleston 1964 Charleston, Robert J. "Wheel-Engraving and –Cutting: Some Early Equipment." *JGS* 6 (1964): 86–87.

Charleston 1966 Charleston, Robert. "The Import of Venetian Glass into the Near East: 15th–16th Century." *AnnAIHV* 3 (1966 [1968]): 158–168.

Charleston 1968 Charleston, R. J. "George Ravenscroft: New Light on the Development of His 'Christalline Glasses.'" *JGS* 10 (1968): 156–167.

Charleston 1974 Charleston, Robert J. "Glass in Persia in the Safavid Period and Later." *AARP: Art and Archaeology Research Papers* 5 (June 1974): 12–27.

Charleston 1978 Charleston, Robert J. *The James A. de Rothschild Collection at Waddesdon Manor: Glass*. Fribourg, Switzerland: The National Trust, 1978.

Charleston 1984 Charleston, R. J. *English Glass and the Glass Used in England, circa 400–1940*. London and Boston: Allen and Unwin, 1984.

Charleston 1989 Charleston, Robert J. "William and Thomas Beilby as Drawing Masters." *Glass Circle* 6 (1989): 20–25.

Cheek 1997 Cheek, Mary Margaret. "The Cooperative Venture of the Union Glass Works, Kensington, Pennsylvania, 1826–1842." *JGS* 39 (1997): 93–140.

Chihuly 1988 *Chihuly: Persians*. Exhib. cat. Curated by Henry Geldzahler; ed. Robert Hobbs. Bridgehampton, N.Y.: DIA Art Foundation, 1988.

Chinese Porcelain **1980** *Chinese Porcelain in European Mounts*. Ed. Francis Watson. Exhib. cat. New York: China Institute in America, 1980.

Christopher Wilmarth **2001** *Christopher Wilmarth*. Exhib. announcement. Chicago: Arts Club of Chicago, 20 September–3 November 2001.

Clark 1987 Clark, Garth. *American Ceramics, 1876 to the Present*. New York, N.Y.: Abbeville Press, 1987.

Clark and Balniel Clark, Kenneth, and Lord Balniel, eds. *A Commemorative Catalogue of the Exhibition of Italian Art 1200–1900, held at the Galleries of the Royal Academy, Burlington House, 1930*. Oxford, U.K.: Oxford University Press, 1931.

Clarke 1974 Clarke, Timothy H. "*Lattimo*—A Group of Venetian Glass Enameled on an Opaque-White Ground." *JGS* 16 (1974): 22–56.

Clairmont 1977 Clairmont, Christoph W. *Catalogue of Ancient and Islamic Glass*. Athens: Benaki Museum, 1977.

Clarke 1891 Clarke, Sarah Freeman. "The Indian Corn as our National Plant." *New England Magazine* 4.3 (March 1891): 66–73.

Clearly Inspired **1999** *Clearly Inspired: Contemporary Glass and Its Origins*. Ed. Karen S. Chambers. Exhib. cat. Tampa Museum of Art, Tampa, Fla. San Francisco: Pomegranate Press, 1999.

Clute 1931 Clute, E. "Craftsmanship in Decorated Glass." *Architecture* 64 (July 1931): 11–16.

Colné 1880 Colné, Charles. "Glass and Glass Ware." Vol. 3.

Reports of the United States Commissioners to the Paris Universal Exposition, 1878. Washington: U.S. Government Printing Office, 1880.

Contadini 1998 Contadini, Anna. *Fatimid Art at the Victoria & Albert Museum*. London: Victoria & Albert Museum, 1998.

Contemporary Crafts **1993** *Contemporary Crafts and the Saxe Collection*. Ed. Davira S. Taragin. Exhib. cat., Toledo Museum of Art. New York: Hudson Hills Press, 1993.

Contemporary Directions **2002** *Contemporary Directions: Glass from the Maxine and William Block Collection*. Ed. Sarah Nichols and Davira S. Taragin. Exhib. cat., Carnegie Museum of Art and Toledo Museum of Art. Pittsburgh, Pa.: Carnegie Museum of Art, 2002.

Contemporary Glass **1982** *Contemporary Glass Studio Craft: Innovative Form and Expression*. Exhib. cat. Summit, N.J.: New Jersey Center for Visual Arts, 1992.

Collins 1955 Collins, A. Jefferies. *Jewels and Plate of Queen Elizabeth I: the Inventory of 1574*. London: The British Museum, 1955.

Cosyns et al. 2005 Cosyns, Peter, et al. "Two Fragments of Mold-Blown Glass Beakers with Greek Inscriptions from Tongeren (Belgium)." *JGS* 47 (2005): 179–183.

Cottle 1986 Cottle, Simon. "The Other Beilbys: British Enamelled Glass of the Eighteenth Century." *Apollo* 124.296 (October 1986): 315–327.

Cottle 1989 Cottle, Simon. "Enamelled Glass: The Beilbys Recollected." *Apollo* 129.328 (1989): 393–398.

Craft Horizons **1958** "Exhibition." *Craft Horizons* 28.2 (March / April 1958): 41.

Craft in the Machine Arts **1995** *Craft in the Machine Arts: European Influences on American Modernism, 1920–1945*. Exhib. cat. New York: American Craft Museum, 1995.

Crockery and Glass Journal **1876** Advertisement. *Crockery and Glass Journal* 4.8 (24 August 1876): 25.

Croiset van Uchelen 1976 Croiset van Uchelen, Anthony R. A. "Dutch Writing-Masters and the 'Prix de la Plume Couronnée.'" *Quarendo* 6 (Autumn 1976): 319–346.

Dailey **2006** *Dailey*. Ed. Dan Dailey and William Warmus. Philadelphia, Pa., 2006.

Dancyger 1990 Dancyger, Ruth. *Edris Eckhardt: Cleveland Sculptor*. Exhib. cat. John Carroll University, Cleveland Artists Series, Cleveland, Ohio, 1990.

Dan Dailey **1987** *Dan Dailey: Simple Complexities in Drawings and Glass, 1972–1987*. Exhib. cat. Philadelphia College of the Arts. Philadelphia, Pa., 1987.

Danto 1998 Danto, Arthur C. "Embodied Soul." *House & Garden* 167 (July 1998): 52–54.

Daum **1978** *Daum: One Hundred Years of Glass and Crystal*. Ed. Noël Daum Exhib. cat. Daum et Cie, Cristallérie de Nancy, and the Smithsonian Institution Traveling Exhibition Service. Washington, D.C.: Smithsonian Institution, 1978.

Daum 1984 Daum, Noël. *La Pâte de Verre*. Paris: Editions Denoël, 1984.

David 1995 David, Elizabeth. *Harvest of the Cold Months. The Social History of Ice and Ices*. Ed. Jill Norman. New York: Viking, 1995.

Davis 1958 Davis, Frank. "A Detroit Exhibition." *Illustrated London News* 233 (20 December 1958): 1098.

Dawson 1984 Dawson, Aileen. *Masterpieces of Wedgwood in the British Museum*. London: The British Museum, 1984.

Decade of Giving **1996** *A Decade of Giving: The Apollo Society at the Toledo Museum of Art*. Exhib. cat. Toledo, Ohio, 1996.

Decorated Glasses **1980** *The Decorated Glasses of William and Mary Beilby, 1761–1778*. Exhib. cat. Laing Art Gallery. Newcastle upon Tyne: Tyne and Wear Museums and Art Galleries, 1980.

De Tommaso 1998 De Tommaso, Giandomenico. "Alcuni Vetri

Incisi dale Collezione del Museo Nazionale Romano," *AnnAIHV* 14 (1998 [2000]): 113–116.

De Vesme and Massar 1971 De Vesme, Alexandre, with Phyllis Massar, *Stefano Della Bella: Catalogue Raisonné*. New York: Collectors Editions, 1971.

Denissen 1985 Denissen, Sabine. "Overzicht van de glasblazers-families te Antwerpen tijdens de 16de en de 17de eeuw." *Bulletin van de Antwerpse Vereniging voor Bodem- en Grotonderzoek* 5 (1985): 9–19.

D'Harnoncourt 1978 D'Harnoncourt, Anne. "Christopher Wilmarth." *Eight Artists*. Exhib. brochure, The Philadelphia Museum of Art, 28 April – 25 June 1978, 8.

Digby 1973 Digby, Simon. "A Corpus of 'Mughal' Glass." *Bulletin of the School of Oriental and African Studies* 36.1 (1973): 80–96.

Dodsworth 1987 Dodsworth, Roger, ed. *British Glass Between the Wars*. Dudley, U.K.: Dudley Leisure Services for Broadfield House Glass Museum, 1987.

Dolez 1988 Dolez, Albane. *Glass Animals: 3,500 Years of Artistry*. New York: Harry. N. Abrams, 1988.

Dorigo 1971 Dorigo, Wladimiro. *Late Roman Painting*. New York: Praeger, 1971.

Dreier 1989 *Venezianische Gläser und "Façon de Venise."* Ed. Franz Adrian Dreier. Exhib. cat. Kunstgewerbe. Berlin: D. Reimer, 1989.

Duncan 1986 Duncan, Alistair. *American Art Deco*. New York: Harry N. Abrams, 1986.

Dussart et al. 2004 Odile Dussart et al., "Glass from Qal'at Sem'an." *JGS* 46 (2004) 67–83.

Dyott 1833 Dyott, T. W. *An Exposition of the System of Moral and Mental labor, established at the Glass Factory of Dyottville*. Philadelphia: the author, 1833.

Effenberger 2004 Effenberger, Arne. "Images of Personal Devotion: Miniature Mosaic and Steatite Icons." In *Byzantium. Faith and Power (1261–1557)*. Ed. Helen C. Evans. Exhib. cat. New York: The Metropolitan Museum of Art, 2004, 209–241.

Egg 1962 Egg, Erich. *Die Glashütten zu Hall und Innsbruck im 16. Jahrhundert*. Tiroler Wirtschaftsstudien. Schriftenreihe der Jubiläumsstiftung der Kammer der gewerblichen Wirtschaft für Tirol. Vol. 15. Innsbruck: Universitätsverlag Wagner, 1962.

Egypt's Golden Age **1982** *Egypt's Golden Age, The Art of Living in the New Kingdom, 1558–1085 B.C.* Exhib. cat. Boston, Mass.: Museum of Fine Arts, 1982.

Eidelberg and McClelland 2001 Eidelberg, Martin, and Nancy A. McClelland. *Behind the Scenes of Tiffany Glassmaking, The Nash Notebooks*. New York: St. Martin's Press in association with Christie's, 2001.

Eisen and Kouchakji 1927 Eisen, Gustavus A. and Fahim Kouchakji. *Glass: Its Origin, History, Chronology, Technic, and Classification to the Sixteenth Century*. 2 vols. New York: William Edwin Rudge, 1927.

Enduring Legacy **2001** *The Enduring Legacy: A Pictorial History of the Toledo Museum of Art*. Julie A. McMaster, ed. Toledo, Ohio, 2001.

Engle 1978 Engle, Anita. *Ancient Glass in Its Context*. Readings in Glass History 10. Jerusalem: Phoenix Publications, 1978.

English Cameo Glass **1994** *English Cameo Glass*. Ed. David Whitehouse. Exhib. cat. Corning, N.Y.: The Corning Museum of Glass, 1994.

Enjoying Persian Pottery **1980** *Enjoying Seven Thousand Years of History: The World of Persian Pottery* (in Japanese). Otsu, Japan: Seibu Hall, 1980.

Erdmann 1952 Erdmann, Kurt. "Zur Datierung der Berliner Pegasus-Schale." In *Archäologischer Anzeiger: Beiblatt zum Jahrbuch des Deutschen Archäologischen Instituts, 1950–51*, 65–66 (1952): 115–131.

Ettinghausen et al. 2001 Ettinghausen, Richard, Oleg Grabar,

and Marilyn Jenkins-Madina. *Islamic Art and Architecture, 650–1250.* New Haven, Conn.: Yale University Press, 2001.

Fauster 1977 Fauster, Carl U. "Libbey Cut Glass Exhibit St. Louis World's Fair 1904." *JGS* 19 (1977): 160–168.

Fauster 1979 Fauster, Carl U. *Libbey Glass Since 1818.* Toledo, Ohio: Len Beach Press, 1979.

Fleming 1965 Fleming, John. *The Penguin Dictionary of Architecture.* Harmondsworth, U.K.: Penguin, 1965.

Fleming 1993 Fleming, Lee. "He Who Builds Glass Houses." *The Washington Post* (6 March 2003): B2.

Follmann-Schulz 2001 Follmann-Schulz, Anna-Barbara. "Die Produkte der Glashütten im Hambacher Forst." *AnnAIHV* 15 (2001 [2003]): 62–67.

Forbes 1955 Forbes, Robert J. "Perfumes." *Studies in Ancient Technology* vol. 3. Leiden: E. J. Brill, 1995: 1–49.

Fortini Brown 1966 Fortini Brown, Patricia. *Venice and Antiquity: The Venetian Sense of the Past.* New Haven, Conn.: Yale University Press, 1966.

Fortini Brown 1997 Fortini Brown, Patricia. *Art and Life in Renaissance Venice.* New York: Harry N. Abrams, 1997.

Foy et al. 1998 Foy, Danièle, Michèle Vichy, and Maurice Picon. "Lingots de Verre en Méditerranée Occidentale, IIIᵉ siècle av. J.-C.–VIIᵉ siècle ap. J.-C.)." *AnnAIHV* 14 (1998 [2000]): 51–57.

Francis 2000 Francis, Peter. "The Development of Lead Glass: The European Connections." *Apollo* 151.456 (February 2000): 47–53.

Franklin 1993 Franklin, Edith. "Where Were You in '62?" *GAS J* (1993): 17.

Frantz 1993 Frantz, Susanne K. "Fritz Dreisbach Received 1993 Rakow Commission." *JGS* 35 (1993): 156.

Frantz 1994 Frantz, Susanne K. *Stanislav Libenský and Jaroslava Brychtová: A 40-year Collaboration in Glass.* Corning, N.Y., and Munich: Prestel, 1994.

Frazer 1977 Frazer, Margaret E. "Apse Themes." In *Age of Spirituality* 1977.

Freestone and Gorin-Rosen 1999 Freestone, Ian C., and Yael Gorin-Rosen. "The Great Glass Slab at Bet She'arim, Israel: An Early Islamic Glassmaking Experiment?" *JGS* 41 (1999): 105–116.

Frelinghuysen 1988 Frelinghuysen, Alice Cooney. "Louis Comfort Tiffany at The Metropolitan Museum." *MMA Bulletin* 56.1 (Summer 1998): 57.

Fremersdorf 1928–84 Fremersdorf, Fritz et al. *Die Denkmäler des römischen Köln.* 9 vols. Berlin: W. de Gruyter, 1928–84.

From Palace to Parlour 2003 *From Palace to Parlour. A Celebration of 19ᵗʰ-Century British Glass.* Ed. Martine Newby. Exhib. cat. The Wallace Collection. London: The Glass Circle, 2003.

Fukai 1977 Fukai, Sinji. *Persian Glass.* New York, Tokyo, and Kyoto: Weatherhill / Tankosha, 1977.

Fused Glass 1985 *Fused Glass: The Artisanry of Frances and Michael Higgins.* Exhib. cat. New York: Fifty / 50 Gallery, 1985.

Gaba-Van Dongen 2004 Gaba-Van Dongen, Alexandra. "Longing for Luxury: Some Social Routes of Venetian-Style Glassware in the Netherlands during the 17th Century." In *Beyond Venice* 2004, 192–225.

Gasdia 1937 Gasdia, Vincenzo Eduardo. *La Casa pagano-cristiana del Celio: Titulus Byzantis sive Pammachii.* Rome: F. Pustet, 1937.

GAS J 1978 Christine Robbins [? Unsigned]. "In Memoriam . . . Dr. Robert Fritz." *GAS J* (1986): 94.

Gasparetto 1973 Gasparetto, Astone. "The Gnalić Wreck: Identification of the Ship." *JGS* 15 (1973): 79–84.

Gasparetto 1979 Gasparetto, Astone. "Una grande mostra storica del vetro veneziano a Londra." *Arte Veneta* 33 (1979): 215.

Gaynor 1991 Gaynor, Suzanne. "French Enameled Glass of the Renaissance." *JGS* 33 (1991): 42–81.

Gazetteer 1861 *A Complete Pronouncing Gazetteer or Geographical Dictionary of the World.* Ed. J. Thomas and T. Baldwin. Philadelphia: J. B. Lippincott & Co., 1861.

Giberson 1997 Giberson, Dudley F., Jr. *When Glass Was One: An Article about the Beginnings of Glassmaking.* Warner, N.H.: Joppa Press, April 1997.

Giambruni 1966 Giambruni, Helen. "National Invitational Glass Exhibition." *Craft Horizons* 26.1 (January / February 1966): 55.

Glanville 1990 Glanville, Philippa. *Silver in Tudor and Early Stuart England: A Social History and Catalogue of the National Collection 1480–1660.* London: Victoria & Albert Museum, 1990.

Glass Club Bulletin 1968 "Descendants of New England Glass Craftsmen Keep History Alive in their Massachusetts Homes." *The Glass Club Bulletin* 86 (June 1968): 11.

Glass Collections 1982 *Glass Collections in Museums in the United States and Canada,* Corning, N.Y.: The Corning Museum of Glass, 1982.

Glass of the Caesars 1987 *Glass of the Caesars.* Ed. Donald B. Harden, Hansgerd Hellenkemper, K. S. Painter, and David Whitehouse. Exhib. cat. Corning, N.Y.: The Corning Museum of Glass, and Milan: Olivetti, 1987.

Glass of the Sultans 2001 *Glass of the Sultans.* Ed. Stefano Carboni and David Whitehouse. Exhib. cat. New York: The Metropolitan Museum of Art / The Corning Museum of Glass, 2001.

Glass Workshop Report 1962 *Glass Workshop Report.* Toledo Museum of Art, June 1962.

Glassworks 1990 *Glassworks.* Part I. Exhib. cat. Renwick Gallery, Washington, D.C., 1990.

Glebow and Hassell 1993 Glebow, Sophie, and Martha Hassell. "A Review of the Boston & Sandwich Glass Company Payroll Book, 1835 to 1841." *The Acorn* 4 (1993): 45ff.

Glen Lukens 1982 Levin, Elaine. *Glen Lukens: Pioneer of the Vessel Aesthetic.* Exhib. cat. Fine Arts Gallery, California State University, Los Angeles, 1982.

Godwin 1952 Godwin, Molly Ohl. "Capolavori Italiano al 'Toledo Museum of Art'." *La vie del mondo* 14.11 (November 1952).

Goldstein 1979 Goldstein, Sidney M. *Pre-Roman and Early Roman Glass in The Corning Museum of Glass.* Corning, N.Y.: Corning Museum of Glass, 1979.

Goodenough 1953 Goodenough, Erwin R. *Jewish Symbols in the Greco-Roman Period.* Bollingen Series 37. New York: Pantheon Books, 1953).

Goodman 1986 Goodman, Neil. "Vito Acconci," *GAS J* (1986): 118.

Gothic Revival Style 1976 Howe, Katherine S., and David B. Warren. *The Gothic Revival Style in America, 1830–1870.* Exhib. cat. Houston: Museum of Fine Arts, 1976.

Grabar 1987 Grabar, Oleg. *The Formation of Islamic Art.* 1973. 2nd ed., New Haven, Conn.: Yale University Press, 1987.

Griffin 1984 Griffin, Miriam T. *Nero: The End of a Dynasty.* New Haven, Conn.: Yale University Press, 1984.

Grose 1977 Grose, David F. "Early Blown Glass: The Western Evidence." *JGS* 19 (1977): 9–29.

Grose 1978 Grose, David F. "Ancient Glass." TMA *Museum News* 20 (1978): 67–90.

Grose 1984 Grose, David F. "The Origins and Early History of Glass." In Klein and Lloyd 1984, 8–37.

Grose 1986 Grose, David F. "Innovation and Change in Ancient Technologies: The Anomalous Case of the Roman Glass Industry." *High Technology Ceramics: Past, Present, and Future.* Ceramics and Civilization 3. Westerville, Ohio: American Ceramic Society, 1986: 65–79.

Grose 1989 Grose, David Frederick. *Early Ancient Glass: Core-Formed, Rod-Formed, and Cast Vessels and Objects from the Late Bronze Age to the Early Roman Empire, 1600 B.C. to A.D. 50.* New York: Hudson Hills Press in association with the Toledo Museum of Art, 1989.

Grose 1991 Grose, David F. "Early Imperial Roman Cast Glass: The Translucent Coloured and Colourless Fine Wares." In Newby

and Painter 1991, 1–18.

Grossmann 2002 Grossmann, R. A. *Ancient Glass: A Guide to the Yale Collection.* New Haven, Conn.: Yale University Art Gallery, 2002.

Gudenrath 2001 Gudenrath, William. "A Survey of Islamic Glassworking and Glass-Decorating Techniques." In *Glass of the Sultans* 2001, 46–67.

Guiffrey 1894 Guiffrey, Jules. *Inventaires de Jean duc de Berry (1401–1416).* Vol. 1. Paris: E. Leroux, 1894.

Haberey 1965 Haberey, Waldemar. "Frühchristliche Gläser aus dem Rheinland." In *Proceedings of the VII International Congress on Glass, Brussels 1965.* Paper 249. Liège: Association internationale pour l'histoire du verre, 1966): 1–7.

Haevernick 1962 Haevernick, Thea Elisabeth. "Beiträge zur Geschichte des antiken Glases—VIII—Zu den Goldgläsern (Fondi d'Oro)." *Jahrbuch des Römisch-Germanischen Zentralmuseums, Mainz* 9 (1962): 58–67.

Hajdamach 1991 Hajdamach, Charles R. *British Glass 1800–1914.* Woodbridge, Suffolk, England: Antique Collectors' Club, 1991.

Hanisee Gabriel 2000 Hanisee Gabriel, Jeanette. *The Gilbert Collection. Micromosaics.* London: Philip Wilson, 2000.

Harden 1935 Harden, Donald B. "Romano-Syrian Glasses with Mould-blown Inscriptions." *JRS* 25 (1935): 163–186.

Harden 1936 Harden, Donald. B. *Roman Glass from Karanis Found by the University of Michigan Archaeological Expedition in Egypt, 1924–29.* University of Michigan Studies, Humanities Series 41. Ann Arbor, Mich.: University of Michigan Press, 1936.

Harden 1968 Harden, Donald B. "The Canosa Group of Hellenistic Glasses in the British Museum." *JGS* 10 (1968): 21–47.

Harden 1971 Harden, Donald B. "Ancient Glass, Pt. III: Post Roman," *Archaeological Journal* 128 (1971): 78–117.

Harden 1978 Harden, Donald B. "Roman and Frankish Glass from France in the British Museum." In *Actes du Colloque International d'Archéologie, Centenaire de l'Abbé Cochet, 1975.* Rouen: Amersfoort, 1978, 301–312.

Harden 1980 Harden, Donald B. "A Hellenistic Footed Glass Bowl of Alexandrian Origin." TMA *Museum News* 22 (1980): 17–25.

Hardie 1998 Peter Hardie, "Mamluk Glass from China?" In Ward 1998, 85–90.

Harris 1927 Harris, J. Rendel. "Glass Chalices of the First Century." *Bulletin of the John Rylands Library, Manchester* 2 (1927): 286–295.

Harvard 1994 Harvard, Susan. "Cut with a Diamond Ring by Lady Rochester." *Christie's International Magazine* 11.4 (June / July 1994): 50–51.

Hasson 1979 Hasson, Rachel. *Early Islamic Glass.* Jerusalem: L. A. Mayer Memorial Institute for Islamic Art, Spring 1979.

Hautecoeur and Wiet 1932 Hautecoeur, Luis, and Gaston Wiet. *Les mosquées du Caire.* Paris: Librairie Ernest Leroux, 1932.

Hawting 1986 Hawting, G. R. *The First Dynasty of Islam. The Umayyad Caliphate A.D. 661–750.* London: Croom Helm, 1986.

Hayes 1975 Hayes, John W. *Roman and Pre-Roman Glass.* Toronto: Royal Ontario Museum, 1975.

Haynes 1948 Haynes, E. Barrington. *Glass through the Ages.* Harmondsworth, U.K.: Penguin, 1948.

Hayward 2004 Hayward, Maria. *The 1542 Inventory of Whitehall: The Palace and its Keeper. Volume II, The Transcripts.* London: Illuminata Publishers, 2004.

Heikamp 1986 Heikamp, Detlef. *Studien zur mediceischen Glaskunst: Archivalien, Entwurfszeichnungen, Gläser und Scherben.* Florence: Leo S. Olschki für Kunsthistorisches Institut, 1986.

Hejdová 1995 Hejdová, Dagmar. "Das böhmische Glas bis zum Ende des 16. Jahrhunderts." In *Das Böhmische Glas, 1700–1950.* Vol. 1. *Barock, Rococo, Klassizismus.* Passau: Passauer Glasmuseum, 1995: 30–35.

Henderson 1995 Henderson, Julian. "Investigation into Marvered Glass: 2." In *Islamic Art in the Ashmolean Museum*, Pt. 1. In Allan 1995, 31–50.

Henein and Gout 1974 Henein, Nessim Henry, with Jean-François Gout. *Le verre soufflé en Egypte*. Cairo: Institut français d'archéologie orientale du Caire, 1974.

Henkel 1930 Henkel, Max Ditmar. *Le dessin hollandais des origines au XVIIe siècle*. Paris: Les Editions G. Voan Oest, 1930.

Henkes 1994 Henkes, Harold E. *Glas zonder glans: Vijf eeuwen gebruiksglas uit de bodem van de Lage Landen, 1300–1800 [Glass without Gloss: Utility Glass from Five Centuries Excavated in the Low Countries, 1300–1800]*. Rotterdam Papers 9. Rotterdam: Coördinatie Commissie van Advies inzake Archeologisch Onderzoek binnen het Ressort Rotterdam, 1994.

Herman 1992 Herman, Lloyd E. *Clearly Glass: Pilchuck Glass Legacy*. Bellingham, Wash.: Whatcom Museum of History and Art, 1992.

Hess 2004 Hess, Catherine, *The Arts of Fire: Ilamic Influences on Glass and Ceramics of the Italian Renaissance*. Los Angeles, Calif.: The J. Paul Getty Museum, 2004.

Hess and Husband 1997 Hess, Catherine, and Timothy Husband. *European Glass in The J. Paul Getty Museum*. Los Angeles, Calif.: The J. Paul Getty Museum, 1997.

Hetteš 1960 Hetteš, Karel. *Old Venetian Glass*. London: Spring Books, 1960.

Higgott 2003 Higgott, Suzanne. "Paul Oppitz, Treatise on the engraved two handle Jug [the Copeland Vase], and on Glassengraving in General." In *From Palace to Parlour* 2003, 46–48, no. 82.

Higgott 2006 Suzanne Higgott. "Nineteenth-century British Glass Associated with Sir Richard Wallace." *The Journal of the Glass Circle* 10 (2006): unp.

Hill and Nenna 2001 Hill, Marsha, and Marie-Dominique Nenna. "Glass from Ain et-Turba and Bagawat Necropolis in the Kharga Oasis (Egypt)." *AnnAIHV* 15 (2001 [2003]): 88–92.

Hind 1948 Hind, Arthur M. *Early Italian Engraving: A Critical Catalogue with Complete Reproduction of All the Prints Described*. 7 vols. London: Bernard Quaritch, 1938–48.

Hobson 1983 Hobson, Diana. "Breaking the Mould." *Crafts* 64 (Sept / Oct 1983): 36–39.

Hoffmann 1977 *Josef Hoffmann 1870–1956. Architect and Designer*. Exhib. cat. London: Fischer Fine Art Ltd, 1977.

Hogan 1974 Hogan, Daniel E. *Dominick Labino: Decade of Glass Craftsmanship 1964–1974*. Toledo, Ohio: Toledo Museum of Art, 1974.

Hollister 1985 Hollister, Paul. "Studio Glass before 1962: Maurice Heaton, Frances and Michael Higgins and Edris Eckhardt." *Neues Glas* 4 (1985): 232–240.

Hollister 1987 Hollister, Paul. "Remembering Labino." *New Work* 29 (Spring 1987): 7–10.

Hollister 1993 Hollister, Paul. "Remembering Charles Kaziun and Paul Ysart." *Paperweight News* 14.1 (January 1993): 16ff.

Hollstein Keyes, G. S. (ed. K. G. Boon), *Hollstein's Dutch and Flemish Etchings, Engravings, and Woodcuts ca. 1450–1700*. Amsterdam: M. Hertzberger, 1949–93.

Hörning 1979 Hörning, Jutta. *Gläser vom XVI. bis XIX. Jahrhundert aus dem Bestand der Kunstsammlungen zu Weimar*. Weimar: Kunstsammlungen, 1979.

Horridge Collection 1959 Horridge, W. *The Horridge Collection of Drinking Glasses*. Sale cat. Plaish Hall: Jackson-Stops, 30 November 1959.

Hudig 1923 Hudig, Ferrand W. *Das Glas: Mit besonderer Berücksichtigung der Sammlung im Nederlandsch Museum voor Geschiedenis en Kunst im Amsterdam*. Amsterdam: the author, 1923.

Hunt's Merchants' Magazine 1852 "American Bohemian Glass." *Hunt's Merchants' Magazine and Commercial Review* 27.1 (July 1852): 133–134.

Hunter-Stiebel 1982 Hunter-Stiebel, Penelope. *Harvey K. Littleton: Glass Sculpture*. New York, N.Y.: Heller Gallery, 1982.

Hutton 1963 Hutton, William. "European Glass in the Museum Collection." *TMA Museum News*, 6.1 (Spring 1963): 1–24.

Hypnerotomachia 1592 *Hypnerotomachia Poliphili. The Strife of Love in a Dream*. London, 1592. Transl. Joscelyn Godwin. New York and London: Thames & Hudson, 1999.

Isacson 1996 Isacson, Maths. "Swedish industrialization and the glassworks." In *The Brilliance of Swedish Glass, 1918–1939*. Exhib. cat. Ed. Derek E. Ostergard and Nina Stritzler-Levine. New Haven: Yale University Press for Bard Graduate Center for Studies in the Decorative Arts, 1996.

I Claudia 1996 *I Claudia: Women in Ancient Rome*. Ed. Diana E. E. Kleiner and Susan B. Matheson. Exhib. cat., Yale University Art Gallery. New Haven, Conn.: Yale University Press, 1996.

Innes and Spillman 1981 Innes, Lowell, and Jane Shadel Spillman. *M'Kee Victorian Glass*. Corning, N.Y.: The Corning Museum of Glass in association with Dover Publications, 1981.

Isings 1957 Isings, Clasina. *Roman Glass from Dated Finds*. Groningen, Netherlands: J. B. Wolters, 1957.

Israeli 1991 Israeli, Yael. "The Invention of Blowing." In Newby and Painter 1991, 46–55.

Italian Art 1930 *Exhibition of Italian Art held at the Galleries of the Royal Academy*. London: Burlington House, January–March 1930.

Italian Art 1931 Clark, Kenneth, and Lord Baniel, eds. *A Commemorative Catalogue of the Exhibition of Italian Art 1200–1900, held at the Galleries of the Royal Academy*. London: Oxford University Press, H. Milford, 1931.

Jackson 1911 Jackson, Sir Charles James. *An Illustrated History of English Plate*. London: Country Life, 1911.

Jackson 1966 Jackson, Lesley, ed. *Whitefriars Glass: The Art of James Powell & Sons*. Shepton Beauchamp, Somerset: Richard Dennis, 1996.

Jackson et al. 1998 Jackson, Caroline M. H., E.M. Cool, and E. C. W. Wager. "The Manufacture of Glass in Roman York." *JGS* 40 (1998): 55–61.

Jaulin 1987 Jaulin, Aline. *Toots Zynsky: Oeuvres*. Paris: Clara Scremini, 1987.

Jenkins[-Madina] 1986 Jenkins[-Madina], Marilyn. "Islamic Glass: A Brief History." *MMA Bulletin* 44.2 (Fall 1986): 3–56.

Johnson 1999 Johnson, Donald-Brian. "Higgins: Fused Glass, Fused Talent." *Modernism* 2.4 (Winter 1999): 21.

Johnson 2003 Johnson, Donald-Brian. "Frances Higgins' House of Glass." *Modernism* 6.1 (Spring 2003): 52–57.

Johnson and Piña 1997 Johnson, Donald-Brian, and Leslie Piña. *Higgins: Adventures in Glass*. Atglen, Pa.: Schiffer Publishing Ltd., 1997.

Jones 1826 Jones, Samuel. *Pittsburgh in the Year 1826*. Pittsburgh, Pa.: Johnston & Stockton, 1826.

Kangas 1991 Kangas, Matthew. "Unraveling Ruffner." *Glass* 43 (Spring 1991): 28.

Kangas 1997 Kangas, Matthew. "Dreisbach's Encyclopedia of Glass." *Glass* 69 (Winter 1997): 46–51.

Kenny 1963 Kenny, John B. *Ceramic Design*. Radnor, Pa.: Chilton Book Company, 1963.

Kerssenbrock-Krosigk 2001 Kerssenbrock-Krosigk, Dedo von. *Rubinglas des ausgehenden 17. und 18. Jahrhunderts*. Germanischen Nationalmuseum Nürnberg. Mainz: Verlag Philipp von Zabern, 2001.

Kisa 1908 Kisa, Anton. *Das Glas im Altertume*. 3 vols. Leipzig: Karl W. Hiersemann, 1908.

Klanntye 1938 Klannte, Margarete von. "Das Glas des Isenbirges." Deutsches Archiv für Landes- und Volkforschung 2.3 (1938): 575–599.

Klein 1987 Klein, Dan. "Diana Hobson," *New Work Glass* 31 (Fall 1987): 16.

Klein 1989 Klein, Dan. *Toots Zynsky: "Tierra del Fuego Series."* Stedelijk Museum, Amsterdam, 20 May–30 June 1989.

Klein 2001 Klein, Dan. *Artists in Glass: Late Twentieth Century Masters of Glass*. London: Michael Beazley, 2001.

Klein and Lloyd 1984 Klein, Dan, and Ward Lloyd, eds. *The History of Glass*. London: Orbis, 1984.

Kleiner 1992 Kleiner, Diana E. E. *Roman Sculpture*. New Haven, Conn., and London: Yale University Press, 1992.

Klesse and Mayr 1987 Klesse, Brigitte, and Hans Mayr. *European Glass from 1500–1800. The Ernesto Wolf Collection*. Vienna: Kremayr & Scheriau, 1987.

Klesse and Reineking von Bock 1973 Klesse Brigitte, and Gisela Reineking von Bock. *Glas*. Cologne: Kunstgewerbemuseum der Stadt Köln, 1973.

Koch 1966 Koch, Robert. *Louis C. Tiffany, Rebel in Glass*. 2nd ed.; New York: Crown, 1966.

Krakauer 1992 Krakauer, Jon. "Dale Chihuly has Turned Art Glass into a Red-hot Item." *Smithsonian* (February 1992): 90–101.

Kröger 1995 Kröger, Jens. *Nishapur: Glass of the Early Islamic Period*. New York: The Metropolitan Museum of Art, 1995.

Labino 1966 Labino, Dominick L. "The Egyptian Sand-Core Technique, a New Interpretation." *JGS* 8 (1966): 124–126.

Labino 1968 Labino, Dominick. *Visual Arts in Glass*. Dubuque, Iowa: W. C. Brown, 1968.

Labino 1974 *Dominick Labino: A Decade of Glass Craftsmanship, 1964–1974*, Exhib. cat., Toledo Museum of Art, Pilkington Glass Museum, and Victoria & Albert Museum. Toledo, Ohio: Toledo Museum of Art, 1974.

Laing 1991 Laing, Ellen Johnson. "A Report on Western Asian Glassware in the Far East." *Bulletin of The Asia Institute* 5 (1991): 109–121.

Lamm 1929–30 Lamm, Carl Johan. *Mittelalterliche Gläser und Steinschnittarbeiten aus dem Nahen Osten*. Berlin: Verlag Dietrich Reimer / Ernst Vohsen, 1929–30.

Lanmon 1969 Lanmon, Dwight P. "The Baltimore Glass Trade, 1780 to 1820." *Winterthur Portfolio* 5 (1969): 15–48.

Lanmon et al. 1990 Lanmon, Dwight P., et al. *John Frederick Amelung: Early American Glassmaker*. Corning, N.Y.: The Corning Museum of Glass, 1990.

Lanmon 1993 Lanmon, Dwight P., with contribution by David B. Whitehouse. *The Robert Lehman Collection*. Vol. 11, *Glass*. New York: The Metropolitan Museum of Art in association with Princeton University Press, 1993.

Lassels 1670 Lassels, Richard. *The Voyage of Italy*. Paris: V. de Moutier, 1670.

Le Corbeiller 1961 Le Corbeiller, Claire. "Miss America and Her Sisters: Personifications of the Four Parts of the World." *MMA Bulletin* 19 (April 1961): 209–223.

Le dressoir du Prince 1995 *Le dressoir du Prince, Services d'apparat à la Renaissance*. Exhib. cat. Écouen, France: Musée de la Renaissance, 1995.

Levey 1983 Levey, Santina M. *Lace: A History*. London: Victoria & Albert Museum, and Leeds: W.S. Maney, 1983.

Levi 1895 Levi, Cesare A. *L'arte del vetro in Murano nel rinascimento, e i Beroviero*. Venice: C. Ferrari, 1895.

Levin 1976 Levin, Elaine. "Arthur Baggs, Glen Lukens." *Ceramics Monthly* 24 (January 1976): 24–30.

Levin 1988 Levin, Elaine. *The History of American Ceramics from Pipkins and Bean Pots to Contemporary Forms*. New York: Harry N. Abrams, 1988.

Libenský and Brychtová 1996 *Stanislav Libenský and Jaroslava Brychtová: Paintings, Drawings and Sculpture*. Exhib. cat. Seattle, Wash.: Elliot Brown Gallery, 1995.

Liefkes 2004 Liefkes, Reino. "Façon de Venise Glass in the Netherlands." In *Beyond Venice* 2004, 226–269.

Life 1966 "Old Crafts Find New Hands." *Life* 61.5 (29 July 1966):

34–39 and passim.

Ling 1991 Ling, Roger. *Roman Painting.* Cambridge, U.K.: Cambridge University Press, 1991.

Lipofsky 1986 Lipofsky, Marvin. "Robert Fritz 1920–1986." *American Craft* 46.4 (August / September 1986): 87.

Littleton 1988 Littleton, Harvey K. *American Craftspeople Project: The Reminiscences of Harvey Littleton.* New York: Columbia University, Oral History Office, 1988.

Lynn 1997 Lynn, Martha Drexler. *Masters of Contemporary Glass, Selections from the Glick Collection.* Indianapolis, Ind.: Indianapolis Museum of Art and Indiana University Press, 1997.

Lynn 2004 Lynn, Martha Drexler. *American Studio Glass 1960–1990: An Interpretive Study.* New York and Manchester, Vt.: Hudson Hills Press, 2004.

***Made in America* 1995** *Made in America: Ten Centuries of American Art.* Exhib. cat., Toledo Museum of Art. New York: Hudson Hills Press, 1995.

Mallett 2004 "A Glass Goblet by Paul Oppitz." In *Sales Catalog.* London: Mallett Ltd., 2004.

Mallett and Dreier 1998 Mallett, John V. G., and Franz Adrian Dreier. *The Hockemeyer Collection: Glass and Maiolica.* Bremen, Germany: H. M. Hauschild, 1998.

Mango 1994 Mango, Marlia Mundell. *The Sevso Treasure, Part One. JRA* Suppl. 12. Ann Arbor, Mich.: *JRA,* 1994.

Marcilhac 1989 Marcilhac, Félix. *René Lalique, maître verrier 1860–1945.* Paris: Les Editions de L'Amateur, 1989.

Markel 1991 Markel, Stephen. "Indian and 'Indianate' Vessels in the Los Angeles County Museum of Art." *JGS* 33 (1991): 82–92.

Masson and Pugachenkova 1982 Masson, M. E., and G. A. Pugachenkova. *Parthian Rhytons of Nisa.* Florence: Licosa, 1982.

***Masterpieces of American Glass* 1990** *Masterpieces of American Glass.* Exhib. cat. Moscow: Museum of the State Institute of Glass, 1990.

***Masterpieces of Glass* 1968** *Masterpieces of Glass.* Ed. Donald B. Harden et al. Exhib. cat. London: The British Museum, 1968.

Matheson 1980 Matheson, Susan B. *Ancient Glass in the Yale University Art Gallery.* New Haven: Yale University Press, 1980.

Maycock 1995–96 Maycock, Susan E. "Louis Vaupel: His Life and Work at the New England Glass Company." *The Acorn* 6 (1995–96): 3–22

Mayer 1933 Mayer, L. A. *Saracenic Heraldry.* Oxford: Oxford University Press, 1933.

McConnell 2004 McConnell, Andy. *The Decanter.* Woodbridge, Suffolk, England: Antique Collectors' Club, 2004.

McFarlan 1992 McFarlan, Gordon. "Early Nineteenth-Century Patterns from the Ford Ranken Glass Archive." *The Journal of the Glass Association* 4 (1992): 1–2.

McKearin 1970 McKearin, Helen. *Bottles, Flasks and Dr. Dyott.* New York: Crown, 1970.

McKearin and McKearin 1941 McKearin, George S., and Helen McKearin. *American Glass.* New York: Crown, 1941.

McKearin and Wilson 1978 McKearin, Helen, and Kenneth M. Wilson, *American Bottles and Flasks and Their Ancestry.* New York: Crown, 1978.

McMaster and Taragin 2002 Julie A. McMaster and Davira S. Taragin. "Pioneering the Alliance of Art and Industry. The Toledo Museum of Art." In *Alliance of Art and Industry* 2002, 11–21.

Mees 1997 Mees, D. C. *Kunstnijverheid, 1600–1800, en Tegels / Applied Arts, 1600–1800, and Tiles.* Rotterdam: Museum Boijmans Van Beuningen, and Amsterdam: Uitgeverij de Bataafsche Leeuw, 1997.

Meinecke 1992 Meinecke, Michael. *Die mamlukische Architektur in Ägypten und Syrien (648/1250 bis 923/1517).* 2 vols. Glückstadt: J. J. Augustin, 1992.

Melikian-Chirvani 1982 Melikian-Chirvani, Assadullah Souren. "Le rhyton selon les sources persanes. Essai sur la continuité culturelle iranienne de l'antiquité à l'Islam." *Studia Iranica* 11 (1982): 263–292.

Mentasti 1982 Mentasti, Rosa Barovier. *Il vetro veneziano.* Milano: Gruppo Editorial Electa, 1982.

Merrett 1662 *The Art of Glass* [by Antonio Neri] ... *Translated into English, with Some Observations ... by Christopher Merrett.* London: printed by A.W. for Octavian Pulleyn, 1662.

Metropolitan Museum 1881(?) *General Guide to the Museum Collections, Exclusive of Paintings and Drawings. Hand-book No. 10.* New York: The Metropolitan Museum of Art, 1881(?)

Miller 1995 Miller, Bonnie J. *Why Not? The Art of Ginny Ruffner.* Tacoma, Wash.: Tacoma Art Museum, with University of Washington Press, 1995.

***Mistress of the House* 1996** *Mistress of the House, Mistress of Heaven: Women in Ancient Egypt.* Ed. Anne K. Capel and Glenn E. Markoe. Exhib. cat., Cincinnati Art Museum. New York: Hudson Hills Press, 1996.

Morey 1959 Morey, Charles Rufus. *The Gold-Glass Collection of the Vatican Library, with Additional Catalogues of Other Gold-Glass Collections.* Ed. Guy Ferrari. Vatican City: Biblioteca Apostolica Vaticana, 1959.

Morley-Fletcher 1984 Morley-Fletcher, Hugo. "Seventeenth-Century Glass." In Klein and Lloyd 1984, 93–115.

Morton 1985 Morton, Alexander H. *A Catalogue of Early Islamic Glass Stamps in the British Museum.* London: The British Museum, 1985.

Mouray 1912 Mouray, Gabriel. "Fernand Thesmar, 1843–1912." *Les Arts* (1912): 19–22.

Mudge et al. 1985 Mudge, Jean M., et al. *Ceramics and Glass at the Essex Institute.* Salem, Mass.: Essex Institute, 1985.

Mulliner 1923 Mulliner, Herbert Hall. *The Decorative Arts in England during the Late XVIIth and XVIIIth Centuries.* London: Batsford, 1923.

Mylonas 1961 Mylonas, George E. *Eleusis and the Eleusinian Mysteries.* Princeton, N.J.: Princeton University Press, 1961.

Nash 1961–62 Nash, Ernest. *Pictorial Dictionary of Ancient Rome.* 2 vols. London: Zwemmer, 1961–62.

Nash 2001 Nash, Leslie Hayden. "Tiffany Favrile Glass." In *Behind the Scenes of Tiffany Glassmaking: The Nash Notebooks.* Ed. Martin Eidelberg and Nancy A. McClelland. New York: St. Martin's Press in association with Christie's, 2001.

Neuwirth 2000 Neuwirth, Waltraud. *Schöner als Bergkristall: Ludwig Lobmyer, Glas Legende.* Vienna: W. Neuwirth, 2000.

Newby and Painter 1991 Newby, Martine, and Kenneth Painter. *Roman Glass: Two Centuries of Art and Invention.* Occasional Papers 13. London: The Society of Antiquaries. 1991.

***New England Glass* 1963** *The New England Glass Company 1818–1888.* Exhib. cat. Toledo, Ohio: Toledo Museum of Art, 1963.

***New Era in Glass* 1933** *Libbey Crystal: The New Era in Glass.* Libbey Glass Company, 1933. Reprinted in Fauster 1979, 315–359.

Newman 1987 Newman, Harold. *An Illustrated Dictionary of Silverware.* New York and London: Thames & Hudson, 1987.

Nicholson et al. 1998 Nicholson, Paul T., Caroline M. Jackson, and W. Gneisinger. "Glassmaking at Tell el-Amarna: An Integrated Approach." *JGS* 40 (1998): 11–23.

***Nineteenth-Century America* 1970** *Nineteenth-Century America: Furniture and Other Decorative Arts.* Exhib. cat. New York: The Metropolitan Museum of Art, 1970.

Noever 2003 Noever, Peter, ed. *Der Preis der Schönheit. 100 Jahre Wiener Werkstätte.* Osterreichisches Museum für Angewandte Kunst. Ostfildern-Ruit, Germany: Hatje Cantz, 2003.

Noll 1973 Noll, Rudolf. "An Instance of Motif Identity in Two Gold Glasses." *JGS* 15 (1973): 31–34.

Oldknow 1996 Oldknow, Tina. *Pilchuck: A Glass School.* Seattle, Wash.: Pilchuck Glass School in association with the University of Washington Press, 1996.

Oliver (Harper) 1961 Oliver (Harper), Prudence. "Islamic Relief Cut Glass: A Suggested Chronology." *JGS* 3 (1961): 9–29.

Oliver 1970 Oliver, Andrew, Jr. "Persian Export Glass." *JGS* 12 (1970): 9–16.

Opie 2004 Opie, Jennifer Hawkins. *Contemporary International Glass: Sixty Artists in the V&A.* London: Victoria & Albert Museum, 2004.

Oppenheim et al. 1970 Oppenheim, A. Leo, Robert H. Brill, Dan P. Barag, and Axel von Saldern. *Glass and Glassmaking in Ancient Mesopotamia.* Corning, N.Y.: The Corning Museum of Glass, 1970.

Ostergard 1991 Ostergard, Derek E. *Art Deco Masterpieces.* New York: Macmillan, 1991.

Paolucci 2002 Paolucci, Fabrizio. *L'Arte del Vetro Inciso a Roma nel IV Secolo D.C.* Firenze: All'Insegna del Giglio, 2002.

Painter and Whitehouse 1990 Painter, Kenneth, and David Whitehouse. "Early Roman Cameo Glasses." *JGS* 32 (1990): 138–165.

Palmer 1989 Palmer, Arlene. *The Wistars and Their Glass, 1739–1777.* Millville, N.J.: Museum of American Glass, 1989.

Palmer 1993 Palmer, Arlene. *Glass in Early America: Selections from the Henry Francis du Pont Winterthur Museum.* Winterthur, Del.: Winterthur Museum, 1993.

Palmer 2005 Palmer, Arlene. *Artistry and Innovation in Pittsburgh Glass, 1808–1882: From Bakewell & Ensell to Bakewell, Pears & Co.* Pittsburgh: Frick Art & Historical Center, 2005.

Palumbo-Fossati 1984 Palumbo-Fossati, Isabella. "L'interno della casa dell'artigiano e dell'artista nella Venezia del Cinquecento." *Studi Veneziani,* 8 (1984): 109–153.

Pazaurek 1927 Pazaurek, Gustav E. "F. Gondelach, der bedeutendste deutsche Glasschneider und seine Rivalen." In *Keramic und Glasstudien* I (1927).

Pellatt 1849 Pellatt, Apsley. *Curiosities of Glass Making.* London: David Bogue, 1849.

Pepper 1971 Pepper, Adeline. *The Glass Gaffers of New Jersey.* New York: Charles Scribner's Sons, 1971.

Perry 2000 Perry, Christopher Woodall. *The Cameo Glass of Thomas and George Woodall.* Shepton Beauchamp, U.K.: Richard Dennis, 2000.

Peterson 1968 Peterson, Susan. "Glen Lukens 1887–1967." *Craft Horizons* 28.2 (March / April 1968): 22–25.

Pfrommer 1987 Pfrommer, Michael. *Studien zu alexandrinischer und großgriechischer Toreutik Frühhellenistischer Zeit.* Berlin: Mann, 1987.

Pirling 1966–2003 Pirling, Renate et al. *Das römisch-fränkische Gräberfeld von Krefeld-Gellep.* Germanische Denkmäler der Völkerwanderungszeit: Serie B, Die fränkischen Altertümer des Rheinlandes. Berlin: Gebr. Mann, 1966; Stuttgart: Franz Steiner: 1989, 1997, 2000, 2003.

Pirzio Biroli Stefanelli 1991 Pirzio Biroli Stefanelli, Lucia, et al. *L'Argento dei Romani: Vasellame da Tavola e d'Apparato.* Rome: L'ERMA di Bretschneider, 1991.

Platz-Horster 1976 *Antike Gläser.* Ed. Gertrud Platz-Horster et al. Exhib. cat. Berlin: Staatliche Museen Preussischer Kulturbesitz, 1976.

Plaut 1972 Plaut, James S. *Steuben Glass.* 1st ed. New York: H. Bitner, 1948; 3rd ed. New York: Dover Publications, 1972.

Plival de Guillebon 1994 Plival de Guillebon, Régine de. "Fernand Thesmar. Émailleur sur cuivre, or et porcelaine." *L'objet d'art* 27 (January 1994): 44–53.

***PMA Bulletin* 1978** "Christopher Wilmarth." *PMA Bulletin* (1978):8.

Podos 1991 and 1992 Podos, Lisa. Part I, "Glass Furniture: A Statement of Luxury," and Part II, "Glass Furniture: A Statement of Technology." *The Glass Club Bulletin* 165 (Fall 1991): 8–16 and 166 (Winter 1992): 3–16.

Poirier 1985 Poirier, Maurice. "Christopher Wilmarth: 'The Medium of Light.'" *ARTNews* 84.10 (December 1985): 70.

Polak 1975 Polak, Ada Buch. *Glass: Its Makers and Its Public.*

London: Weidenfeld and Nicholson, 1975.

Polzer 1986 Polzer, Joseph. "A Late Antique Goddess of the Sea." *Jahrbuch für Antike und Christentum* 29 (1986): 71–108.

Poole 1995 Poole, Julia E. *Italian Maiolica and Incised Slipware in the Fitzwilliam Museum.* Cambridge, U.K.: Fitzwilliam Museum, 1995.

Pope-Hennessy and Christiansen 1980 Pope-Hennessy, John, and Keith Christiansen, "Secular Paintings in 15th C. Tuscany: Birth trays." *MMA Bulletin* 38.1 (Summer 1980): 11–12.

Porges 1993 Porges, Maria. "Therman Statom: Northern Tide." *American Craft* 55.3 (June / July 1995): 39.

Porter 1987 Porter, Venetia. "The Arts of the Rasulids." In *Yemen: 3000 Years of Art and Civilisation in Arabia Felix.* Ed. Werner Daum. Innsbruck: Pinguin Verlag, 1987.

Pugachenkova and Rempel 1965 Pugachenkova, G. A., and L. I. Rempel. *History of Uzbek Art from Ancient Times to the Mid-Nineteenth Century* (in Russian). Moscow: Iskusstvo, 1965.

Price 1991 Price, Jennifer. "Decorated Mould-Blown Glass Tablewares in the First Century A.D." In Newby and Painter 1991, 56–75.

Putney 2002 Putney, Richard H. *Medieval Art, Medieval People: The Cloister Gallery.* Toledo, Ohio: Toledo Museum of Art, 2002.

Raby 1999 Julian Raby, "*In Vitro Veritas.* Glass Pilgrim Vessels from 7th-C. Jerusalem." In *Bayt al-Maqdis*, Part 2: *Jerusalem and Early Islam.* Oxford: Oxford University Press, 1999, 113–183.

Rademacher 1933 Rademacher, Franz. *Die deutschen Gläser des Mittelalters.* Berlin: Verlag für Kunstwissenschaft, 1933.

Rappe 1894 Rappe, Thorburg. "Sweden." In *Art and Handicraft in the Women's Building of the World's Columbian Exposition Chicago, 1893.* Ed. Maud Howe Elliott. Chicago and New York: Rand, McNally & Company, 1894.

Rath 1998 Peter Rath, *Lobmeyr 1823: Helles Glas und klares Licht.* Vienna, Cologne, Weimar: Böhlau, 1998.

Read 1926 Read, Herbert. "The Eumorfopoulos Collection: Western Objects—Part I." *Apollo Magazine* 3 (April 1926): 187–192.

Redford Glass 1979 *Reflections: The Story of Redford Glass.* Exhib. cat., Clinton County Historical Museum. Plattsburgh, N.Y.: Clinton County Historical Association, 1979.

Regan 2002 Regan, Margaret. "All That Glitters: Fritz Dreisbach helps set the gold standard for glass art." *Tucson Weekly* (5 December 2002).

Reichmann 2001 Reichmann, Chr. *Gelduba um 200 n. Chr.: Modell einer römischen Kulturlandschaft im Museum Burg Linn, Krefeld.* Exhib. cat. Krefeld, Germany, 2001.

Revi 1967 Revi, Albert Christian. *Nineteenth Century Glass: Its Genesis and Development.* 1st ed., New York: Nelson, 1959. Revised, New York: Galahad Books, 1967.

Revi 1981 Revi, Albert Christian. *American Art Nouveau Glass.* 1968; Reprint, Exton, Pa.: Schiffer Publishing Co., 1981.

Rhoades 1958 Rhoades, Orille Bourassa. *The World of Antique Arts: Antiquity to Yesterday, Fifty Broad Fields.* Chicago: Lightner, 1958.

Ribeiro and Hallett 1999 Ribeiro, Marie Queiroz, and Jessica Hallett. *Os vidros da dinastia Mameluca no museu Calouste Gulbenkian / Mamluk Glass in the Calouste Gulbenkian Museum.* Lisbon: Fondação Calouste Gulbenkian, 1999.

Richardson 1992 Richardson, Lawrence, Jr. *A New Topographical Dictionary of Ancient Rome.* Baltimore, Md.: Johns Hopkins University Press, 1992.

Richter 1914 Richter, G. M. A. "The Curtis Collection of Ancient Glass." *Art in America* 2 (1914): 72–87.

Ricke 1998 Ricke, Helmut. "Bert Frijns: The Netherlands." In *The Glass Skin.* Exhib. cat., The Corning Museum of Glass. Corning, N.Y., 1998, 54ff.

Riefstahl 1961 Riefstahl, Rudolf M. "Ancient and Near Eastern Glass." TMA *Museum News* 4.2 (1961): 27–46.

Ritman Collection 1995 *The Joseph R. Ritman Collection of 16th and 17th Century Dutch Glass.* Sale cat., Sotheby's,

London, 14 November 1995.

Ritsema van Eck and Zijlstra-Zweens 1993 Pieter C. Ritsema van Eck and Henrica M. Zijlstra-Zweens. *Glass in the Rijksmuseum.* Vol. 1. Zwolle: Waanders Uitgevers, 1993.

Rochebrune 2004 Rochebrune, Marie-Laure de. "Venetian and Façon de Venise Glass in France in the 16th and 17th Centuries," In *Beyond Venice* 2004, 142–163.

Rogers 1967 Rogers, Millard F. "The European and American Glass Collection." *Apollo* 86 (December 1967): 478–485.

Rogers 1983 Rogers, J. Michael. "Glass in Ottoman Turkey." *Sonderdruck aus Istanbuler Mitteilungen* 33 (1983): 239–266.

Rorabaugh 1979 Rorabaugh, W. J. *The Alcoholic Republic: An American Tradition.* New York: Oxford University Press, 1979.

Rosen 1993 Rosen, Ingrid. *Fem tidiga glaskonstnarrinnor.* Stockholm: Carlssons Publishers, 1993.

Rosenberg 1922–28 Rosenberg, Marc. *Der Goldschmiede Merkzeichen.* 3rd ed., 4 vols. Frankfurt am Main, Germany: Frankfurter Verlags-Anstalt, 1922–28.

Rosenstock 1989 Rosenstock, Laura. *Christopher Wilmarth.* New York: Museum of Modern Art, 1989.

Rothenberg 1976 Rothenberg, Polly. *Decorating Glass—Painting, Embossing, Engraving, Etching.* New York: Crown, 1976.

Royal Hunter 1978 *The Royal Hunter: Art of the Sasanian Empire.* Ed. Prudence Oliver Harper, with Jens Kröger, Carol Manson Bier, and Martha L. Carter. Exhib. cat. New York: Asia House Gallery, 1978.

Royall 1829 Royall, Anne. *Mrs. Royall's Pennsylvania, or Travels Continued in the United States.* Vol. 2. Washington, D.C.: 1829.

Rückert 1963 Rückert, Rainer. "Venetianische Moscheeampeln in Istanbul." In Hans Martin Erffa, ed., *Festschrift für Harald Keller.* Darmstadt: E. Roether, 1963, 223–234.

Rush 1973 Rush, James. *The Ingenious Beilbys.* London: Barrie & Jenkins, 1973.

Saguì 1997 Saguì, Lucia. "Un piatto di vetro inciso da Roma. Contributo ad un inquadramento delle officine vetrarie tardoantiche." In *Studi in onore di Lucia Guerrini: Studi Miscellanei* 30 (1997): 337–358.

Sangiorgi 1914 Sangiorgi, Giorgio. *Collezione di vetri antichi dalle origini al V secolo D.C.* Compiled and edited by Giorgio Sangiorgi, with preface by W. Froehner. Rome: Bestetti e Tumminelli, 1914.

Sargentson 1996 Sargentson, Carolyn. *Merchants and Luxury Markets.* London: Victoria & Albert Museum, in association with The J. Paul Getty Museum, 1996.

Scatozza Höricht 1986 Scatozza Höricht, L. A. *I vetri romani di Ercolano.* Ministero per I Beni Culturali ed Ambientali, Soprintendenza Archeologica di Pompei, Cataloghi, vol. 1. Rome: L'ERMA di Bretschneider, 1986.

Schmidt 1911 Schmidt, Robert. "Die venezianischen Emailgläser des XV. und XVI. Jahrhunderts", *Jahrbuch der königlich-preussischen Kunstsammlungen*, 32 (1911): 249–289.

Schmidt 1914 Schmidt, Robert. *Brandenburgische Gläser.* Berlin and Leipzig: G. Reimer, 1914.

Schmidt 1957 Schmidt, Erich F. *Persepolis II: Contents of the Treasury and Other Discoveries.* Chicago, Ill.: The University of Chicago Press, 1957.

Seibel 1998 Seibel, Fritz. *Technologie und Fertigungstechniken römischer Glashütten.* Berlin: Galda und Wilch, 1998.

Seling 1980 / 94 Seling, Helmut. *Silber und Gold: Augsburger Goldschmiedekunst für die Höfe Europas.* Munich: Hirmr, 1994.

Shaw 1973 Shaw, J. T., ed. *Sunderland Ware: The Potteries of Wearside.* 4th ed., rev. Sunderland, England: Sunderland Public Libraries, Museum and Art Gallery, 1973.

Sillib 1914 Smit, Rudolph. *Schloß Favorite und die Eremitagen der Markgräfin Franziska Sibylla Augusta von Baden-Baden.* Heidelberg: Neujahrsblätter des Badischen Historischen Kommission, 1914.

Silver for the Gods 1977 *Silver for the Gods: 800 Years of Greek and Roman Silver.* Ed. Andrew Oliver, Jr., and Kurt T. Luckner. Exhib. cat. Toledo, Ohio: Toledo Museum of Art, 1977.

Silverman 1936 Silverman, Alexander. "Joseph Locke, Artist." *The Glass Industry* 17.8 (August 1936): 272–275.

Simonsfeld 1887 Simonsfeld, Henry. *Der Fondaco dei Tedeschi in Venedig und die deutsch venezianischen Handelbeziehungen.* 2 Vols. Stuttgart: J. G. Gotaa'schen Buchhandlung, 1887.

Smit 1984 Smit, F. G. A. M. *A Concise Catalogue of European Line-Engraved Glassware, 1570–1900.* Peterborough, U.K.: the author, 1994.

Smith 1991 Smith, John P. *Osler's Crystal for Royalty and Rajahs.* London: Mallett, 1991.

Smith 1992 Smith, John. "Glass Furniture in the Nineteenth and Early Twentieth Centuries." *The Journal of the Glass Association* 4 (1992): 18–25.

Smith 2006 Smith, John P. "Paul Oppitz, From Bohemia to Clapham." *The Journal of the Glass Circle* 10 (2006): unp.

Spanish Glass 1974 *Spanish Glass in the Hermitage.* Leningrad: Aurora Art Publishers, 1974.

Spillman 1986 Spillman, Jane Shadel. *Glass from World's Fairs 1851–1904.* Corning, N.Y.: The Corning Museum of Glass, 1986.

Spillman 1992 Spillman, Jane Shadel. "The Leighton–Ford Correspondence." *The Acorn* 3 (1992): 3ff.

Spillman 1998 Spillman, Jane Shadel. "American Pressed Glass in Vienna," *The Glass Club Bulletin* 183 (Fall 1998): 5–9.

Starkey 1998 David Starkey, ed. *The Inventory of King Henry VIII: Society of Antiquaries MS 129 and British Library MS Harley 1419: The Transcript.* London: Harvey Miller for the Society of Antiquaries, 1998.

Steenberg 1950 Steenberg, Elisa. *Swedish Glass.* Trans. Lillian Ollén. New York: M. Barrows and Company, Inc., 1950.

Stern 1995 Stern, E. Marianne. *Roman Mold-blown Glass, The First Through Sixth Centuries.* Rome: L'ERMA di Bretschneider in association with the Toledo Museum of Art, 1995.

Stern 1999 Stern, E. Marianne. "Roman Glassblowing in a Cultural Context." *AJA* 103 (1999): 441–484.

Stern 2001 Stern, E. Marianne. *Roman, Byzantine and Early Medieval Glass, 10 B.C.E–700 C.E. Ernesto Wolf Collection.* Ostfildern-Ruit, Germany: Hatje-Cantz Publishers and New York: Distributed Art Publishers, 2001.

Stern and Schlick-Nolte 1994 Stern, E. Marianne, and Birgit Schlick-Nolte. *Early Glass of the Ancient World, 1600 B.C.–A.D. 50. Ernesto Wolf Collection.* Ostfildern-Ruit, Germany: Verlag Gert Hatje, 1994.

Strasser 2002 Strasser, Rudolf von, with Sabine Baumgärtner. *Licht und Farbe. Dekoriertes Glas—Renaissance, Barock, Biedermeier: Die Sammlung Rudolf von Strasser.* Vienna: Kunsthistorisches Museum, and Milan: Skira, 2002.

Strauss 1955 *Glass Drinking Vessels from the Strauss Collections.* Exhib. cat. Corning, N.Y.: The Corning Museum of Glass, 1955.

Sturgis 1894 Sturgis, Russell. "The Coleman Collection of Antique Glass." *Century Magazine* 48 (1894): 554–558.

Suda 1991 Suda, Dr. Kristian. "Zámečníková: A Singular Encounter." *Glass* 45 (Fall 1991): 35.

Sullivan 1995 Sullivan, Scott. "The Glass Leprechaun." *Newsweek* (16 October 1995): 52.

Svensk Jugend 1964 *Svensk Jugend.* Exhib. cat. Stockholm: Nordiska Museet, 1964.

Swetnam-Burland 2000 Swetnam-Burland, Molly. "Bacchus / Liber in Pompeii: A Religious Context for the Villa of the Mysteries Frieze." In *Villa of the Mysteries* 2000, 59–73.

Syson and Thornton 2001 Syson, Luke, and Dora Thornton. *Objects of Virtue: Art in Renaissance Italy.* London: The British Museum, and Los Angeles: The J. Paul Getty Museum, 2001.

Te Duits 1992 Te Duits, Thimo. "Bert Frijns: The Celebrated Dutch Artist Who Eschews the Use of Color." *Glass* 49 (Fall 1992): 34.

Theophilus 1991 Theophilus, Jeremy. "Sources of Inspiration." *Crafts* 113 (Nov / Dec 1991): 44–47.

Theuerkauff-Liederwald 1994 Theuerkauff-Liederwald, Anna-Elisabeth. *Venezianisches Glas der Kunstsammlungen der Veste Coburg: Die Sammlung Herzog Alfreds von Sachsen-Coburg und Gotha (1844–1900).* Coburg: Die Kunstsammlungen, and Lingen: Luca Verlag, 1994.

Thorpe 1929 Thorpe, W. A. *A History of English and Irish Glass.* Vol. 2. London: The Medici Society, 1929.

TMA *Amercian Paintings* Strickler, Susan E., William Hutton, Toledo Museum of Art. *American Paintings.* Toledo, Ohio, 1979.

TMA *European Paintings* The Toledo Museum of Art. *European Paintings.* Toledo, Ohio, 1976.

TMA *Guide* Paula Reich. *Toledo Museum of Art Map and Guide.* London: Scala Publishers in association with the Toledo Museum of Art, 2005.

TMA *Statom's Hydra* 2002 *Looking Like a Memory, Therman Statom's Hydra.* Gallery brochure. Toledo, Ohio: Toledo Museum of Art, 2002.

TMA *Welles Sculpture Garden* 2001 *Georgia and David K. Welles Sculpture Garden Guide.* Toledo, Ohio: Toledo Museum of Art, 2001.

***Toledo Treasures* 1995** *Treasures from The Toledo Museum of Art.* Toledo, Ohio: Toledo Museum of Art, 1995.

Torsten-Bröhan 1992 Torsten-Bröhan, H. von. *Glaskunst der Moderne — von Josef Hoffmann bis Wilhelm Wagenfeld.* Munich: Prestel, 1992.

***Traum und Wirklichkeit* 1985** *Traum und Wirklichkeit, Wien 1870–1930.* Ed. Robert Waissenberger. Exhib. cat. Vienna: Museen der Stadt Wien, 1985.

***Treasures* 1992** David Whitehouse et al., *Treasures from The Corning Museum of Glass.* Corning, N.Y.: The Corning Museum of Glass, 1992.

Triantafyllidis 1998 Triantafyllidis, Pavlos. "New Evidence of Glass Manufacture in Classical and Hellenistic Rhodes." *AnnAIHV* 14 (1998 [2000]): 30–38.

Triantafyllidis 2001 Triantafyllidis, Pavlos. "Achaemenian Glass Production." *AnnAIHV* 15 (2001 [2003]): 13–17.

***Trésor de Saint-Denis* 1991** *Le trésor de Saint-Denis.* Exhib. cat., Musée du Louvre. Paris: Réunion des musées nationaux, 1991.

Turrell 1983–84 Turrell, James. "Light in Space." *GAS J* (1983–84): 5–10.

Uchida 1960 Uchida, Yoshiko. "John Burton: The Fluid Breath of Glass." *Craft Horizons* 20.6 (November / December 1960): 26.

Untracht 1962 Untracht, Oppi. "The Glass of Edris Eckhardt." *Craft Horizons* 22.6 (November/December 1962): 36ff.

Valotaire 1929 Valotaire, Marcel. "The Trend of Decorative Art, The Salon d'Automne." *The Studio* 97 (January 1929): 91ff.

Van Kester 2001 Van Kester, Peter. "Bert Frijns: The Glass is Half Full." *Glass* 83 (Summer 2001): 47ff.

Van Royen 1991 Van Royen, P. C. "Naar wijder horizon: Scheepvaartbetrekkingen tussen de Lage Landen en Italië." In *Amsterdam: Venetië van het Noorden.* Ed. Margriet de Roever. 's-Gravenhage, Netherlands: Gary Schwartz / Amsterdam: Gemeente-Archief, 1991, 104–119.

Vaupel 1995–96 "The Autobiography of H. F. Louis Vaupel." *The Acorn* 6 (1995–96): 23–87.

Vecellio 1591 Vecellio, Cesare. *Corona delle Nobili et Virtuose Donne.* 1st ed., Venice: the author, 1591. Reissued in many editions through the end of the nineteenth century. See also: *Pattern Book of Renaissance Lace: A Reprint of the 1617 Edition of the Corona delle Nobili et Virtuose Donne, by Cesare Vecellio.* New York: Dover, 1988

***Verre en Syrie* 1964** *Le Verre en Syrie.* Bulletin des Journées Internationales du Verre 3. Liège: l'Association internationale pour l'histoire du verre, 1964.

Vickers 1996 Vickers, Michael. "Rock Crystal — The Key to Cut

Glass and *Diatreta* in Persia and Rome." *JRA* 9 (1996): 48–65.

***Villa of the Mysteries* 2000** *The Villa of the Mysteries in Pompeii: Ancient Ritual, Modern Muse.* Ed. Elaine K. Gazda. Exhib. cat. Ann Arbor, Mich.: Kelsey Museum of Archaeology and the University of Michigan Museum of Art, 2000.

Vincent 1975 Vincent, Keith. *Nailsea Glass.* London: David and Charles, 1975.

Volsek 2004 Volsek, Jörg. "Stadt Mönchengladbach: Römische Befunde im ehemaligen Kriegsgefangenelager." In *Archäologie im Rheinland 2004.* Ed. Jürgen Kunow. Stuttgart: Theiss, 2005, 102–103.

Von Elbe 1975 Von Elbe, Joachim. *Roman Germany: A Guide to Sites and Museums.* Mainz: Verlag Philipp von Zabern, 1975.

Von Rohr 1991 Von Rohr, Alheidis. *Lauensteiner Glas 1701–1827.* Hannover, Germany: Historisches Museum, 1991.

Von Saldern 1955 Von Saldern, Axel. "An Islamic Carved Glass Cup in The Corning Museum of Glass." In *Artibus Asiae* 18.3–4 (1955): 257–270.

Von Saldern 1959 Von Saldern, Axel. "Glass Finds at Gordion." *JGS* 1 (1959): 23–49.

Von Saldern 1968 Von Saldern, Axel. *Ancient Glass in the Fine Arts Museum, Boston.* Boston: Museum of Fine Arts, 1968.

Von Saldern 1975 Von Saldern, Axel. "Two Achaemenid Glass Bowls." *JGS* 17 (1975): 37–46.

Von Saldern 1980 Von Saldern, Axel. *Glas von der Antike bis zum Jugendstil, Sammlung Hans Cohn.* Mainz, Germany: Verlag Philipp von Zabern, 1980.

Von Saldern 2004 Von Saldern, Axel. *Antikes Glas, Handbuch der Archäologie.* Munich: C. H. Beck, 2004.

Vose 1984 Vose, Ruth Hurst. "From the Dark Ages to the Fall of Constantine." In Klein and Lloyd 1984, 40–65.

Waggoner 1989 Waggoner, Shawn. "Glass Art People: Toots Zynsky." *Glass Art Magazine* 4 / 5 (July / August 1989): 89.

Wakefield 1982 Wakefield, Hugh. *Nineteenth-Century British Glass.* 1961. 2nd ed., rev. London: Faber & Faber, 1982.

Wallis 1868 Wallis, George. "The Glass — Domestic and Decorative." In *The Illustrated Catalogue of the Universal Exhibition Published with The Art Journal.* London: George Virtue, 1868, 101–102.

Ward 1998 Ward, Rachel, ed. *Gilded and Enamelled Glass from the Middle East.* London: The British Museum, 1998.

Wedepohl 2001 Wedepohl, K. Hans, Wolfgang Gaitzsch, and Anna-Barbara Follmann-Schulz. "Glassmaking and Glassworking in Six Roman Factories in the Hambach Forest (Germany)." *AnnAIHV* 15 (2001 [2003]): 56–61.

Warren 1981 Warren, Phelps. *Irish Glass: Waterford, Cork, Belfast, in the Age of Exuberance.* 1970. 2nd rev. ed. London: Faber and Faber, 1981.

Watkins 1943 Watkins, Lura Woodside. "Some Notes on Victorian Cased Glass." *Antiques* 43.4 (April 1943): 182.

Waugh 1947 Waugh, Sidney. *Steuben Glass.* New York: Steuben Glass, 1947.

Weatherman 1974 Weatherman, Hazel Marie. *Colored Glass of the Depression Era.* Book 2. Springfield, Mo.: Weatherman Glassbooks, 1974.

Weeks 1883 Weeks, Joseph D. "Report on the Manufacture of Glass." In *Report on the Manufactures of the United States at the Tenth Census.* Washington, D.C.: U.S. Government Printing Office, 1883.

Weinberg and Goldstein 1988 Weinberg, Gladys D., and Sidney M. Goldstein. "The Glass Vessels." In *Excavations at Jalame: Site of a Glass Factory in Late Roman Palestine.* Ed. Gladys D. Weinberg. Columbia, Mo.: University of Missouri Press, 1988, 38–102.

Weitzmann 1977 Weitzmann, Kurt. *Late Antique and Early Christian Book Illumination.* New York: George Braziller, 1977.

Westropp 1928 Westropp, M. S. Dudley. "Molded Glass."

Antiques 6.6 (December 1928): 538–543.

Whitehouse 1991 Whitehouse, David. "Cameo Glass." In Newby and Painter 1991, 19–32.

Whitehouse 1997 Whitehouse, David. *Roman Glass in The Corning Museum of Glass.* Vol. 1. Corning, N.Y.: The Corning Museum of Glass, 1997.

Whitehouse 2001 Whitehouse, David. *Roman Glass in the Corning Museum of Glass.* Vol. 2. Corning, N.Y.: The Corning Museum of Glass, 2001.

Whitehouse 2003 Whitehouse, David. *Roman Glass in the Corning Museum of Glass.* Vol. 3. Corning, N.Y.: The Corning Museum of Glass, 2003.

Whitehouse 2005 David Whitehouse. *Sasanian and Post-Sasanian Glass in The Corning Museum of Glass.* Corning, N.Y.: The Corning Museum of Glass, 2005.

***Wiener Werkstätte* 1967** W. Mrazek, ed. *Die Wiener Werkstätte: Modernes Kunsthandwerk von 1903–1932.* Exhib. cat. Vienna: Österreichisches Museum für Angewandte Kunst, 1967.

Wilde 1981 Wilde, Davis S. "The Glass Man of Grand Rapids." *Prism: A Magazine of Area Arts and People* 1.2 (Spring 1981): 8.

Willmott 2004 Willmott, Hugh. "Venetian and *Façon de Venise* Glass in England." In *Beyond Venice* 2004, 270–307.

Wilmotte 1997 Wilmotte, André. *Au Temps de Jean-Baptiste Wilmotte, 1842–1913: graveur à la roue aux Cristalleries du Val Saint-Lambert de 1856 à 1907.* Ivoz-Ramet, Liège, Belgium: Andre Wilmotte, 1997.

Wilson 1972 Wilson, Kenneth M. *New England Glass and Glassmaking.* New York: Thomas Y. Crowell, 1972.

Wilson 1989 Wilson, Jack D. *Phoenix & Consolidated Art Glass 1926–1980.* Marietta, Ohio: Antique Publications, 1989.

Wilson 1993 Wilson, Kenneth M. "New Discoveries in American Glass, 1760–1930." *Antiques* 144.6 (December 1993): 810–811.

Wilson 1994 Wilson, Kenneth M. *The Toledo Museum of Art. American Glass, 1760–1930.* 2 vols. New York and Toledo: Hudson Hills Press in association with The Toledo Museum of Art, 1994.

Wilson 2005 Wilson, Kenneth M. *Mt. Washington & Pairpoint Glass.* Vol. 1. Woodbridge, Suffolk, England: Antique Collectors' Club, 2005.

Wixom 1962 Wixom, William. "A Venetian Tazza with Putti." *Bulletin of the Cleveland Museum of Art* 49 (1962): 26.

Wolff 2003 Wolff, Gerta. *Roman-Germanic Cologne: A Guide to the Roman-Germanic Museum and City of Cologne.* Trans. Claudia Lupri. Cologne: J. P. Bachem Verlag, 2003.

Wood 1984 Wood, Perran. "The Tradition from Medieval to Renaissance." In Klein and Lloyd 1984, 67–91.

Woods 2004 David Woods, "The Crosses on the Glass Pilgrim Vessels from Jerusalem." *JGS* 46 (2004): 191–195.

Wortz 1986 Wortz, Melinda. "Larry Bell." *GAS J* (1986): 58–61.

Young 1983 Young, Hilary. "Thomas Heming and the Tatton Cup." *The Burlington Magazine* 125.962 (May 1983): 285–286.

Záměčníková 1992 Záměčníková, Dana. "Personal Mythologies: Notices from Prague." *GAS J* (1992): 79.

Záměčníková 1993 Záměčníková, Dana. *Where Image Meets Form.* Lathup Village, Mich.: Habatat Galleries, 1993.

Záměčníková 1999 Záměčníková, Dana. "Katia, Two Dogs, Pat Horse, Mana Mouse and Marian." *GAS J* (1999): 60.

Zecchin 1968 Zecchin, Luigi. "Fortuna d'una parola sbagliata." *JGS* (1968): 110–113.

Zecchin 1971 Zecchin, Luigi. "Una fornace muranese all'insigna della Sirena." *Rivista della Stazione Sperimentale del Vetro* 1.2 (1971): 19–23.

Zecchin 1986 Zecchin, Luigi. *Il Ricettario Darduin.* Venice: Arsenale, 1986.

Zecchin 1987–89 Zecchin, Luigi. *Vetro e Vetrai di Murano: Studi sulla Storia del Vetro.* 3 vols. Venice: Arsenale Editrice, 1987–89.

Zuffa 1954 Zuffa, Mario. "I vetri muranesi del Museo Civico di Bologna." *La Mercanzia* 11.3 (March 1954): 3–8.

INDEX